Reinventing Cinema

REINVENTING CINEMA

Movies in the Age of Media Convergence

CHUCK TRYON

RUTGERS UNIVERSITY PRESS
New Brunswick, New Jersey, and London

Library of Congress Cataloging-in-Publication Data

Tryon, Chuck, 1970–
Reinventing cinema : movies in the age of media convergence / Chuck Tryon.
 p. cm.
 Includes bibliographical references and index.
 ISBN 978-0-8135-4546-2 (hardcover : alk. paper)
 ISBN 978-0-8135-4547-9 (pbk. : alk. paper)
 1. Motion pictures—United States—History—21st century. 2. Digital media—
Influence. 3. Motion picture industry—Technological innovations. 4. Digital
cinematography. 5. Convergence (Telecommunication) I. Title.

PN1993.5.U6T79 2009
791.430973—dc22

 2008043711

A British Cataloging-in-Publication record for this book is available from the British
Library.

Visit our Web site: http://rutgerspress.rutgers.edu

Manufactured in the United States of America

Contents

Acknowledgments

The genesis for this project began many years ago when I first began thinking about the role of digital media in unsettling traditional definitions of cinema. While the final version of the book bears little resemblance to its origins, I am very grateful to Richard Dienst, Siobhan Somerville, Dino Felluga, Arkady Plotnitsky, and Vincent Leitch for their comments and advice on my work. Other people who have offered suggestions and advice about the project at various stopping points along the way include my colleagues at the University of Illinois, Georgia Tech, and Catholic University: J. P. Telotte, Ramona Curry, Jason Jones, Jay Bolter, Rodney Hill, Lisa Gitelman, Alex Russo, and Susan George. More recently, at Fayetteville State, a number of colleagues have consistently provided steady encouragement, including Ed McShane, Eric Hyman, Dean Swinford, Alison Van Nyhuis, Sarah Frantz, Kim Kirkpatrick, Brenda Hammack, and Sonya Brown.

Conversations at conferences and online have been incredibly helpful as I assembled the book in its current form. I am especially grateful to Jonathan Gray, Kathleen Fitzpatrick, Jason Rhody, Tim Anderson, Avi Santo, Richard Edwards, Steven Shaviro, Alexandra Juhasz, Patricia Aufderheide, Julia Lesage, Chuck Kleinhans, Jason Mittell, Lisa Nakamura, Michael Newman, Elana Levine, Rachel Thibault, Michael Tucker, David Silver, Tara McPherson, Michele White, Michael Kackman, Nick Rombes, Derek Kompare, Matthew Gold, Chris Cagle, Amy Monaghan, Nels Highberg, and Tama Leaver.

Toby Miller provided an insightful reading of the manuscript as the project was nearing completion, for which I am very grateful.

The work in this book has been informed by the digital media it purports to study. I have made extensive use of blogs, social bookmarking sites, and wikis not only to store research but also to receive feedback and suggestions. To that end, I would like to thank a number of people who have commented on or linked to blog entries where I developed material for this book, including Agnes Varnum, A. J. Schnack, Cynthia Rockwell, Sujewa Ekanayake, Tom Watson, Lance Mannion, Anne Thompson, Karina Longworth, Billie Hara, and David Hudson.

I am grateful as well to dozens of friends, old and new, who have always been supportive and even helped me get away form the computer for a few hours. I consider myself lucky to have cultivated so many warm, caring relationships. George Williams, Mike Duvall, Lara Vetter, and Renée Trilling have all remained a wonderful support system. Jessica Banov provided a number of useful suggestions about the cover image and frequently helped me think through some of the key ideas in the book. Andrew Martel, Myron Pitts, Jen Calhoun, Matt Leclercq, Corey Johnson, and the rest of the newspaper gang have provided much needed breaks from work. Antony Grow and Anca Stefan have shown me incredible friendship and warmth throughout my time in Fayetteville. Jim and Chris Hansen were the first people with whom I began having conversations about the movies, discussions that continue to this day. I'd also like to thank Leslie Mitchner at Rutgers University Press for her generous and enthusiastic support of my work throughout this process. I am also extremely grateful to the copyeditor, Eric Schramm, who not only cleaned up my prose considerably but also provided a thoughtful, attentive, and detailed reading that significantly improved the book.

Different versions of the discussions on DVDs, portable media players, and special effects have appeared in *Post-Identity* 5.1 (Winter 2007), *Film Criticism* 28.2 (Winter 2003–04), and the *Journal of Film and Video*. I am grateful to the editors of these publications for permitting republication here.

Finally, this book would have been impossible to complete without the help of my parents, Charles and Glenda Tryon, and my sister, Kristen, who have never wavered in their support.

Reinventing Cinema

INTRODUCTION

In June 2007, two stories in the entertainment press underscored the ways in which film culture has been redefined by digital cinema. First, Lionsgate and the Weinstein Company made the decision to release documentary raconteur Michael Moore's exposé of the health care industry, *Sicko*, one week earlier than planned because of the threat of rampant internet piracy. A pirated version of *Sicko* had been leaked briefly to the video sharing site YouTube, and eager bloggers were weighing in with their readings of the film several days before movie critics and political pundits were slated to see and review the movie. While many bloggers enthusiastically endorsed or challenged Moore's political views, the decision to move forward the film's release date suggested that studio accountants were perhaps less concerned about changing people's minds about the U.S. health care system than they were about protecting their opening week box office. The renewed focus on piracy prompted a diversity of responses, with at least one critic arguing that leaking Moore's film would actually help it financially by providing it with additional exposure.[1] Significantly, Moore's complaints about the film being pirated emphasized not only the potential for lost profits but also the concern that audiences would be unable to get the optimum experience of seeing the movie in a theater, with the filmmaker telling the *Hollywood Reporter*, "Every filmmaker intends for his film to be seen on the big screen."[2] While any real impact on *Sicko*'s box office and critical reception would be difficult to

determine, the brief cycle focusing on piracy illustrated the challenges the Weinstein Company faced in shaping the popular buzz surrounding the film and ensuring the film's profitability.[3] However, the debate over *Sicko* also provoked a number of questions about the role of film distribution in shaping reception and the role of newly powerful audiences in helping to shape the meaning of a film.

During the same week, Susan Buice and Arin Crumley became the first filmmakers to make the deliberate decision to self-distribute an entire feature-length movie on YouTube. Their film, *Four Eyed Monsters*, had gained an enthusiastic audience through festival screenings and a four-walling tour organized online, but most important through video podcasts produced by Buice and Crumley that described the making of their self-financed film while building suspense about their dating relationship. This YouTube distribution was tied to a promotion for the movie-oriented social networking web site Spout.com, with Spout agreeing to pay one dollar toward Buice and Crumley's substantial credit-card debt for every member who joined the site through the link to *Four Eyed Monsters'* Spout.com page. While the piracy of *Sicko* was seen as illustrating the need for better policing of illegal file sharing, Buice and Crumley believed that in a competitive independent film distribution market their film would benefit more from being available online for free, in order to generate interest that would lead to increased DVD sales. Their use of YouTube has become a frequently cited model that other do-it-yourself (DIY) filmmakers have emulated with the hope of achieving broader success.

While the two films I describe here come from vastly different film cultures—a Hollywood indie originally financed by Disney's Miramax versus a movie assembled in a small apartment in Brooklyn and paid for using credit cards—both movies illustrate the degree to which film culture is being redefined by digital media. In fact, in both cases, the computer is seen as a primary means by which many audiences will encounter both films, at least initially. In addition, both histories depict the ability of networked movie audiences to shape the reception of a movie, with blogging and social networking serving as key tools, either for sharing a film illegally or for using word-of-mouth to create an audience. Digital cinema, therefore, offers a significant departure from film, particularly when it comes to the distribution, exhibition, and reception of movies.

In fact, these dramatic changes have prompted a number of observers to describe what is happening as a paradigm shift. Emerging Pictures CEO Ira Deutchman echoed the sentiments of many of his colleagues when he argued, in February 2008, that movies are in "the

transitional post-major studio pre-Internet era," a phrase that became one of the more oft-cited slogans for making sense of the shifting production, distribution, exhibition, and promotional contexts.[4] Similarly, the emergence of digital cinema inspired a number of film critics to enthusiastically predict, as Wheeler Winston Dixon put it, that "the digital reinvention of the cinema is every bit as revolutionary as the dawn of cinema itself, and it comes with an entirely new set of rules and expectations."[5] In this sense, digital cinema seems to unsettle not only the traditional economic protocols associated with the film industry but also the textual models available to the digital filmmaker, allowing for a potentially vast expansion of what constitutes a cinematic text. The result of this redefinition of the cinematic text has been not only the revival of short films that could be distributed digitally but the popularization of "supplemental" shorts on DVDs or on the web that expand the world of the film, prompting Barbara Klinger to argue that digital cinema has ushered in "a new golden age of the short."[6] At the same time, digital technologies also encouraged filmmakers to explore new, nonlinear, and interactive storytelling formats.

While it is tempting to regard these events as implying a revolutionary shift in movie production practices and consumption habits, it is important to recognize the extent to which distribution and exhibition models remain bound to more traditional models of movie consumption as a social activity. Digital cinema, after all, is not merely the replacement of film projectors with digital technologies. It also engages cinema as a range of social practices, beyond theaters and our domestic screens and into the wider social world as well. In this sense, movie watching is not an isolated activity shaped solely by a technological apparatus. Instead, watching movies, as Charles Acland reminds us, always "consists of a variety of behaviors, actions, moods, and intentions."[7] And although digital technologies may provide new delivery and exhibition systems, they are also part of a larger arrangement of behaviors, practices, and discourses that inform movie consumption. In fact, while some observers have worried that portable media players, digital cable, and broadband internet would pull people away from the big screen, movie theaters themselves continue to serve a vital cultural role. While a Netflix subscription or video-on-demand may encourage tired parents to stay at home rather than venturing out amongst the crowds of kids at the local multiplex on a Friday night, digital cinema may be equally responsible for drawing people back into the theater through trailers and other promotional clips distributed digitally.

This book addresses the significant changes to film culture that are taking place under the rubric of digital cinema. Perhaps the most

visible transformations are in the realm of production through special effects typically seen in Hollywood blockbusters; however, as the above examples suggest, digital cinema is also effecting change in the distribution, exhibition, advertising, and reception of movies often in complicated and unpredictable ways. In fact, the very definition of what counts as a film text is subject to reinterpretation, as filmmakers make use of video podcasts and DVD extras to provide supplemental elements not included in the original film. The "text" of *Four Eyed Monsters*, for example, also includes the podcasts, the web site, and even the social networking sites where the filmmakers have set up pages. While there is a much longer history of filmmakers making use of supplemental features, such as making-of documentaries, what seems especially useful here is the way that these expanded film texts can provide new ways of thinking about how we engage with the cinema.

Because these changes have opened up so many possibilities for production and distribution, in fact, many feel as if the optimal experience of watching movies with a group of strangers in a darkened theater is about to disappear, replaced by something else entirely, a perception that has left a number of film critics and theorists mourning the withering away of cinema culture, while digital media enthusiasts view an open horizon that presents new narrative—and financial—possibilities. At the same time, with many independent films being released simultaneously to theaters, on cable, or on DVD, viewers with Netflix or video-on-demand can circumvent the screening schedule, watching movies whenever they choose, albeit at the cost of not seeing them on the big screen. Still others make their own videos or remix Hollywood films, posting their work to the web, while others share these videos by linking to them on blogs or in social networking sites. In short, cinema is being reinvented, with consequences that remain as yet unpredictable not only for movie fans but also for the filmmakers themselves, a situation that can provoke both excitement and uncertainty, as traditional business models and traditional modes of watching come under question. The goal of this book is to make sense of the ways in which new cinema technologies are being used not only by the major media corporations but also by DIY independent filmmakers and movie bloggers, as they all seek to navigate this moment of transition.

While digital cinema technologies offer the enticing possibility of a global cinema culture, the case studies I explore are generally limited to practices within the United States. Scholars such as Toby Miller et al. and Charles Acland, among others, have provided important reminders about the ways in which Hollywood films permeate across global borders, while a number of genres—martial arts films, anime, European art

films—cross back, and many other countries are negotiating the digital transition more or less simultaneously with the United States. At the same time, film blogs, like blogging in general, helped to figure a global film culture, as conversations about shared cinematic tastes often crossed national borders. Though Acland reminds us to be skeptical of the idea of a "standardized global movie patron," blogging can help to foster a sense of global collectivity. However, because individual contexts vary, I have generally focused on practices that are taking place inside the United States.

WHAT IS DIGITAL CINEMA?

This book defines digital cinema broadly to account not only for the use of digital technologies in production and post-production but also in terms of the distribution and exhibition of movies. Discussions of the transition into digital filmmaking have, quite often, focused on the material object of film itself.[8] These scholars take note of the fact that celluloid itself is likely to disappear in the early part of the twenty-first century in order to address how changing the physical object alters what we study and whether "film" itself is an obsolete term. Catherine Russell puts this question most succinctly when she asks, "Is it still cinema without celluloid?"[9] Of course, because we have watched movies in a variety of contexts—on television, on videotape, and more recently on our computer screens—for some time, these definitions remain elastic.[10] At the same time, many "films" are made digitally and broadcast on television or never play on screens at theaters at all. Thus, this book takes for granted the idea that films circulate in a variety of media and may, in fact, be consumed in a variety of media protocols.

In this context, it is worth considering Lisa Gitelman's definition of media as "socially realized structures of communication, where structures include both technological forms and their associated protocols."[11] If we treat the theatrical projection of movies as a medium, many of these protocols might include arriving in time to watch the trailers, sitting quietly during the movie, buying popcorn or other snacks, or other behaviors sanctioned by the theater, as well as the use of a projector to display a movie image on a giant screen. Thus, as Amanda Lotz writes of television, a medium such as film "is not just a machine, but also the set of behaviors and practices associated with its use."[12] By this logic, digital cinema, while changing many practices, will no doubt preserve others. In fact, given continuities in architecture and theater design, many critics, including John Belton, argued that digital projection in theaters might do very little to alter the

experiences of moviegoers, and in many cases theaters have sought to make adoption appear as seamless as possible.[13] Of course, as Charles Acland points out, digital projection entails far more than simply the look and sound of a movie; it also involves temporal arrangements, such as the ability to create more flexible film schedules or to create simultaneous event screenings with remote locations.[14] As a result, digital projection presents the opportunity for more than the rebooting of film by preserving the opening-night print quality of a film. It can also restructure the rhythms of the movie programming schedule, allowing exhibitors to shut down at a moment's notice a poorly performing film and to replace it with a more popular one, potentially reinforcing the blockbuster logic of Hollywood and by extension placing even further emphasis on theaters as sites designed primarily for the reception of those films.

Other digital cinema technologies have had a more measurable and more frequently debated effect on audience practices. In particular, as Barbara Klinger has noted, home theater systems have contributed to the "theatricalization" of domestic space in a variety of ways, turning the home into an entertainment paradise. In turn, the comforts provided by home theaters have now been adapted by many of the newer multiplexes. Klinger cites the examples of stadium seating, cup holders, and other amenities; however, more recently, some theaters, including the Landmark Theatre at the Westside Pavilion, have pushed the domestication of the theater even further by incorporating features such as couches and pillows to provide a combination of the comforts of home with the pleasures of getting out of the house, leading some critics to worry that theater audiences would bring their domestic behavior—talking during the movie, for example—into the public theater.[15]

In addition, the proliferation of portable media players and the emphasis on the computer as a site for film consumption have, together, significantly altered the contexts in which audiences encounter films. In this context, we must remain attentive to the ways in which the vast proliferation of screens informs reception practices and the intermedia relationships they produce. While audiences remain more likely to consume movies on their TV sets, either via DVDs or cable or broadcast television, the computer is gradually becoming an alternate site for screening movies, as the examples of *Sicko* and *Four Eyed Monsters* suggest. At the same time, the TV itself has become "computerized" through technologies such as the digital video recorder (DVR) and video-on-demand (VOD), as well as through services such as Netflix's set-top box that allows many of the titles from their archives to be downloaded directly to the consumer's television set. Moreover, the

computer is increasingly conditioning the screen experience itself, as film fans are encountering paratextual materials about the films they watch via digital media. More crucially, both portable media players and computer screens address an interactive viewer. In fact, classic terms such as viewer, spectator, and audience may not offer the most precise terminology for describing our new relationship to the screen, prompting a number of older film critics to complain about disruptive audience behavior—such as text messaging and chatting with friends—or that image-addicted youth would become oblivious to the world around them because of their attachment to these new devices.

As my examples illustrate, it is important to caution against treating digital cinema as a single object. While film scholarship has often focused on the ideological workings of a single film text, my approach to digital cinema places emphasis on the multiple modes of delivery and their role not only in shaping reception protocols but also in shaping distribution models. Following Henry Jenkins, I argue against what he refers to as the "black box fallacy," the assumption that at some future point, there will be a single "black box" through which all media is transmitted into the home. As Jenkins observes, what seems to be happening is quite the opposite: a proliferation of devices, some portable, others linked to the television or computer, that provide multiple means through which consumers can gain access to desired content.[16] A variation of this fallacy is the fear, often articulated by older newspaper critics, that younger generations will only watch movies on their cell phones or portable media players, thus missing out on the immersive experience of watching a movie on the big screen.[17] However, this depiction of portable media players misunderstands their practical use as a means for watching short videos such as trailers or teasers rather than viewing an entire film on a three-inch screen, although these players can be used for impromptu screenings during moments of forced waiting at doctors' offices, on subways, or in airplanes. Instead, we must be attentive to the ways in which different media devices can invite different forms of content and even encourage new modes of storytelling that go beyond the boundaries of a feature film or broadcast TV series.

Perhaps most important, digital cinema must be understood in terms of significant transformations of production and distribution more generally associated with digital technologies. In this sense, digital cinema is inseparable from some of the larger debates about the role of digital media in restructuring social and political life. In the more zealous versions of this shift, new media enthusiasts celebrate the unlimited potential of cyberspace to transform everyone into a potential media outlet, via blogs, for example. Similarly, Chris Anderson

rhapsodized about the ability of the internet, bolstered by virtually infinite storage space, to offer consumers limitless selections of movies available at any time they want them, with Anderson concluding that "on the infinite aisle, everything is possible."[18] Everything, perhaps, except leaving the store. Anderson's description of "long tail" marketing and elaborate filtering systems illustrates the ways in which consumers are able to locate personalized content, creating countless niche markets for music and DVDs, to name two of his main examples. In fact, as Dan Schiller argues, this digital hype helped foster new modes of access to markets, turning the web into "a self-service vending machine of cultural commodities."[19] Schiller is no doubt correct to identify the ways in which media convergence is informed by the principles of capitalist political economy, and internet delivery systems certainly hasten the processes of niche marketing. In fact, I am invariably shocked to see how successfully the filtering system on Netflix is able to predict my taste in movies and, therefore, to entice me to watch more movies (or at least remain a loyal customer).

And yet, in the case of digital cinema, it would appear that the internet remains available for some forms of nonmarket activity while also opening up modes of production and distribution for independent and DIY producers. In fact, as Yochai Benkler observes, the digitally networked environment creates a situation in which "all the means of producing and exchanging information and culture are placed in the hands of hundred of millions, and eventually billions, of people."[20] Thus, instead of viewing the web merely as a "vending machine" for cultural commodities, Benkler identifies the ways in which digital networks can be used to foster "decentralized and nonmarket-based production."[21] Benkler is careful to remind us that these productions are not utopian fantasies but practical possibilities built upon the social and technological structure of the web. In this context, the web becomes a site not only where audiences go to download or purchase movies but also to write and talk about them or, in some cases, make and self-distribute their own. For this reason, I am attentive to a wide range of digital cinema practices, both commercial and noncommercial. In fact, just as media conglomerates are busy inventing new means for distributing cultural commodities, DIY filmmakers are creating their own distribution models, while challenging many of the standard practices associated with the distribution of indie films.

In addition, digital cinema also fosters other forms of amateur activity, such as the production of movie remixes, in which fans borrow footage from older films and remix it in order to create a new meaning. While this activity can offer interesting reinterpretations of the original

texts, these forms of production can also feed back into the processes of commodification. Although my approach emphasizes new forms of participation, I also want to distance myself from models of participatory culture that see it as inherently liberating or that dismiss the ways in which fan practices have become commodified by the entertainment industry. In fact, while studios initially regarded many fan practices, such as making movie remixes and posting them on YouTube, as potentially a threat to profits, most major media conglomerates have grown to embrace such activities, correctly seeing them as reinforcing, not challenging, the processes of exchange. As Barbara Klinger argues, "Both cultivated by media industries and constituting an active and heterogeneous cadre of devoted viewers, fans represent a crucial, but normative, part of the circuit of exchange between producing and consuming cultures."[22]

BACKGROUND

Thus, it is important to recall that media convergence is not merely technological. It is also the result of a deliberate effort to protect the interests of business entities, policy institutions, and other groups. Even while digital cinema has upset a number of traditional distribution models, it also seems clear that the conversion to digital is driven by desires to reduce expenses such as costly print fees while also opening up additional revenue streams such as special event screenings and the transmission of films directly into the home. In this sense, the introduction of digital cinema must be understood in terms of a much longer history of failed attempts at incorporating digital projection into theaters. In fact, as William Boddy has documented, there have been experiments with the electronic delivery of motion pictures since at least the 1930s, both in the United States and in Great Britain.[23] These experiments have reemerged from time to time, with two or three particularly notable efforts, such as the attempts in the 1960s by video activists to create small-format community video production and exhibition venues across the country. Later in the 1980s, Francis Ford Coppola invested heavily in video production, spending $26 million to shoot *One from the Heart*, only to see it gross a miniscule $1 million in theaters.[24] The debate over the viability of digital cinema in its current format reemerged after successful test screenings of *Star Wars I: The Phantom Menace* in the summer of 1999, an event that many observers saw as the death-knell of film as we knew it, with film critic Godfrey Cheshire predicting widespread adoption of the format by 2002.[25] And yet, by the summer of 2008, theaters were only gradually beginning to

incorporate digital projectors, largely due to the promise of the major studios to help subsidize the costs and to the production of several high-profile and extremely profitable 3-D films that required digital projection. I mention this history in some detail to outline the fact that electronic or digital cinema could have taken a much different path, and it has only succeeded at supplanting film because of institutional, cultural, and economic factors that have made digital distribution and exhibition appear to be more viable than using film.

In this context, Brian Winston provides a useful model for thinking about the patterns of media change. He argues that models of media change should take into account "the primacy of the social sphere" in shaping technological developments.[26] In fact, as Winston's model of technological change illustrates, it is only when "supervening social necessities"–perceived or actual needs that a communication technology can fulfill–intervene that a technology is adopted. At the same time, because the introduction of a new technology may disrupt existing social patterns, diffusion can sometimes be constrained, a process Winston described as "the 'law' of the suppression of radical potential."[27] In *The Television Will Be Revolutionized*, Lotz observes that these trends persist in the era of digital television, and given the technological continuities between the film, television, and digital media industries, it should come as little surprise that these patterns have informed the adoption of various elements of digital cinema, with a number of new media entrepreneurs inventing or financially supporting new technologies that could radically destabilize the film industry while other groups seek to constrain these new inventions.[28] For example, such innovations as day-and-date releasing appeared to provide independent filmmakers with new avenues for distribution, no doubt enriching digital cable providers at the same time. However, the practice has sent groups such as the National Association of Theater Owners (NATO) into crisis mode, with many NATO theaters refusing to carry films released via day-and-date strategies. These debates have presented enormous challenges to various factions of the film industry as it seeks to make sense of the new digital distribution platforms.

Thus, while many of the elements of digital cinema are becoming apparent, it is less clear how those features will be utilized in a post-filmic era. Studio filmmakers are increasingly relying upon digital technologies to record and edit movies. Spurred on by the popularity of a number of digital 3-D films, digital projection of movies in theaters is now becoming commonplace, with the result that film projectors may soon be confined to museums. Powered by the virtually limitless storage space available on the web, major media conglomerates now reach

and track film consumers in new ways, with technologies such as the Netflix recommendation algorithm providing uncannily accurate assessments of cinematic taste. Portable media technologies further contribute to the "anything, anytime, anywhere" mantra, allowing people to carry and access films and TV shows with them wherever they go. At the same time, digital platforms provide new opportunities for DIY filmmakers to produce, distribute, and exhibit their films to a potentially global audience. In addition, bloggers are challenging the legitimacy of print-based film critics, redefining who counts as an expert on film. All these sweeping changes have contributed to the perception that film as both a medium and an activity is in a moment of profound transformation.

FRAMEWORKS

This book addresses the transition to digital cinema by focusing on a few key technological shifts and the ways in which the reception of those new technologies has been shaped by industry discourses, entertainment journalism, and other marketing and promotional discourse. While the focus on technological shifts may suggest a technological determinism, I write under the assumption that these new media technologies have been framed for consumers by industry discourse, thus positioning their potential uses, even while consumers themselves often renegotiate their use, finding unexpected potentials in certain technologies while rejecting others.

Chapter 1 surveys the role of the DVD in promoting the figure of the "film geek," the home consumer who is able to obtain a cinematic education in part through the supplemental features found on most discs. When the DVD was first mass-marketed, this production of cinematic knowledge was often touted as inherently liberating, as bringing a virtual film school into anybody's home. This concept of the "film geek" is informed by what Michele Pierson refers to as the discourses of connoisseurship. While Pierson is referring primarily to commentaries that accompany science fiction films and promote them via their use of special effects, DVDs are marketed, in part, as a way for movie audiences to build and demonstrate cinematic knowledges.[29] This chapter takes seriously the idea that, in addition to selling a specific movie, DVD packaging also sells a very specific experience of film culture in general. The DVD format, with its extensive use of commentary tracks, making-of videos, and other paratextual and extratextual materials, has informed wider reception practices, including the practices of collecting DVDs and of repeated viewings of preferred films. However, while

DVDs participate in the selling of film culture, even while entertainment companies seek to sell DVDs, this process of shaping interpretation is never fully complete, and consumers can, and often do, offer alternative or resistant readings not only to the film themselves but also the meta-commentary that frames them.

The second chapter focuses on the role of digital effects in fostering debates about the death of film, particularly when it came to the medium's ostensibly unique status in representing reality. As concepts of cyberspace increasingly became central to popular culture, we also witnessed the emergence of digital special effects in Hollywood films. This use of digital effects was often seen as encroaching upon film as a medium, potentially leading to the end of cinema's ability to represent reality because digital effects could allow for the manipulation of the filmed or photographed image. In this context, the introduction of digital effects also led to debates about future innovations such as digital projection and virtual reality that might replace the communal act of moviegoing, implicitly imagining a potential end to film as a medium. These discussions were played out in a series of late-1990s science fiction films that focused on or were set in cyberspace, such as *The Matrix*, *Dark City*, and *The Thirteenth Floor*. These cyberthrillers, as Claudia Springer described them, invariably dealt with the ability of the individual to find a larger community within the deceptive cyber-worlds in which the characters reside.[30] In addition, special effects spectacles helped to foster the cultures of appreciation discussed by Pierson and others and provided an aesthetic of novelty that can be used to entice audiences into theaters.

Chapter 3 follows up on debates about the role of the DVD and of special effects in redefining the film medium by looking at industry and popular press discussions of the digital projection of movies in theaters, which was often seen as fostering the decline of moviegoing as a public and social activity. Many of these concerns emerged around a contradictory set of fears that digital projection could foster more interactive moviegoing experiences while also diminishing the sense of cinema as a collective experience. These fears were confirmed when portable media players such as the video iPod threatened to turn movie watching into an intensely personal experience. Cinemas responded to these concerns by selling digital projection as both a more immersive experience, through techniques such as 3-D, and as a social activity.

With the transition to digital projection moving forward, a number of independent filmmakers and media entrepreneurs also began to recognize the possibilities of digitally distributing films as well, both to

movie theaters via satellites or to home consumers via the internet. Because the internet seemingly offers unlimited "shelf space" for digital copies of films, these possibilities have often been celebrated as providing consumers with what Chris Anderson described as an "infinite menu" of movie choices, an abundance of options unavailable in the era of centralized distribution.[31] To that end, chapter 4 looks at a wide range of "one-click distribution" techniques. In treating online distribution in this way, I make little distinction between mail-order models that allow consumers to purchase or rent DVDs online and models that allow consumers to purchase or stream films online. While the latter approach may extend even further the sense of immediacy implied by "one-click distribution," both mail order and streaming have led to a number of experiments by the major media conglomerates and by DIY and independent distributors. These models include more mainstream experiments by Netflix with streaming videos online via their Watch Now player, as well as techniques used by independent filmmakers to self-distribute or promote their films online. Many of these new distribution models privilege convenience and consumer choice as primary criteria for movie watching. At the same time, digital distribution techniques have also been adopted by a variety of independent and DIY groups to break through the dominant Hollywood distribution models, with many, including Robert Greenwald's Brave New Films and the filmmakers behind *Four Eyed Monsters*, explicitly defining themselves against traditional Hollywood distribution practices, often through highly innovative uses of social networking technologies that exploit word-of-mouth promotion of their films.

As the discussion of social-networking technologies suggests, digital cinema also entails a transformation of film reception practices in addition to shaping production and distribution. Chapter 5 addresses one of the more common expressions of this new mode of reception, the film blogs where audiences write about and discuss films and film culture in general. In much the same way that digital distribution has been touted as offering DIY filmmakers new opportunities, film blogs have been described as liberating consumers from the whims of newspaper film critics, who are often depicted as elitists out of touch with common taste. In this sense, film bloggers have often been portrayed, both positively and negatively, as gatecrashers who are redefining what counts as a critic. Blogs have, of course, become a means by which official and unofficial publicity about media and celebrity culture circulates, and, like any network, blogs operate through a system of inclusions and exclusions that value certain transmissions over others. While this is one of the more common narratives associated with

web-based film writing, I also argue that bloggers should be understood in terms of a larger desire for community that is mediated by the cinema and, more precisely, the social elements of moviegoing as an activity. Bloggers, in particular, often identify with the desire to be first on the scene, to be part of a larger conversation, one that belies the image of the isolated basement blogger alone in his or her basement.

Finally, chapter 6, "Hollywood Remixed," tackles the various practices associated with fan-produced videos, in particular movie mashups that use existing films and remix them to reinterpret the original. These video practices range from fake trailers to tribute videos and compilation videos that revise, rework, or mashup Hollywood narratives, often, though not always, with the goal of parodying the original. Most of the videos I describe are virtually devoid of original content, relying instead on the mashup creator's skill as an editor in order to produce meaning. These mashups have presented a significant challenge to U.S. copyright law, testing the boundaries of what counts as parody or what counts as "original" work. At the same time, despite the mildly subversive tone of many of these videos, they also offer Hollywood studios an opportunity to reclaim fan labor as a means of marketing and promoting Hollywood films. While the traditional oppositions associated with co-optation and DIY production no longer hold up under critical scrutiny, these activities should not simply be celebrated as examples of an active audience reclaiming these films to create new meanings out of them. Instead, they should be recognized as part of a larger entertainment economy given their role in providing further attention to Hollywood films. Thus, fake trailers, much like the paratextual materials included on DVDs, become means not only to sell (or gently mock) a given film, but they also become a way of promoting a certain form of engagement with digital cinema culture.

These six case studies by no means cover all aspects of the transition to digital cinema. For example, I do little to address digital sound's role in reshaping the theatrical experience. I have also generally avoided discussing the intermedia relationships between film and video gaming, even though the video game and movie industries have strong ties, whether through adaptations of movies into video games (or the reverse), through shared visual aesthetics, or through the use of game players such as the Xbox 360 to stream movies, not to mention the use of gaming software to "author" movies using a video game engine. What I have sought to do, however, is to place in critical tension activities across a variety of digital formats by groups ranging from DIY filmmakers to amateurs and fan groups to the entertainment industry itself. When Buice and Crumley arranged to release their film via YouTube, it

was not only a statement that traditional distribution models weren't working, but also an attempt to reinvent distribution and, simultaneously, to reshape the practices and activities associated with movie viewing. When digital pirates posted a copy of *Sicko* to the web, it certainly raised concerns about lost studio profits, but it also illustrated the degree to which many viewers wanted to engage with Moore's documentary. Although these two events may have been relatively minor in the larger debates about digital cinema, they reflect the ways in which filmmakers, audiences, and studios have sought to make sense of the changes introduced by digital cinema.

1

THE RISE OF THE MOVIE GEEK
DVD *Culture*, *Cinematic* *Knowledge*, *and the Home Viewer*

One of the most successful horror films of 2002 was Gore Verbinski's *The Ring*, a remake of the 1998 Japanese film *Ringu*, which had itself become a cult classic among fans of horror films and Japanese cinema. In *The Ring*, Rachel Keller (Naomi Watts) faces the challenge of identifying the source of a mysterious videotape that kills anyone who watches it exactly seven days later. Rachel learns about the tape after her niece, Katie, dies and she overhears a group of students discussing the tape. The film then depicts Rachel's investigation, in which she discovers the story of an isolated young girl known for her mysterious powers. But the most memorable scenes in *The Ring* are those that feature characters fixated on various screens, the television sets and computer monitors that have come to dominate our daily lives. Throughout the movie, we see extended scenes showing Rachel fast-forwarding, rewinding, and pausing the videotape on an editing machine with the hope of identifying clues about her niece's death, thus placing emphasis on the VHS format over its digital counterpart, even though DVD players had been commonplace in the United States for several years. Appearing a few years after the launch of the DVD format, *The Ring* seems to offer an allegory for the obsolescence of the VHS format, while also presenting a film culture much more identified with private, domestic screenings than with public moviegoing.[1]

In fact, this image of isolated domestic audiences watching movies at home is a crucial structuring device from the very opening sequence

of the movie. After an establishing shot of Katie's upper-middle-class suburban home, Katie and a friend are shown blankly staring into a television screen positioned to occupy the same space as the camera, the flickering blue light of the TV set reflected in their impassive faces. As Katie stares blankly into the screen, she remarks, in what is the opening line of the film, "I hate television," proceeding to criticize the banal shows and misleading commercials offered on TV. It is no accident that Katie's remark about that most invasive home media technology opens a film about media technologies, especially given the rivalry between the two media; however, rather than merely privileging film as a superior storytelling medium to television, the scene also establishes the idea of suburban life as reproducing fragmented, isolated communities, with teens and families disconnected from each other. In fact, as the scene unfolds, we realize that Katie and her friend are watching TV in her bedroom, separated from the rest of the house. Thus, the power of this scene derives from its ability to tap into the perception that home entertainment centers have fed into the fragmentation of audiences, with people choosing to watch movies in the comfort of home rather than seeing movies collectively, visually depicting the post-9/11 cocooning described by Barbara Klinger in her discussions of domestic movie cultures.[2] Such perceptions were fed by the mass-marketing of the DVD, which many observers have identified as one of the causes of the turn toward consuming movies at home rather than in theaters.

However, the film also offers another model of spectatorship, one that has become readily identified with DVDs and their careful packaging of cinematic history. In order to make sense of the videotape, Rachel turns to her former boyfriend Noah, a self-described "video geek," in order to identify clues that will lead her to the source of the tape. Thus we see Rachel and Noah repeatedly watching the tape and taking note of details, such as parts of the image that are hidden from the screen. While these references generally operate in service to the film's larger detective plot, they also help to illustrate the emerging figure of the film geek, the film fan or cinephile educated on the language of film via the commentary tracks and making-of documentaries that are now included on most DVDs. In fact, around the time that DVDs were becoming popularized, *New York Times* film critic Elvis Mitchell was moved to argue that regular home audiences were being transformed into movie geeks, a status that was normally accessible only to a "moneyed geek elite" that could afford expensive home theater systems or expensive movie prints or collectible laser discs and VHS tapes, thereby democratizing access to cinematic knowledge that had previously only been available to insiders.[3] In this sense, *The Ring* subtly

participated in theorizing the process of media change by depicting a rivalry between VHS and DVD, while promoting the new modes of engagement associated with digital cinema. Further, *The Ring*, in part through the supplemental features included on the DVD, helped to foster a wider discursive movement that promoted the DVD in terms of a number of the myths associated with digital cinema. In addition to promoting an idealized image of an enlightened media connoisseur, industry efforts to sell the DVD as a superior home format marketed it as inherently democratizing, both in terms of access to new films and in terms of access to new forms of knowledge.

For a movie such as *The Matrix*, to name one popular example, viewers were made aware of how the directors, Andy and Larry Wachowski, were able to produce the gravity-defying and time-bending stunts that made the film so popular. Making-of documentaries showed the film's actors and stunt personnel performing in front of green screens while banks of cameras watched, suggesting by implication that new modes of filmmaking were being born. However, in addition to educating the film viewer about film techniques or about the studio system, DVDs also educate viewers in terms of a certain mode of watching and thinking about movies. Thus, while this cinematic education may alert viewers to the techniques of production, DVDs typically place emphasis on aesthetic appreciation rather than critical engagement. In that sense, DVDs address audiences via what Michele Pierson has referred to as a "discourse of connoisseurship" meant to sustain the sense that a given film is worthy of further attention or investigation primarily on the basis of the artistic craft of writers, directors, actors, cinematographers, and in some cases special effects wizards and stunt coordinators.[4] In terms of how these DVD extras ought to be read, I am less interested in the specific contents of these paratextual features than in the way they have been promoted. In this sense, DVDs would seem to provide an important test for Toby Miller's assertion that "commodities hide not only the work of their own creation, but their postpurchase existence as well."[5] After all, the labor of producing the film is right there, included as a special feature. However, these extras invariably obscure the work of below-the-line laborers and, quite often, mask the fact that digital media have led to the increased use of nonunion labor, often on a part-time basis.[6]

In this chapter, I address the role of the DVD in the construction of a "movie geek" culture by reading the DVD both as a technology and as a cultural artifact that privileges certain modes of reading at the expense of others. It is, of course, important to acknowledge the role of prior playback technologies such as the VCR and the laser disc in

the creation of the "movie geek," as exemplified by Quentin Tarantino, whose star image is directly tied to his background as a video store clerk; however, the use of DVD extras and other supplemental texts have helped to provide the conditions by which movies should be read. Perhaps most famously, DVDs have further fed into the fragmentation of the original text by providing clear examples of the decisions and choices made by directors and screenwriters in the construction of a film narrative. At the same time, this notion of textual incompleteness can serve any number of ideological functions. On the one hand, textual incompleteness within documentary films may offer viewers an awareness that a significant political issue, such as the war in Iraq, remains unresolved, therefore soliciting the active participation of the audience in supporting a political candidate or taking other forms of action to express opposition to the war. On the other hand, incompleteness helps to foster the vast expansion of the story world of major Hollywood franchises, and by extension their mar-ketability into multiple formats well beyond the original theatrical screening and even the DVD itself. Finally, DVDs engage with the poli-tics of authorship, often in complicated and even contradictory ways, as filmmakers seek to assert their position as authors. While such special features as commentary tracks and making-of documentaries can rein-force interpretations, they are also consumed—and sometimes challenged—by active audiences who engage with these materials. In all cases, the DVD as cultural artifact cannot be separated from the discourses of connoisseurship that seek to define a contemporary movie geek, specifically one who participates in the ongoing consumption of Hollywood films.

THE RISE OF THE DVD

In the late 1990s and early 2000s, DVDs famously provided the film industry with significant new forms of revenue. As numerous critics have noted, many Hollywood films begin to see profits only after their DVD release, prompting some to suggest that the theatrical release is merely a means of promoting the DVD, a loss leader with an eye toward the home market. John Thornton Caldwell goes so far as to say that the DVD experience is "the primary consumer product."[7] All this was per-fectly clear by 2002, the year *The Ring* was released to theaters. As enter-tainment reporter Edward Jay Epstein documents, "In an average week in 2002, some 50 million Americans—more than twice the weekly movie audience—went to one of the country's more than thirty thou-sand local video stores to rent a movie, spending some $24 billion,

approximately four times what they spent on movie tickets."[8] DVDs have continued to provide a crucial revenue stream, with consumer spending on sell-through DVDs holding relatively steady at around $16 billion per year in 2006 and 2007.[9] Since then, those numbers have been offset somewhat by the rise of digital cable, video-on-demand, and digital distribution via services such as Apple's iTunes. Nevertheless, the DVD remains a significant force not only in the marketing of films and television series but in shaping their reception, as evidenced by big box retailers such as Wal-Mart, Target, and Costco. As David D. Kirkpatrick noted, Wal-Mart, among others, carefully screens DVDs and other materials to avoid offending their conservative customers,[10] prompting digital media entrepreneur Patrick von Sychowski to assert that for the film studios, "Wal-Mart is more important than Regal Cinemas."[11]

Given that DVD players have become naturalized as a significant part of the home entertainment system, it easy to forget how they were initially promoted and how quickly they were adopted by the home consumer. After their launch in 1996, DVD players soon became commonplace as studios sought to take advantage of the new format. In the first half of the year 2000, 2.7 million players were shipped, making the DVD player "the fastest-growing consumer electronics product in history."[12] Further, electronics manufacturers, learning from the format wars between VHS and Betamax, quickly adopted a single format, making it easier to market and promote the DVD as a viable alternative to VHS.[13] In addition to the aggressive marketing and promotion of the DVD format as superior to video, Hollywood studios also sold the DVD as a collectible object. While videotapes and laserdiscs were initially priced out of the range of most home consumers, in order to protect theatrical distribution, DVDs were priced as a sell-through item, with prices in the range of $14–18, depending on the number of special features and the collectibility of the DVD.[14] Thus, from the beginning, DVDs were promoted for purchase rather than rental. These marketing efforts were assisted by the inclusion and heavy promotion of the extras that accompanied most DVDs and allowed consumers to gain behind-the-scenes access to their favorite films. As Barbara Klinger observes, this pricing strategy has profoundly democratized ownership of films, thereby allowing consumers to incorporate films into their home libraries, a process that provides collectors with the ability to position themselves within a wider taste culture.[15] At the same time, media journalists such as J. D. Lasica have speculated that DVD extras are designed to discourage piracy and thus protect industry profits that are presumed to be lost to home viewers downloading movies illegally.[16] However,

the primary effect of the promotion of DVD extras has been to teach a certain type of engagement with movies, one characterized by discourses of cinematic knowledge or connoisseurship, in which the home viewer is treated as an expert—or potential expert—in films and film culture.

DVD AND ARCHIVABILITY

Because of their collectibility and their association with discourses of connoisseurship, DVDs contribute to what might be described as a new brand of cinephilia, one that is more willing to embrace obscure and virtually unknown films, as audiences seek to position themselves as insiders with a unique knowledge of film culture. At the same time, DVD audiences can revisit and embrace cult films or other movies that have typically been marginalized within standard reception cultures. Thomas Elsaesser refers to what he describes, in this context, as the ability of the DVD to confer "a new nobility on what might once have been mere junk."[17] In this sense, it is important to recognize the role of DVDs in mediating access to film history. While the fantasy of complete and total access to the history is a mere fiction, an ideal that can never be reached, DVDs do feed into a rhetoric of discovery as studios dig deeper into their collections in order to find new movies to redistribute and promote.

Many of these arguments about the relationship between cinephilia and the DVD were played out in a special issue of the online journal *Senses of Cinema*, in which a group of scholars weighed in on the domestic format's effect on film appreciation. Steve Erickson credits video and DVD with helping film audiences to become more knowledgeable about film history. He points out that Quentin Tarantino's genre mixing—combining elements of French New Wave films with blaxploitation and Hong Kong action films, for example—demonstrates the long-term effects of what he refers to as "videophilia," a pleasure in embracing these unknown films via the home video format. In fact, part of the Tarantino legend is inseparable from myths of success associated with the digital (or video) auteur. Profiles of Tarantino invariably make reference to his having worked as a video store clerk who enthusiastically gushed about obscure films to customers, allowing them to discover the films that he would later incorporate into his own screenplays and films.[18] However, Erickson is also quick to criticize this new videophilia and Tarantino's appropriation of these films, arguing that it produces a sense of amnesia regarding the historical and cultural differences between various films.[19]

In the same *Senses of Cinema* series, Theo Panayides challenges Erickson's critique of videophilia and asserts that the difference between past and present forms of cinephilia

> is video—and, if I can bring any particular perspective to this little gathering, it's surely that of a film-buff shaped almost entirely by the VCR. The reasons are geographical rather than aesthetic, yet I suspect my experience would be broadly similar even if I lived in the US or a big European city. It's impossible to resist the lure of films on demand—the opportunity to compare and contrast, study influences, scramble narratives: it is, quite simply, a question of control.[20]

Panayides' argument complicates positions that dismiss home video merely as part of a larger commodity chain. While DVD distribution across the globe remains remarkably uneven, Panayides does emphasize the ways in which home video constructs a more active and engaged film audience, not only teaching us about the history of cinema but also instructing us to see ourselves as in control over the image and even over our access to it. This potential for distributing DVDs is perhaps best illustrated by the broad reach of Netflix, a video service that allows audiences to order DVDs online and have them delivered by mail, usually within a day or two. In this sense, film buffs living in smaller cities that do not have independent video stores are now more likely to be able to encounter obscure experimental, foreign, and documentary films, and to regard themselves as participants in a wider film culture. In both articles, however, the DVD is defined largely in terms of its position in producing a new generation of film geeks, for whom Tarantino, with his database aesthetic, becomes an iconic figure.

DVDs AND NEW MODES OF VIEWING

The DVD has been promoted in large part for its ability to provide ostensibly unprecedented access to behind-the-scenes stories and other features that will expand our understanding of film production and film history. However, while the DVD has been crucial to the development of the "movie geek," it is important to emphasize that VHS helped to establish the possibility of the domestic cinephile, while also opening up new interpretive approaches within film and media studies. As D. N. Rodowick points out, even before the DVD, VHS had already begun to erode the scarcity model on which the study of film had been based. In fact, Rodowick observes that "only a few short years marked the transition from scarcity to an embarrassment of riches, though at a price: *film had become video*."[21] Instead of the limited access to Hollywood films, viewers were now presented with much more control

over their viewing experience. Before the introduction of VHS, consumers would have to see an older film in a repertory theater or wait for that film to appear on television, and VHS went a long way toward setting the stage for the more recent on-demand culture than now shapes domestic film cultures.[22] This emphasis on access continues to condition debates about domestic film cultures, as new media entrepreneurs and mass media journalists celebrate the widespread access to the history of movies made possible through domestic formats.

In addition, studios quickly made their libraries available for sale on the DVD market, often combining related films in a single package, such as Paramount's collectors' edition of the *Godfather* trilogy, while institutions such as the American Film Institute (AFI) periodically released Top 100 lists that seem designed to encourage DVD sales of selected canonized films, a process that essentially validated the discourses of connoisseurship that made the DVD an immensely marketable technology. This new market has provoked what might be regarded as a mania of archivability as DVD producers seek to track down footage that can be redeployed in special features on a DVD. As Bryan Reesman noted, the producers behind *Blade Runner: The Final Cut Special Edition* shot over eighty hours of interviews in addition to wading through countless hours of deleted scenes and other behind-the-scenes material in order to assemble what has been marketed as the definitive DVD edition of Ridley Scott's film.[23] The result is that the DVD format also became a means by which film history could be endlessly packaged and repackaged for new audiences, shaping not only the films that we watch, but how we come to define the film canon. In this sense, DVDs became a means by which film audiences could begin to position themselves as experts on cinema history, acquiring a prepackaged history of cinema. In order to capitalize on this desire to consume prepackaged images of Hollywood's past, a number of media conglomerates sought to take ownership of the film libraries of the major movie studios, such as Sony's 2004 purchase of Metro-Goldwyn-Mayer, which provided them with access to eight thousand films they could repackage for domestic rental or purchase.[24]

In this context, it is worth thinking about the role of the DVD in creating new regimes of cinematic knowledge, as the DVD itself offers an important challenge to traditional modes of film consumption, not merely adding to existing practices, but potentially redefining our relationship to the film medium. As Derek Kompare observes in his discussion of DVD editions of television series, these new products "are not mere enhancements of media; they are reconceptions, profoundly altering our relationship with dominant media institutions and with

media culture in general."[25] While Kompare is primarily thinking about the role of DVDs in reshaping the temporality of TV watching and the consumption of television series, a similar reconceptualization seems to be taking place with regard to the consumption of films. As I have suggested, the reception of movie DVDs is shaped by the extras included on most releases, and these paratextual materials help to set the conditions by which viewers interpret films. In this regard, DVDs have been identified as turning average film viewers into connoisseurs, experts on movie culture with new access to studio-sanctioned forms of cinematic knowledge. There is, of course, a much longer history of using supplemental features to promote movies. As Caldwell observes, many DVDs simply repurpose the electronic press kits that were sent out to film reviewers and trade journalists before the rise of the DVD, and making-of features have long been a staple of Hollywood culture, as, for example, Disney's broadcast of making-ofs and other promotional features on its television series *The Wonderful World of Disney*.[26]

The DVD has been marketed, in part, on its ability to provide audiences with insider access to the making of the film through director's commentary tracks, making-of documentaries, and other behind-the-scenes supplemental materials, all of which participate in the repackaging of the home viewer's experience of a film. These materials, as well as the menus and even the DVD packaging, can provide a specific frame for interpreting a film. In fact, *The Ring* provides an interesting case study. Unlike most DVDs with clearly defined menu titles, *The Ring*'s DVD toys with the viewer's ability to navigate the menu and, by extension, to control her viewing experience. In addition to the "play movie" and "scene selection" options, one menu item, "Don't Watch This," offers a short, disorganized reel of deleted scenes. Instead of presenting these scenes in any kind of context, the scenes are organized randomly as a short film that ostensibly provides more background to the killer videotape myth while reinforcing the video geek motif that informs *The Ring*. Such a technique seeks to define *The Ring* as artier than the standard schlock horror film, potentially expanding the movie's core audience beyond the teenagers most associated with the genre, a reading that is reinforced through the film's intertextual references to past Hollywood auteurs such as Alfred Hitchcock, avant-garde and experimental filmmakers such as Maya Deren and Luis Buñuel, and visual artists such as Francis Bacon. The selection "Look Here" invites viewers to watch a trailer for the Japanese original, which was distributed in conjunction with the DVD version of the American remake.[27] Finally, an "Easter egg," a "hidden" feature that consumers find by searching further down the menu, contains the full content of the videotape that

supposedly kills anyone who watches it seven days later. While the "video" plays, the viewer's remote control is disabled, preventing her from stopping, rewinding, or fast-forwarding. Several seconds after the video has finished playing, the sound of a telephone ringing is heard, echoing the premise of the film. In this sense, the packaging of the DVD helps to condition the interpretation of the film as a critique of contemporary media technologies while also providing consumers with the thrill of discovering "hidden" meanings in the film. Even though their initial novelty has faded, Easter eggs remain a significant component of the packaging of the DVD experience: many film buffs consult web sites such as The Easter Egg Archive or Egg Heaven in order to track down hidden features, demonstrating the ways in which the computer—or at least internet access—has come to condition domestic movie viewing practices.

While this access no doubt provides viewers with new knowledge about the processes of making a film, it also, arguably, has other ideological functions as well by shaping how audiences interact with the movies they watch. At the same time, as the online discussions of Easter eggs suggests, unsanctioned and unofficial meanings still emerge. Although I share the argument that DVDs offer a second site for the production of meaning, DVDs are certainly not the final word on interpretation and, in fact, may open novel interpretations unavailable in the "original" version of the film.

DVDs, FRAGMENTATION, AND INCOMPLETENESS

Thus, DVD audiences have learned to position themselves into certain movie watching practices. As we saw with the extra features on the DVD for *The Ring*, these disciplinary practices include placing the viewer in control over her movie watching experience, with the disabled remote control serving as the exception that proves the rule: at home we are able to master the flow of cinematic images, while in theaters we are forced to succumb to the temporal rhythms of theatrical projection, which require moviegoers to arrive at the theater at a specific time.

DVDs extend the logic of domestic film cultures associated with videotape. Like the VCR, the DVD player has become identified with fragmenting the film text in ways that cinephiles and other film buffs regard with ambivalence because they seem to subvert the practice of passively submitting to a film rather than actively engaging with it. This sense of fragmentation, particularly as it played out in the era of the VCR, is perhaps best articulated in Charles Tashiro's description of

what he refers to as "videophilia."[28] Tashiro's account of remote-control wielding film collectors echoes the popular accounts of VCRs as enabling home viewers to "time shift" and therefore wield greater control over their home entertainment experiences.[29] This notion of "time shifting" originates with Akio Morita, founder of Sony, who describes the issue as one of consumer empowerment, as an ability to take control over one's schedule, recalling that "in the fifties and sixties, popular programs in the United States and later in Japan caused people to change their schedules. People would hate to miss their favorite shows. I noticed how the TV networks had total control over people's lives, and I felt that people should have the option of seeing a program when they chose."[30] These concepts of interactivity, consumer choice, and time-freedom have only expanded in the age of DVRs and TiVo, in which viewers can more easily construct their own TV schedules, recording shows that fit their personal tastes. In fact, as a number of critics have noted, DVRs can help to foster interest in a television show by allowing audiences to record and watch all episodes of a show after it originally airs, potentially creating new audiences for buzzed-about shows, though at the risk of having audience members fast-forward or zap through the ads.[31] This notion of incompleteness can also pose additional problems for filmmakers who wish to protect the intended version of a film.

However, the potential for time-shifting and fragmentation represented by DVDs has reshaped domestic film cultures in other ways by turning films into objects that can be manipulated at will, not only by consumers but also by producers. One of the major effects of the DVD is the ability to offer multiple versions of a given film. In this sense, digital media, and DVDs in particular, work against the notion that media objects can ever be truly finished. This concept of "incompleteness," to use Nicholas Rombes' term, represents one of the potential sites for consumers to navigate their relationship with media texts.[32] For example, while Lodge Kerrigan was editing *Keane*, director Steven Soderbergh reedited the film in order to suggest a dramatic reinterpretation of the film's narrative, which Soderbergh describes as "Keane 2.0." Soderbergh did not shoot any additional footage and, in fact, deleted nearly thirty minutes from Kerrigan's rough cut of the film. Even though Kerrigan's film apparently was not influenced significantly by Soderbergh, both versions of the film were included on the DVD, providing viewers at the very least with a tutorial of how the editing of a film contributes to its meaning, once again positioning consumers as "experts" on the production of Hollywood films.[33]

It is important here to note that "incompleteness" can be used to drive the purchase of various "collector's editions" of popular Hollywood films, sold in this case through the star power associated with Soderbergh as a director. In this sense, movies should be understood, as Thomas Elsaesser suggests, in terms of their role in commodifying an "experience." While Elsaesser is primarily interested in the theatrical experience, the expanded film text—whether DVD extras, online webisodes, or video game tie-ins—are all very much a part of this new form of spectatorship. In fact, the film itself may be little more than "an advertisement for the games, gadgets, and toys" that fill out this experience.[34] Similarly, Kimberly Owczarski points out, using the case study of BMW's online film series, "the Web redefines the role of the film text as one aspect of an entertainment and advertising chain."[35] If a film is never truly finished, then every version of the film is also potentially for sale, pushing the truly completist collector to ensure that she has every edition of the film, as witnessed by the multiple versions of Ridley Scott's *Blade Runner*, which has been released in at least three different versions. Thus, while the multiple editions of *Blade Runner* may offer the film scholar virtually endless opportunities for play in interpreting the film's meaning, the multiple editions are inseparable from their status as commodities. Likewise, a project such as "Keane 2.0" serves as a promotion for Steven Soderbergh's auteur image, branding him as a star director who can confer similar status onto Kerrigan.

While Rombes' notion of incompleteness may teach viewers something of a lesson on deconstruction, an acknowledgment that movie texts are never final, incompleteness can be used to close off undesirable or politically threatening meanings represented in certain films. This use of the principles of incompleteness is best represented by ClearPlay, a specialty DVD player that allows concerned movie audiences to edit out any material from a movie that they might find morally offensive, such as depictions of nudity, violence, and profanity, while still providing a seamless version of the movie.[36] The technology allows viewers to select various levels of tolerable content, providing viewers with an immense amount of control over what they see on screen. Quite naturally, a number of directors, including Steven Soderbergh and Steven Spielberg, have expressed concern about what they regard as a violation of their intentions as directors. Significantly, William Boddy speculates that as digital projection takes hold, this type of textual cleansing could also be used to create "family hour" versions of films, with theaters presenting a PG-version of a film in the early evening and an R-rated version later at night.[37]

While critics have pointed to *Keane* as an important example of how digital video might allow filmmakers to rethink the concept of a final version of a film, incompleteness can also serve contemporary political documentaries by providing them with new ways of covering their subject. By avoiding the expectation of a final version of a documentary, political filmmakers have been able to remain flexible in the light of new events. For example, documentary filmmaker Robert Greenwald, who has produced a number of movies criticizing the George W. Bush administration, retooled a number of his documentaries in order to make them as up-to-date as possible. After screening his documentary *Uncovered: The Whole Truth about the Iraq War* at over 3,000 house parties in December 2003, Greenwald reedited the film, adding updated footage for a second version, which was retitled *Uncovered: The War in Iraq* and released to movie theaters in the weeks before the 2004 election, allowing him to find a second audience and to keep the film's politics fresh in voters' minds. Thus, as information damaging to the Bush administration's case for war continued to come out, Greenwald could respond to it, keeping his documentary in the news as the election approached. It is worth noting that this lack of a final version of a documentary film may raise important questions about the politics behind the reedited version, particularly if the new material challenges the arguments of the original film.

Similarly, Andrew Jarecki's 2003 documentary *Capturing the Friedmans* uses its supplemental materials to shape the situation of its interpretation. In this case, a documentary's supplemental materials actually remind us of the ways in which movies are intimately tied to a viewing public prepared to debate or discuss the political issues raised by a film, while also calling attention to the ways in which a documentary can effect change by unearthing forgotten truths or by challenging accepted truths by offering new evidence. *Capturing the Friedmans* focuses on the experiences of the Friedman family starting in the late 1980s, after the father, Arnold, and his youngest son, Jesse, were accused of molesting dozens of young boys during after-school computer classes held in the Friedman family's Long Island home. While Arnold died in jail after pleading guilty to charges of child molestation, Jesse maintains his innocence, despite a guilty plea he now claims that he was pressured into taking. In addition to standard interviews, Jarecki famously incorporated the family's Super-8 films and home videos to document the disintegration of the family after the charges were announced. When Jarecki began making the film, the Friedman family saw the documentary as an opportunity to clear Jesse's name. This reading would seem to be reinforced by the testimony of Debbie Nathan, an

expert on child molestation scares. And while Jarecki's original marketing of the film suggested that the goal of the documentary was to clear Jesse's name, he later seemed to repackage the film to position viewers as a kind of jury designed to weigh the evidence and determine whether Arnold and Jesse were guilty, leading a number of documentary scholars, including Paul Arthur, to criticize the film for abdicating its responsibility in making any sort of final argument about the case.[38]

This repackaging of the film is evident from the supplemental features that accompany the film on DVD. In addition to many of the standard features such as a making-of documentary, a follow-up on the main characters, and a director's commentary track, the DVD also included footage from several question-and-answer sessions that took place after screenings of the film, including the Q&A session from the Long Island premiere, which many of the subjects from the film attended. These sessions not only had the effect of establishing that the story depicted in *Capturing the Friedmans* was still unfolding, but they also studiously abstain from taking a position on the criminal case. In this sense, it is fair to criticize the film and the paratextual materials that frame it, as Arthur does, for shaping audience interpretation of the case. However, the *Capturing the Friedmans* DVD might also be read as opening up lines of interpretation by using the DVD extras not to impose interpretive closure but to open it up, not necessarily about the Friedman case but about the definition of family and about the role of photography and film in mediating the family. At the same time, the supplemental features model the idea that documentaries matter, that they can have genuine consequences on the real world. Thus, instead of reading DVDs as potentially closing off interpretation, it is also possible that DVD extras can empower viewers to open up alternative readings.

However, the most notable use of this notion of incompleteness has been in the creation of vast story worlds tied to major media franchises, such as the *Matrix* films, in which the film itself serves primarily as a means of stimulating interest in the wider media franchise, one that extends well beyond the DVD itself into other ancillary materials, including video games, comic books, and online communities and alternate-reality games. Reworking the adage that "all screenplays are also business plans," John T. Caldwell observes that any screenplay being considered for production

> generates considerable attention and involvement at the earliest story sessions and producers' meetings by personnel from the firm's financing, marketing, coproduction, distribution, merchandizing, and new media departments or divisions. Such discussions and analysis seek to ensure that any new film or [television] series will create

income-producing properties (reiterations of the original concept) that can be consumed via as many different human sensory channels as possible.[39]

This vast expansion of the original film text suggests that the narratively contained world of the feature film is now the exception, as target audiences are encouraged to extend their consumption into other outlets beyond the initial theatrical screening. To be sure, this process of cross-promotion has existed for some time, whether through fast-food tie-ins or action figures; however, the process of incompleteness suggested by DVDs has helped to reconceptualize film narrative in ways that tie together the fictional world of a film with the economic goals of a studio.

In accounting for the new status of these expanded story worlds, Henry Jenkins argues that they challenge the interpretive faculties of film critics who are trained to anticipate a contained narrative.[40] Describing this process as transmedia storytelling, Jenkins asserts that film critics were unprepared for the degree to which media franchises such as the *Matrix* films demanded more from their viewers than a self-contained film lasting approximately two hours. However, while Jenkins demonstrates awareness of the economic motives associated with transmedia storytelling, he generally places more emphasis on the collaborative activities of meaning production that such media franchises provide. Thus, the economic incentives behind the world of the Matrix films, for him, are less important than the search for meaning ("What is the Matrix?") associated with that media franchise. However, while this search for meaning is no doubt valuable, Caldwell's comments underscore the degree to which production itself is now driven by the desire to build and sustain media franchises. To that end, Hollywood studios have increasingly turned toward the production of films that can be used to foster an ongoing franchise. In fact, in 2008 many studios shut down or downsized their independent or art house production facilities in favor of emphasizing the proven commodities and big spectacles that can be more readily marketed in multiple formats: TimeWarner closed down Warner Independent Features and Picturehouse while Paramount shut down the marketing, distribution, and physical production departments of Paramount Vantage, the company responsible for recent Oscar nominees *No Country for Old Men* and *There Will Be Blood*.[41]

More recently, of course, many of the features normally found on DVDs have migrated to the web, serving as a promotional tool for films that will be coming out in theaters or on DVD. In this sense, this vast expansion of story worlds can enter into the domain of promotion as

well. As media producers confront a competitive and crowded market-place, they face the challenge of finding new ways of sustaining attention on their movie and the commodities that accompany it in order to establish and sustain a movie franchise's "event" status. This promotional practice can be illustrated by the posting of several "sweded" videos to YouTube to promote Michel Gondry's *Be Kind Rewind*. Gondry's film featured a couple of hapless video store clerks who accidentally erase the store's entire collection of VHS tapes and are therefore forced to reenact entire films from memory in order to satisfy their customers, a process they call "sweding." The film is essentially a celebration of the amateur production cultures that make movies in basements and backyards, often for just a few close friends. The choice of films depicted in the sweded videos, such as *Robocop*, *Ghostbusters*, and *Driving Miss Daisy*, were meant to appeal to fan nostalgia for Hollywood's VHS era. The depiction of characters lovingly recreating these older films was also meant to inspire fans of the film—or of web video in general—to produce their own sweded videos, inviting them into the feedback loop of promotion and participation.[42] For the most part, the sweded films, especially as they appear in *Be Kind Rewind*, serve as affectionate parodies of the original films, reminding us of the goofy enjoyment fans might get out of re-creating their favorite movie scenes. While the practice of making movie parodies and placing them on the web was hardly new, Gondry's film sought to confer a degree of whimsical nobility on the practice, a sentiment that was actively circulated in the promotion of the film. This use of web video is not inconsistent with earlier web video practices that frequently rely upon citations of earlier films and are often deeply rooted within the commercial cinema culture, as Barbara Klinger has pointed out.[43] At the same time, the distinctly homemade quality of the sweded videos also articulates a larger nostalgia for VHS itself as the format becomes increasing obsolete.

This need for cross-promotion prompted Mimi Slavin of Warner Bros. to remark, "Partners help you create that sense of 'bigness.'"[44] One result has been to expand even further the commercial tie-ins with fast food franchises, automobile manufacturers, and other advertisers, but this textual expansion has also included the use of actors reprising their characters from film, such as Will Ferrell in his role as a 1970s basketball star from *Semi-Pro* endorsing products such as Old Spice and Bud Light in television commercials, using Ferrell's ironic seventies shtick to sell deodorant and beer to his male fan base. In this sense, incompleteness cannot be separated from its place within an advertising and promotional chain designed to sustain interest in a narrow range of media franchises, often at the expense of independent and international

productions. Thus, while the DVD itself may have opened up alternative screening sites that allow viewers to access films they might otherwise have missed, contributing to a cinematic education of sorts, the principle of incompleteness, once extended, becomes just another way to promote Hollywood films to a youthful audience. In this sense, incompleteness is part of a larger process that Caldwell has described as a kind of "second-shift aesthetics" in which media conglomerates seek to "critically exploit digital media aesthetics to leverage cultural capital, visibility, and financial benefit."[45] While Caldwell's formulation of a "second-shift" refers primarily to "after-hours" segments of television shows played on the web, similar strategies of providing alternative "programming" inform film productions as well.

DVD COMMENTARY TRACKS AND CINEMATIC KNOWLEDGE

Throughout this chapter, I have argued that supplemental features on DVDs have the primary effect of reconceptualizing the activity of movie watching, expanding interpretive practices while possibly opening up apparently closed texts to new readings. The DVD, both as a material object and as a packaged commodity, participates in the promotion of the viewer as movie geek, as a viewer actively participating in film culture rather than merely passively consuming movies. This active spectatorship can be articulated through making-of documentaries and director's commentary tracks that serve as virtual film schools or through framing devices that promote some form of political participation. To be sure, the model of the attentive viewer existed long before the DVD; however, the film industry has been successful in linking the DVD to film appreciation, even while using that model to significantly expand the opportunities for commodifying movie content, as illustrated by the multiple versions of *Blade Runner*. The movie geek concept is central to many of the supplementary materials included on DVDs; however, perhaps the most heavily promoted feature is the commentary track, which appears to offer unprecedented access to the insiders who made and starred in Hollywood films. Mixing a number of modes, including film pedagogy, backstage gossip, and self-promotion, director's commentary tracks provide a key means by which the movie geek has been defined.

On the one hand, these texts can cement a romanticized image of movie production within a wider public. As Caldwell exhaustively documents, DVD commentary tracks take on a variety of genres, many of which serve to reinforce the ideology of a small number of above-the-line personnel as authors of the film, often rendering invisible what he

describes as "the digital sweatshop" in which many Hollywood workers operate.[46] These textual materials, in other words, work to assert authorial control over the text or to allow the director as author to position his film within a larger film history, as is the case with the *Dark City* DVD, which insistently depicts the film's connections to science fiction classics such as *Metropolis*. For other critics, DVDs, through this principle of incompleteness, risk confusing what counts as the "primary" film text, which may, in fact, have implications for the interpretation of a given film. Robert Alan Brookey and Robert Westerfelhaus, in particular, are wary about the effects of the DVD on film culture. In "Hiding Homoeroticism in Plain View," they argue that DVDs confuse "the distinction between primary and secondary texts as they have been conceived and made use of in the past."[47] Specifically, they cite the director and stars' commentary tracks that are included on the *Fight Club* DVD, material they refer to as "extratextual" in order to differentiate it from the movie as it played in theaters but also to differentiate it from what was typically regarded as "secondary" material because of its "proximity" to the original text on the DVD. Such a claim places far too much emphasis on an original film experience, establishing the theatrical screening as primary, and ignores the fact that such paratextual materials as movie trailers and magazine articles often accompanied our readings of films made prior to the DVD era.

In addition, quite often, this paratextual material does not, in fact, close off interpretation, but instead can be used to make visible how material operates in the production of meaning, as the examples of Greenwald's *Uncovered* and Jarecki's *Capturing the Friedmans* both illustrate. The inclusion of bonus features on the DVD, such as film trailers, may be used to shape interpretation of the film text; however, the "proximity" of the trailer to the film might also make it possible for viewers to see how the theatrical trailers misrepresent the film narrative in order to market it to various targeted audiences. Lisa Kernan argues that "the act of viewing a film after having seen its trailer enables spectators to 'learn after the event' (Freud's *nachträglichkeit*) that trailers were an illusory unity; in the process reminding us that the unitary worlds presented by film and television images and narratives themselves are illusory."[48] In this context, Kernan adds in a footnote that DVDs have accelerated this process; however, I would argue that in many cases DVDs have, in fact, *reversed* the process, as many people who buy or rent a DVD will extend their experience of a movie by watching the special features after watching the movie itself. Thus, instead of serving exclusively to promote upcoming films, trailers often retroactively illustrate how the film was sold, a point that becomes

especially vivid if two or more trailers are included on the DVD. This point does not diminish Kernan's basic argument and it may, in fact, augment her observation that the viewing of trailers can actually challenge the "unity" of the film. While trailers remain an important tool in promoting and shaping interpretations of films, DVDs point to the ways in which films can now serve to interpret trailers as well.

It is important to note, as well, that these notions of authorship can also be complicated by savvy filmmakers who are attentive to the limits of commentary tracks in fostering an author-image. In this context, Devin Orgeron offers a significantly different reading of the role of the DVD in reconstructing the auteur.[49] Looking at the work of director and screenwriter Wes Anderson, Orgeron notes that Anderson's career "coincides with the birth and refinement of DVD technology" and that Anderson has self-consciously used that technology to create an "open and equally self-aware authorial image."[50] Orgeron points out that in his commentary tracks, Anderson often remarks self-referentially on the role of authorship and creativity in many, if not all, of his films. In *The Royal Tenenbaums*, in particular, Anderson places the construct of the "genius" under critique by depicting a "family of geniuses," many of whom are themselves authors, in a state of personal crisis, and Anderson's observations about the film's narrative emphasize the connections between members of the Tenenbaum family and his own relationship with his mother. In this sense, the new auteurism identified with DVD commentary tracks should be considered in relationship to this sense of self-awareness.

In making the assertion that DVD extras might work to close off alternate meanings, Brookey and Westerfelhaus's argument assumes an utterly passive viewer who will uncritically accept the reading of the movie given to them by the director, screenwriters, or stars. In their discussion of the *Fight Club* commentary tracks, they argue that director David Fincher and stars Brad Pitt and Edward Norton close off any interpretation of the film that might read the relationship between the two main characters as homoerotic. The film itself is, no doubt, loaded with homosocial references. The narrator, Jack (Norton), compares his relationship to Tyler Durden (Pitt) to that of the famous sitcom couple Ozzie and Harriet, while the film also depicts shirtless men ritualistically beating each other silly. Finally, Jack finds himself jealous of the attention that a younger participant, Angel Face, receives from Tyler at one point. In particular, Brookey and Westerfelhaus cite an exchange on a commentary track featuring Pitt, Norton, screenwriter Jim Uhls, director David Fincher, and Chuck Palahniuk, author of the *Fight Club* novel, in which Palahniuk describes a fight scene as "shorthand" for a

sexual relationship, a comment that is then apparently dismissed by Fincher and Pitt as a "joke." Brookey and Westerfelhaus reinforce their reading by noting that Norton has already asserted the insider status of the viewer by stating that "anyone listening in here is cool," that is, in on the joke.[51] While Norton's comments do position consumers of commentary tracks as insiders, it is less clear that Pitt and Fincher's jokes will be read in the way that Brookey and Westerfelhaus suggest. In fact, attempts to foreclose homoerotic or queer readings of *Fight Club* may actually serve to call attention to them, making audiences more aware of the possibility of queer readings, and Norton's suggestion that viewers are "cool" may be read as sharing in the film's attempt, however shallow and superficial, to challenge the political status quo. It also assumes that viewers are more likely to be "duped" by the special features that accompany a feature film than by the film itself. While Brookey and Westerfelhaus seem to extend the idea that viewers might be able to construct oppositional readings to the original film, this ability seems to stop for them when it comes to the supplemental features. In short, they assert that DVDs provide the viewer with an illusion of greater agency, implying that this perception of greater agency, in fact, helps to exploit an ideology of direct address to reinforce politically conservative interpretations.

CONCLUSION

DVDs place home audiences in a position of virtual mastery, the entire history of cinema available at the click of a remote. In addition, the DVD, along with the contemporary home theater system, has clearly reshaped the home viewing experience. Instead of seeing the home viewing experience as inferior to moviegoing, theaters are now seen as "loss leaders" for promoting the DVD. At the same time, DVDs feed into desires to collect and repackage film history. This perception of the home theater as superior to moviegoing informs contemporary debates about the new DVD format war between Blu-Ray and high-definition DVD (HD DVD). In a 2007 commercial promoting the HD DVD format, *Sopranos* actor Michael Imperioli, who played the film buff Christopher, promoted the HD format as "the ultimate film experience." Imperioli invokes his status as a filmmaker and film fan to lend credibility to the new format, associating it not only with the pleasures of home theater systems but also with the taste cultures identified with canonical Hollywood cinema. This emphasis on the "ultimate film experience" thus continues to inform industry representations of domestic film cultures. However, while the rivalry between HD and Blu-Ray ended

quickly, with Blu-Ray surviving as the format of choice for the industry, there was some debate about the continued place of the DVD as a format for out-of-theater consumption. As Netflix and Blockbuster moved toward the production of set-top boxes that would allow consumers to download movies via the computer to their TV sets and as Apple's iTunes began making films available, the DVD itself began to appear outmoded, perhaps changing yet again the viewing practices of movie consumers. As Eric Kohn observed in a *Moviemaker Magazine* article on the triumph of Blu-Ray, "Nothing lasts forever when it comes to technology."[52] While Kohn is no doubt correct that the obsolescence of older formats is built in to entertainment commodities, it is rather striking to see that ephemerality underscored so directly in an article celebrating the emergence of the Blu-Ray format. At the same time, there is some speculation that studios chose Blu-Ray not because of its superior quality but because executives surmised that it would be more difficult to pirate.[53] But the more crucial point is that the promotion of the technology itself remains intimately tied to the discourses of connoisseurship that helped foster a movie geek culture around the DVD.

This chapter began with a discussion of how DVDs have become a crucial means by which audience practices are now shaped by DVD discourse. DVDs are not only explicitly tied to the apparent migration of the crucial audience from movie theaters into the family home, but they also redefine film audiences as "film geeks," as increasingly engaged with a wider film culture. This redefinition functions on a number of levels, including the use of letterboxing rather than pan-and-scan presentations of the image, as well as director's commentary tracks that position the viewer as an "insider," getting inside information about the making of their favorite films. In this regard, DVDs introduce new challenges to debates about how we define film audiences and how we understand audience activity. As I have argued, it is important to resist readings of commentary tracks that depict audiences as cultural dupes, ready to accept the comments of film directors and actors as the unquestioned truth about a film. Even while a commentary track such as *Fight Club*'s may seem to foreclose a queer reading, audiences are still generally prepared to offer resistant or critical readings that suit their own purposes or uses for a popular culture text. While the "reality effect" of commentary tracks may exceed that of the film itself, viewers can and do continue to make their own meanings, as we will see in our discussion of film blogs and user-generated movie mashup videos. But before I address these audience activities in detail, I want to track the industrial discourses that have conditioned or shaped the emergence of these new audiences. One of the most powerful

attempts to define those audiences was in the 1990s cyberthrillers, where Hollywood films sought to wrangle with the emerging digital culture and with the new digital technologies that seemed to offer film-makers a way to reinvent cinematic storytelling, namely the digital effects that could make movies far more malleable than ever before. These films represented a unique challenge not only to film audiences but also to the film scholars who saw the use of digital special effects as foretelling the end of film as a medium.

2

THE SCREEN IS ALIVE
Digital Effects and Internet Culture in the 1990s Cyberthriller

In March 2003, I attended a special screening of D. A. Pennebaker's *Ziggy Stardust and the Spiders from Mars (1973)* at a drive-in theater in Atlanta as part of a local film festival. As I watched I discovered that *Ziggy Stardust* was the perfect movie with which to indulge my desire to experience a film at a drive-in, with its 1970s "innocence" meshing with the nostalgia for the past when drive-ins were far more common. But at one crucial moment, I glanced in my rearview mirror and saw a scene from *The Matrix Reloaded*, a movie I hadn't yet seen, being projected on a screen directly behind my car. The shot, of what appeared to be a series of doorways opening into an infinite regress of rooms, was pretty astonishing, but the experience of glancing into the mirror and seeing a "contemporary" version of our cyberspace future while watching and listening to Bowie's *Ziggy Stardust* evoked another image of the "future" from 1973. That image was intimately tied to Bowie's own interrogations of performance and self-fashioning through his multiple rock star personas, suggesting for me a temporal dialectic of special effects in which the new returns as the always-the-same, a repetition that Walter Benjamin saw as crucial to the modern experience of history. As Susan Buck-Morss argues, "The temporal dialectic of the new as the always-the-same, the hallmark of fashion, is the secret of the modern experience of history. Under capitalism, the most recent myths are continuously superseded by new ones, and this means that newness itself repeats mythically."[1] Thus, despite the "novelty" implied by the

special effects in *The Matrix Reloaded*, seeing the film's special effects juxtaposed against an earlier era of cinematic futurism underscored for me the degree to which the newness of special effects is recycled, reworked, and revisited. While it is, no doubt, the case that virtually all Hollywood films rely upon digital effects to a greater or lesser degree, science fiction and fantasy films of the 1990s provided a unique site for thinking about the role of digital effects in reshaping cinematic narrative and in rethinking the definition of film as a medium.

I mention the *Ziggy Stardust* anecdote not simply because it plays out the unique schematics of watching movies in a drive-in theater years after the original drive-in moment had passed but because both films are so deeply invested in the use of special effects to represent the future of cinema and how that future might be tied to unstable definitions of the human. In this context, the *Matrix* films reveled in the fantasy of what Vincent Mosco described as a "post-biological future" in which humans could transcend their frail bodies.[2] While we are no doubt prepared to see the computer special effects as a crucial organizing element of *The Matrix* films, both formally and narratively, it is worth emphasizing that Bowie's concert film was equally based in the "special effects" of performance and staging, of creating an illusory image of an imagined (space age) future. It should be added that my moment of recognition was not a fully innocent one. Steeped as I was in Walter Benjamin's concept of the dialectical image, I was fully prepared to recognize the historicity of both images. My epiphany at the drive-in was also informed by Anne Friedberg's useful Benjamin-inspired observation of the analogy between the automobile windshield and the movie screen.[3]

Finally, the use of special effects in *The Matrix Reloaded* should also serve as an important reminder of the role of digital effects in extending the marketing and promotional arms of Hollywood studios. As Edward Jay Epstein observed, the use of digital effects "further offers the prospect of a licensing cornucopia of heroes (and anti-heroes) for toys, interactive games, and amusement park rides."[4] While audiences have, in certain circumstances, rebelled against the digitization of certain characters, such as Jar Jar Binks in *The Phantom Menace*, the tremendous popularity of digitized characters in Peter Jackson's *Lord of the Rings* films, among many others, illustrates the degree to which audiences can embrace digital effects when wrapped in an enticing narrative. Significantly, these questions continue to provide boundary cases through which debates about the definition and future of cinema are discussed. While digital effects, such as morphing and compositing, have become a relatively standard tool in the cinematic storytelling toolkits, the effect of novelty they produce still has the power to

provoke. Digital special effects continue to be promoted in terms of technological and cinematic novelty, with "innovators" such as the Wachowski brothers often described as inventing a new language for cinema. The use of digital effects can provoke intense, almost visceral, complaints among film critics attached to the materiality of film, illustrating the ways in which digital effects fit neatly into the overall perception that cinema is being reinvented. However, this chapter seeks to argue that digital effects do little to upset traditional concepts of cinema. Because so many of these movies are sold as spectacles that are best experienced on the big screen, they might, in fact, help to foster the excitement over new theatrical releases.

Instead of simply reading digital effects in terms of their role in sustaining the marketability of ancillary products, this chapter investigates their function in sustaining a number of myths regarding digital cinema. In particular, the use of digital effects in Hollywood science fiction films has invoked debates about the potential for digital technologies in general to challenge traditional definitions of the human, as well as traditional definitions of what counts as film. In addition, these effects are invariably marketed in terms of their novelty, their ability to present unprecedented experiences for audiences, an assertion that seems specifically designed to lure audiences back into movie theaters. Finally, digital effects have engaged with popular debates about audience fears of being manipulated. Because digital effects brought to the surface the malleability of the motion picture image, they could also be used to explore concerns that audiences themselves might be manipulated by malevolent, if often undefined, invisible forces. However, as I argued in the chapter on DVDs, audiences are frequently aware of the role of the DVD as a medium in shaping interpretation, particularly when they are confronted with an especially creative—or confusing—menu, or when they encounter supplemental features that may challenge their original interpretations of a film. Here, I seek to expand that analysis of digital media to the introduction of digital special effects to movies and, specifically, to address how digital effects were themselves theorized by a number of cyberspace thrillers beginning in the mid-1990s and by the promotional materials that shaped the interpretation of these films. For the most part, this chapter looks at cyberspace films from the late 1990s. While the use of digital effects continues to evolve, the films addressed here were important because of the way they helped to narrate the adoption of digital effects, in part by setting their plots "in" cyberspace (*The Matrix, The Thirteenth Floor*) or in spaces that can be read as allegorizing it (*Dark City*). In addition, all three films reflected those wider cultural practices of mythologizing cyberspace, of

imagining it as allowing us to transcend space, time, and politics as Vincent Mosco has so effectively documented.[5]

At the same time, the increasing reliance on digital effects encouraged observers to imagine a fully digital cinematic future, in which the medium of film itself becomes outmoded, with digital projection replacing film projection and filmmakers increasingly relying on digital video cameras and other special effects techniques. The comparison between digital projection and digital effects is not accidental. In both cases, digital media are seen as encroaching on the stable medium of film, forever altering it, whether those changes are seen as providing us with new possibilities or eclipsing the stable, century-old medium of film. In an address at the 2005 Global Digital Distribution Summit, Daniel Langlois, founder of Softimage, which specialized in 3-D computer animation techniques and produced many of the special effects for blockbusters such as *The Matrix*, *Titanic*, *Men in Black*, and *Jurassic Park*, painted a narrative of technological revolution against the cinematic status quo. He compared the introduction of digital projection to the introduction of digital effects, recounting that in 1986 Hollywood producers told him that they would never use digital effects; he depicted the skeptical studio executive as saying, "This is technology. This is not film. This is not art."[6] While presenting the studios as hopelessly resistant to inevitable change, Langlois also underscored the opposition between the film medium as "art" and digital media as "technology," a dialectic that held tremendous power when digital effects were first introduced. His comments may have been addressed primarily to other new media entrepreneurs, but their role in shaping new media discourse should not be ignored. Langlois, in particular, seeks to naturalize digital effects, to see them as the inevitable outcome of cinema's evolution away from the mechanical medium of film. However, such evolutions are far from inevitable and, in this case, are the result of an arrangement of studio, theater, and new media interests.

In order to address the reception and promotion of digital effects, this chapter begins by examining debates about the role of digital technologies in potentially manipulating audiences. Not surprisingly, these concerns about deception have often been addressed either in films that depict historical figures, such as *JFK*, *Forrest Gump*, or *Contact*, or films that depict the use of political power, such as *Wag the Dog*. In the first three of these films, digital effects are used to alter documentary footage of the past, often to create a fictional encounter that did not happen, while *Wag the Dog* expresses the fear that an already pliant voting public could be even more easily duped through the power of digital images. From there, I turn to a series of science fiction thrillers set in cyberspace

to investigate how those films deepen and, in some cases, complicate the digital cinema myth that digital special effects threaten the stability of cinematic representation. The chapter then traces an underlying—and rarely acknowledged—subtext of the discussion of digital effects in the entertainment press, on DVD extras, and in other promotional discourse, arguing that audiences rarely encounter digital effects in a purely naïve state and are therefore aware of the practice of manipulation. Of course, this promotional discourse also cannot be entirely separated from the ongoing attempts to promote a specific kind of experience of Hollywood films, one that is characterized by astonishment at the technological wizardry of the major media conglomerates that produce these films.

MANIPULATED IMAGES AND THE POLITICS
OF DIGITAL DECEPTION

As Hollywood films began using digital special effects, questions emerged about how they might be used. According to Lev Manovich, in most Hollywood films digitization is carefully masked in order to preserve the mimetic status of the film. In *The Language of New Media*, Manovich argues, "Although most Hollywood releases now involve digitally manipulated scenes, the use of computers is always carefully hidden."[7] Manovich's argument relies upon the assumptions of a desire for realism, in which textual elements collaborate to produce the effect of "unretouched photographic records of events that took place in front of the camera."[8] While Manovich suggests that "physically impossible" images, such as the fight scenes in *The Matrix* or tuning sequences in *Dark City*, may be motivated by the film's narrative, such an argument seems to rely on a naïve spectator unfamiliar with the use of formal techniques in the manipulation of time and space common to Hollywood narrative cinema. As DVD commentary tracks shape cinematic knowledge, viewers frequently read these scenes in terms of a technological fascination, in which the filmmakers have created a new, possibly unexpected effect that surpasses what they have seen in the past.

These concerns about digital technologies and human identity revolve around two key narratives that have emerged in discussions of how digital technologies will transform the medium of film and the construction of identity. The first narrative involves the belief that digital media produce more realistic—and therefore deceptive—representations. Caught within the desire for unmediated representations is the belief that computer technologies might be able to broadcast directly to the brain, allowing audiences to completely immerse themselves in the

world of the film. In a June 2002 interview in *Wired* magazine to promote *Minority Report*, Steven Spielberg, reflecting on the transition from film to digital, predicted: "Someday the entire motion picture may take place inside the mind, and it will be the most internal experience anyone can have: being told a story with your eyes closed, but you see and smell and feel and interact with the story."[9] The full sensory experience imagined by Spielberg seems to promise something that goes far beyond that of celluloid. At the same time, Spielberg's imagined cinematic future also depicts a fully internal, personal experience that stands in stark contrast to the collective cinematic experiences that we associate with public moviegoing, linking the digital by extension with a retreat into the private sphere and away from the larger community.

These questions about identity usually hinge on a sense of uncertainty regarding the role of visual technologies in representing reality and fulfilling the evidentiary role that has been assigned to photography, questions that have cropped up with a vengeance in critical theory with the emergence of digital photography in the 1990s. In *The Reconfigured Eye*, William J. Mitchell writes that "by virtue of the [digital photograph's] inherent manipulability, it always presents a temptation to duplicity. So the inventory of comfortably trustworthy photographs that has formed our understanding of the world for so long seems destined to be overwhelmed by a flood of digital images of much less certain status."[10] Mitchell's account is reinforced by Manovich, who argues that "in contrast to photographs, which remain fixed once they are printed, computer representation makes every image inherently mutable—creating signs that are no longer just mobile but also forever modifiable."[11] While the mutability of photographic and cinematic images would later be seen as offering viewers, or more precisely users, the opportunity to alter Hollywood films for their own purposes, it is difficult not to see these observations as offering something of a conservative critique of the instability of digital images.

This fear of deception was vividly addressed in Barry Levinson's 1997 film *Wag the Dog*, in which a philandering president launches an imaginary war against Albania in order to deflect attention from a growing political scandal. The film, of course, gained an unusual resonance when President Bill Clinton became enmeshed in his very own sex scandal, complicating his own decision to bomb a factory in the Sudan suspected of helping to arm Osama bin Laden. In order to successfully sell the scandal, one of the president's spin doctors brings in a Hollywood director, Stanley Motss (Dustin Hoffman), to fashion images of beleaguered Albanian civilians that U.S. soldiers could then rescue. Motss skillfully manipulates images filmed against a green screen, using

digital compositing technologies to create a war that, in all actuality, does not exist. In one powerful scene, he hires a young actress, Tracy Lime (Kirsten Dunst), to play a young Albanian peasant woman whose home is being threatened by the war. To make the image even more emotionally powerful, Motss decides to depict Tracy carrying a small dog in her arms; however, because there is no dog available, Motss asks Tracy to cradle a bag of chips instead, which he will then replace using stock images of a dog. While the scene reduces to a few keystrokes what would likely require hours of digital animation, it also illustrates the degree to which audiences feared that digital technologies might be used to promote political manipulations. At the same time, the scene provided an ironic reversal of what would later become a common practice of digital product placement. While product placement has been a common feature of Hollywood films and television series, digital product placement illustrates the ways in which digital effects can be used to further strengthen the connection between entertainment and marketing.[12] By distinctly uniting Hollywood and Washington, *Wag the Dog* was able to tie questions about manipulation to both entertainment and politics, raising important concerns about the ability of digital technologies to deceive naïve audiences.

These debates about the evidentiary role of photography and film crystallized in the 1990s in the context of Hollywood blockbusters, most famously in two films directed by Robert Zemeckis, *Contact* and *Forrest Gump*. In *Forrest Gump*, the titular character takes an ambling tour through recent American history, stopping off for digitally manipulated interviews with Presidents John Kennedy and Richard Nixon while chatting up John Lennon and Yoko Ono on *The Dick Cavett Show*. These encounters were digitally edited to make it appear that Gump had interacted with these public figures, although the illusion of authenticity was consistently disrupted by the star presence of Tom Hanks. In *Contact*, we see the planned flight of astronaut Eleanor Arroway apparently being announced at a press conference by President Clinton. The blurring of news and fiction was enhanced by cameos from the likes of Larry King, Geraldo Rivera, and Robert Novak.[13] In both films, public figures are incorporated into fictional narratives, running the risk that audiences might be confused about the veracity of the events they are watching. In this context, J. Robert Craig traces the evolution of digital effects, noting a significant distinction between Zemeckis's playful depiction of Forrest Gump's interaction with the 1960s and the more seamless use of special effects in *Contact*. In the latter film, the digital effects depicting Clinton's press conferences, in Craig's words, assault "what we typically think of as the verity of the photographic image."[14] Citing Susan

Sontag's argument on the evidentiary role of photography, Craig goes on to argue that digital photographs will challenge this role, creating confusion over the reality of historical images.[15]

However, as Craig acknowledges, because both films were heavily promoted as spectacles identified with a special effects wizard such as Zemeckis, the potential for confusion is less clear. Making-of documentaries and promotional segments on shows such as *Entertainment Weekly* depicted familiar actors such as Tom Hanks and Gary Sinise performing in front of green screens in order to show how specific effects—Hanks talking to John Lennon or Sinise losing his leg—were fabricated. In this sense, the concerns about a naïve, easily manipulated viewer must be balanced against supplemental and promotional discourses that shaped the reception of films making extensive use of digital effects. As Craig observes, Zemeckis's use of Clinton's speeches seems to be implying that audiences are now fully capable of regarding visual images "with a healthy skepticism."[16] What struck me about the insertion of Clinton speeches into *Contact* was not that I was convinced the president had willingly participated in the film but the sheer astonishment at witnessing such a masterful use of special effects. In fact, rather than creating a seamless world, the special effects had a distancing effect, in which I found myself contemplating not the film's meditation on extraterrestrial life but Zemeckis's intervention into the politics of images. In short, these critiques of digital manipulation assume a passive, credulous viewer, not a networked user capable of challenging, interrogating, and even reediting these images for her own purposes. While many of these observations about digital effects were written well before Photoshop became a relatively standard feature on home computers, allowing virtually anyone with a computer to participate in the manipulation of images, these accounts fail to take into consideration the skepticism many viewers already extend toward media images.

SPECIAL EFFECTS AND DEFINITIONS OF THE HUMAN

While Zemeckis's use of special effects led to debates about their role in deceiving audiences, cyberthrillers of the 1990s participated in even more explicit attempts to mythologize the rise of digital cinema. In addition to addressing the inherent instability of digital images, these movies built upon that malleability to address the stability of human identity. Drawing from the digital myth that computers could help to transcend the frailty of human bodies, these films depicted characters who could upload or download themselves into new bodies, virtually at will. As Vincent Mosco observes, citing Ray Kurzweil's account of a

"postbiological future," this myth seems to promise "what amounts to the end of death as we know it."[17] Kurzweil, recognizing the exponential rate at which computational power increased as described in Moore's Law, believed that we would eventually transcend death by uploading our consciousness onto a computer. While Kurzweil's fantasy of immortality has been disputed, what seems more significant is the persistence and power of the myth itself within popular culture. This promise of overcoming the limitations of the human body was addressed narratively in a cycle of cyberspace thrillers, *The Matrix*, *The Thirteenth Floor*, and *Dark City*, all made in the late 1990s. In all three films, the instability of the cinematic image produced through digital effects becomes a means by which the films explore these questions about fluid identities. Significantly, a number of cyberthrillers framed their meditation on cinematic representation in imagery meant to evoke the cinematic past, thus combining nostalgia for the history of film with their futuristic projections of a post-biological and post-filmic future.

Josef Rusnak's low-budget cyberspace thriller *The Thirteenth Floor* offered one of the more direct attempts to theorize the relationship between digital technologies and human identity. Like *Dark City* and *The Matrix*, *The Thirteenth Floor*, released in 1999, evokes our cinematic past, specifically the detective films of the 1930s and 1940s, in much the same way that Ridley Scott's *Blade Runner* recalled earlier film genres in order to reflect on changing definitions of the human. The main character, Douglas Hall, collaborates during what he believes to be the year 1999 on a stunning virtual reality (VR) program modeled on the 1937 Los Angeles that provides the setting for many of Raymond Chandler's detective novels. The attraction to 1937 hardly seems accidental: it is the moment in U.S. history most often associated with a "golden age" of cinema. Perhaps more crucially, much like *Blade Runner*, the connection to Chandler's detective novels seems to evoke a fantasy image of Los Angeles. In fact, as Mike Davis has keenly observed, the noir films of the 1940s provided "some of the most acute critiques of the culture of late capitalism."[18] *The Thirteenth Floor* evokes Los Angeles in part because of its relationship to the idea of Hollywood as "dream factory," while also recognizing the role of a new generation of digital media that might be even more capable of fabricating fantasies.

The detective plot allows the film to explore these questions about a postbiological future and the fantasies that inform them. When his collaborator, Fuller, is murdered, Hall enters the virtual environment because he believes that Fuller has placed a clue to the murder inside the 1937 VR program. Hall's experience entails a complete immersion

into the virtual environment; when he arrives in the VR simulation, Hall inhabits the body of one of the characters living in the simulation, with the result that all of his senses are engaged by the virtual world. After becoming established in the virtual 1937, Hall discovers that his colleague has been using the virtual environment to conduct an affair with a nightclub dancer, reinvigorating questions about the potential for sensory plenitude offered by digital technologies. In this sense, the film seems to affirm the mind-body split fantasized by many digital utopians in its treatment of digitization and identity, with the "thinking" Hall separated from the body he inhabits. The 1937 world, Hall quickly discovers, is lively, especially compared to his dull, alienating 1999 world, filmed primarily in a gray palette with stark, lifeless skyscrapers identified with Hall's work as a computer programmer. Hall's worlds begin to collapse when a bartender from the 1930s simulation reads a letter intended for Hall explaining that his existence in the 1990s is also a computer simulation and that his programmer has been jacking in to his consciousness in order to commit murders within the simulated 1930s world. Hall escapes his cyber-prison due to a "rule" within the world of the film that stipulates that if your body is killed while your consciousness is displaced, then your consciousness takes over the dead person's body, creating what Robin Wood, following Douglas Sirk, might describe as a kind of "emergency exit" that allows Hall's personality to "live" in spite of the fact that it was created as a simulation.[19] Thus, when Hall's creator is killed while using Hall's body, Hall takes over the body of his creator in the "real" world of the 2030s, revealing that Hall's own world in the 1990s is also a simulation. The film concludes with Hall safely in the "real" present of the film, early in the twenty-first century, reunited with his love interest in her seaside Los Angeles home, thus offering a return to the "natural" world. *The Thirteenth Floor* can be understood as suggesting that digital technologies, when they achieve full realism, are inherently deceptive and, therefore, dangerous. As a result, the film seems largely consistent with other cyberthrillers that enforce this split, and while the film does suggest the potential for danger, it also entertains the fantasy of immortality.

ILLUSION AND SPECTACLE IN "THE MATRIX"

While *The Thirteenth Floor* replicates the basic narrative logic of the cyberthriller, *The Matrix* addresses that logic both within the film's narrative and through its use of digital effects, which film audiences were invited to see as an innovation that would change the ways in

which films are made and promoted. In addition, the entire trilogy was marketed to an active community of fans who engaged in discussions of the films and other elements of a much larger story world, with the first film functioning in part to generate interest for a wide variety of "supplemental" texts, including graphic novels, video games, the second and third feature films, and the animated film *The Animatrix*.[20] Thus, in addition to providing a cyberthriller narrative that used special effects to participate in the mythologizing of cyberspace as a remedy for the lack of social community, the *Matrix* films engaged with a networked film audience, presenting them with an elaborate narrative world to interpret, debate, and discuss. As Jenkins observes, "This is probably where *The Matrix* fell out of favor with the film critics, who were used to reviewing the film and not the surrounding apparatus."[21] To some extent, Jenkins's discussion of the textual world spawned by *The Matrix* celebrates their creation of an active, engaged audience, while underplaying the degree to which major media conglomerates have tremendous economic incentive to create and sustain these worlds. At the same time, it is crucial to emphasize the role that these extratextual features played in fostering a number of myths not only about the nature of human identity but also about the characterizations of consumers as a kind of virtual community, a perception that was only reinforced by the films' quasi-religious narrative of transcendence over space and time. However, while it is easy to dismiss such reveries in the post-dotcom era—especially the promised worldwide community often associated with internet connectivity—it is worthwhile to be attentive to the ways in which the cyberspace myths delineated in the broader *Matrix* text reflect larger desires for community and democracy, myths that are sometimes reborn in accounts of digital cinema production and reception cultures.[22]

The Matrix famously traces the development of a beleaguered software programmer, Thomas Anderson, who operates as a hacker by night under the name Neo. When Neo meets a fellow hacker, Trinity, she knows that he is trying to break through the forces of domination that have "enslaved" him within the world of the matrix, setting up from the beginning a fantasy of rebellion against a loosely defined system of authority. In this sense, the film establishes a new kind of digital politics, in which cyberspace technologies and their opportunity for fluid identities can, in fact, lead to a form of emancipation from corporate and governmental powers represented within the film's allegory by virtual reality "agents," nondescript corporate detectives who monitor and regulate all activity within the artificial world. Thus, the narrative of liberation from this oppressive system in *The Matrix* is consistent

with digital myths about the "end of politics."[23] This fantasy of an end to the political domination allegorically represented in *The Matrix* was, no doubt, enticing and likely served as one of the major factors in attracting such a large, international, and mostly youthful fan base.

Many of these questions were played out visually in the film's innovative use of digital special effects. In *The Matrix*, a monochromatic tone, similar to the visual style of *The Thirteenth Floor*, dominates the artificial city where Neo lives, quickly coding the artificiality and dreariness of the simulated 1990s world. Like *The Thirteenth Floor*, *The Matrix* implies that digital technologies both produce unstable identities and place them in a "world of appearances," where reality proves to be just another illusion, but also where individuals increasingly find themselves isolated from the real world, separated from any kind of community. This notion of a world of appearances is famously reinforced through one of the film's many references to philosophy, particularly the work of Jean Baudrillard when Neo retrieves a disk hidden in a hollowed-out copy of Baudrillard's *Simulations and Simulacra,* setting up more or less explicitly the ongoing treatment of the artificiality of the cyberspace world inhabited by Neo at the beginning of the film. In short, the film initially appears to be asserting an essentially "cyberphobic" position by depicting the virtual world as cold, sterile, lifeless, and above all fake.

However, in contrast to the flat color scheme, the film's special effects provided audiences with an experience that Tom Gunning has described as an "aesthetic of astonishment."[24] While Gunning was writing about early cinema audiences, his arguments apply to the dazzling special effects deployed in the Wachowski brothers' film, which mixed jaw-dropping kung fu performances with time-defying special effects as Neo, Trinity, and the other remaining humans seem to stop—or at least slow down—time during their fights with the agents. In describing the aesthetic of astonishment, Gunning challenges one of the central, foundational narratives about early cinema audiences, namely the legend, unsubstantiated by contemporary journalistic accounts, that audiences at the earliest screenings of the Lumière brothers' *Arrival of a Train at the Station* were terrified by the images they saw and ducked behind their seats in horror or even ran screaming from the theater. Gunning proceeds to argue that the myth of frightened spectators has its ideological uses in depicting early cinema's audiences as naïve, incapable of distinguishing image from reality: "Thus conceived, the myth of initial terror defines film's power as its unprecedented realism, its ability to convince spectators that the moving image was, in fact, palpable and dangerous, bearing towards them with physical impact."[25] Instead,

Gunning explains, these early films exploited their illusionistic nature, with audiences taking pleasure in witnessing the play between realistic and illusionary qualities. Thus, rather than being frightened by the image of the approaching train, viewers were thrilled by it, taking pleasure in the projection of moving images. Gunning goes on to argue that "rather than mistaking the image for reality, the spectator is astonished by its transformation through the new illusion of projected motion. Far from credulity, it is the incredible nature of the illusion itself that renders the viewer speechless."[26] In short, early cinema audiences were not fooled by the illusion of motion so much as they were astounded by the production of this illusion by the cinematic apparatus.

A similar logic holds in the depiction of special effects in *The Matrix*. While viewers may have been shocked initially by the "twist" revelation that the world of the matrix was not real, this sense of shock exists only on an initial viewing. After the initial viewing, of course, audiences are not duped by the film's astounding, almost visceral special effects. Instead, the "astonishment" produced by *The Matrix* grew out of the fascination with the effects themselves, the transformation of time, space, gravity, and motion through the film's use of virtual camera movement. The Wachowski brothers typically referred to this technique as "bullet-time photography," which they discussed not only in the film's extra-laden DVD but also in trade literature in order to promote digital cinema as a means of reviving and even transcending analog film. For example, Dayton Taylor has discussed the film's "bullet-time" photography technique, in which a camera seemed to pan around a frozen moment in time, both in terms of the technique's relationship to film history, by connecting the technique to the still images in Chris Marker's *La jetée,* and in terms of the inevitability of digital technologies going forward.[27] In this sense, I read the film's apparently cyberphobic narrative as less important than the wizardry of the special effects themselves. While Patricia Mellencamp sees a "contradiction" between the film's narrative and its use of some of the most advanced media technologies, privileging the narrative over the pleasures of the special effects misreads how audiences used the film.[28] In fact, the techno-wizardry of the original *Matrix* film is inseparable from the marketing of the film via the DVD special features, one of the first truly "collectible" DVDs to hit the market after the launch of the new home format in 1997.

While such desires for an escape from embodiment may have enticed some early virtual reality pioneers, they also provided a useful illusion of mastery over the changes in communications and social relations associated with the popularization of the internet in the late

1990s. Within the logic of the cyberspace film, bodies therefore become transformed into mere containers for information; an artificial reality emerges that masks real social relations; and these transformations result in a profound reworking of our experiences of time and space. As Claudia Springer argues in her essay on the 1990s cyberthriller, "Cyberspace functions as a device for filmmakers to recreate the self in a depleted and corrupt external world, experimenting with both liberatory and repressive scenarios."[29] In the case of *The Matrix*, the repressive world identified with cyberspace is the world of work itself, the dystopia of skyscrapers and offices that initially constrain Neo's personal freedom and turn him and his fellow humans into little more than a power source for keeping the matrix functional. Of course, as Springer also observes, while these films offer the fantasy of an escape from embodiment, they also inevitably require a return to the real, to the status quo of physical embodiment. Thus, even though Neo could choose the sensory pleasures offered by the Agent, because those pleasures (the delicious steaks that entice Cypher back into the matrix, for example) are not physically real, Neo, and the film itself, reject them in the name of hanging onto "real" embodiment.[30] In this sense, the film is able to entertain the fantasy of fluid identities and the possibility for self-reinvention even while returning to traditional definitions of the human.

VIRTUAL CITIES AND STOLEN MEMORIES IN "DARK CITY"

Similar questions regarding definitions of the human inform Alex Proyas's 1998 film *Dark City*. The film focuses on the experiments of an alien race known as "Strangers," who have transported a number of humans to a remote location in outer space where they investigate human consciousness in order to locate that elusive entity, the "human soul," essentially—according to the logic of the film—that intangible quality that allows humans to not only survive but thrive as a species. The Strangers' search is augmented by the production of artificial memories, which they implant into the human subjects of their experiments using a giant syringe. These fabricated memories are grounded in part through the manufacture of objects—souvenirs, photographs, diaries, scrapbooks, or snow globes, for example—designed to sustain a link to an artificially produced environment. Their search is later thrown off course when John Murdoch, one of the city's human inhabitants, unconsciously refuses to be injected with the faked memories and begins to evolve and take on many of the powers used by the Strangers to manipulate the city.

Like *The Thirteenth Floor*, these questions about digital technologies and identity are mapped onto nostalgic representations from film history, namely *Dark City*'s overt references to both film noir and to classic science fiction films such as Fritz Lang's *Metropolis*. While *Dark City* never achieved the rabid enthusiasm associated with the *Matrix* films, it did develop a cult following, in part through a deliberate use of the DVD to frame interpretation. Noting *Dark City*'s heavy use of an Expressionistic style not unlike Lang's, a short essay on the DVD reminds viewers that Lang's film received mixed reviews. The implication is that Proyas's film will eventually be regarded as a classic, once future audiences recognize and understand its innovative storytelling and visuals: "The story of *Dark City* has been told in a new and innovative cinematic language, which only the ticking of time can determine its' [*sic*] influence on the filmmakers of the future."[31] Further, *Dark City*'s DVD commentary tracks place emphasis on the film's visual design and on its status as an important advance in science fiction storytelling. On one commentary track, the film's director is joined not only by writers Lem Dobbs and David Goyer but also by cinematographer Dariusz Wolski and production designer Patrick Tatopolous, thereby calling attention to production values rather than star performances. In addition, a second commentary track was contributed by film critic Roger Ebert, most likely to bestow his status as a tastemaker onto what had been something of a box office and critical failure. Ebert's commentary track operated within what John Caldwell calls the "resuscitation" genre, one in which Ebert is a frequent participant, not only through his contributions on DVDs but also through such events as his annual Overlooked Film Festival in his hometown of Champaign, Illinois.[32] In this sense, the DVD very clearly frames *Dark City* as an object of study and one that has something to tell us not only about the nature of identity but also about the history and future of cinema.

This depiction of a knowledgeable viewer informs the relationship between the spectator and the diegetic world of the film. While a naïve viewer may struggle to make sense of the artificial world depicted in *Dark City*, the informed viewer, guided by commentary tracks and supplemental essays, operates from a position of knowledge in relationship to the characters. These retroactive viewings shape our interpretation of John's attempts to make sense of his surroundings. During the film's opening scene, John wakes up—is literally reborn—without memories and is forced to try to make sense of his surroundings. As the film unfolds, he is informed by a psychiatrist, Dr. Schreber, who has collaborated with the Strangers in their experiments, that all human memories are artificially produced and that the city itself is constantly

being altered through a technique the Strangers refer to as "tuning." Knowledge of these fabricated memories, sustained by the artificial city manufactured nightly by the Strangers, produce in John a wariness of his surroundings, a recognition that nothing can be accepted at face value.

In this sense, the film's narrative might be read as cyberphobic, as reinforcing the idea that digital technologies are prone to be used in order to deceive and manipulate viewers. However, as I have argued, digitization has a much more complicated position within cinematic narrative. In fact, once John develops the ability to "tune," he is able to remake the city in his own benevolent way, implicitly reinforcing the idea that in cyberspace, our identities are not constraining, and we can make and remake ourselves as we choose.

Drawing from a film noir visual style, the city is characterized by images of industrial production, including the elevated trains, the Automat, and the forties-era automobiles that traverse the city. This industrial image corresponds to cinema's status as an art of "mechanical reproduction," replete with the many associations that follow—a linear narrative progressing incrementally at twenty-four frames per second in a temporal segmentation that follows the logic of the assembly line. Manovich observes that "cinema followed this logic of industrial production as well. It replaced all other modes of narration with a sequential narrative, an assembly line of shots that appear on the screen one at a time."[33] This image of a sequential narrative, supported by the linearity of the industrial mode of production, becomes transformed within the digitized space of *Dark City*. Thus, even though it is the case that within the diegetic space of the film, digital technologies are visibly not in use, these industrial technologies are subsumed under the malleability of the artificial environment. In fact, the characters' employment of older technologies—classically modernist technologies, such as the gears, wheels, levers, and assembly lines that serve as the city's substructure—can be read as caught up in the nostalgia for these earlier modes of production and for the stability they might provide against the disorientation associated with digital technologies.

As part of their experiments, the Strangers implant new artificial memories into selected human subjects in order to see how they will react: if given the memories of a serial killer, will that person continue to murder? If given the memories of a lounge singer and adulteress, will that person continue to cheat on her husband? We gradually learn that none of the city's human inhabitants have any memory of their "real" past on earth; they are, in essence, cut off from any real past and trapped in a perpetual present, just as they are equally caught within

the hermetic space of the Strangers' artificial city. As Mr. Hand, one of the Strangers, explains, "We fashioned this city on stolen memories, different eras, different pasts, all rolled into one." In some sense, as Garrett Stewart points out, the city designed by the Strangers reflects the logic of postmodernism in its endless recycling and recombination of already assembled texts.[34] The eclecticism of the architectural space in *Dark City* appears to suggest nostalgia for some lost moment in the American and cinematic past. However, the artifice of the city emphasizes the extent to which this imagined past is itself artificial, a construction of so many Hollywood representations. At the same time, the detective plot—with its emphasis on restoring the order of things— serves the logic of cyberspace films. Like *The Thirteenth Floor* and *Strange Days*, *Dark City* becomes a detective story concerned less with resolving a particular crime than with unmasking the truth within "a world of appearances" and restoring a more stable social order, reinforcing the role of digital technologies in deceiving viewers.

This mistrust of appearances culminates in the scene in which John watches photographic slides that are ostensibly pictures of his youth on Shell Beach, which he views with his "Uncle Karl." The camera rests behind John and Karl, who are in front of a small home movie screen as Karl operates the slide projector, amazed that John cannot remember any of these events that are ostensibly from his youth. As they view the slides, we learn that according to the memories fabricated by the Strangers, John was badly burned in a house fire. Rolling up his sleeves, John demonstrates that his arm is not scarred, therefore communicating through physical evidence that these photographic images, and therefore the past itself, have been fabricated. This sequence is followed by a shot of the Strangers diligently working to prepare the night's souvenirs as on an assembly line, manufacturing the memories that support human interactions and prevent the human beings from realizing their real conditions within the city, similar to the replicants' cherished photographic mementos in *Blade Runner*. In this context, Garrett Stewart comments that *Dark City*'s images of digitally manipulated images mark "the outmoding not just of photography by the simulacral mock-up, but of cinema from within itself, by computerized encroachments of every description."[35] *Dark City*, like *Blade Runner*, conveys the outmoding of cinema and photography through the digitally manipulated image, which becomes an unreliable means for grounding identity. Like Deckard, who is forced to confront the possibility that his photographs do not refer to a "real" past, John recognizes the artificiality of his own memories in part through the photographic slides that

have been designed to contain him within the social fabric of the artificial city. However, instead of seeing the film as merely nostalgic for a stable moment in the past, *Dark City* seems to pursue a more ambivalent stance by implying that digitization allows for the possibility of reinventing oneself.

Dark City's solution to the crisis of fabricated memories attempts to disavow the fear of artificial memories and, metaphorically, the power of digitization. During the climax of the film, John begins to fight the Strangers on their own terms, developing and using their tuning skills against them. John faces off against the Strangers in a battle of wills, again suggesting the importance of human emotion, as the city the Strangers created crashes around them, with buildings collapsing to the ground while others "grow" at crooked angles before John finally defeats the collective will of the Strangers. After John defeats the Strangers, he rebuilds the city, producing a world that appears more natural than its predecessors. Significantly, at the end of the film, Emma (now transformed into Anna) works at a ticket counter in a downtown movie theater, suggesting a retreat into that earlier mode of image production. After rebuilding the city, John is reunited with Emma/Anna, whose previous set of memories—of her life with John—have been supplanted so that she no longer knows him. However, the film implies her attraction to him through her offer to guide him to Shell Beach. In this sense, the film resorts to romantic love as the resolution to the identity crisis, suggesting that there was already *something* in John that Emma found desirable (and vice versa), thus implying a human soul, a traditional human subject, uncorrupted by the machinations of the Strangers, which is what prompted the Strangers' experiments in the first place. The film's ending thus reaffirms the Strangers' belief in the human capacity for individualism, reinforcing the concept of the traditional human subject in the face of the dangerously seductive technologies that produced the artificial world.

However, instead of seeing *Dark City* as merely nostalgic, I would argue that the film, in some ways at least, embraces the fluidity of digital technologies. John's rebuilding of the city according to his own "memories" suggests that digital technologies allow for the possibility of transforming one's identity. Just as Thomas Anderson was able to transform himself into the hacker hero Neo, John, using the Strangers' tools, essentially reinvents the city—and thus himself. The city begins to develop the character of John's (artificial) memories, reflecting the "simpler times" that Shell Beach had come to represent. John also chooses an identity for himself based on his knowledge that his memories are

a mere fabrication. Even though the film maintains the sheen of nostalgia, underneath the surface the possibility of reinventing oneself via digital technologies emerges. Thus, while the film sustains the recognition that the identities of the human inhabitants are constructed, John's reworking of the city suggests that they will be able to forge their own identities, thus recasting many of the fears raised by the film that digitization will lead to unstable human identity and allowing *Dark City* to have it both ways. Digital technologies are dangerous because they reinforce the possibility that we will be trapped in an easily manipulated world of appearances, but they are also liberating because they provide us with the potential for perpetual self-reinvention.

CONCLUSION

In the late 1990s, the medium of film saw itself undergoing profound changes. These changes amount to what Wheeler Winston Dixon calls "the dawn of a new grammar, a new technological delivery and production system, with a new set of plots, tropes, iconic conventions, and stars."[36] At the time, Dixon worried that these new filmmaking modes would lead to an intensified focus on producing expensive franchise films geared primarily toward teenagers with the hope of attracting the largest possible audience while minimizing financial risk. A few years later, *New York Press* reviewer Armond White, writing a review of the Wachowski brothers' *Speed Racer* (2008), seemed to confirm Dixon's fears. Noting the film's perceived excess of special effects, its televisual aesthetic, and its emotional flatness, White argued, "*Speed Racer* kills cinema with its over-reliance on the latest special effects, flattening drama and comedy into stiff dialogue and blurry action sequences. It really is like watching the world's biggest HD television screen—not the visionary advance of Kubrick's *2001: A Space Odyssey*, Bertolucci's *The Conformist* or Altman's *McCabe & Mrs. Miller.*"[37] White's review essentially pits *Speed Racer* against "cinema values," suggesting that if the film turned out to be a box office success, then cinema itself will have been lost to so much Hollywood hype. By this logic, *Speed Racer* becomes just the latest example of digital effects taking us "from realism to digital unrealism" in its multilayered, candy-colored blending of human actors and digital animation. White goes on to blast the film for naïvely touting an anti-corporate narrative while using the film as the centerpiece of a vast entertainment-marketing machine. This role for summer blockbusters is, of course, widely known. Massive special effects films put enormous budgets at risk in order to create multiple

marketing streams that have, for some time now, been described in terms of "corporate synergy." However, as Thomas Elsaesser observes, the blockbuster "is not only a moneymaking but also a meaning-making machine."[38] By this logic, cyberthrillers and other blockbusters should be understood, at least in part, as attempts to define our relationship to cinema.

Even though *Speed Racer* turned out to be one of the biggest box office disasters of the summer of 2008, the role of digital effects spectacles in drawing audiences into theaters essentially remained unchallenged, perhaps suggesting that the film's other perceived flaws—its incoherent story and shallow characters—were primarily to blame for the film's box office failure and quick exit from theaters. In this sense, Dixon's nightmarish predictions about the future of cinema have largely come true; however, more recently, Dixon has pointed out that complaints about a reliance on hyperkinetic visuals miss a larger point about the digital reinvention of cinema, namely the ability of digital filmmakers to operate on the margin of film culture, where they can cheaply produce and distribute movies.[39] These new filmmakers often bypass the theater altogether, delivering films to an abundance of potential screens ranging from high-definition television sets to cell phones. Thus, while digital effects provide filmmakers with new tools for telling stories, the true reinvention of cinema is taking place on the margins, often outside of Hollywood, where innovative filmmakers seek new ways to distribute their work.

In *Dark City*, the computer graphics and morphing bring to light this new cinematic language in order to understand what it means to be human. The relationship between digital special effects and an aesthetic of astonishment persists in contemporary high-concept blockbusters. At the same time, *The Matrix*, *The Thirteenth Floor*, and *Dark City* point to the ways in which digital effects became the subject of many Hollywood blockbusters, particularly through the genre of the 1990s cyberthriller. Not content merely to be astonished by the digital spectacle, these films often positioned viewers as outside observers witnessing the transformation of cinema as we knew it. Perhaps more crucially, these films are caught up in what Mackenzie Wark acutely describes as the production of "cyberhype," which he diagnosed as the central organizing principle behind *Wired* magazine, where cyberthrillers such as *Dark City*, *The Matrix*, and *Minority Report* were frequently promoted. In this sense, cyberhype becomes little more than "the swanky image of nothing but the promise of even niftier images."[40] Thus the use of digital effects, in many ways, just extends the business-as-usual

practices of Hollywood studios seeking to promote high-concept films. Further, as Spielberg's comments on digital film production indicate, the use of digital effects also pointed to other futuristic alterations in the film medium. While Spielberg professed a strong preference for film projection and the play of light that make it appear as if "the screen is alive," these digital effects only pointed to the ways in which the distribution, exhibition, and production of movies were being reimagined, especially as movie studios saw digital projection as a cheaper and more flexible alternative to film.

3

WALL-TO-WALL COLOR
Moviegoing in the Age of Digital Projection

During the March 2006 Academy Awards broadcast, Oscar nominee Jake Gyllenhaal offered what seemed like an innocuous introduction to one of the show's notorious film montages, commenting that "there's no place to see [movies] but the big screen." The montage featured epic scenes from widescreen masterpieces such as *Ben-Hur* and *2001*, in order to remind viewers of cinema's ability to present scenes of vast scope and scale. Because 2005 had been widely recognized as a difficult year financially for the film industry, Gyllenhaal's remarks amounted to a desperate attempt to lure audiences away from their home systems and back into movie theaters, or, more likely, to discourage younger audience members from pirating movies. Of course, these carefully scripted comments, which were directed less at the audience attending the Oscars than the audience watching at home on television, were undercut by the fact that those viewers were watching the Oscar telecast on the very home theater systems that were now seen as the latest rivals for movie theaters. And while 2005's low box office has proved to be a slight aberration, as the sequel-laden summers of 2007 and 2008 illustrated, the image of imperiled movie theaters continues to shape discourse about contemporary screen culture. As I argued in the chapter on DVDs, Hollywood films often depicted these home theater systems as promoting social isolation and encouraging the fragmentation of the movie audience. The emphasis on Hollywood epics also invokes the aesthetics of watching on a big screen, the desire to be over-

whelmed by the cinematic image, something that watching films on home systems or, especially, on personal computers could not match.

Gyllenhaal's comments were caught up in a larger debate about the transition from film projection to digital projection in theaters. Long anticipated as a means of making movie distribution simpler, faster, and cheaper, digital projection finally seemed like a viable alternative to film projection at the very moment when studios worried that audiences were abandoning the multiplexes for other entertainment options. In order to combat fears about anticipated declines in theatrical attendance, digital projection has been presented, at least in part, as a means of offering moviegoers newer and better experiences. If digital effects were marketed via what Mackenzie Wark refers to as a cyberhype that would produce "niftier" images, digital projection was marketed both in terms of providing images that were better in quality than celluloid and more capable of offering new modes of storytelling, including 3-D movies and interactive narratives. At the same time, digital projection was promoted as means of making movie distribution more flexible. Instead of being tied down to the weighty materiality of film canisters, digital copies of movies could be transported much more easily across greater distances; some critics and filmmakers, however, feared that this transition would come at the price of potentially ushering in the end of cinema itself, or at the very least the end of the social role of movies.

This chapter focuses on arguments about the transition to digital projection and the related discussions of the rise of portable media technologies such as the video iPod in order to trace out how narratives of decline or transformation formed around these technologies. In many cases, these accounts go as far as imagining the end of cinema itself. Proponents of digital projection also relied upon a number of myths associated with cyberspace in general and digital cinema in particular. While many critics worried that digital cinema could never match the richness in color associated with film, new media entrepreneurs touted the ability of digital cinema projectors to provide an image that would never degrade or that film projection could never match, especially when it came to such revived novelties as 3-D. More important, promoters of digital cinema have emphasized the possibility that digital projection would also lead to an increased diversity for audiences because the costs of delivering a digital file would be far cheaper than converting to a film print. At the same time, digital cinema was touted as providing theaters and their audiences with greater flexibility in choosing the movies they wanted to see. Meanwhile, portable media allowed consumers to download and watch movies wherever they

wanted, leading to the mantra of "anything, anytime, anywhere," commonly associated with convergence culture and leading a number of film critics to worry about a "platform agnostic" younger generation that would lead to the demise of cinema. While these fantasies—or nightmares—about the eclipse of the cinematic century are enticing, they also reflect an almost willful historical amnesia: similar pronouncements about film arose at the dawn of television, cable, and the VCR, all of which were supposed to put an end to moviegoing because of the convenience of watching movies at home and the potential dangers of going out.

BIG SCREEN NOSTALGIA

In case audiences missed Jake Gyllenhaal's scripted Oscar remarks in 2006 promoting the visual pleasures of moviegoing, at the March 2008 Academy Awards host Jon Stewart performed a skit in which he pretended to be distracted from his hosting duties because he was watching a movie on his iPhone. Stewart's movie of choice, David Lean's epic blockbuster *Lawrence of Arabia*, was obviously intended to provoke some of the same sentiments expressed in Gyllenhaal's remarks a couple of years earlier. Stewart went on to satirize the practice of watching movies on portable media by turning the device, one of the new iPod Touches, on its side, so that the film image itself would flip, more closely matching the aspect ratio, if not the size of the original, while commenting: "To really appreciate it, you have to watch it in widescreen." While Stewart's comments might easily be read as an ironic form of product placement, appealing to Stewart's hip and wired young demographic, the distinction between seeing Lean's film on a giant theater screen and on the tiny three-inch iPod screen was hard to miss. It is worth noting that the reference to watching movies on widescreen was also a tacit acknowledgment that viewers had, in fact, been conditioned to understand widescreen's appeal from years of watching movies on DVD and widescreen TV sets at home, and yet Stewart's comments evoked the fear that the genuine widescreen experience was in danger of being lost, and along with it, the profits associated with theatrical box office. In this sense, the comments by Stewart and Gyllenhaal were expressions of a wider strategy described by John T. Caldwell of " 'disciplining' potentially disruptive new media technologies that threaten established revenue streams."[1] Of course, even while Stewart depicted the video iPod as an unsatisfying alternative to the big screen, Hollywood studios were scrambling to figure out how to profit from these tiny, often personalized screens.

In addition to the promotional discourse associated with the Oscars, a number of films and film critics mourned what seemed like the lost public ritual of moviegoing. This nostalgia for an earlier era of moviegoing was invoked in the 2007 "double-feature" *Grindhouse*, co-directed by two of Hollywood's most ardent genre revisionists, Quentin Tarantino and Robert Rodriguez. The film famously sought to reintroduce the grindhouse theater experiences of the 1970s to contemporary film audiences, faithfully re-creating grindhouse screenings complete with fake missing reels and the artificial scratches and pops associated with a film strip that has been projected too often. To complete the effect, Tarantino and Rodriguez added fake trailers and announcement reels with a 1970s aesthetic. Reviews of the film focused on its ability to evoke a specific moment in the history of moviegoing, an era that often becomes defined in terms of both the troubling materiality of celluloid and the public film cultures associated with grindhouse theaters. In "*Grindhouse* Aims to Resurrect Movies, Not Bury Them," Godfrey Cheshire, who famously predicted the "decay of cinema" in 1998, revisits that argument, explaining that "in effect, *Grindhouse* reminds us of what we've lost, are losing, are soon to lose— and it does so at the most *basic* of levels. Instead of recalling, say, the gorgeous palette and sensory perfection of a first-run David Lean epic, it gives us the blotches, splices, and glitches that signal the 'mortality' of any movie" (emphasis in the original).[2] As his title suggests, Cheshire's elegiac review mourns the transformed exhibition contexts signaled by the transition from film to digital projection, with the materiality of film supplanted by the apparently less satisfying digital production and projection techniques.

Similarly, John Patterson wistfully evokes the thrill of attending grindhouse movies in the 1970s and the controlled danger they offered, with Patterson explaining his taste for "the sordid, sticky-floored grindhouses" he associates with his teenage years.[3] In both cases, *Grindhouse*, with its double-feature format, fake trailers, trashy aesthetics, and artificially manufactured technical difficulties, evoked deeply felt expressions of nostalgia for a film culture irretrievably lost to digital technologies that appear distressingly sterile in comparison to film's decaying materiality. And while Tarantino's segment, "Death Proof," seemed to be trying to deconstruct the grindhouse genre with a postfeminist narrative of empowered stuntwomen fighting back against an abusive male stuntman, it also offered what amounted to a celebration of the materiality of film. In fact, its hour-long car chase scene is completely devoid of digital effects, underscoring Tarantino's preference for film over the abstraction of digital media. However, even while

Cheshire and Tarantino might have mourned what they perceived as the lost warmth of film, *Grindhouse*, perhaps unintentionally, proved that most audiences no longer made such distinctions. Instead, as Wheeler Winston Dixon, who had in the past mourned the death of the film medium, noted of the acceptance of digital cinema: "The majority of viewers—and I include many of the new generation of academics here—make no such distinction."[4]

As my examples suggest, these debates about digital projection are not just aesthetic debates but debates about the screen experience itself, about the public film cultures associated with the practices of moviegoing. This argument regarding the role of digital projection in redefining cinema is informed by Kevin J. Corbett's argument that the perseverance of moviegoing may be attributed to "industrial efforts to exploit the theater's symbolic value."[5] In other words, theaters remain important not merely because they serve as a "loss leader" for promoting the DVD version of Hollywood blockbusters—although that is no doubt an important task—but also because they serve to emphasize the importance of Hollywood films as part of a larger public culture, preserving moviegoing as "an important and symbolic social act."[6] Thus, despite continued perception of threats to moviegoing as a practice, such as television, home theater systems, and movie piracy, fans continue to attend movies, particularly when that movie is promoted as an "event" that must be experienced in a theater, while studios seek to exploit other forms of revenue. Many of these arguments came to shape the widespread public debates about digital projection as they began simmering in the late 1990s and came to the forefront in the years that followed. While digital projection may do little to change the basic architecture of the motion picture theater, in which a moving image is projected against a big screen in a darkened theater in front of a room full of strangers, these technological transformations provoked a larger debate about the future of cinema and of film's ongoing role in shaping contemporary film culture.

INDUSTRIAL DISCOURSE ON DIGITAL PROJECTION AND DISTRIBUTION

Debates about digital projection grew out of a larger shift in exhibition practices, as movie conglomerates sought to deal with an unstable market. While many exhibition histories imply that home entertainment systems and portable media offered the primary threat to movie theaters, the actual history is a bit more complicated. In his groundbreaking study of moviegoing in the 1990s, Charles Acland argues that

industry insiders began to recognize that the major theater chains had overexpanded significantly, especially with the shift toward megaplexes that often featured fourteen or more screens. In fact, as Acland points out, the decade of the 1990s saw a tremendous disparity between the increase in the number of new movie screens and the growth in theatrical attendance. Citing statistics provided by the National Association of Theater Owners (NATO), Acland explains that "from 1990 to 1999 attendance grew by 24 percent while the number of screens increased 56 percent."[7] In fact, by 2007, America had over 40,000 screens, an increase of one-third over a single decade. The larger number of screens also meant that each screen was watched by an average of one hundred people over the course of a single week, typically on weekend evenings, which meant that many screens went largely unwatched especially during the week, leading to some speculation about how these empty spaces, often housed in or near busy retail centers, could be used during off-hours.[8]

This led to significant financial struggles for a number of theater owners and, in turn, to a debate about the state of screen culture, one that has changed the ways in which the theatrical experience is understood. One version of this transformation included the move from film to digital projection, a shift that Acland identifies as a logical next step for media conglomerates seeking to streamline distribution and increase profits. As Acland argues, "This next 'solution' to exhibition involved the age-old dream of eliminating the frustratingly material element of film; the digital projection and delivery of motion pictures arose as the most hotly debated and anticipated developments of the late 1990s."[9] The costs of distributing a major studio film for a saturated release are often quite substantial. As Edward Jay Epstein observes, the average cost in 2003 of producing prints of a major studio release was $4.2 million, while films with a narrower distribution averaged $1.87 million, substantial totals given the overall costs of producing and promoting a film. At the same time, studios were required to staff distribution hubs across the world in order to manage the timely delivery of film prints, a task that could be significantly streamlined with digital projection.[10] However, while a number of studios eagerly embraced the reduced expenses that digital projection seemed to offer them, theater owners and film directors were less sanguine about the effects of digital distribution on the film medium. While the primary concern of the theaters was the cost of subsidizing the expensive projectors that would be needed to replace film projectors, this debate also centered on a number of questions about the discourses surrounding screen cultures, including

concerns about the decline in public film cultures that digital projection seems to predict.

Like many attempts to define cinema culture, debates about digital projection often raged within industry discourse, where its role in film culture was primarily defined. Spearheading this discourse were new media moguls such as Mark Cuban and Daniel Langlois, both of whom sought to define digital projection in terms that would give it transformative power, and the studios and theater owners who were negotiating the terms of digital conversion. Questions about digital projection were becoming even more insistent in December 2005 when Cuban, who announced that his Landmark Theatre chain would convert to digital projection, came under heavy criticism from cinephiles and other film industry observers. Cuban's comments came after a year in which box office dropped dramatically, producing a sense of crisis that permeated discussions of the movie industry. In a speech at the 2005 Digimart conference, Cuban enthusiastically asserted that his aggressive adaptation of digital projection had irritated industry insiders, which once again allowed him to frame himself as the revolutionary outsider bucking against a stagnant distribution system: "If you've been reading the Hollywood trades, we've been pissing off a lot of people and we like that."[11]

Of course, even while Cuban was championing Landmark's conversion to digital projection as a cutting-edge alternative to film, Hollywood studios were in the process of negotiating with theater owners on a transition strategy. Because of the expense involved in converting, especially for theaters heavily invested in film projectors, the transition to digital projection has been more difficult than Cuban suggests. While Cuban has been able to invest in digital projection equipment for his Landmark Theatre chain, the Hollywood studios and NATO have been engaged in an ongoing debate over how to move forward with digital projection. One of the primary reasons for the delay in converting to digital projection has been the battle over who would finance the installation of digital projection equipment in the 37,000 auditoriums in the United States alone. The negotiations began to resolve themselves in December 2005 when announcements from the major studios, including DreamWorks, Sony Pictures, Universal Pictures, Warner Brothers, and Twentieth Century Fox established a financial arrangement that would help underwrite the cost of converting to digital projection.[12] However, even as late as December 2006, NATO was still concerned about the role of Digital Cinema Initiatives (DCI), a joint venture of Disney, Fox, Paramount, Sony Pictures Entertainment, Universal, and Warner Bros. in establishing technical

specifications for digital projection. Among other issues, NATO president John Fithian expressed concern over the fact that the DCI technical specifications were encroaching upon the role of theaters in making decisions about theater design.[13] In addition, digital projection would prove to raise a number of thorny questions for both independent film producers, especially those who chose to continue shooting using film, and theater owners, who would face greater difficulties in investing in conversion to digital. As Edward Jay Epstein observed, digital conversion would also have to address concerns about antitrust violations by making sure not to exclude nondigital movies made by independent filmmakers.[14]

Of course, the biggest factor in impeding conversion was that theaters remained concerned about the potential that the transition to digital would be unnecessarily costly to movie theaters. Estimates of conversion costs have ranged from $75,000 to $150,000 per auditorium, a sizeable expense, especially for megaplexes with fourteen or more screens.[15] In order to help subsidize the costs of conversion, four major studios—Disney, Twentieth Century Fox, Paramount, and Universal—agreed to pay "virtual print fees" that the major theater chains themselves could use to pay back $1.1 billion in credit collectively negotiated by the three largest theater chains to pay for conversion, suggesting that both studios and theater owners had essentially embraced digital projection.[16] Once the financing was negotiated, digital projection began to look more or less inevitable, especially as studios and theaters began to promote it as a means of providing new forms of entertainment unavailable on film, although tightened credit in 2008 threatened to slow down the rate at which theater chains were able to undergo conversion.[17]

However, despite the well-documented enthusiasm for digital projection, the conversion process for independent and art house theaters was less clear. Because locally owned theaters typically have fewer screens than most multiplexes, the cost per screen of converting was much higher. There have been a number of attempts to help independent theaters make the conversion, including the non-profit Cinema Buying Group (CBG), which joined with NATO to help subsidize conversion costs for independents. Others, such as the digital cinema company Emerging Pictures, run by Fine Line executive Ira Deutchman, have worked on establishing a less costly "i-cinema" projection standard that would fall somewhere in between the DCI standard and DVD projection.[18] These more flexible standards would allow independent theaters some freedom to convert at a lower cost; however, digital projection may present unique burdens to independent

theaters that are forced to convert in order to remain viable in the age of digital cinema.

SELLING DIGITAL PROJECTION

Even though these debates generally played themselves out primarily between theater owners and studios over who would shoulder the costs of conversion, the industry also faced the challenge of selling digital projection to the moviegoing public. While many moviegoers likely notice little difference between film and digital projection systems, many theaters felt the need to ensure that the shift would be well received, especially among cinephiles who had been educated to prefer film. These tensions about digital projection were encapsulated in a pre-film advertisement that ran in Carmike Theaters in the summer of 2007 promoting their decision to convert to the DLP (Digital Light Processor) digital projection system designed by Texas Instruments. This transition is explicitly sold in language and imagery that is meant to identify the transition to digital as a sign of progress. The video reinforces the technological details described on the DLP web site, which reports that the DLP chip uses an array of up to two million mirrors, which in combination with a digital signal, a light source, and a projection lens, produces a digital image that can be reflected onto a screen. The three-chip system promoted in the Carmike Theaters advertisement, we are told, is capable of producing at least 35 trillion different colors, suggesting a palette that matches even the richest textures of film. In addition, the advertisement reminds us that the heavy film canisters that were so expensive and difficult to distribute would be replaced by satellite transmission or computer disk.[19] By placing DLP in this context of technological innovation, Carmike was able to position the company, much like Mark Cuban, as being on the cutting edge of technological innovation.

The promotional clip builds upon the technophilia often associated with digital technologies, celebrating the quality of the DLP image by comparison to the flaws commonly identified with the film medium. The video opens with an image of scratched and worn film leader, immediately invoking the frail materiality of the film medium, intentionally and lovingly reproduced in Tarantino and Rodriguez's *Grindhouse*. This is followed by a shot of the heavy, unwieldy film reel canisters being lugged into the projection room, again emphasizing the sheer bulk of the film medium against the "pure" information of the digital image, and perhaps unintentionally highlighting the fact that digital projectors would actually cut down on the number of projectionists needed to staff an average theater. From there, the advertisement

proceeds to show the scratches and "flaws" that appear on a film strip after it has been projected repeatedly using a simulated home movie clip, complete with the faded colors that suggest the image has aged, weathered beyond repair, while also using the cheaper aesthetics of home movies to make it appear that film itself is a less attractive medium. Against this "problem" of film's fragility, DLP establishes itself as a solution, promising better, longer-lasting color and sharper images. This promise is reinforced through person-on-the-street testimonies from Carmike customers who eagerly tout the strengths of the DLP image, with one enthusiastic patron raving that with DLP "the screen is alive," while others describe "wall-to-wall color," suggesting a complete immersion in the image, with the former comment unintentionally echoing Spielberg's nostalgic celebration of film's vividness versus what he regarded as the sterility of digital imagery.

But perhaps the most significant testimonial features a customer who proclaims that digital projection is to film as MP3s are to vinyl. Given the attempts to cast digital projection within a larger media history, this last testimonial seems, by far, the one most loaded with contradictions. As any audiophile will acknowledge, many collectors prefer the sound of vinyl to that of MP3s because the MP3 is a "lossy" compression format, in which information is tossed out to make the file smaller. Of course, vinyl records, like their celluloid counterparts, are also subject to deterioration over time, but many audio fans appreciate what they regard as the warmth of records over the sterility of MP3s or other digital audio formats. These audience testimonials seem designed to counter the frequently emphasized assertion that digital projection does not yet match the richness of film; however, they also position the everyday film fan as a technophile, conscious of the distinctions between film and digital projection, and position movie appreciation itself as being embedded in celebratory attitudes toward new technologies.

While digital projection is often discussed in terms of the aesthetic of the image, its biggest effect may be on the flexibility it offers theater owners in exhibiting movies. A poorly performing film could be quickly replaced or shuttled to a smaller theater in order to maximize profits within the theater. As Acland points out, discussion of digital projection has been taking place since the early 1990s, with a broadcast-style model utilizing high-definition television (HDTV) technologies representing one of the early alternatives. In addition, digital distribution obviates the expense of producing thousands of prints of blockbuster films, cutting distribution costs by thousands of dollars. It would also likely reduce the labor costs for theater owners, especially the laborious

task of splicing reels together and attaching trailers to the appropriate films. However, as Acland also observes, these claims must be regarded with some amount of skepticism, given that the consequences of conversion cannot be fully predicted in advance.[20] These questions of industry common sense often mask larger desires about changing the industry, naturalizing technological and social shifts that are far from natural or inevitable.

Digital projection has also led to a number of experiments in the presentation of the image, all of which are designed to promote digital cinema in terms of its potential for novelty. One such experiment is the revival of experiments in 3-D technology, which began to receive renewed attention in 2007, with popular blockbuster filmmakers ranging from James Cameron and Robert Zemeckis to Peter Jackson and Steven Spielberg experimenting with the format. In fact, the animation division of DreamWorks announced in March 2007 that they would produce all of their animated features exclusively in stereoscopic 3-D technology starting in 2009, with the first film, *Monsters vs. Aliens*, slated for a summer 2009 release. In addition to serving as an attraction that could bring larger audiences back into the theaters, 3-D offers a number of financial incentives for studios. In the context of expensive blockbusters, adding a third dimension would represent a minimal cost of only $5 million for features and $15 million for animated films, while likely drawing in much larger audiences than standard feature films, with some estimates suggesting that 3-D films can draw three times as many viewers as the same title projected in 2-D.[21] Perhaps more crucially for the studios, 3-D also serves as a counter to the problem of piracy. A projected 3-D film recorded by a video camera renders only blurry, two-dimensional images, while even the most expensive home theater systems would have difficulty matching the experience of watching a 3-D image on the big screen.

As most of the promotional articles touting digital 3-D are careful to point out, 3-D films were initially developed to attract audiences back into theaters in the 1950s. Studios sought to compete with television and, explains Robert Sklar, believed that novelty was the way to do it. The revival of 3-D in the early twenty-first century appears to follow the same logic. It is also well worth pointing out that the stereoscopic techniques used for 3-D had, in fact, been achieved well before their popularization in the 1950s, although the social and financial incentives came much later, as studios scrambled to get audiences back into theaters, often through the promise of a more fully immersive theatrical experience.[22] This desire for immersion, especially as it has been reimagined by proponents of digital 3-D, cannot be separated from

what Andre Bazin diagnosed as film's drive toward realism.[23] This new attempt at full immersion is one that is defined largely by digital cinema auteurs such as Zemeckis and Cameron and the media conglomerates themselves who are seeking to redefine the moviegoing experience, one that is often echoed in reviews that compare movies to rollercoaster rides and other amusements.

In this context, the discourses to sell digital 3-D have much in common with the promotion of alternate screening formats such as the IMAX system commonly associated with institutional sites such as science museums and, more recently, with amusement parks, placing the IMAX experience as something outside the everyday activity of moviegoing. The decision to locate IMAX theaters at these sites not only helps to condition how IMAX movies will be received but also determines the kinds of movies that are made by the company. As Charles Acland has carefully documented, the historical association between IMAX and museums began to loosen in the 1990s, as IMAX screens began appearing in other venues such as amusement parks, where the immersive experience could be used to provide the illusion of movement, as reflected in the creation of a number of "ride-films."[24] In addition, IMAX has presented a number of 3-D films for a number of years using both the cross-polarized system not unlike the 3-D films of the 1950s and, subsequently, an LCD system, a practice that remains deeply invested in the attempt to provide audiences with what Acland describes as "an illusion of material presence."[25] And IMAX continues to market itself primarily in terms of both technological innovation and immersive experience through such events as *U2 3D*, which was billed as "the first-ever live-action digital 3-D film."[26] In this sense, IMAX strives not only to provide the spatial immersion of a three-dimensional sensory experience but also something closer to temporal liveness as well, therefore moving closer to what Bazin saw as the ideal for cinema.

And yet, when I watch an IMAX film (or a 3-D film, for that matter), I am acutely aware of the fact that I am not only watching a movie, but also watching the technology that made that particular movie—and its attempt to produce a sense of full immersion into the world of the film—possible. I am, in essence, looking at the box rather than in the box. As Acland argues, "Unlike conventional cinema, it is impossible to forget you are watching IMAX technology."[27] In some sense, this is a product of IMAX's own processes of branding. As Acland points out, IMAX cameras frequently appear in the films, calling attention to the company's technological acuity but also bringing to the surface a self-reflexivity that deflects from the possibility of full immersion. A similar experience haunts most 3-D productions, whether due to the

invasive glasses spectators are required to wear or the visual clichés of swords thrusting directly at the viewer. As a result, digital 3-D, like IMAX, seems to reproduce the dialectic between immediacy and hyper-mediacy, as defined by Jay David Bolter and Richard Grusin.[28] As they point out, the development of new media technologies is invariably caught up in the desire for greater immediacy, for the illusion of pres-ence, and yet this desire to produce a sense of immersion is often con-fronted by our awareness of the constructedness of the artifice, an experience that Bolter and Grusin refer to as "hypermediacy."[29] While I am skeptical of Bolter and Grusin's suggestion that the primary goal of art is to achieve this sense of immersion, I share their sense that new technologies such as digital 3-D and the different variants of IMAX can often appear hypermediated, reminding us that we are, in fact, watch-ing a technology involved in the production of realism rather than something approximating an unmediated experience.

Much of the promotional discourse surrounding 3-D coalesced around the release of Zemeckis's *Beowulf* adaptation, emphasizing the idea that *Beowulf* and other 3-D movies had the potential to transform the medium of film. Such articles often reflected the tension between the ultimate goal of immediacy and the hypermediated quality of digi-tal 3-D, with most calling attention to the limitations of digital 3-D, such as the continued need for glasses to view the image properly. In a *Wired* article promoting *Beowulf* in particular and digital cinema in gen-eral, 3-D is rewritten from a 1950s visual novelty into a new opportu-nity for digital auteurs to entertain audiences. James Cameron evoked space-age motifs to describe 3-D as a "new frontier," while he described plans for his own live-action 3-D science fiction film as "*Titanic* in space." Others, such as Fox executive Jim Gianopoulos, sought to dram-atize the impact of 3-D: "It's a bigger quantum leap than talkies. Talkies were an evolution of the medium. This is a complete transformation of the medium."[30]

Like other promotional discourse, the *Wired* article evokes a rheto-ric of novelty and experimentation, promising that 3-D will provide not merely the visual gags commonly associated with it but even new storytelling techniques. The article also reinforces the commonly accepted narrative that such visual experimentation is necessary to pro-tect struggling theaters from alternative forms of entertainment such as home theater systems and portable media players. While an adaptation of *Beowulf* might seem like an odd choice for 3-D, the epic poem, famil-iar from many a high school and college literature course, in fact pro-vided a dramatic means for offering a new technology in the guise of an older, more established story, thereby using the politics of adaptation in order to dramatize the shift to a new mode of storytelling. Thus one of

the oldest stories in the English language becomes a means for visual auteurs such as Robert Zemeckis and screenwriter Neil Gaiman to display the immediacy of 3-D. A similar strategy seems to have motivated the first live-action feature film, a remake of *Journey to the Center of the Earth* (2008), itself an adaptation of Jules Verne's classic science fiction novel, one that could be used to illustrate the unique properties of 3-D through dramatic special effects. In both cases, 3-D projection seemed well suited to exploit the special effects imagery common to science fiction and fantasy films while also providing audiences with stories that were familiar, thereby making the transition into 3-D appear simultaneously novel and familiar.

The spectacular elements of 3-D were also exploited in a couple of concert documentaries, including *U2 3D*, which was billed as the first 3-D concert movie, and *Hannah Montana/Miley Cyrus: The Best of Both Worlds*, which was marketed toward the highly coveted pre-teenager demographic. The U2 concert film, in particular, seemed especially suited to exploiting the double sense of liveness associated with movies, especially given U2's association with visually spectacular concerts. Both concert films attracted unusually large audiences, with *U2 3D* grossing over eight million dollars domestically and *Hannah Montana* earning $65 million. In both cases, these concert films were billed in part as special events designed to draw audiences back into theaters, with theaters offering something that would have been unavailable for home theater system, and, in fact, the Hannah Montana film was able to capitalize on the scarcity of 3-D screens in order to create the illusion of an exclusive event.[31] In all cases, the major emphasis is on the ability of 3-D to provide a novel moviegoing experience, one welcomed by movie audiences and theater owners alike. As Jim Tharp, Paramount's president of distribution, argued, "Theater owners are excited by this technology because it not only provides a more special movie-going experience but also a meaningful growth opportunity as research suggests more people come to see 3D movies, and ticket pricing has more flexibility."[32] In this respect, 3-D was largely understood as a means of providing audiences with a special event, an added incentive to leave the privacy of their homes for movie theaters, a new form of spectacle that home entertainment systems could not match.

DIGITAL DILEMMAS: DIGITAL PROJECTION AND THE "DEATH OF CINEMA"

The development of digital projection and the resulting experiments with alternate screening formats have led some critics to view these

changes as ushering in the death of cinema. For these critics, cinema appears to be taking on the characteristics of broadcast television, losing its unique material properties and, potentially, its social role as a public ritual. These concerns played out to some extent in the nostalgic reviews of *Grindhouse*, but the most explicit cinematic homage to the death of film may be Bill Morrison's 2002 cinematic symphony *Decasia*. *Decasia* splices together decomposing film stock from the silent era, featuring images of coal miners seemingly being crushed by mold pressing down from the top of the film frame and shots of a boxer in the ring fighting against an empty void within the frame, beautifully evoking what D. N. Rodowick describes as an individual film's strip's "unique traces of destruction with a specific projection history."[33] This specific history, we are visually reminded, is in danger of being lost forever as digital copies come to replace film. As J. Hoberman observes, *Decasia* "is founded on the tension between the hard fact of film's stained, eroded, unstable surface and the fragile nature of that which was once photographically represented."[34] The film is impossible to watch without some awareness of the inherent fragility of the film medium and the knowledge that much of our collective film history has already been lost or is in danger of degrading. It also serves as a reminder that the ways in which we make and watch movies are changing irrevocably as well, transforming these eroding images into an elegy for modern cinema, and *Decasia* into the ultimate documentary of the death of film.

During the late 1990s, with cinema's centennial coinciding with the end of the millennium and the height of dotcom euphoria, there seemed to be an almost relentless desire to declare the death of cinema, or at least its decline into museums and archives, where only the most curious would encounter these artifacts of a lost past. These fears were articulated by film moguls, mass media journalists, and academic film critics alike, with Robert C. Allen summarizing this sentiment by suggesting that the 1990s were "Hollywood's last decade," while a popular anthology of essays proclaimed "the end of cinema as we know it."[35] Morrison's film seems consistent with the genre of film criticism that seems to foretell or anticipate the death of cinema. Articles anticipating the end of cinema have become a staple of popular film criticism, often appearing in the editorial pages of major newspapers or in alternative weeklies. Significantly, many of these essays use a predictive, anticipatory tone, describing things that have not yet happened but that appear to be an inevitable consequence of the looming digital utopia—or dystopia, as these film critics would have it. As Philip Rosen points out, these forecasts, whether from promoters or critics of digital utopias, often "designate a trajectory of desire."[36] Reading these articles about

digital cinema, it is not difficult to locate a reverse trajectory back into a desired positioning of the movie audience, one that resists many of the changes threatened or promised by digital media. While many of these changes are aesthetic, including the fear that televisual story-telling techniques will infect film, most have to do with the positioning of the audience itself.

Perhaps the most influential of these essays, Godfrey Cheshire's two-part series for the *New York Observer*, "The Decay of Film" and "The Death of Cinema," appeared in 1999, just as digital projection in the-aters seemed to loom on the immediate horizon. It was also a moment when major theater chains were struggling financially as a result of overexpansion during the early 1990s. Many of Cheshire's fears have not been realized, but his arguments about the decay of film as a medium have been revived by a number of popular film critics and cinephiles. He predicted that digital projection in theaters would be fully adopted by 2002 and that consequently movies themselves would be radically altered. Cheshire may have been too quick to anticipate digital projection, but the expense of distributing and manufacturing reels of film suggests that this change is inevitable.

Cheshire also speaks to larger debates about public film cultures and echoes many of the myths associated with digital cinema. Beyond worry-ing that digital cinema will replace film, he also articulates the concerns that the model of community associated with moviegoing would be lost if the technological and institutional frameworks associated with movie theaters is altered. Most important, Cheshire argues that digital projec-tion would contribute to further erosion between film and television, pro-ducing what might be considered a "broadcast model" of spectatorship, as theaters host "live" events such as sporting events, concerts, and even finales of popular television shows. This is a goal clearly shared by NATO,[37] and, indeed, theater owners and content providers have sought out new ways to use theaters for such events. For example, by 2006, a number of movie theaters provided live HD broadcasts from the Metropolitan Opera in theaters throughout North America, and by 2008, a number of theater owners broadcast live World Cup matches and hosted live video game competitions, suggesting that theaters were not only pro-viding public exhibition of television content but were also becoming vir-tual amusement parks as well.[38] Thus the connection between digital projection and a broadcast model carried with it a larger concern that a movie culture associated with film appreciation was in danger of dying, replaced by a more active, participatory audience.

Cheshire goes on to associate this broadcast model with unruly audience behavior, such as talking to the screen or using cell phones

during the movie. This behavior is frequently cited as a problem whenever studios are seeking a factor for explaining declining box office; however, theaters have always been the site of various forms of behavior that often get coded as disruptive. In fact, a NATO Talking Points memo identifies "rude audience behavior" as a potential impediment for some moviegoers, while encouraging local theater managers to create what they call "a culture of civility," in which moviegoers will automatically be disciplined into behaving appropriately.[39] These "rude" behaviors—text messaging during movies, cell phone use, and inappropriate talking—are most often associated with the teenage audience that, in fact, provides theaters with their most frequent customers. Barbara Klinger also discusses the habit of blaming audiences for low theatrical attendance, noting that "although critics have complained that the allegedly sloppy aesthetics of television watching, in which viewers talk and engage in otherwise distracting behavior, have invaded movie theaters, scholars such as Roy Rosenzweig and Janet Staiger have shown that theaters have always been the site of such misbehavior."[40] In fact, horror film audiences, in particular, are notorious for shouting back at the screen and engaging in precisely the unsanctioned activity described by Cheshire. In addition, such problems seem to disappear or go unnoticed during summers in which studios and theaters enjoy record-breaking profits, as they did during the summers of 2007 and 2008. What goes unquestioned in virtually all accounts of moviegoing is the social role that movie theaters play. In fact, NATO has been careful to emphasize the social aspects of moviegoing, as they did in a series of talking points issued for ShoWest 2008, an annual film industry conference, stating that "when people want to go out, they can't download their friends, spouses, kids or dates—they have to go out, and they go out to the movie theater."[41] While the NATO comments seem designed to pre-emptively ward off concerns about a potential industry decline, they also echo the concerns of Cheshire and other critics who emphasize the public ritual of moviegoing.

Following in Cheshire's footsteps, a number of popular critics and entertainment journalists have echoed Cheshire's claims about the collapse of the institution of cinema. These articles include Edward Jay Epstein's critique of Hollywood's business model in his book *The Big Picture* and described in a series of *Slate* magazine articles as "Hollywood's Death Spiral." Film critics David Denby and Joe Morgenstern and film historian Neal Gabler also wrote variations of this "death of cinema" article in 2006–07, responding for the most part to the box office slump of 2005.[42] Similarly, authors such as Chris

Anderson cite theatrical attendance in 2005 as evidence that audiences are bored of the limited selection available at theaters, choosing instead to consume entertainment at home or via portable media players.[43] All these essays depict the changes in screen culture as potentially revolutionary, changes that will lead to the "end of cinema as we know it," instead of identifying continuities between cinematic forms. What interests me about these articles is not their predictive power. In fact, Hollywood has proven remarkably resilient in its business practices, reinventing itself on multiple occasions over the course of the twentieth century, and while the projection technologies have changed, potentially leading to a number of aesthetic and even cultural shifts, the basic practice of watching movies in a darkened theater remains unchanged. Instead, what interests me is the persistence of this genre of popular film criticism. These claims quite often overlap with accounts of the sets of practices associated with watching movies, in particular the evolution of moviegoing as a practice. In particular, they seem invested in thinking about moviegoing as a public activity and concerned that digital projection will somehow alter the public film cultures that go to movie theaters.

These death-of-cinema articles often reinforce a number of unquestioned narratives about film culture that need to be interrogated more carefully. These articles typically start with the assumption that fewer people are going to movie theaters than in the past. This characterization of recent box office history needs to be carefully interrogated because quite often reports of declining box office are based on a highly selective reading of movie theater attendance. However, based on the perception that movie attendance is declining, a larger set of arguments about changes in movie culture typically unfold. First, these critics argue, the moviegoing experience itself has become degraded in large part because of technological changes such as digital projection and distribution, with digital projection in particular importing the behaviors of practices and behaviors of private television audiences into the public space of the movie theater. In other words, digital projection technologies will make moviegoing so much like watching television that cinema as an art form will lose its distinctiveness. Second, these articles more recently point to portable media players such as video iPods as further damaging cinematic aesthetics and, by extension, obviating the social role of movies by promoting a personal relationship to moving images. However, while portable media players have, in fact, become a widespread means by which younger audiences access entertainment, I argue that they can actually serve to promote moviegoing as an activity.

MOVIEGOING IN THE AGE OF DIGITAL PROJECTION

In a *Los Angeles Times* editorial, "The Movie Magic Is Gone," Hollywood historian Neal Gabler laments the decline of film culture, citing numbers that suggest a dramatic decline in movie attendance.[44] In particular, Gabler reports that "a recent Zogby survey found that 45% of American moviegoers had decreased their attendance over the last five years, with the highest percentage of that decrease in the coveted 18-to-24-year-old bracket." However, as Kristin Thompson points out, a March 6, 2007, *Variety* article by Ian Mohr paints a much different picture.[45] Mohr reports that international box office set a record of $16.33 billion while U.S. grosses rose 5.5 percent over 2005. Thompson correctly points out that perceptions of declining box office are often based on the fact that 2002 was an unusually good year for the Hollywood studios, due in large part to the release of films from four of Hollywood's major franchises: *Spider-Man, Harry Potter, The Lord of the Rings,* and *Star Wars*. Similarly, the summer of 2007 proved to be a record-breaking year for Hollywood, with North American summer box office totals exceeding $4 billion for the first time, and with attendance again driven by a number of high-profile sequels, including *Spider-Man 3, Shrek the Third, Pirates of the Caribbean: At World's End, Rush Hour 3, Ocean's Thirteen, Harry Potter and the Order of the Phoenix,* and *The Bourne Ultimatum*. The summer of 2008 also featured a number of easily marketable properties, including *Iron Man, Indiana Jones and the Kingdom of the Crystal Skull, Kung Fu Panda,* and *Batman: The Dark Knight*, as well as the film adaptation of the long-running TV series *Sex and the City*.

As Thompson points out, domestic movie attendance has remained at around 1.5 billion admissions annually since 1992, with a peak in 2002 of 1.64 billion in 2002, suggesting that attendance itself has remained reasonably stable.[46] In addition, according to a study released by the Motion Picture Association of America (MPAA), the average moviegoer saw 8.5 movies in 2007, a slight increase over the 8.0 movies in 1998, and the average person saw about six movies per year in 2007, numbers that have actually increased slightly since 1998.[47] It does seem significant, however, that audiences *perceive* themselves as attending fewer movies, as the Zogby poll suggests. Such a perception may be attributed to the bias of the question itself that asks audiences to self-report on their moviegoing habits. When participants are self-reporting about movie attendance, they may be more likely to echo the received narrative about declining North American box office attendance and read those narratives into their own practices, even if they have continued to see movies in theaters at a relatively consistent level.

This is not to suggest, however, that the location of the movie audience is not shifting. In fact, as John T. Caldwell observes, "less than 15 percent of feature revenues now comes from theatrical box office income."[48] However, these box office numbers do illustrate the degree to which narratives about media convergence leading to a decline in moviegoing are complicated.

Debates about the rise of home theater systems and the more recent transitions into digital projection have fed perceptions that behaviors associated with watching movies at home have contaminated public moviegoing. In "The Decay of Film," Cheshire describes the unruly audiences who "talk, hoot, flip the bird" at the screen and therefore disrupt the concentration required for serious film viewing or, more precisely, the absorption into the narrative world of the film.[49] Cheshire's claims about the unruly behavior of movie audiences were far from exceptional, and his comments seem to privilege one form of moviegoing, associated with rapt contemplation, over more active audiences that might "flip the bird" or shout back at the film's chief villain, for example. Cheshire's invocation of television here also brings with it all of the culturally laden baggage associated with television as a medium when compared to film.[50] Thus, behaviors that normally remain private come to affect public moviegoing.

Cheshire's comments are most significant in their more general fears about the televisualization of public space and the ostensible role of television in contributing to the decline of public culture. Cheshire implicitly associates television with private space while defining movie theaters as public spaces; however, as a number of critics, including Lynn Spigel and Anna McCarthy have shown, television since its inception has always participated in a complicated negotiation of public and private space. In *Ambient Television*, McCarthy points out that televisions are often identified with leisure time spaces such as bars and restaurants and waiting areas such as airports and doctors' offices, while Spigel has shown that televisions were initially seen as intrusions into the domestic space of the family home.[51] In particular, he imagines that theaters would cater to audience desires for "event" broadcasting of concerts or sporting events that would resemble "live" television broadcasts in a movie theater, and that networks might charge audience members $20 each for the pleasure of watching the final episode of a popular television series in theaters.

Cheshire was correct to anticipate that digital projection might allow for the possibility of special event screenings, as theaters have been used to show concerts and other live events; however, these uses remain the exception, and movie audiences are perpetually disciplined

into the "culture of civility" touted by NATO as a selling point of the movie experience.[52] In fact, audiences are consistently reminded not to engage in behaviors that will detract from this culture of civility through pre-show announcements reminding audiences to be quiet and to turn off cell phones and pagers. AMC theaters, for example, in conjunction with Best Buy, has produced a number of fake trailers, including one for "Soar," a fake animated feature parodying the conventions of Disney films such as *The Lion King*, in which an eagle fails to rescue another bird who has fallen helplessly into a volcano because he is distracted by a cell phone, dramatizing the degree to which cell phones and other unwanted noises can distract moviegoers. Similar announcements include action-adventure spoofs in which a cell phone sets off a nuclear bomb set to annihilate an entire city.

MOVIEGOING AND INTERACTIVITY

Digital projection has also introduced the possibility of interactivity, allowing viewers the possibility of becoming active agents in the manipulation of images. Philip Rosen defines interactivity as "a kind of exhibition in which a receiver is addressed as having some or all of the capacities of the sender or programmer."[53] This interactivity may entail choices about the direction of the narrative or, more broadly, the ability to program what films play at a given theater. In this sense, interactivity becomes tied to a number of digital cinema myths, including the promises of diversity, abundance, and choice, as well as the belief that digital cinema will produce new forms of community and participation, thereby democratizing movie theaters. Cheshire worries that digital projection may usher in a more participatory era of moviegoing in which audiences will become active programmers rather than passive viewers, through what he derisively calls "that newfangled *interactivity* you've heard so much about" (Cheshire's emphasis). Echoing Acland's identification of digital projection with a "broadcast" model, Cheshire imagines that theaters will feature interactive specials such as "Oprah's America," town halls involving a national audience. Thus far, this form of interactivity has not been widely used in theaters, although Robert Greenwald and MoveOn.org have made limited use of this town-hall approach through electronic town halls in which viewers at house parties across the United States call in to ask questions about a film. However, there is little evidence to suggest that the possibility of such interactive features will necessarily mean that they will be used. Simply because digital projection makes it possible to incorporate interactive features into theatrical films does not mean that such features will be

enthusiastically welcomed or that they will necessarily become a commonplace feature of movies. However, if the experiments with live video gaming competitions are any indication, it appears that some forms of interactivity may now start being felt in movie theaters.

While interactivity seems to have had little effect on theatrical screenings, it has become a feature of web-based movies and, in some cases, experimental screening venues such as museums. One version of this is the interactive movie *Mystery at Mansfield Manor*, in which the viewer, or player, is given the task of solving a murder at the mansion of an elderly oil mogul who plans to announce that he is editing his will at a dinner for family members, friends, and political connections.[54] The player, represented by a police detective, interacts with the characters, interrogating them about their actions on the night of the murder as well as seeking to determine a possible motive for committing the murder. As a narrative, *Mansfield Manor* recalls many of the challenges to traditional cinematic identification introduced by interactive cinema. As Lev Manovich points out, "The subject is forced to oscillate between the roles of viewer and user, shifting between perceiving and acting, between following the story and actively participating in it."[55] *Mansfield Manor* makes this oscillation explicit through the detective plot as we are invited to interrogate the suspects and observe their responses. However, these interrogations also expose the limitations of interactive cinema in that the "movie" proceeds through a series of menus, requiring the player to choose from a limited number of options, thus offering only a limited amount of open-endedness. Further, because *Mansfield Manor* is a web-based game designed primarily for consumption on a home computer, it allows little opportunity for negotiating audience interactions. The game is designed to be played and consumed in just a few hours—I solved the mystery in about ninety minutes—suggesting what is essentially a minimally interactive narrative, one in which the viewer cannot depart from the basic drive to solve the mystery.

In addition, the Mutable Cinema Interactive Engine presents an alternative model for interactive cinema, placing more emphasis on audience and viewing dynamics. Mutable Cinema bills itself as setting up a dynamic between the "player" who makes the choices and an audience that watches the film unfold, with these dynamics creating a "unique" experience every time the movie is played.[56] Instead of a closed narrative such as a detective plot, Mutable Cinema offers a number of combinatorial possibilities that place less emphasis on narrative closure, on "solving" the narrative, than on the interactions between the player, who makes storytelling decisions in real time, and the

audience watching the movie in a public space such as a gallery or theater. In addition to choosing between parallel storylines, the player is also given the opportunity to choose between multiple camera angles and even to scramble those storylines into a new narrative. While Mutable Cinema may prove to be primarily an experiment contained within the space of the museum or gallery, it also shows the potential for thinking about the ways in which interactive cinema could be used to reflect on the activity of moviegoing. In both cases, however, it appears that interactivity itself essentially has been discursively contained within carefully regulated models of narrative flow.

Often this notion of interactivity builds upon shared cinematic tastes and offers the promise of a larger film community in which a spectator can become a participant. In addition to using interactivity as a means of rethinking cinematic narrative, there have been some attempts to use digital projection technologies in order to create what might be described as a "theater-on-demand" system. Much like the digital utopian ideal of active participants collaborating in shaping the narrative, these uses build upon a desire for greater participation and choice in our entertainment options. In particular, Brazil's Rain Theater-on-Demand system has allowed moviegoers grouped in internet film clubs to make recommendations about what will play in theaters. Unlike the "live" interactivity suggested by narrative manipulation, the theater-on-demand system requires participants to decide in advance what films they would like to watch at their local theaters and when they would like to watch it, reinforcing the "anything, anytime, anywhere" promise associated with digital cinema. Building upon a network of 149 art-house screens operated by the Rain Network, a cinema-on-demand initiative called MovieMobz allows moviegoers to "program" their theater in much the same way that home viewers can watch movies on demand. The MovieMobz approach would also allow viewers to share wish lists with friends and to alert friends about which films and screenings they are planning to attend, placing emphasis on the social, public aspects of going out to the theater to see a movie.[57]

However, while the MovieMobz model seems to offer consumers much greater choice than they might have had in the past, the flexibility offered by digital projection also threatened to weaken the power of independent films even further. In fact, as early as 2002, many exhibitors warned that films that opened slowly would be forced out of theaters quickly by studios or theater owners looking to maximize the profits from a given screen, leading to increasing turnover in theaters and by extension relying even further on a blockbuster model to ensure that each screen was being watched by as many people as possible.[58]

However, the recognition that social networking tools could be used to build interest in seeing a film on the big screen inspired a number of independent moviemakers to use a mashup of Google Maps in order to identify the location of potential audiences for their film. In this technique, viewers place an arrow or mark pointing to their home address on a map on the web, and if a city shows enough interest, the film's producers will arrange a screening in a local theater or community center. The Google Maps mashup was used by Deborah Scranton to promote her documentary *The War Tapes*, and Susan Buice and Arin Crumley used a similar technique to set up screenings of *Four Eyed Monsters*. This technique can be particularly effective in visually illustrating interest in a film and even in reinforcing the sense of a larger film community with similar tastes and interests. In this sense, interactivity can be used to foster forms of localism that could provide welcome alternatives to more centralized forms of control, as well as providing independent filmmakers with new models for distributing their movies. It is no doubt the case that such interactivity also provides distributors with more flexible distribution alternatives that would allow them to discontinue underperforming screenings of some films in order to increase the number of screens dedicated to a more popular film. One potential result of this flexible scheduling could be that independent films, which often have much smaller marketing budgets than studio movies, might find themselves elbowed out because of the populist appeal of more commercial fare. However, the more pertinent point is that both of these techniques use the idea of the audience as programmers to emphasize digital cinema's potential in creating new forms of community. In this sense, rather than creating isolated viewers who are disconnected from each other, oblivious to the social pleasures of moviegoing, interactivity seeks to reinvent these social elements by formalizing networks of moviegoers with shared cinematic tastes.

VIDEO MOBILITY: VIDEO iPODS AND THE SHRINKING SCREEN

While a number of digital pessimists have expressed concern that digital projection in theaters could lead to the end of traditional models of moviegoing, the biggest concern has typically been the proliferation of portable media players, which seem to portend not only the end of cinematic aesthetics but also the end of the social activity of moviegoing itself. Just as the DVD player, video on-demand (VOD), and digital projection threaten to reconceptualize the medium of film, these tiny, mobile screens also challenge traditional assumptions about the

dynamics of movie watching. Moreover, portable video also raises important questions about the role of movies in negotiating public and private space, inspiring a number of critics to worry about the ways in which screening experiences will be reconfigured for younger audiences who are described as "platform agnostic," those who consume media in whatever format is available regardless of the quality or size of the image. Now, with these technologies, the screen itself becomes mobile, with individual spectators capable of watching their personal libraries of films, television shows, and videos wherever they wish, from crowded subway trains and treadmills at the gym to long checkout counters at the grocery store.[59] Thus, movies and other forms of entertainment become means to fill time in public spaces, to alleviate the boredom of waiting for time to pass, easing the potential discomfort of being alone in public. However, while the social role of portable media players may have appeared to have been ingrained into the technology's design, it is important to recall, as Judy Wajcman observes, that the meanings associated with a technology "are continually being negotiated and reinvented" by marketers as well as consumers.[60] Thus, as the portable media player increasingly becomes a routine, mundane technology, its meaning and its uses within a larger movie culture will continue to be renegotiated.

However, the most common claim is that portable video seemed to represent something of an alternative to the practice of going to the theater or reserving time for watching a movie, associating movie watching with convenience rather than with a leisure-time activity. The shrinking screen transforms our relationship to visual entertainment, so that, as Nicholas Rombes describes it, "it is the screen which is trapped by us."[61] Rombes' comments imply the degree to which cinema becomes personalized in these accounts of portable video, and those changes are explicitly tied to new relationships between media and social norms and expectations, presenting a number of challenges for social conventions as people learn to negotiate these technologies. At the same time, the smaller screen also seems to offer the promise of greater control over the selection and availability of images. However, unlike a number of critics who worried that portable media players—particularly Apple's video-enabled iPod—would eventually serve as a substitute for the activity of moviegoing, these devices have primarily served as supplements to moviegoing and can even redirect attention to the big screen, in part by serving as a means for disseminating trailers and other promotional materials associated with a film. If DVDs helped to set in motion the idea that film texts are forever incomplete, capable of being modified and developed into ever larger story worlds,

portable media players allow their users to access that world wherever and whenever it is convenient.

The popularity of portable media players reflects, in some ways, a potential deepening of the processes of mobile privatization described by Raymond Williams, a complex process based on two major tendencies: "on the one hand mobility, on the other hand the more apparently self-sufficient family home."[62] This process of mobile privatization has led, in part, to the built environment of suburban sprawl and the related phenomena of gated communities and home theater systems that place emphasis on safety from external threats, as well as the automobiles and endless parking lots that make such mobility possible. At the same time, privatized mobility also helped create the need for connectivity associated with the broadcast of information and entertainment, first on radio and later on television and then with access to the internet. However, portable media players offer the promise of perpetual, privatized entertainment, one that would seem to extend the possibility for further social isolation from a larger community. This desire is, of course, socially constructed. There is no inherent need for non-stop access to portable entertainment. Instead, as Dan Schiller suggests of mobile phones, "changing social relations comprise the crucible in which specific technological potentials are forged or allowed to fail."[63] In this sense, portable media players have succeeded in part because advertisers and marketers were able to link them up to desires for highly individualized forms of entertainment that are available anywhere and everywhere.

Of course, the small screens, usually no more than three or four inches, seem to work against the visual pleasure of becoming immersed in the visual spectacle that has been a commonplace feature of moviegoing for over a century. David Denby articulates this distaste for portable entertainment in the context of describing his inability to get comfortable while watching a feature film on his video iPod: "In a theatre, you *submit* to a screen; you want to be mastered by it, not struggle to get cozy with it."[64] Much like Jon Stewart and Godfrey Cheshire, Denby uses the example of the epic widescreen film *Lawrence of Arabia* to describe the clearly undesirable non-spectacle of Peter O'Toole and Omar Sharif riding camels traversing his thumb. In fact, the use of David Lean's desert epic as an example suggested an almost uncanny nostalgia not only for the widescreen experience itself but also for a certain era of moviegoing, one that predated the multiplexes of the 1970s and 1980s and the high-concept blockbusters associated with the era, privileging instead the epic films of Hollywood's golden age and the movie palaces of that period. Denby's distaste for portable entertainment

relies upon media dynamics that are not appropriate to the tiny screens of portable media players. Instead of emphasizing the forms of sensory and narrative immersion associated with film and television, respectively, portable entertainment may offer new models of attention more associated with distraction and with extending the narrative world of a movie or television show beyond the confines of the larger screens. Thus, while many critics have emphasized their dislike for watching television and movies on computer screens or on their mobile phones and video iPods, networks have devised more creative ways to make use of motion pictures in these contexts. The examples suggested by Denby—of epic and blockbuster films such as *Lawrence of Arabia* and *Pirates of the Caribbean*—seem to have been chosen precisely because they are the wrong kinds of content for these portable screens. Similarly, Ryan Stewart of the blog Cinematical describes the experience of watching a movie on his cell phone in undesirable terms, comparing the idea of watching on video iPods to "watching a movie on a Dick Tracy watch."[65] By comparing video iPods to the retro-futurism of *Dick Tracy* comics, Stewart is able to depict them as deluded technological fantasies that are essentially childish, caught in a young boy's dream of what movie watching might be like in a fantasy future. Thus, unlike the physical discomfort described by Denby, Stewart's comments reject portable video as a movie watching medium because it smacks of boyish gadgetry and a particularly obsolete—or at least retro—form at that.

While Denby and a number of other critics sought to illustrate the aesthetic shortcomings of watching movies on portable media players, the subtext of many of their arguments reflected an intergenerational hostility toward the Millennials, the generation born between roughly 1982 and 2003 and frequently characterized by their facility with new technologies.[66] Constructions of a generational zeitgeist often provide theoretical cover for analyzing larger social trends, yet discussions of Millennials and their supposed aversion to moviegoing coalesced around debates about the popularization of portable media players. In his July 12, 2007, "Beyond the Multiplex" column, Andrew O'Hehir questions the perceived "threat" to moviegoing represented by video iPods:

> If there's a specter that's haunting Indiewood and Hollywood alike, it's the shambling figure of some semi-shaved, post-collegiate 22-year-old watching movies on his cellphone. Now, I don't know anybody who has actually watched a feature film on a telephone, and I'm not even sure it's feasible. (The iPhone's ads show people watching film trailers and YouTube videos, not entire movies.)[67]

While O'Hehir's citation of *The Communist Manifesto* playfully dismisses critics' fears about a "revolution" led by cell phone-carrying tech geeks, his more crucial point is that the iPhone and video iPod are more compatible with shorter texts, not the full-length movies that Denby stubbornly struggles to watch. Instead, portable video becomes a means for media producers to promote films and television series that can be watched later at home or in theaters, while Denby and others read the technology in terms of generational fears about declining visual literacy. Similarly, as Karina Longworth points out, "The idea that we're all going to abandon the multiplex for the supermobile is nothing more than one generation's fantasy of another."[68] Longworth's "generation gap" argument is particularly useful in that she points out that many of these death-of-cinema articles express broad assumptions about younger generations of movie audiences. However, despite his confidence that "cell phone cinema" will not replace watching movies on bigger screens, O'Hehir essentially leaves unchallenged the assumption that a "big weird change is coming" in which audiences will no longer pay "to go sit in a dark room with some strangers."[69] As I have argued, movie theaters have retained a place of primary importance in distributing and, especially, in promoting films and a broader film culture, as evidenced by the relatively consistent box office numbers in recent years, and teenagers continue to identify theaters as an important part of social life. Thus, while some basic practices in how we encounter films may be changing, the ideological role of movie theaters as an important part of our public culture remains crucial.

This is not to suggest that Millennials have not been shaped by their encounters with technology. In fact, generational factors do inform the practices associated with media consumption. As Amanda Lotz points out, many of the distinctions that inform perceptions of media are not as entrenched for Millennials, most of whom grew up with cable television, carried cell phones provided by their parents, and were introduced to the internet at a fairly young age, although access to these technologies is partially determined by social class and other factors.[70] In this sense, Millennials not only appear to be technologically savvy but also more prepared to accept a media-saturated environment. This technological flexibility often leads cultural critics to define the younger generation as platform agnostic. In some sense, these comments reflect a misunderstanding of media convergence. As Henry Jenkins reminds us, "Convergence refers to a process, not an endpoint. There will be no single black box that controls the flow of media into our homes."[71] Or, I would add, into our back pockets. Instead, the multiple platforms carry with them different behaviors and assumptions

associated with the technology itself. While it would be possible for users to watch entire movies on their iPods, a more likely scenario would be the consumption of trailers or short promotional videos related to a larger media franchise, products of what *Wired* magazine referred to as "snack culture."[72] In this context, Bill Hague describes consumers who seek out platform-appropriate mobile content: "You want mobile content, something you can digest in less than five minutes. You can't just take the old content and repurpose it [*sic*], you've got to come up with something that plays to the qualities of the different platforms, which means huge opportunities for the production community."[73]

In fact, to see portable video as competing with or replacing the moviegoing experience—or even watching movies at home—considerably misunderstands how these technologies have been used. Instead, portable video should be understood as supplementing bigger screens both at home and in theaters, offering alternative means of access to media content. One of the more common uses of mobile video has been the production of short "minisodes" to promote TV series such as *Smallville* and *Doctor Who*. Twentieth Century Fox also used twelve one-minute episodes to promote Sacha Baron Cohen's mockumentary *Borat: Cultural Learnings of America for Make Benefit Glorious Nation of Kazakhstan,* using movie highlights and deleted scenes that might have normally been saved for the DVD.[74] These short features are meant to appeal to audiences who want to expand the narrative world of the show, to consume more content involving their favorite characters. While there is no doubt some pleasure in seeing the hapless "journalist" from Kazakhstan embark on additional adventures, the primary effect of such webisodes is to attract continued attention to the character and, by extension the film itself, which viewers would more often than not consume in theaters and eventually on cable or DVD. This practice seems to be reflected in industry research on media consumption. NATO has observed, for example, that moviegoers who own or subscribe to four or more home entertainment technologies are far more likely to be frequent moviegoers than those who do not, attending 10.5 movies per year, while those with fewer than four attend approximately seven movies per year in theaters.[75] In this sense, home entertainment technologies and moviegoing may in fact mutually reinforce each other, selling a deeper investment in the entertainment industry at every turn. Thus, it is far from clear that ownership of multiple home entertainment technologies will necessarily discourage theater attendance.

This new content clearly provides media conglomerates with yet another platform for promoting their content, but it also raises

questions about how these narratives will be consumed and how they fit within the larger story worlds of these franchises. Also in play is their status as "entertainment" versus "promotional" content, definitions that have important implications for how media workers are compensated. While the *Borat* episodes function primarily to promote Fox's movie, performers in these videos have argued that such work should be classified as entertainment, entitling them to get paid for the additional work. In fact, these webisodes were the subject of intense labor negotiations between Hollywood studios and the Writers Guild of America (WGA).[76] After the group's 1988 contract, in which the writers had negotiated for residuals that constituted only a tiny percentage of the grosses from the home video market (VHS and DVD), the WGA learned its lesson: in 2007 the group fought both for more substantial residuals for web content and for defining webisodes and other short videos as entertainment content rather than marketing material. While writers and other production personnel continue to labor in what John Thornton Caldwell refers to as "unruly workworlds,"[77] the WGA succeeded in cultivating sympathy with audiences who had grown accustomed to accessing content on the web. Through a series of videos posted to YouTube and on the United Hollywood blog, prominent actor-writers such as Tina Fey and the writers for *The Office* were able to demonstrate the importance of digital media, in part through their skillful exploitation of online video.[78] As Caldwell observed, unions were crucial to this fight over the definition of video content, adding that "only critical legal arguments from the unions—that these were syndicated end-uses, not just marketing—forced the networks to back away from the digital free-for-all."[79]

These portable screens also challenge cultural norms when it comes to discussions of the boundaries between public and private viewing experiences. As Dan Schiller observes, conventional popular press articles often complain about the ways in which "wireless is used to subvert conventional expectations."[80] Beyond merely altering moviegoing habits, portable media is frequently discussed in terms of the ways in which it alters—and even threatens—traditional social norms. This uncertainty about new media technologies altering social norms is not unusual. As Schiller points out, cell phone users provoked a reconsideration of deeply felt notions of social etiquette, with many observers complaining that cell phone users are "loud mouths, or that they make the rest of us into involuntary eavesdroppers."[81] Moreover, wireless technologies have also led to complaints about text-messaging teenagers who distract other spectators, driving NATO to emphasize policies that would curtail cell phone use in theaters, including

proposing the installation of cell phone jamming technologies in theaters as a potential solution to the problem.[82]

Similarly, portable video players appear to threaten to turn us into potential voyeurs, while also placing people who watch mobile video into a social bubble, isolating them from the surrounding world. If movie theaters offered a collective experience, then the video iPod seems to suggest highly individualized experiences, albeit in public spaces such as subway cars, grocery store lines, airports, or other locations where people are compelled to wait. In fact, the rise of portable video led to a number of articles about "laptop etiquette" on airplanes when passengers might be tempted to glance at what their seat neighbor is watching.[83] However, because many of these sites, especially doctor's offices and airport terminals, feature forced waiting and, in some cases, TVs that are all but impossible to ignore, the decision to tune out by watching personal content may be seen as a subtle form of resistance against the ubiquity of such content in public spaces.[84]

Typically handheld video technologies are seen as intruding into public space and making people more distracted and less capable of social interaction. Conservative commentator George Will, for example, offers an extreme version of this condition, worrying that the video iPod will contribute to a "social autism" in which bored youth become so caught up in their tiny screens that they "have no notion of propriety when in the presence of other people, because they are not actually in the presence of other people, even when they are in public."[85] Will's editorial essentially saw video iPods as perpetuating a trend away from an idealized culture of civility and implicitly attributes this lack of decorum to an incident in which several students were caught having sex in their school's auditorium. In this sense, Will links video iPods to a larger set of antisocial behavior that threatens social norms. A similar, if less panicked and moralistic, account comes from *Wall Street Journal* film critic Joe Morgenstern, who describes what he calls the "death knell . . . of theatrical exhibition as we know it": a young mother watching a movie on her iPod in a movie theater while her children happily watch the animated feature projected in the big screen. Leaving aside the fact that the mother was providing her children with the exact theatrical experience that Morgenstern claims is dying, the scene in the theater and a subsequent conversation with a sales clerk at an electronics store lead Morgenstern to conclude that "the digital revolution, having contaminated movies as a social experience, now provides the alternative of isolation."[86] Once again, generational divides dominate and the fear that new technologies will reshape social norms is projected onto

a fear of younger generations, in particular the much discussed Millennials.

In many ways, video iPods and other forms of mobile video seem to extend the logic of public space associated with the mobile phone, protecting pedestrians from having to interact with public space. In his discussion of mobile phone use, J. G. Ballard argues that its actual purpose "is to separate its users from the surrounding world and isolate them within the protective cocoon of an intimate electronic space. At the same time, phone users can discretely theatricalize themselves, using a body language that is an anthology of presentation techniques and offers to others a tantalizing glimpse of their private and intimate lives."[87] While mobile video technologies involve a different kind of performance, mobile video itself would seem to serve as a means of creating barriers that will inhibit interaction with others. It could allow people to retreat into their own mobile programming, theatricalizing his or her access to the latest hip technology in a performance of conspicuous consumption, as many people complained after Apple's introduction of the iPhone in the summer of 2007. In addition, as Amanda Lotz speculates, this performance may go beyond the public demonstration of access to the latest technologies and may even include the public demonstration of personal tastes in movies and television shows.[88]

Ballard's and Will's comments both echo the reductive lamentations of the role of television and other technologies in the decline in public life, with Will's "social autism" mapping neatly onto Ballard's "protective cocoon." In criticizing these technologies, both writers emphasize the ways in which they inhibit "genuine" social interaction. However, as Anna McCarthy points out, "a lot gets obscured when we move too quickly to demonize television as an agent of the cultural decline of public life."[89] In much the same way that Cheshire's aversion to the televisualization of public space betrays an anti-television bias, complaints about the video iPod are inseparable from wider fears about the encroachment of "private" media in public spaces. While McCarthy is primarily interested in television's social and institutional role in public space, her emphasis on site-specificity offers a useful way of complicating mere condemnation of the apparent televisualization or cinematization of public space, especially when that public space includes the movie theater. No matter what, portable media technologies have provoked a number of questions about the social and cultural implications of changing media use. At the same time, portable video further intensifies the incompleteness of the story worlds associated with motion pictures and television series. Blurring the boundaries between

promotional and entertainment content, webisodes call for a new language for thinking about the definition of a film text and for thinking about our relationship to this material.

These concerns have certainly informed the advertisement and marketing of technologies such as the video iPod, which took on an almost iconic status as the technology that was revolutionizing our relationship to entertainment. Seemingly in response to Denby's complaints about the absurdity of watching *Pirates of the Caribbean* on an iPod or Will's fears about video iPods destroying public space, a 2007 Apple advertisement, "Calamari," promoting their new iPhone sought to defuse the fears that such activities are both unpleasant and antisocial. The advertisement begins by imaging a scenario in which you are watching *Pirates of the Caribbean* on your iPhone and suddenly develop a craving for some seafood. With the iPhone, the advertisement suggests, you could stop the movie and use the iPhone's wireless connection to find the nearest seafood restaurant, which you could then call using the iPhone as a cell phone. Beyond depicting the iPhone as providing the solution for virtually any need you might imagine, the commercial imagines a hip, urban, sophisticated, and social consumer who is engaged with the latest Hollywood film and also ready to try the latest restaurant—a cinephile and a foodie. While the specific viewing conditions of watching a movie on a tiny cell phone screen are not addressed, the image of a giant squid attacking Johnny Depp's boat is enticing enough to provoke hunger, and the iPhone becomes not an instrument of isolation in the home but an instrument that allows the viewer to facilitate the activity of going out. Like most Apple products, the iPhone was very much wrapped up in Apple's savvy marketing techniques that make ownership of the product a necessity for people living on the cutting edge of new technologies. At the same time, the advertisement is careful to position the iPhone as something that facilitates social interaction, allaying the fears that mobile video will lead to a decline in social interaction.

CONCLUSION

In addition to reshaping moviegoing practices, digital projection and other new screen technologies have contributed to a reimagination of who counts as a movie distributor, altering especially the possibilities available to independent filmmakers. In this context, Gabler argues that digital media have also contributed to the dissolution of a vibrant, unified cinema culture, explaining that "when people prefer to identify themselves as members of ever-smaller cohorts—ethnic, political,

demographic, regional, religious—the movies can no longer be the art of the middle."[90] Gabler adds that the film industry contributes to this sense of cultural fragmentation by increasingly producing films designed for niche audiences, primarily to the younger viewers who are most likely to go to movie theaters, especially on opening weekend. Gabler also attributes this fragmentation to the internet, arguing that it is a "niche machine, dividing its users into tiny, self-defined categories"; however, he stops short of clearly defining what constitutes the "middle" that is being displaced by digital media. And given the ongoing popularity of major Hollywood blockbusters—at least if the continued record box office totals are any indication—viewers continue to share in the ritual of watching the latest new release with a large audience. Gabler's description of internet film cultures also underestimates the degree to which they can be used to facilitate further conversation about films and other media, and while the audience for most film blogs may be relatively limited, the ease of publishing a blog may in fact facilitate public conversations about cinema as an institution and its relationship to the political sphere. However, although Gabler's comments offer a bleak prognosis for the future of public film cultures, I argue instead that what might be called the era of "desktop distribution" has actually ushered in new models for the engaged film audiences that watch and discuss films in a variety of public and private contexts, even while providing new avenues for major media conglomerates to reach those same audiences.

4

DESKTOP PRODUCTIONS
Digital Distribution and Public Film Cultures

In 1998, just a few months before the release of *The Blair Witch Project*, Stefan Avalos and Lance Weiler's *The Last Broadcast* appeared on the festival circuit. It was billed as the first "desktop feature film," the first feature-length motion picture filmed, edited, and screened entirely with digital technologies.[1] Like *The Blair Witch Project*, *The Last Broadcast* is presented as a documentary of footage found after the producers of the film were killed. The filmmakers, a group of publicity-hungry young men with a cable-access show called *Fact or Fiction*, enter the woods in search of a local legend known as the Jersey Devil. The film consists of "found footage" left behind after their deaths and interviews conducted by the director of the documentary we are supposed to be watching. However, unlike *Blair Witch*, *Broadcast* functions less as a horror film and operates more as a satire of documentary filmmaking, specifically those self-righteous documentaries that focus on overturning court verdicts. Because Avalos and Weiler's film appeared a few months before *The Blair Witch Project*, many commentators focused on the narrative similarities; however, a more important relationship might be the ways in which both films successfully used new media to promote and distribute their films.

The story behind *The Blair Witch Project*'s wildly successful distribution is well known. The filmmakers created buzz through an innovative marketing campaign that included a Sci Fi Channel mockumentary that promoted the film and a number of web sites designed to create the

illusion that the murders depicted in the film were real. From this innovative web campaign, the film grossed over $140 million in U.S. box office alone before being followed by a somewhat less successful sequel. *The Last Broadcast*, on the other hand, quietly found an audience via self-distribution. After a brief theatrical run, *The Last Broadcast* expanded its audience significantly on video, receiving 350,000 rentals in its first thirty days at Hollywood Video and selling over 100,000 units via Weiler's DVD label. The film was also broadcast on HBO and IFC, bringing in additional revenue. Weiler reports that the film has grossed well over $3 million dollars, an impressive return on a $900 initial budget, and he has since self-distributed a second feature, *Head Trauma*, by choice. While Weiler's numbers may not equal those of *The Blair Witch Project*, he did not have to rely on a studio, even an independent one, such as Artisan, to distribute and promote the film. Weiler's experience has illustrated what many observers saw as the remarkable potential for do-it-yourself distribution in the digital age.[2] It also helps to promote a larger narrative that identifies digital media as a potentially utopian system that allows anyone the opportunity to become a successful filmmaker, one that has proven attractive for a number of new media enthusiasts such as Mark Pesce who, in a Digimart address, described "networked digital distribution" as a means of escaping gatekeepers such as Wal-Mart, whom he depicted as having a "stranglehold" on DVD sales.[3]

This chapter investigates a number of attempts to capitalize on using the internet in order to distribute and promote films. Digital distribution, because of the availability of unlimited bandwidth and increasing access to broadband internet, has been widely promoted as an alternative to a theatrical system that often excludes independent and do-it-yourself (DIY) filmmakers. This notion of unlimited bandwidth led Chris Anderson, editor-in-chief of *Wired* magazine, to map out the concept of the long tail, the idea that digital distributors, unconstrained by the limits of shelf space associated with bricks-and-mortar stores, could profit by selling even small numbers of obscure songs, movies, or books; in fact, he came to discover that 98 percent of the content in a digital catalog sells at least once a quarter, at little expense to the seller.[4] In this sense, discussions of digital distribution frequently relied upon the ideals of unlimited diversity of content and a level playing field for anyone who wanted to make a movie. At the same time, the perception that digital distribution could allow filmmakers to avoid the gatekeepers also led to the recognition that films with politically unpopular viewpoints could be distributed to niche audiences via the web. As a result, Anderson's concept became one of

the chief articulations of the myth of (infinite) abundance, allowing consumers to find and watch whatever they could imagine, while web-based retailers such as Rhapsody, Amazon, and Netflix could rake in immense profits. The language of diversity and abundance associated with independent digital distribution also informs the promotion of day-and-date releasing, as new media entrepreneurs such as Mark Cuban sought to find new avenues where they could distribute movies. This promotion of day-and-date met quite a bit of resistance, in large part because it threatened a model designed to protect movie theaters as a primary source of profit, as well as their place as a central site for the promotion of a larger public film culture. Finally, digital distribution often utilized or built upon social networking technologies such as MeetUp.com and Facebook in order to help movie fans find people with similar interests in their community. To be sure, these networking technologies could be used to facilitate the marketing of films and tele-vision series; however, digital distribution is rooted in a utopian impulse that recognizes the potential for sustaining a vibrant docu-mentary and independent film community.

LONG TAILS AND BROKEN GATES

This utopian fantasy of digital distribution has attracted further atten-tion with the advent of seemingly unlimited storage space that makes it possible to imagine the idea of a complete film library available at the click of a mouse. In fact, *New York Times* film critic A. O. Scott looked at the archival possibilities represented by the web and was led to argue: "It is now possible to imagine—to expect—that before too long the entire surviving history of movies will be open for browsing and sam-pling at the click of a mouse for a few PayPal dollars."[5] Scott's descrip-tion of universal archivability of and access to the entire history of cinema is consistent with the more general fantasy of doing away with the materiality of film and with the related desire to do away with any of the material constraints that might slow down the widest possible distribution of motion picture entertainment. Scott's comments obscure many important questions, including the expense of translat-ing films to a digital format and, more important, what counts as part of film history. In addition, it minimizes the inherent instability of dig-ital as a storage medium. In fact, Bob Fisher, citing an MPAA report, notes that "because of the degradation of signals and obsolescence of formats, digital media should be migrated every four to five years."[6] Thus, in much the same way that over half of the films produced before 1950 have been lost, it is equally likely that a significant portion of our

digital cinema library will be lost, whether due to unawareness or neglect or some other factor, making Scott's account of a complete digital library largely a theoretical fiction, albeit one that is rather enticing to consumers primed for unlimited choice.

It is precisely this fantasy of archivability and access that guides Chris Anderson's arguments about the future of distribution in *The Long Tail*, in which Anderson argues that with virtually unlimited storage space, digital distributors can make huge profits off of niche markets. This infinite bandwidth, Anderson goes on to add, results in the "shattering of the mainstream into a zillion different cultural shards."[7] In classic postmodern fashion, Anderson offers an enticing scenario in which this unlimited access also blurs the boundaries between independent and mainstream producers and high and low art, as consumers seek out whatever texts interest them, offering what amounts to an enticing model of media change in which more is inevitably better. Few scenarios illustrate Anderson's thesis more effectively than Henry Jenkins's anecdote about a discussion of anime in a north Georgia convenience store with a teenage cashier, a scenario that he described as a form of pop cosmopolitanism.[8]

However, while there is tremendous value in opening up distribution channels to a larger number of content creators, this shift from distribution models based on scarcity to models based on abundance has had complicated effects, particularly within the independent film industry, a situation that many industry insiders, including former Miramax executive Mark Gill, came to refer to as a "crisis."[9] Anderson's arguments tend to downplay the production costs of films, songs, and other media, and while Weiler's $900 budget suggests that self-financed and inexpensively produced films can turn a profit, the scale of his film's financial success is somewhat unusual. At the same time, this unlimited selection has led to a complicated scenario in which unlimited choice runs up against an incredibly crowded marketplace, as thousands of movies compete for the limited attention of consumers. In addition, the concept of the long tail downplays the role of theatrical distribution and other classical "gatekeeping" mechanisms in shaping the reception and marketing of movies. As filmmaker Jamie Stuart observes, a movie that receives even a brief theatrical run "is given a credibility that it would otherwise not have." While Stuart hastens to add that this perception will change as future audiences adjust to watching movies on multiple platforms, digital distribution has led to quite a bit of confusion, especially as independent filmmakers seek to navigate this crowded new terrain.[10] In this context, this chapter seeks to unpack a number of experiments in digital distribution undertaken

by various independent and DIY filmmakers. Because digital retailers are still in the process of perfecting video-on-demand downloads through home computers, I make little distinction here between the economics of what Anderson describes as "hybrid retailers" that use mail-order systems and services that deliver goods directly via the internet.[11] Nor do I differentiate between streaming video and digital downloads. While each approach certainly has consequences both for the filmmakers and for viewers, all these approaches are defined by broader narratives about the role of digital media in reinventing distribution. Instead, I am more interested in unpacking how the perception of unlimited digital distribution helped to support a number of other digital cinema tenets, namely the perception that it would democratize distribution and, in some cases, would even lead to active politicized movie audiences. This approach is informed by Janet Wasko's argument that instead of looking at the development of new technologies themselves, we should instead "look to the social setting in which these technological developments occur."[12] In this sense, the debates about new distribution technologies illustrate larger desires for enlightenment and choice, as well as access to a larger, potentially global film culture.

With the advent of digital media, filmmakers have increasingly turned to digital production and distribution techniques in order to find new audiences for their films. In some sense, this "choice" is largely out of necessity, given that approximately 13,000 films are screened at film festivals every year while only about 500 receive theatrical distribution of any form, creating a huge bottleneck that closes off theatrical to only a narrow sliver of films.[13] While self-distribution on the web offers an enticing means of addressing this dilemma, filmmakers have used the web not only to promote their film but also to shape the reception of it, as independent filmmakers begin to find new platforms that may place less emphasis on theatrical premieres.

BRAVE NEW FILMS HOUSE PARTIES

As filmmakers began to recognize the power of digital distribution techniques as a means of evading media gatekeepers, they experimented with various screening models in order to provoke political change. In perhaps the most successful of these experiments, Robert Greenwald's *Uncovered: The Whole Truth about the Iraq War*, a documentary about the Bush administration's use of cooked evidence to justify the war in Iraq, opened up a vibrant debate when it was first released in late November and early December 2003. At the time, many observers took note of its unusual distribution more than of the content of the film itself. Instead

of distributing the film to theaters where it might have found a limited, if enthusiastic, art house audience, Greenwald organized house parties using MoveOn.org, MeetUp.com, and other social networking sites, an approach designed to frame the film's reception by creating a public conversation about the film's chief arguments. Volunteers would offer to host screenings and would place messages on MeetUp.com in order to alert people in the community of a screening. Several days before the scheduled premiere, the hosts received a DVD copy of the film, which they would play on the night of the premiere. In order to create a kind of "imagined community" of viewers, Greenwald scheduled a teleconference for a specific time, which the various house parties could join, when Greenwald and other participants in the film would take questions from viewers across the United States. The result was a collection of alternative sites where groups could engage with perspectives on the war that were not being addressed adequately on television news and in major newspapers. In this sense, Greenwald's documentary was an important example of the possibilities of an alternative to centralized media outlets associated with what Yochai Benkler refers to as "the emergence of a networked information economy."[14]

Uncovered's significance is inseparable from the narratives about web-based politics circulating during the 2004 Democratic primaries, a cinematic analog to Howard Dean's populist presidential campaign. Indeed, the release strategy introduced important questions about how a networked film culture could be mobilized for political change. The marketing and distribution of the film, much informed by recent scholarship on the decline of public culture, sought to use house parties to create public events where progressives could gather and find community. At the same time, the house parties—and the related access to a distribution system operating outside of the mass media—allowed for the potential that people might have greater access to a diversity of viewpoints that could inform not only their voting choices but their everyday practices as citizens. As Benkler argues, a diversity of perspectives "gives individuals a significantly greater role in authoring their own lives, by enabling them to perceive a broader range of possibilities."[15]

One of the primary popular sources for this attempt to revive what appeared to be a declining public culture was Robert Putnam's *Bowling Alone: The Collapse and Revival of American Community*, in which Putnam asserted that participation in social and political activities, such as bowling leagues and political parties, has declined rapidly since a peak in the 1960s.[16] While Putnam expressed some skepticism about the emergence of the then-nascent virtual communities online, his book proved to be a major influence on the social networking site Meetup.com.[17] The idea

behind Meetup.com is that members could find other locals interested in similar activities—Wiccan groups were early adopters—and plan to meet at a specified time and place. The web site gained significant momentum during the Dean campaign and was ultimately adopted by Greenwald's Brave New Films, in conjunction with MoveOn.org, to facilitate "house parties" at homes, churches, and community centers where people could gather in small groups to watch the movie, offering an enticing model of collective activity. Thus, while online technologies were used to organize social interaction, the experience of watching was collective, with audience members gathering in public or semipublic spaces to watch and, presumably, discuss the film as a group.

It is crucial to point out that Putnam's account of the decline of public culture relies upon what Judy Wajcman refers to as "a nostalgia for an idealized past when people belonged to a harmonious community and spent time chatting with friends and neighbors."[18] Such accounts of lost community, echoed by new media pioneers Howard Rheingold and Manuel Castells, who sought to forge virtual communities, omit quite a bit, particularly when they identify the decline of community as beginning in the 1960s. In addition, there is certainly the risk that what Wajcman refers to as "virtual communities of choice" will only serve to reinforce cultural homogeneity and exclusivity because participants may seek out only those opinions that reinforce their own perspectives on the world.[19] The potential that networked digital distribution will only reproduce a series of mutually exclusive echo chambers is certainly high; however, Greenwald's house parties, at the very least, represent one alternative to the current centralized broadcast culture. In addition, through their attempts to provoke political conversation about significant issues—not only the war in Iraq but subsequently Wal-Mart's employment policies and Fox television news—Greenwald's Brave New Films does provide at least one alternative model for fostering a more engaged political culture.

Greenwald's "house party" model provided the basis on which many reviewers evaluated the film. Joshua Tanzer, in *OffOffOff*, an alternative New York magazine, summarizes the most common reactions to the film: "This is not just a documentary—it's a technological phenomenon that was never possible before. It's both a movie and a movement."[20] In a similar context, *Salon.com* writer Michelle Goldberg uses pop musician Moby's house party to model the degree to which the participants did not necessarily achieve consensus about the film's politics, noting that "views were far from uniform about the justice and justifications of the war."[21] She cites one partygoer who claimed to support the war for the humanitarian reasons of establishing a liberal

democracy in Iraq, echoing the arguments made by neoconservative war planners such as Paul Wolfowitz. These articles collaborate in the framing and marketing of the film, but what seems significant about them is the fact that the content of the film may be less relevant than the practice of distributing it online and the experience of watching it collectively in a semipublic space, one that would invite further conversation about Greenwald's arguments.

These reviews were responding in part to Greenwald's depiction of the documentary as oppositional not only to a compliant news media but also to a Hollywood studio system whose distribution models were too slow and clunky in the age of digital media. Rather than releasing the film to art-house theaters, which requires that a filmmaker negotiate with national theater chains and distributors, the producers distributed the film through progressive news sources and web sites including *The Nation*, the Center for American Progress, Alternet.org, and MoveOn.org. As Greenwald himself comments, this distribution process allowed him to release the film much more quickly, which in turn permitted him to make a documentary film that could incorporate even the most recent events. In fact, the documentary included news stories that were less than a month old, an incredibly swift turnaround for a documentary film, defining *Uncovered* less as a final object than as a means for disseminating information about the war in Iraq. Digital distribution also allowed Greenwald to bypass the time and expense of creating a film print. Of course, the house party model itself was crucial both to the film's wide distribution and to its definition as a cultural phenomenon, with Greenwald using the technology created by Meetup.com to screen the documentary simultaneously at over 2,600 locations, on December 7, 2003. These activities were widely noted in media accounts. In *Salon*, Goldberg compares these screenings to the release of a blockbuster film, observing that "2,600 screens is a huge release for an hour-long documentary. Hollywood blockbusters typically open on about 4,000 [screens]."[22] Goldberg's comment is somewhat misleading, because blockbusters play on those 4,000 screens four or five times a day over several weeks, often in packed theaters, while the house parties were a one-time event, but it is fair to say that Greenwald's distribution methods likely assured the film a much wider audience than it would have otherwise received through a more traditional route. In fact, as Mark Pesce argued, *Uncovered* helped to illustrate the viability of networked distribution models, selling over 100,000 copies in the first month of its release and making $1.5 million. While such sales figures may not compare to wide-release films, *Uncovered* also cost only $300,000 to produce, suggesting that some forms of niche distribution could be financially sustainable.[23]

The paratextual materials promoting *Uncovered* were crucial in shaping its reception, as the film itself models many of the principles of political dialogue. The film opens with a brief montage of its "experts," in which it touts the credibility of the film's interviewees. In a Buzzflash interview, Greenwald underlines the issue of credibility: "These people are willing to step forward and go public. Some of the people were in favor of the war—and yet the way the pre-war information was distorted by the Bush administration is of deep concern to these true patriotic Americans."[24] By having experts such as former ambassador Joseph Wilson and longtime CIA worker Ray McGovern outline their qualifications, Greenwald seeks to challenge the Bush administration's claims to expertise and to emphasize the ways in which dissenting voices were marginalized in the buildup to the war—a breakdown of the very deliberative practices modeled by the film's distribution and exhibition. In fact, the film oddly seemed to celebrate the intelligence community, creating a point of identification with the CIA and intelligence officials, who are depicted as having been betrayed by the Bush administration's willingness to isolate itself from dissenting opinions.

After the experts montage, *Uncovered* describes some of the more compelling deceptions associated with the war. Most specifically, Greenwald documents the shift in language from apocalyptic threats of weapons of mass destruction (WMD) to claims of evidence of WMD programs. These scenes portray Bush administration officials predicting catastrophe if Saddam Hussein is left in power, followed by intelligence officials deconstructing their arguments. In fact, the film's extensive use of associative editing between several press appearances by Bush administration officials underscores the degree to which opposing viewpoints were minimized. This sequence includes speeches and interviews in which Condoleezza Rice, Dick Cheney, Donald Rumsfeld, and George W. Bush repeat the talking point of a "smoking gun in the form of a mushroom cloud." Greenwald then edits together Bush administration officials repeating the same stock phrases, suggesting a seamless and consistent web of information they were disseminating through televised news conferences and interviews, a practice that Greenwald's Brave New Films continues to deploy in both feature-length documentaries and short videos posted online. In this sense, the film functions in part as a media critique, demonstrating the ways in which a compliant news media—particularly cable news networks such as Fox News and Sunday morning talk shows such as *Meet the Press*—participated in the buildup to war.[25] The film concludes with a section in which Greenwald asks his interviewees to offer their definitions of patriotism, a sequence that might be read as articulating Greenwald's political

vision of democratic participation. In this sequence, *Uncovered* seeks to redefine patriotism in terms of "taking the unpopular course," as one interviewee describes it, and being willing to criticize the government.

This emphasis on engaged political participation would come to inform Greenwald's subsequent documentaries, especially *Outfoxed: Rupert Murdoch's War on Journalism*, which depicts the ways in which Fox News deliberately skews news to favor conservative policies. While most viewers likely knew Fox News's reputation for conservative bias, the primary purpose of the documentary is to define the precise techniques that the channel uses in reinforcing a political point of view. In order to illustrate his arguments, Greenwald used secretly obtained memos that list the channel's talking points for a given day, as well as interviews with current and former Fox News employees who could testify to the channel's practices. Perhaps most effectively, Greenwald enlisted a group of volunteer monitors to track down and compile evidence of bias on Fox News, which he liberally cited in the movie under the doctrine of "fair use." While Greenwald's citations clearly had the transformative purpose of criticizing Fox News, what was unusual was the amount of quoted material he used in the film. In fact, as Robert S. Boynton argued in the pages of the *New York Times*, "nobody has ever made a critical documentary about a media company that uses as much footage without permission as Greenwald has, and the legal precedents governing the 'fair use' of such material, while theoretically strong, are not well established in case law."[26] Greenwald's pioneering attempts to push the limits of fair use represented a departure for many documentary filmmakers, who are necessarily cautious about facing lawsuits over the use of copyrighted material. In this sense, Greenwald not only has imagined new distribution systems but also challenged documentary production practices in his use of citations. After the house party screening of *Outfoxed*, Greenwald, in cooperation with Chris Brock, announced the launch of the media watchdog group, Media Matters, which asked audiences to report media distortions to a web site where they would be posted and opened up for discussion. In this sense, Greenwald and Brock sought to build upon the potential of this networked audience to monitor the mass media and to provide alternatives to it.

DRINKING THE THEATRICAL MILKSHAKE: MOVIE PIRACY

Greenwald's approach to networked digital distribution also stands in stark contrast to a studio system that is cracking down on digital movie piracy. In a *Boston Globe* article, Greenwald comments, "You have my permission to give it away. This film is meant to be a tool, so you will

take it and do with it as you will."[27] In fact, Greenwald later backed up this pledge when he made all the interviews from *Outfoxed* available via Bit Torrent and the Internet Archive, where individuals could use and remix them under a Creative Commons license without obtaining permission, even at the risk of having individuals create videos that convey opposing arguments.[28] As digital distribution was increasingly becoming a possibility, debates frequently focused on internet piracy, especially in a cultural moment in which the FCC, then headed by Michael Powell, was seeking to allow further consolidation of media ownership. These discussions of piracy continue to inform much of the discussion of digital cinema, to the point of shaping many of the decisions made about new technologies, including the selection of Blu-Ray as the new high-definition DVD format and the use of watermarks in digitally projected movies so that pirated copies of films could be traced back to specific screenings and specific times.

More often than not, debates about piracy are cast in terms that suggest a "war" over the control of media content, suggesting that this battle is as much ideological as it is technological, and piracy is invariably cited as a number one concern of the movie industry. In some sense, this ideological battle is pitched through press releases and articles that likely exaggerate the amount of money studios lose every year to digital piracy. In fact, in his comments at the 2008 ShoWest Convention, NATO president John Fithian devoted about one-third of his speech to piracy. Evoking one of the more quotable lines from Paul Thomas Anderson's *There Will Be Blood*, Fithian stated that "somebody else's straw is in our milkshake, and they're drinking it up. That straw is movie theft."[29] Fithian's comment depicts theater owners as the hapless victims, memorably represented in Anderson's film by the evangelist Eli Sunday, who is defeated by the ruthless capitalist Daniel Plainview, who has sucked Sunday's oil wells dry. The metaphor sets up what Fithian portrays as an epic battle against criminals who are profiting by stealing from the industry.

According to *PC World Magazine*, the MPAA reported $6.1 billion in annual piracy losses, positioning piracy as a significant threat to industry stability, although these estimates seem to vary widely, with Fithian reporting that theaters would have sold 100 million additional tickets in 2007 were it not for piracy.[30] In his discussion of illegal file-sharing, J. D. Lasica describes a Hollywood old guard hopelessly stuck in the past, aware perhaps that the game has changed but unprepared to do anything—other than making draconian but ultimately ineffective legal and technological efforts—to adjust. Significantly, as the subtitle of Lasica's book suggests, the "war" to combat piracy often targets the youth of the Millennial or "digital" generation. These attempts to cast

blame on teens and young adults led to the MPAA reporting that 44 percent of Hollywood's piracy losses could be attributed to file-sharing college campuses and using these numbers to seek legislation that would severely restrict file sharing on college campuses. While it later turned out that the MPAA numbers were greatly exaggerated—the MPAA later put the total at approximately 15 percent—the Hollywood argument relied upon a generational conflict that blamed unruly youth, who in fact remain some of the studios' most loyal customers.[31]

In addition, the MPAA and other organizations made use of public service announcements (PSAs) designed to educate audiences into recognizing the negative effects of piracy. In some of these PSAs, youth-oriented stars, such as Jack Black and Christopher Mintz-Plasse ("McLovin" in the teen hit *Superbad*), present mock lectures suggesting that piracy will take money out of their pockets. The McLovin PSA, directed by *Superbad*'s Judd Apatow, is especially instructive, with Mintz-Plasse playing a variation of his hyperactive, nerdy character and complaining that piracy is making him so broke that he can no longer engage in recreational drug use. In this sense, the video uses an (ironic) image of teenage rebellion in order to dissuade teens from downloading movies illegally. However, a more compelling set of PSAs sought to depict pirated copies as vastly inferior to DVD copies. In June 2007, the MPAA and the city of New York announced a plan to combat piracy that included a series of consumer-oriented PSAs depicting scenes from classic movies such as *Titanic* and *The Sixth Sense* being recorded by a camcorder in a theater.[32] In each case, the quality of the recording is poor, with scan lines detracting from the visual pleasure associated with both films, but what is most memorable about the videos is that they feature disruptive audience members coughing to drown out key dialogue or walking in front of the camera to block the image, precisely the unpleasant moviegoing experiences that the theaters themselves have fought against for years in their competition with home entertainment. The fake trailers conclude with green ratings bands with fictional ratings such as PS for "poor sound" and RO for "Ripped Off." In this sense, the PSAs present a highly contradictory message, one that educates against piracy but only by presenting the crowds at theaters as an unpleasant distraction that will detract from a viewer's enjoyment of a movie, precisely the opposite of the desired message of the advertisement.

"BUBBLE" AND DAY-AND-DATE RELEASING

While the house party model has been one of the most familiar approaches to digital distribution, Mark Cuban's day-and-date releasing

strategy represents one industry attempt to challenge standard traditional distribution models, placing further emphasis on the home as a primary screening site for movies. This distribution method is most commonly associated with Steven Soderbergh's release of his low-budget crime drama *Bubble*, which was released on the same day in theaters, on DVD, and on cable television. This distribution would effectively subvert the practice of protecting theaters with a six-month window between the theatrical premiere of a film and its release on DVD, although as a number of observers have noted, the window has contracted significantly since the mid-1990s when the DVD began to emerge as a marketable commodity. By July 2008, Cuban was even promising to release films on his HD-NET cable channel before releasing them in theaters, suggesting that the social experience would continue to attract audiences to theaters, even when the films had already played on TV.[33] Though *Bubble* was far from the first film to be distributed using day-and-date releasing, Soderbergh's star power as a director made the film an important test for thinking about how digital distribution models might work. In fact, as Janet Wasko points out, a number of pay-per-view services were launched in 1985, and cable companies and Hollywood studios alike have sought to capitalize on it as a potential distribution outlet, while media conglomerates have experimented with a variety of release patterns for home video.[34] The promotion of day-and-date placed emphasis on the idea of consumer choice, particularly for the adult audiences who represented the target audience for Soderbergh's film. Soderbergh followed this up in 2009 with *The Girlfriend Experience*, his second film as part of a six-movie deal with Todd Wagner and Mark Cuban's 2929 Entertainment designed to test the potential of day-and-date. While Greenwald offered one model of how to promote films on the basis of political participation, one of the most defining figures in debates over digital distribution and its effect on audiences has been Cuban, who has repeatedly spelled out his vision of a consumer-oriented media universe through his web site Blog Maverick, through participation in the Digimart Global Distribution Forum, and most crucially through the business practices of Cuban's media empire, which includes Landmark Art House Theatres, the HDNet cable channel, and his movie distribution company Magnolia Pictures. In fact, Cuban can—in some sense—be seen as an "author" of *Bubble* in that his promotion of the film shaped how it would be received and reviewed by audiences and critics alike.

Cuban, perhaps more than any other new media entrepreneur, has become a champion of digital media in transforming cinema, casting himself as a rebel fighting back against a system stuck in the past. But

while Cuban has clearly positioned his production and distribution techniques as resistant to the Hollywood system, he has also carved out a niche within the art house and independent market with Magnolia Pictures and Landmark Theatres, fulfilling art house distribution and exhibition tasks, respectively, in a fully vertically integrated system. In addition, he has characterized his art house audiences as politically engaged and eager to talk about movies after having watched them, modeling this practice for new audiences by including footage of question-and-answer sessions on the DVD of *Capturing the Friedmans*. Magnolia has also been involved in the distribution of other high-profile independent films and documentaries, including *No End in Sight, Control Room, Fay Grim, Jesus Camp, Keane, The War Within, Enron: The Smartest Guys in the Room*, and *Redacted*, many of which, like *Bubble*, received a day-and-date release and were promoted as films that would provoke discussion and debate, whether in theaters or at home. Cuban's focus on independent and documentary films illustrates that simultaneous release is more likely to benefit "smaller" films where the directors are simply struggling to make sure their films get seen, a conclusion confirmed by a panel at the 2008 Silverdocs documentary film festival, with independent producers Ira Deutchman and Steven Beer agreeing that it makes it more likely that their films will be seen, despite the fact that filmmakers may feel that their film has not received a proper theatrical release.[35]

Cuban's approach to distribution challenges a number of assumptions about the role of the six-month window in protecting theaters from competition with the home market. The six-month window was the compromise reached between Hollywood studios, theater owners, and video retailers after a series of experiments with windows of varying lengths, including as much as one to two years. As Frederick Wasser documents in *Veni, Vidi, Video*, studios were initially reticent about the home video market, worrying that it would cut into their profits. But as home video became an increasingly significant component of entertainment culture, studios experimented with various windows between the theatrical release date and the release of the movie on VHS. Twentieth Century Fox, for example, initially maintained a two-year window between release dates, but in 1981 experimented with a ten-week period for the Dolly Parton, Lily Tomlin, and Jane Fonda vehicle *Nine to Five*. This experiment was based on the argument that theatrical and home audiences were demographically different and that the video release would not harm ticket sales.[36] However, because theaters were still worried about losing business, the studios and theaters settled on a six-month window, which would allow theaters to hold on

to the competitive advantage of having exclusive access to motion pictures for several months, thus limiting competition between theaters and cable, VHS, and, eventually, DVD.

But as the DVD market has become increasingly lucrative, studios themselves have been considering alternatives to the six-month window, in part to take advantage of the press and marketing generated by the theatrical release. Edward Jay Epstein has traced these experiments with narrowing the window, noting that blockbusters released in July and August are typically released to DVD about four months after their theatrical debut in order to ensure they will be available for sale during the Christmas holiday.[37] In fact, according to statistics compiled by NATO, the average window between theatrical and video release has declined from five months and twenty-two days in 1997 to four months and fifteen days in 2007. That decrease is even more dramatic in the fourth quarter (October–December), with the window dropping from exactly six months in 1997 to four mouths and two days in 2007, suggesting again the relationship between DVDs and holiday merchandising.[38] Another frequently cited reason for collapsing the release-date window is piracy. In fact, Warren Lieberfarb, a former president of Warner Home Entertainment, asserted that in order to alleviate piracy, "the delay periods between theatrical, video, and video on demand need to be condensed even further."[39]

While movie theater owners have expressed caution about collapsing this window, there is some debate about its true impact on movie attendance. In his analysis of day-and-date, Boddy concludes that studio and exhibitor interests are likely "irreconcilable."[40] Such economic motives are typically masked in ideological approaches that nostalgically depict the social activities of moviegoing and the pleasures of seeing movies on the big screen. One such attempt to "sell" the moviegoing experience was a NATO memo released in December 2006 as a preemptive strike of sorts against Cuban's day-and-date release of *Bubble*. In the memo, NATO compiled a long list of quotations from studio executives and Hollywood directors, including Steven Spielberg, James Cameron, Jonathan Demme, and Walter Salles, all implicitly touting the preservation of the theatrical window, citing the theater as the crucial site where audiences should encounter films and defining moviegoing as a public ritual that would be diminished by simultaneous release. Spielberg, for example, is quoted as wishing to preserve "the social magic of going out to the movies, seeing it with a lot of people you have never met and sharing an experience." Similarly, Salles cites Fellini's comparison of a movie theater to a cathedral, implicitly transforming moviegoing into a religious ritual and linking moviegoing to a

larger myth of community and even transcendence, something that digital cinema seems poised to destroy.[41]

Theaters, of course, have led the charge against reducing the DVD window, but independent filmmakers have embraced the possibilities of releasing their movies simultaneously in multiple platforms. Significantly, few of the directors cited in the NATO compilation would be classified as independent, and the reasons cited by the directors and executives generally emphasize the excitement of moviegoing and industry profits. While some industry executives, including Sony Pictures Classics president Tom Bernard, have argued that collapsing the window would prevent independent films from building word-of-mouth momentum, the overall effect is less clear.[42] For indie filmmakers, DVD and video-on-demand (VOD) represent a virtual art house, a precursor to the "celestial jukebox" cited by Chris Anderson among many other new media enthusiasts that might allow them more opportunities to find a wider audience, in part by generating discussion through simultaneous theatrical, DVD, and VOD distribution. In this context, Joshua Sapan, president and CEO of Rainbow Media, observes that indie films may even "do better in the theaters if there is more buzz" as a result of simultaneous release.[43] As Sapan's comments suggest, indie films and documentaries may be more likely to generate interest as more people see and discuss them, and to some extent new indie films rely on the networked film audiences that watch—and discuss—the films they see. Like Cuban, the Independent Film Channel has participated in a variation of day-and-date releasing, agreeing to release twenty-four films simultaneously in theaters and on cable through their First Take Initiative, making the films available to as many as 40 million subscribers.[44] When it was first launched, the IFC plan made ten to fifteen independent and documentary films available at a cost of $6.95 per month for subscribers or $5.95 per film, less than the price of an individual movie ticket, but slightly more than the price of renting a video from a bricks-and-mortar video store such as Blockbuster. IFC's First Take purchased rights to a number of independent and foreign (non-U.S.) films, including those by notable indie and art house auteurs such as Ken Loach (*The Wind that Shakes the Barley*), Gus Van Sant (*Paranoid Park*), and Hou Hsiao-Hsien (*Flight of the Red Balloon*), as well as Mumblecore director Joe Swanberg's *Hannah Takes the Stairs*.[45]

Thus, while day-and-date appeared to threaten the sanctity of the theater, it also offered yet another means by which new media enthusiasts could depict digital cinema as offering audiences with a greater abundance and diversity of films, as well as more flexible means by which they could access these films. In promoting day-and-date,

Soderbergh and Cuban have emphasized the convenience of watching a film at home while arguing that audiences will still attend theatrical screenings in order to get out of the house, placing emphasis on consumer choice and convenience, concepts that must be understood as ideological, potentially shaping the role of movies in everyday life. Such promotions tend to reinforce an opposition between going out and staying in that sustain an artificial distinction between public and private, an opposition that must be complicated in the networked age, as I argued in my discussion of digital projection. While distribution strategies such as IFC First Take and Cuban's day-and-date releasing have made it much easier for people living outside urban centers to gain access to independent and foreign films, the emphasis on the convenience of watching movies at home takes movie watching from something associated with effort to something associated with domestic space. At the same time, these approaches underscored the challenges faced by an increasingly complicated distribution system, especially for independent films, one that led to a general consensus that the indie industry was in crisis.[46] There was some speculation that the IFC model of collapsing the window between release dates would potentially prove viable in sustaining some version of theatrical distribution, at least in major cities, while also allowing greater access on demand.[47]

NETFLIX AND HOME FILM CULTURES

In May 2008, responding to the many new forms of digital distribution of movies, the satirical news web site *The Onion* featured a video purporting to document a historical tour of a bricks-and-mortar Blockbuster video store. In the video, tourists pose with actors hired to play video store clerks, while other actors pretend to be customers sifting through the videos looking for a night's rental. Throughout the video, a number of tourists express astonishment at the fact that consumers had to drive "five miles" just to rent and then return a movie. Others are shocked that the store may not have a copy of a film available for rental. Another tourist, noting the Blockbuster's seemingly timeless décor, remarks that the historical tour is like "stepping into a time machine." The point of the video is hard to miss: in 2008, video stores now seem like an archaic artifact of a lost past, the bright blue and gold Blockbuster design a testament to an era of movie consumption that is irrevocably gone. At the same time, the video mocks Blockbuster's notoriously limited selections and its stores' strong bias toward new releases, while also parodying the faux nostalgia associated with historical tours. Still, the video is ultimately meant to remind us of

one of the more commonplace narratives of digital cinema in the age of the celestial jukebox: the fantasy of immediate access to the entirety of film history with no late fees.

In addition to day-and-date releasing, there have been other significant attempts to market to the home consumer using the promises of unrivaled diversity and access. Most prominent among these is the rise of Netflix as a DVD rental outlet, with the mail-order service in many ways displacing the stand-alone or bricks-and-mortar video store as a crucial access point for renting DVDs for home viewing. While it would be easy to see Netflix and other mail-order video services such as Blockbuster and GreenCine simply as a means of disseminating DVDs to the widest possible audience, these video services potentially alter how we watch movies and how we think about film culture.[48] Even though home video has been a primary means for audiences to encounter films for some time, Netflix would seem to intensify these domestic film cultures by allowing audiences to avoid the video store altogether. Instead of traveling to a video store, audiences create a "queue" of movies online, with the top movies in the queue being mailed out to the consumer, usually within a day or two after customers return their previous rental. By paying a monthly fee rather than paying per rental, consumers can watch a movie and return it at their convenience without worrying about the late fees associated with most free-standing video stores. In addition, the fact that there is no retail space allows the company to keep a much larger selection of DVDs at a single location than would be possible at a bricks-and-mortar video store, providing customers in rural and suburban neighborhoods virtually equal access to rare and obscure films that might only be found in specialty video stores, moving consumers closer to the dream of the celestial jukebox. The Netflix model was so successful that Blockbuster began emulating it with their own subscription service, eventually prompting the satirical *Onion* skit depicting the video store as a relic.

Yet even the mail-delivery service is in danger of appearing obsolete, as Netflix has made a number of its movies available as streaming video through its "Watch Now" player, further establishing ties between film viewing and the computer. Thus, instead of waiting several days for movies to circulate in the mail, customers can now watch a streaming video version of selected films on their computer screens. The initial audience for this venture was limited, however, because the Watch Now players worked only on PCs, played only on Internet Explorer, and required a high-speed internet connection, although by November 2008 Netflix had created a Watch Now player for Macs.[49] What's more, the conditions for watching films on a computer are not

ideal, as the individualized screen makes it difficult for more than a few people to comfortably watch at a given time. Thus the ultimate goal remains to transmit films from Netflix directly to the television set. This was finally realized in May 2008 with the development of a set-top box, initially sold for $99.99 and compatible with any Netflix plan that included unlimited viewing. Two months later, Netflix cemented a deal with the video game company Xbox that allowed customers to stream movies via their video game players.[50]

And yet, even with the various set-top boxes, movies are still delivered and selected via the internet, thus extending and deepening the connection between the internet and film culture more generally. Both the Watch Now player and the set-top box also emphasize immediacy, the ability to watch a movie whenever the mood strikes, rather than waiting two or three days for a movie to arrive, with the set-top box clearly following the basic logic of video-on-demand by offering immediate access to a choice of movies. This issue has led Barry Keith Grant to argue, "When we no longer need to go to the cinema because the cinema comes to us, then cinema loses whatever 'aura' it may have had."[51] Grant goes on, much like Cheshire, to note that access to movies at home has led to a diminishing of the theatrical experience, with people chatting during movies rather than becoming absorbed in the film, and suggests that while interest in cinema may have expanded, it comes at the loss of a certain experience of or attention to film itself. Of course, this lost aura also carries with it the potential to produce a wider participation in a networked film culture, where residents of a small city such as Fayetteville, North Carolina, can have access to a selection of videos that would have been unprecedented even a few years earlier. However, this fantasy of immediate access to the history of cinema is also complicated by another key factor. While Netflix has over 100,000 titles in its catalogue, it currently has the rights to stream only about 10,000 titles via its Watch Now player and set-top box, suggesting that true unlimited access remains on the horizon, a myth that informs critical discourse.[52]

The Watch Now player entered a market in which dozens of other competitors sought to compete for a position within the digital cinema and television distribution markets while also selling the wider public on these new modes of exhibition. While it would be impossible to cover all the models of digital film distribution here, there have been a number of alternatives to the Netflix subscription-based model. Perhaps the most significant has been an advertiser-based model used most prominently by the NBC Universal-News Corp joint venture, Hulu. Instead of paying a monthly subscription fee, viewers watch

television shows via the internet from networks and cable stations owned by NBC and Fox with brief commercial interruptions, a model that is also used by News Corp's social networking site MySpace. The commercial breaks are typically shorter than those on TV, running about fifteen seconds compared to a string of ads on TV that typically last two minutes. Local advertising is displaced in favor of national supporters, and the site runs using Flash software, which means that the user does not have to download additional software and can watch on any internet browser. Like many digital cinema and TV ventures, Hulu has marketed itself both in terms of convenience, promising to allow viewers to watch "when, where, and how you want," while also promoting it as a youthful alternative to the "old" medium of TV, to the point that Hulu came to represent an almost generational divide between passive viewership of TV and active engagement with Hulu. Indeed, even though Hulu's film content was relatively limited as of November 2008—a small number of films primarily from Fox, Universal, Sony, and MGM—the site had taken steps toward becoming an outlet for independent film by hosting *Crawford*, David Modigliani's documentary about the Texas town George W. Bush famously adopted as his hometown. Viewers could watch the film for free, with limited commercial interruption, and the film's comments section became an impromptu site for reviews of the film as well as reviews of the politics of the Bush era. Such uses were consistent with the site's attempts to promote itself as user-oriented, not only by encouraging comments, but also by allowing viewers to cut and paste segments from their favorite films and to share them with other users.

The Hulu model has been picked up by other services, including YouTube, which announced in November 2008 that it would offer a streaming feature-film service that would be supported by advertising revenue. Similarly, SnagFilms, which deals exclusively in documentary films, allows viewers to watch documentary shorts and features with relatively brief commercial interruptions. In addition to appealing to convenience, the site also promotes itself as a venture that supports the documentary and independent film industry, an extension of founder Ted Leonsis's much-discussed "filmanthropy" model in which methods of film distribution are meshed with the practices of philanthropy.[53] In this case, SnagFilms provides filmmakers with half the proceeds from the advertising revenue. Additionally, the site has sought to redefine the practice of video sharing in order to define potential viewers themselves as filmanthropists, as participants in fostering a more socially conscious film culture. This approach was promoted under a four-word mantra: "Find. Watch. Snag. Support."[54] By adding a widget to their

web site or blog, viewers were told they could "donate their pixels" to the films being shown and the causes the filmmakers supported. In addition to building upon existing social networks to show their films as widely as possible, the widget allows a user to click a link that will take him or her to the web site of charities supported by the film's director or producer. Thus, while SnagFilms draws from many of the digital utopian myths of content diversity and user participation, the site also illustrates how those utopian elements may be used to support a vision of social justice.

Although the fantasy of one-click delivery remains in its infancy, the Netflix player and, especially, Netflix's extensive film library did feed into the fantasy of near-immediate access to the entirety of film culture imagined by film critic A.O. Scott and new media entrepreneur Chris Anderson, who uses Netflix to illustrate his principle of the long tail. In fact, Anderson describes these changes in almost revolutionary terms, arguing that Netflix is "a remarkably democratizing force in a remarkably undemocratic industry."[55] In this sense, Netflix also offers an apparent solution to the longstanding division between urban and rural film cultures that often shaped access to certain films. Even in the age of the VCR, most chain video stores found in rural locations have less selection than video stores in university towns and major cities, a concept that Anderson refers to at various points as "the tyranny of locality" or "the tyranny of geography."[56] His comments serve as an important reminder that much of our discussion of screen cultures is shaped by the experiences of urban—and more recently suburban— cultures, a point vividly illustrated in Joan Hawkins's description of driving across the South Dakota plains and becoming acutely aware of the number of homes sporting satellite dishes.[57] Similarly, in my own experience, Netflix has been an indispensable service, especially in a town without a single independently owned video store.

While video stores require that movies be kept on display on shelves, taking up valuable storage space, Netflix makes it easier to distribute a wider selection of films to even the most remote locations, feeding Anderson's arguments that the future of business is the kind of niche marketing that allows Netflix to make a much larger inventory available to home consumers. To be sure, access is far from universal, and a number of media conglomerates have worked to direct and, in some cases, block the flow of digital images. These access issues have emerged most frequently with television networks, particularly in the United States. For example, the Sci Fi Channel series *Battlestar Galactica* produced a number of webisodes that fans from outside the United States could not access. While American fans were willing to help their

overseas partners by posting many of these webisodes on YouTube or other video sharing sites, the Sci Fi Channel's attempt to control access to the show led Australian media scholar Tama Leaver to write about "the tyranny of digital distance," thus pointing to one of the more significant limitations to this myth of universal access.[58]

This promise of cinematic diversity nevertheless remained one of the crucial selling points of the Netflix model, especially as it became one of the most commonly cited examples of Anderson's concept of the long tail, in which online retailers are able to provide deeper catalogues and, therefore, greater choice. This abundance of cinematic and televisual choices clearly seems to have affected the rental habits of subscribers. In *The Long Tail*, Anderson cites a speech by Netflix CEO Reed Hastings, in which Hastings argues that, in the past, 90 percent of Blockbuster's rentals were of new theatrical releases. Hastings notes that those numbers are slightly lower online, with 70 percent of rentals consisting of new movies, but for Netflix these numbers are virtually reversed, with 70 percent of what their customers rent coming from the back catalog.[59] Hastings is careful to point out not merely that Netflix offers a superior catalog or that their customer base is different from Blockbuster's. Instead, he is promoting the company's recommendation system that helps consumers to identify movies they would be most interested in seeing. The system works through a complicated algorithm that compares a customer's rentals and rankings—on a scale of one to five—against others with similar tastes. After a Netflix subscriber has ranked fifty or more films, the Netflix recommendation system is able to make remarkably accurate recommendations of other films he or she might like. In this sense, Netflix is able to help their customers negotiate what Barry Schwartz has described as the "paradox of choice," the frustration that many consumers face in response to having too many choices.[60] In promoting this recommendation system, Netflix often emphasized the fact that their most recommended film was the relatively obscure 1974 Francis Ford Coppola thriller *The Conversation*, a staple of "Introduction to Film" syllabi but not something that average video consumers would necessarily seek out on their own, thus implicitly advertising the idea that they were able to provide consumers with a more diverse and artistic slate of movies.

This emphasis on helping customers navigate the celestial jukebox can be understood, in part, in terms of the "Netflix Challenge," a contest sponsored by the company beginning in 2006 and running, according to the company's web site, until 2011, in which participants try to improve Netflix's recommendation algorithm by ten percent. The winning competitor would receive a one million dollar prize, while Netflix

would reap the benefits of the collective labor of the estimated 169 teams (as of 2008) who are, in essence, providing the company with a tremendous pool of volunteer labor (although competitors do retain ownership of any code they write for the contest). If no single winner is selected, Netflix would keep the cash prize. Not surprisingly, a *Wired* article romanticized the contest for pitting high-tech computer engineers against the likes of "just a guy in a garage," the pseudonym of one mysterious competitor. That moniker evokes the Radio Boys, the technological wizards of the 1920s who managed the contradictions of the era's cultural shifts in part by developing hobbies such as building wireless radio sets.[61] While the *Wired* account of the Netflix contest seems less specifically gendered, it does illustrate a desire for mastery over an abundance of movie choices. "Just a guy" turned out to be a retired British psychologist, adding to his allure as an outsider. But the contest itself, whether Netflix would be forced to part with the cash or not, helped to promote Netflix to *Wired* readers by selling the company's understanding of "crowdsourcing," the practice of mining collective intelligence in order to solve a problem such as the algorithm. At the same time, readers were consistently reminded of the video service's efforts to provide the best recommendations possible.[62]

In addition to shaping the temporality of video watching and the apparent abundance offered by digital distribution, online video services such as Netflix and GreenCine restructure the "public space" of the video store, moving the activity of finding video rentals out of the store and into the home. As a result, a number of critics have mourned the loss of the public film cultures associated with the local video store. Many accounts, in fact, describe, the "human touch" available in bricks-and-mortar video stores that are generally not found online, such as the friendships customers develop with knowledgeable clerks or the opportunity to meet neighbors.[63] Mark Glaser, among others, places emphasis on the tactile quality of picking up videotapes and DVDs for examination while walking the aisles, an experience that digital menus cannot replicate.[64] And yet another aspect to the lost sense of community reflected in the closure of local video stores, though rarely commented upon, is the inevitable loss of jobs that results.[65]

In some ways, the networked properties of Netflix and other video rental services are meant to compensate for this lost sense of localism and community. They do so in part by offering social networking tools such as the web site's friends program, where customers can link to and access their friends' queues and movie reviews. In addition, consumers can find the most popular film rentals in their zip code, adding another community-oriented tool for selecting movies or for seeing their tastes

reflected (or not reflected) in what others in their community are watching. All these options can inspire conversation about the films, and, in fact, the rental web sites often overlap with social networking sites such as Facebook, Spout.com, and MySpace, allowing friends to share their evaluations of films online. In this sense, Netflix represents one attempt to combine the new digital distribution technologies with social networking software in order to create virtual communities analogous to those Glaser and others have associated with bricks-and-mortar video stores. Thus, Netflix should be understood not only as promoting the fantasy of the celestial jukebox, of an abundance of entertainment choices, but also as promoting a related promise of community that is a crucial feature of digital cinema.

MUMBLECORE, "FOUR EYED MONSTERS," AND DIGITAL DISTRIBUTION

As I have argued throughout this chapter, digital film distribution is caught up in debates about the promises of unlimited choice and increased community that are potentially offered through social networking and other digital media tools. Brave New Films uses the house-party model to forge localized networks of politically engaged audiences, while other filmmakers have used the network to create more dispersed film audiences based less on geographic proximity than on shared cinematic tastes, a goal reflected in phenomena ranging from Mark Cuban's day-and-date strategies to Netflix's marketing techniques. Moreover, these modes of distribution have also been seen as providing new avenues for independent films to find audiences in an increasingly competitive environment through the promise of a diversity of choices that have historically been unavailable except in major cities and university towns. This new distribution has inspired a culture of DIY filmmakers, including a new indie movement known as Mumblecore (sometimes spelled Mumblecorps), featuring a group of loosely affiliated filmmakers including Andrew Bujalski, Mark and Jay Duplass, Joe Swanberg, Kris Williams, and Aaron Hillis. The term Mumblecore, coined by Bujalski's sound editor Eric Masunaga, describes the talky, often improvisational scripts that typically feature urban twentysomethings adjusting to the uncertainties of life after college. Mumblecore films are often characterized by their low-budget, homemade aesthetic and, more important, by their skillful use of social networking tools such as blogs and MySpace pages, in order to promote their films and to find wider audiences. While Mumblecore filmmakers constitute only the tip of a much larger iceberg of independent and DIY

filmmakers, they have often been used to promote a new, younger generation of filmmakers revolutionizing traditional production and distribution practices.

In fact, much of the publicity for Mumblecore filmmakers has focused on their status as a new post-Sundance generation of independents adept at using social networking technologies in order to sustain their outsider status. A ten-film Mumblecore series that played at New York's IFC Center, "The New Talkies: Generation D.I.Y.," reflected not only the do-it-yourself production practices and the filmmakers' membership in the so-called Generation Y, but also characterized the filmmakers as virtual revolutionaries, not unlike those who produced the "talkies" that radically changed cinema in the 1920s. Further, the DIY sensibility allows the filmmakers to define themselves against a previous generation of independent filmmakers associated with the Sundance Film Festival. During the 1980s and 1990s, Sundance was considered the primary outlet for budding filmmakers to get discovered and distributed. Yet with the exception of the Duplass Brothers and their film *The Puffy Chair*, Sundance has rejected the Mumblecore filmmakers. As a result, Mumblecore has portrayed itself as "more indie" than Sundance, which they define as too commercial and too unforgiving for the truly independent filmmaker.[66]

A number of film magazine articles sought to affiliate the movement with a range of past filmmakers, including those from 1970s and 1980s American indie cinema, as well as with filmmakers such as Albert Maysles, John Cassavetes, and Eric Rohmer—all known for films characterized by an observational style.[67] By distancing themselves from Sundance, the Mumblecore filmmakers were able to brand themselves more specifically in relationship to the South by Southwest Film Festival (SXSW), which came to be seen as more integrated with the do-it-yourself spirit of digital distribution, which served both Mumblecore filmmakers and the festival itself. In a glowing indie WIRE article, Matt Dentler, one of the organizers of SXSW, argued that Mumblecore reflected the festival's willingness to take programming risks with unknown but talented filmmakers. Like other critics, Dentler saw the emergence of Mumblecore as reflecting the rise of a new generation of filmmakers raised on social networking technologies.[68] However, the Mumblecore movement can best be understood as the articulation of a deeper desire for the return to authenticity that digital distribution seemed offer. Even though many of the Mumblecore films had significant distinctions, the branding of their collective represented both a form of rebellion against an earlier generation of "independent" filmmakers who were now perceived as overly commercial and an

expression of digital cinema's potential for presenting the distinct voices of a new generation of filmmakers.

Like many other cinematic movements, Mumblecore's most visible stars are young white male directors, raising questions about the true diversity of the movement, and many of its most prominent members have expressed concern that the label is reductive, obscuring aesthetic differences between them. Amy Taubin, for example, complains about "the homogeneity of the new crowd," while J. Hoberman wryly describes it as "demographically self-contained. Straight, white, middle class."[69] Taubin echoes a commonly held perception that the Mumblecore filmmakers, Swanberg in particular, tended toward self-absorption and the "lad culture" of men's fashion magazines, reading the movement largely as a brand. Despite this backlash, the success of the Mumblecore filmmakers in branding themselves became clear when "Mumblecore" was a finalist for Word of the Year, as selected by the New Oxford American Dictionary.[70] This helped to establish Mumblecore as one of the most recognizable examples used to illustrate the perception that cinema was being revolutionized in the era of digital convergence, not only in terms of its form but also its content. And the filmmakers all demonstrated a profound awareness of the potential of social networking technologies for promoting their films as well as for cultivating an online independent film culture.

The emphasis on digital distribution in many of the promotional articles often led to a seemingly contradictory depiction of Mumblecore as the unfiltered reflections of a new generation of filmmakers with a highly mediated sensibility, associated with social networking tools, web video, and other digital media technologies. In this sense, the films they produce implicitly and sometimes explicitly take on the changes associated with these new forms of communication, while also building an audience through the socially networked film audiences that are watching and discussing their films. Dennis Lim's fawning *New York Times* article, for example, characterized Mumblecore as having "a true 21st-century sensibility, reflective of MySpace-like social networks and the voyeurism and intimacy of YouTube."[71] Similarly, Dentler argued that these films have "the immediacy and audacity of Web 2.0. Because, much like the vloggers and bloggers gaining momentum around the globe, these were films coming without filters and directly from the source."[72] One of Swanberg's first films, *LOL*, the title of which refers to the instant-messaging shorthand for "laughing out loud," emphasizes the ways in which social communication is mediated by digital technologies, while the Duplass brothers' *The Puffy Chair* builds its premise from a misleading advertisement on the online auction site e-Bay.

In fact, in addition to making several acclaimed films, including the IFC First Take feature *Hannah Takes the Stairs*, Swanberg and Williams collaborated on the Nerve.com online series *Young American Bodies*, which features four-to-five minute episodes focusing on the sex lives of young adults living in Chicago.[73] In addition to providing an alternative site for Swanberg and Williams to find an audience, The Nerve series also promotes other work produced by the filmmakers. In this sense, the links between their online videos and their feature films suggest a kind of continuity rather than an artificial separation between media, reflecting that the principle of incompleteness, grounded in DVD culture, now extends to web video and digital distribution as well.

Much like the Mumblecore films, Susan Buice and Arin Crumley's *Four Eyed Monsters* became identified with the DIY culture associated with SXSW. Similar to many of the DIY films, *Four Eyed Monsters* is a movie that is very much about those communications technologies that mediate personal relationships while also making use of those technologies in the film's distribution. In fact, the film has become inseparable from the paratextual materials, the video podcasts, blogs, and social networking sites, that Buice and Crumley have used to promote the film. *Four Eyed Monsters*, a semi-autobiographical account of their dating relationship, focuses on Susan and Arin's decision not to speak directly to each other during the first few weeks of their relationship.[74] After meeting online, Susan and Arin concluded that early dating relationships are often characterized by misrepresentations and miscommunications and so chose to communicate via notes, letters, email, music, and art. While the movie uses many of the standard features of the romantic comedy, including dating scene montages and romantic music, it also serves to challenge the conventional romance movie through Buice and Crumley's attempts to avoid some of the clichés associated with those films and the expectations they create. As a result, their dating relationship, as depicted in the film, is mediated by their artwork, making *Four Eyed Monsters* a personal work that challenges the limits of autobiography, romantic comedy, and even documentary. In this sense, Susan's artwork becomes a crucial component of the film, creating what might be described as a self-consciously homemade aesthetic.

This documentary and autobiographical style comes across in the video podcasts they produced to promote *Four Eyed Monsters* when it did not initially receive theatrical distribution, while also illustrating this concept of a homemade aesthetic.[75] The film's official web site emphasizes their status as DIY filmmakers, with the homepage designed to resemble a page of notebook paper; in their podcasts, they

directly address the camera, underscoring the ways in which the film is a project rooted in their personal experiences. Most of these begin with Crumley and Buice posing behind an old radio microphone against a black background as they introduce the subject of the upcoming episode, emphasizing their personal contributions to the film and calling attention to the mediated quality of the podcasts. Foregrounding their status as independent filmmakers, they depict the challenges of making a feature film throughout the podcast series, with episodes focusing on their efforts to obtain financing, their guilt at borrowing money from family members, the challenges of getting into film festivals, and even the ways in which DIY filmmaking upsets traditional notions of authorship. In episode seven, "If You Give a Mouse a Cookie," Crumley and Buice depict the argument that unfolded when one of the collaborators sought credit as a "director" of the film. In the introduction to the episode they argue that "more and more, films and other creative projects are being made by ama-teurs who have no need to be mindful of the standard defined roles." Of course, their podcast actually serves as a way for them to regain control over the narrative by depicting the ways in which *Four Eyed Monsters* is their story, one for which they should get primary credit as directors, and illustrating the degree to which the roles of independ-ent and DIY productions remain tied to larger institutional and eco-nomic factors within cinema culture.

Because Buice and Crumley were unable to obtain a distribution deal, they decided instead to engage in a vigorous campaign to market their movie online with the video podcasts depicting the process of making the film. This helped *Four Eyed Monsters* gain a large cult fol-lowing on the web, but the couple remained thousands of dollars in debt from their production costs. Thus their experiences would seem to represent the classic cautionary story of independent cinema, that of filmmakers who took a huge financial risk only to fail to achieve the holy grail of distribution.[76] Their story turned out differently, however. In an effort to pay off their debts, Buice and Crumley became the first filmmakers to post an entire feature-length work on YouTube, simulta-neously striking a deal with the movie-based social networking site Spout.com. For a limited time during the summer of 2007, interested viewers could watch *Four Eyed Monsters* in its entirety. During a short segment that preceded the movie, viewers were asked to join Spout.com, with the web site donating one dollar toward paying off Buice and Crumley's credit card debt for every person who joined. While this distribution model may not represent a viable possibility for other independent filmmakers, Buice and Crumley managed to find a

much wider audience. As of September 2007, the YouTube version of their film had been viewed 820,000 times, a number that would have qualified the movie as a moderate indie "hit," although it is less clear how many of those viewers watched the film from beginning to end or to calculate how many visitors came back for repeat viewings. To be sure, those numbers are also skewed by the fact that the film was available online for free, and many people went to the page simply out of curiosity. Nevertheless, it does underscore some of the possibilities of networked distribution and illustrates alternative distribution strategies in which independent filmmakers can benefit by giving away their film for free.

Another successful DIY distribution technique was used by Hunter Weeks and Josh Caldwell for their documentary *10 MPH*. The film focuses on their cross-country trip from Seattle to Boston, which Caldwell completed on a Segway scooter. Having already attracted national attention for their cross-country odyssey, the filmmakers also decided to self-distribute, in their case through digital downloads directly from the film's web site. Using a model similar to the one used by the rock band Radiohead to distribute their album *In Rainbows*, Weeks and Caldwell allowed fans to download the film while paying whatever amount they deemed appropriate. Some buyers paid as little as ten cents, while others paid as much as $100, with Weeks estimating an average payment of about six dollars for 1,000 downloads.[77] The digital downloads also helped serve to promote DVD sales, both of which could be used to help fund future film projects. In this sense, Weeks and Caldwell, like other independent and documentary filmmakers, sought to use digital technologies to reinvent the processes of movie distribution. Following the lead of filmmakers such as Robert Greenwald, many of these independents recognized the role of social networking technologies not only in building a wider audience but also in cultivating a longer-term sense of community. Through the use of video podcasts and other supplemental features, these filmmakers not only expanded the notion of the film text itself but also used the network to build a community of goodwill around their films.

CONCLUSION

The experiences of these DIY filmmakers illustrate both the challenges and the possibilities faced by independent filmmakers in the era of digital distribution. While it would be inappropriate to suggest that digital distribution by itself is causing the flourishing of independent productions, digital media have expanded the sense of who can get involved in

making and distributing films, reviving the desires for success, participation, and community associated with digital media while also building upon the promises of abundance and diversity associated with the celestial jukebox. In an interview with *Cinematical Indie*, Arin Crumley points out that even with the networked audiences who have spread the word about *Four Eyed Monsters*, audience enthusiasm has not necessarily translated into financial stability.[78] Similarly, Mumblecore auteur Joe Swanberg acknowledged in 2007 that he still had to take on part-time work to subsidize his filmmaking career. However, Crumley and Buice remain in what might be described as the "cautiously utopian" camp with regard to the future of DIY production and distribution. This sensibility informs Crumley's account of what might be described as "one-click" distribution: "If there was a system that kind of mimicked what our world is capable of today—which is distribution worldwide everywhere from one click—then I think every content producer, large, small, independent, whatever, would all ultimately find the value in embracing that . . . even though it could be a little rough in the transition there."[79] Essentially, what Crumley imagines is one large democratic playing field of videos in which consumers would have an unlimited choice of films to watch through a combination of social networking and digital projection technologies. He goes on to add:

> Theoretically, you should be able to have a theatrical jukebox to where anything can be shown there. It's just a matter of, well, what do people want to see? Who knows, maybe they'll decide via text message two minutes before the movie starts. All kinds of crazy things could occur, and just like every other screen—our cellphones, our iPods, our televisions, our computers—we have taken over the surface of any screen we can get a hold of. The thing we have not been able to get, as audience members and human beings—we don't have any control over what's going on the movie screens. It's just whatever Hollywood pumps out for the most part. It's really about someone else deciding that this [is] what you have as an option.

Crumley's utopian vision of a theatrical jukebox takes us back to the problems raised by A. O. Scott's vision of a digital cinema library, one characterized by unlimited access to the full spectrum of film history. Moreover, Crumley depicts an alternative to a limiting Hollywood system that "pumps out" generic films which give audiences and filmmakers alike little to no choice. At the same time, Crumley's model offers an inviting approach for thinking about how networked film audiences can find new ways of watching movies. What seems significant about the theatrical jukebox as Crumley imagines it is that it is a distinctly social system, much like the socially networked film clubs of the Rain system in Brazil,

in which audiences decide via text messaging what they will see, sometimes minutes before the movie starts. In this sense, Crumley offers a rather optimistic version of the potential for interactivity and digital projection, a vision that he would later spell out more explicitly in collaboration with Lance Weiler and M. Dot Strange in their web distribution startup From Here to Awesome, which tutors filmmakers in pitching, promoting, producing, and distributing their films using digital and DIY approaches. A number of similar services have begun to cater to DIY filmmakers, including IndieFlix, B-side, and IndiePix, all of whom offer distribution services either on DVD or on the web. Similarly, Without a Box has extended its festival-submission service to indie distribution. Finally, MyMovieStudio has sought to build upon the crowdsourcing phenomenon by using social networking technologies to choose a film that should be made and then to raise money for the filmmakers. All these companies are involved in the reinvention of the distribution process and reflect a burgeoning desire for participation within a wider indie film culture.

While Crumley's model seeks to emphasize the role of social networking technologies in promoting films, what he does not explicitly address is the role of "buzz" in potentially sinking films, particular medium-budget indie films that have found themselves crowded out from above by Hollywood franchises and from below by the new DIY films. While crowdsourcing may very well help filmmakers build an audience, it can also shut down possibilities for others, particularly the middlebrow films that may depend upon a gradual, platformed release in order to manage expectations. These shifts have had particularly devastating implications for the major indie studios. As former Warner Independent and Miramax executive Mark Gill observed, "Fooling the audience is getting harder for the major studios in the age of blackberries, instant messaging, and cell phone texting. Good buzz spreads quickly, bad buzz even faster."[80] However, both Crumley and Gill are attentive to the ways in which socially networked film audiences have come to shape release patterns, where films play and for how long, and even the kinds of films that get made.

While Greenwald's house parties may offer a significant alternative to the isolated home viewer unable to connect with others who share politics, other forms of digital distribution, such as the Netflix Watch Now player, may take advantage of the social networks established online in order to promote an entirely consumerist model of networked film cultures, one that more strongly resembles what Dan Schiller has described as "a self-service vending machine of cultural commodities."[81] Although digital distribution no doubt provides greater access than ever to this vending machine model, it has also

provided independent filmmakers new forms of access to the means of production and distribution, while also opening up entrance points to film culture. Thus, instead of independent films being confined to city centers, DIY filmmakers can reach audiences in other locations. In addition to the role of social networks in using fan labor to promote Hollywood films, blogs and discussion boards can serve a far different and more liberating purpose. This potential has been cultivated in a larger film blog culture where a number of independent film bloggers have been able to sustain public, open-ended conversations about the movies they watch.

<div align="right">

5

</div>

TOPPLING THE GATES
Blogging as Networked Film Criticism

In July 2006, the *New York Times'* A.O. Scott wrote an unusually candid column on the role of film critics in the age of blogs. Observing the gap between reviewers' tastes and box office totals, Scott asked, "Are we out of touch with the audience? Why do we go sniffing after art where everyone else is looking for fun, and spoiling everybody's fun when it doesn't live up to our notion or art? What gives us the right to yell 'bomb' outside a crowded theater?"[1] Scott went on to note that tepid reviews of *The Da Vinci Code* and *Pirates of the Caribbean: Dead Man's Chest* failed to stem the tide of audiences eager to see those films, while many critically acclaimed films were unable to find an audience. The defensiveness of Scott's article directly addressed the perceptions that the print-based film critic was being challenged by a populist rebellion, a shift he connected in part to the apparent democratization of film criticism through blogs and other online forums where anyone can become a critic. Although Scott's comments reinforce a relatively standard opposition between the critical embrace of high art and fan enthusiasm over low culture, they also touch on the degree to which the film critic as arbiter of local or national film taste has appeared to be under siege. Columns on endangered film critics quickly became a staple of major daily newspapers and magazines.[2]

As if in response to Scott's column, digital media enthusiast Scott Kirsner celebrated what appeared to be the decline of an older generation of gatekeepers: "Roger Ebert may be endangered, *Entertainment*

Weekly on its way to extinction."[3] Kirsner utilized a predictive tone to characterize the emergence of blogs not only as inevitable but also as revolutionary, changing forever the landscape of film and media culture. Although Kirsner's comments obscured the ongoing financial crisis in the newspaper industry that has seen dozens of professional film and arts critics lose their jobs, both he and Scott were drawing from a larger perception that formerly passive consumers—often characterized as cultural dupes stuck with lowest-common-denominator entertainment—were now becoming actively involved in the production of culture. This participation in a process of media change reflected a wider cultural destabilization. As a result, Clay Shirky was moved to argue that, in the era of blogging and wikis, "everyone is a media outlet," while Dan Gillmor referred to "the former audience" and Chris Anderson eagerly added the populist refrain that "the new tastemakers are us."[4] In fact, the relentless promotion of blogging and other forms of online expression led *Time* to declare "You," that is, the active consumer, the Person of the Year in 2006.[5] However, while *Time* sought to provide examples of everyday citizens who had become celebrities via the power of blogging and viral videos, what ultimately came across was not a vibrant critical culture but one characterized by self-absorption and the preservation of relatively traditional models of celebrity. The cover itself famously featured a computer where the monitor is a mirror-like panel reflecting the reader's image back at her. At the same time, many of the articles highlighted celebrities launched via the web, such as MySpace-turned-MTV-reality-show-celebrity Tila Tequila or the web series LonelyGirl15, interpreting much of the activity on the web via the rhetoric of stardom and discovery. Lost in this revolutionary hype was Henry Jenkins's recognition that bloggers, for the most part, "have become important grassroots intermediaries—facilitators, not jammers, of the signal flow."[6] In fact, bloggers are often contacted by members of the marketing departments of movie studios to solicit publicity for their films. In this sense, much of the radical potential of blogging—its ability to shake up the landscape of media culture—was contained by the role of blogging in perpetuating and promoting the products of horizontally integrated media conglomerates that could now extend even further the reach of many of their media franchises.

This celebratory language fit neatly within larger myths that commonly circulated in discussions of the new digital cinema culture's movie blogs. Much like the digital distribution and projection systems that were developing alongside them, movie blogs became identified with a democratization of film culture, allowing anyone with a computer and an internet hookup to weigh in on the latest Hollywood film

and to see their reviews carry the same weight as professional critics. The desires for these experiences have informed the prolific activity that takes place within the film blogosophere. In fact, as Yochai Benkler has illustrated, blogs contribute to the "increasing freedom individuals enjoy to participate in creating information and knowledge."[7]

It is impossible for me to write about blogging without acknowledging my own investments in the genre, and as a result I am implicated in many of the desires that have been used to define blogging as a web genre. I have been an active blogger for over five years, writing primarily about documentary and independent movies but also discussing my academic research. In many ways, this chapter represents an attempt to make sense of the role of blogging within a larger media culture, as well as its role for me as a participant in a wider conversation about movies and television. Because of my own specific tastes in movies and blogs, it will inevitably be partial, focusing on the film blogging cultures with which I am most familiar. Further, because academic inquiry typically calls for critical distance, I write with the awareness that my position as a kind of participant-observer will likely guide how I approach the practices associated with blogging. However, I am certainly attentive to the fact that my own investment in blogging grew out of the recognition, articulated by Robert McChesney among many others, that the FCC proposal to allow further consolidation of media ownership would potentially drown out alternative viewpoints.[8] Later, I began to recognize my blog as a site where I could foster discussions of recently released movies and write critical reviews. While these reviews could be, and sometimes have been, used to promote the movies I discuss, they were also intended to participate in a dialogue about the role of those movies within a wider public culture. In this sense, while blogging has very clearly become part of a promotional machine in which consumers collaborate with media producers in marketing films and television shows, the utopian potential of blogging remains an important consideration.

From this perspective, blogs must be understood as occupying a complicated space within what many observers have referred to as the attention economy, and this chapter reflects my own ambivalence about the ways in which blogs fit within a larger media network. On the one hand, it is tempting to read blogs as heralding the end of the traditional consumer, a shift that has been characterized as producing an active audience that will no longer be satisfied with passively consuming entertainment. One of the more enthusiastic proponents of these new forms of activity is Clay Shirky, who pronounced the consumer "dead" because "in the age of the internet, no one is a passive consumer anymore because everyone is a media outlet."[9] Our status as active

participants—Shirky deliberately avoids using the term "consumer"—ostensibly guarantees that we will no longer be subjected to bland, milquetoast entertainment as media outlets are forced to compete for our attention. Shirky is clearly talking about potentials here: not everyone blogs or uses email, of course. And his revolutionary rhetoric obscures the relative power of the signals that these media outlets might have. Few if any bloggers have the reach of a television network or major motion picture studio, even if the relative reach of the major TV networks is in decline; however, Shirky's comments illustrate the point that the desire to mythologize the internet is alive and well.

In this sense, blogging becomes just another stage in the media marketing chain. As John T. Caldwell points out, "The collapse of barriers between media producers and consumers, then, is less about democracy than it is about co-creating with viewers information cascades on multiple media platforms."[10] The result is the creation of what Caldwell refers to as "producer-generated users," who end up doing much of the work of promotion and marketing once reserved for the studios themselves.[11] As Caldwell surmises, this attempt to harvest the labor of fan cultures has become all the more crucial in a crowded media marketplace that has become increasingly cluttered with content. From this perspective, blogging as an activity is an extreme form of what Toby Miller et al. refer to as the "cultures of anticipation," with bloggers serving a crucial role in calling attention to specific Hollywood films and even to the Hollywood brand itself by perpetuating conversations about upcoming movies and the celebrity culture that helps to drive film promotion.[12] And yet it would be a mistake to characterize bloggers solely as cultural dupes who are oblivious of their place within this network. As Caldwell goes on to point out, consumers can disrupt or challenge these promotion practices. At the same time, blogging can foster what Benkler describes as "a more critical and self-reflective culture" that allows individuals to become more critical "readers" of media texts.[13]

No matter what, blogs have clearly unsettled the media landscape, challenging definitions of what counts as film criticism and what role the print-based critic will serve. While Scott's comments may represent his frustration with audiences who seemed to be ignoring the guidance and good judgment of the film critic, they also illustrated that traditional norms of criticism were in the process of being upended as well. Jonathan Rosenbaum, for example, argues that "we're living in a transitional period where enormous paradigm shifts should be engendering new concepts, new terms, and new kinds of analysis, evaluation, and measurement, not to mention new kinds of political and social formations, as well as new forms of etiquette."[14] While I am skeptical of

Rosenbaum's use of the term "paradigm shift" to describe the new blogging practices, his comments underscore the need for a new language that will account for the highly personal but often deeply interconnected practices of film writing on the web, as well as the new modes of distribution and exhibition that allow filmmakers to promote films online using podcasts and other features.

These questions about film criticism cannot be separated from the financial crises that hit a number of major magazines and newspapers as they scrambled to figure out how to profit in the new media landscape. Newspapers, in particular, have seen subscription rates decline dramatically, with the *New York Times*, to name one example, seeing its circulation drop 9.2 percent between October 2007 and March 2008, while overall newspaper advertising revenues declined 7 percent.[15] By April 2008, a number of prominent film critics, including Nathan Lee of *Village Voice*, David Ansen of *Newsweek*, and Jan Stuart and Gene Seymour of *Newsday*, had been laid off or taken buyouts.[16] In addition, the *Washington Post* was forced to push out over one hundred members of its editorial staff, including two of its top film critics, Stephen Hunter and Desson Howe, a decision that provoked widespread criticism.[17]

What often gets overlooked in these reports is the fact that despite declining revenues, newspapers themselves continue to be widely read, a detail that challenges the assumption that there is no longer a reading public engaged with a wider print culture. Jonathan Rauch observes that readership of newspapers has actually increased; however, online advertising revenue cannot match print revenue, in part due to the heavy migration of classified advertising to free online sites such as Craigslist.[18] In addition, many of the most avid readers of print-based reviews are, in fact, bloggers who comment on and engage with these reviews.

The more notable aspect of these arguments is not the debate over whether blog book critics are supplanting their newspaper counterparts, but the attempt to establish levels of distinction between professional and amateur critics. In the *Guardian*, for example, Jay Rayner argued that the distinction between bloggers and print-based critics hinged precisely on questions of expertise before going on to impute a level of expertise to professional critics that is unavailable to bloggers. This set in motion a false opposition between expert interpretation and democratized opinion without recognizing the degree to which many bloggers operate from a position of professional expertise. In some sense, the print-based critics echo what Benkler has referred to as "the Babel objection," the idea that when there are too many voices, expert opinion will be drowned out by other, less informed, viewpoints. However, as Benkler observes, most web cultures have developed

relatively sophisticated filtering mechanisms that direct attention toward a few high-profile blogs where the majority of users tend to congregate, suggesting that web conversations may not include outside voices as readily as many observers have suggested.[19]

BLOG CHARACTERISTICS

In understanding how blogs function, as well as how they have been defined by both enthusiasts and critics, it is important to emphasize some of the major traits common to most blogs. Rebecca Blood offers a rudimentary but persistent definition of a blog as "a frequently updated webpage with dated entries, new ones placed on top."[20] The frequent updates tend to privilege a focus on the contemporary, often at the expense of more historical analysis; however, because blogs usually involve links and comments, they can encourage sustained attention to a specific topic. While not all blogs allow comments, mechanisms for feedback are built into blogging software through the economy of incoming links and discussion on other web sites. As Chris Anderson has observed, blogs can serve as part of a "reputation economy," through which individuals can gain attention from a wider readership.[21] It is certainly the case that this reputation economy can foster a desire for celebrity or fame, often at the expense of critical analysis; however, as Benkler points out, "communities of interest" such as film blogs can serve a vetting process by which individual contributions to a conversation can be judged.[22] Through a sort of filtering process, the most reliable blogs will usually cultivate a positive reputation within the film blogging community. In this sense, the networked elements of blogs help to foster something not unlike a peer-review system, in which bloggers develop a reputation through more engaged blog posts. Further, as these conversations suggest, blogging communities are often involved in processes of self-theorizing, seeking to make sense of the genre and its relationship to topics of interest. As a result, blogs can be understood as having three major traits: they are *heavily linked*, *critically engaged*, and *frequently updated*. In many ways, these traits are mutually reinforcing. The frequent updates allow a writer to spend tremendous energy focusing on a single topic over the course of several weeks or months, while the large number of links permits writers to sustain a conversation over several days or even weeks. While not all blogs can maintain the same level of critical engagement, the desire for credibility typically ensures that many prominent bloggers will strive to produce posts that are not only thoughtful but also engaged with the concerns of a wider readership. It is important to note that the

mechanisms of blogs, particularly the focus on the contemporary, on remaining up to date, can be exploited by the media industry itself as it seeks to find new ways to promote movies and television shows.

Blogs are heavily linked: One of the most misunderstood features of blogging, at least as it has been represented in journalistic accounts, is the fact that blogs are heavily linked, resulting in conversations across blogs rather than the lone "basement blogger" figure. Instead, the conversation facilitated by blogs contributes to the desire for collectivity commonly associated with moviegoing. While a number of critics such as Godfrey Cheshire worried about the perceived demise of moviegoing as an activity and others express concern about the decline in print-based criticism, film blogs are an expression of what Charles Acland has described as "a dream of a global collectivity."[23] The heavily linked nature of film blogs encourages conversation and networking that often extend well beyond the blog into meetings at film festivals, as well as collaborations on film-related projects. In this sense, film blogs can serve as a means for fostering a vibrant social and political culture, one that can revive moviegoing as an activity. In addition to this desire for global community, bloggers have also formed local communities using the same social networking techniques that made the Robert Greenwald house parties possible. A number of film bloggers have, in fact, made a point of promoting local film production and reception cultures, including S. T. Van Airsdale's The Reeler, which focuses on New York's screen cultures, and Andy Horbal's Mirror/Stage, which discusses the Pittsburgh film scene, again suggesting the potential for blogs in cultivating a local subjectivity around shared interests in film culture. In both cases, blogs have been used to promote the practice of public moviegoing while also managing to reach out to a specific film community, while a number of DIY filmmakers sought to appeal to this desire for a collective, shared experience.

In order to facilitate this sense of global collectivity, there are a number of resources that serve to organize or connect blogs. The most crucial resource for creating communities of bloggers has been GreenCine Daily, which has been managed by Berlin-based blogger David Hudson for several years and serves as an extension of GreenCine's video rental service. GreenCine Daily functions primarily as an aggregator, linking to articles in prominent newspapers, magazines, and academic journals, as well as significant blog entries on film culture, often with a strong international focus. As Hudson himself notes in an interview with *Film in Focus*, GreenCine is a blog people visit "to find out where to read about movies."[24] In this sense, GreenCine Daily, while drawing in a number of readers, also serves to

redirect them to other blogs. Aggregator blogs serve as social tools, providing a filtering mechanism through which readers can make sense of an overwhelming diversity of voices. In addition to contributing to the overall community within the film blogosphere, Hudson's blog also serves to place film culture within a wider political and social context by highlighting articles and blog entries that appear outside of sources that cinephiles might normally read.

It is important not to fully romanticize the networked status of blogs. Judy Wajcman observes that "networks create not merely insiders, but also outsiders, the partially enrolled, and those who refuse to be enrolled."[25] Wajcman is attentive to the ways in which the experiences of technologies such as the web may not be standard, and the practices and tastes addressed in film blogs may exclude many people from feeling like full participants, whether due to a lack of familiarity with the topics or due to a lack of comfort with the tools of blogging. In a related sense, Clay Shirky has mapped out the "power-law" distribution of incoming links within the blogosphere. Shirky found that a small number of high-profile blogs tend to receive most of the links. In fact, he found that the top dozen blogs accounted for nearly 20 percent of all incoming links. If incoming links can be understood as a form of reputational currency, then much of the attention remains directed toward a few popular blogs, possibly excluding alternative voices that might challenge standard viewpoints and providing high-profile bloggers with a much greater ability to shape the conversation.[26] In addition, this link economy may make it more difficult for new participants to enter a conversation, especially if a group has a long history. And while smaller blogs may receive significantly less traffic, it is also the case that media professionals do monitor blogs. For the most part, these professionals read prominent sites such as Television without Pity or Perez Hilton, although others keep track of more general blog reactions, often through Really Simple Syndication (RSS) feeds that alert them to any mention of a subject, allowing bloggers to write back to the industry.[27] These exclusions are certainly significant; however, the social networks have provided an important space where filmmakers and cinephiles can theorize their relationship to a larger film culture, a crucial task in this moment of digital transition.

Blogs are critically engaged: Film blogs have often been promoted as allowing new forms of conversation between producers and consumers, between industry professionals and enthusiastic audiences, in some sense turning consumers themselves into producers and inspiring the populist rhetoric that describes everyone as a (potential) media outlet. Because a number of film bloggers work in the industry in a variety of

capacities, film blogs have become an important site for defining indus-
try common sense, or in some cases promoting definitions of film as stu-
dios, new media entrepreneurs, and employees alike negotiate the
transition into digital cinema. At the same time, cinephile bloggers can
use blogs to think and write critically about the films they consume. As I
have argued, a number of documentary and independent filmmakers
have used the network of bloggers to find a wider audience for their films.
In addition, a number of journalists, academics, and industry employees
maintain blogs, allowing conversations between different groups that, in
the past, may have communicated less frequently. These networks also
complicate any simple notion of blogging as either a professional or ama-
teur activity. While very few bloggers manage to make a living on the
writing they do in blogs, many earn some revenue from selling advertis-
ing, although the reputational rewards tend to be more significant. This
practice may be most commonly associated with academic bloggers,
though a number of popular authors, including J. D. Lasica and Chris
Anderson, have blogged large sections of their books and now serve a
crucial role in shaping the public understanding of digital cinema.

At the same time, blogs have, in some instances, allowed workers
within the film industry to depict their experiences as laborers within a
shifting set of industry practices. One of the more effective examples of
this was United Hollywood, a situational blog collectively written by mem-
bers of the Writers Guild of America (WGA) during their strike in spring
2008.[28] While no longer active, it is a useful example of how blogs have
sought to define common sense within the film industry. In addition to
disseminating information about the reasons for the strike—negotiations
over residuals from internet sales of media texts—the writers were able to
use the blog to win the public relations war with the media conglomerates.
By providing video of striking writers, many of whom were also familiar
actors and directors such as Tina Fey, the WGA provided visual points of
identification with the strikers. Other writers produced short video skits in
the tradition of YouTube, again illustrating the writers' talent and skill in
arguing that they should be better compensated. Similarly, Totally
Unauthorized, a blog by a female lighting technician in Hollywood,
provides the perspective of a below-the-line laborer. The anonymous
author provides an unusually candid description of the experiences of
these highly specialized workers, reminding us, for example, that strikes
such as the Screen Actors Guild work stoppage in July 2008 can also affect
less glamorous workers, many of whom have little savings or may face los-
ing health insurance if they are unable to work enough hours.[29]

In addition to narrating film production, movie blogs can also pro-
vide sites for attentive discussions of media culture more generally.

In this context, a number of film bloggers have deliberately sought to define their role, both within a larger critical culture associated with print-based reviews and within film culture more generally. Despite attempts by a number of print critics to identify bloggers as unqualified, it should go without saying that web writing on film is often done by people who have training in the language of film analysis and film theory. In launching his Mirror/Stage blog, Andy Horbal used the concept of the "termite critics," bloggers who "devote themselves to some small part of the cinema and nibble away at it until sated, at which point they will move on to another."[30] Like other bloggers, Horbal self-consciously defines film blogging in opposition to professional film criticism, although in Horbal's case he is specifically describing it against the film criticism of the 1960s and 1970s, when, as Horbal argues, reviewers sought to write the "definitive review" of a given film. Echoing the language of Henry Jenkins and Pierre Lévy, Horbal describes these activities in terms of a "collective intelligence," in which interpretations are not imposed by the "city leaders" but the "citizens" of the community.[31]

Blogs are frequently updated: More than any other trait, Rebecca Blood's foundational definition emphasizes the expectation that blogs will be updated frequently, and while blogging has become increasingly naturalized as a genre, there is an unstated assumption that a blogger will write posts several times a week or month. This definition of blogs gives the impression of spontaneity, the perception that blogs are the unfettered and often uncensored expressions of a wider public. However, web writing about film is also shaped by the temporal rhythms of film culture itself. While television blogging is often shaped by the programming schedule, film bloggers must navigate the release schedules of the movie studios. It is worth noting that audiences are now less likely to watch TV shows simultaneously, thanks to DVRs. Similarly, video-on-demand may, to some extent, disrupt the practice of going to see movies on opening night; however, as Charles Acland points out, the social pleasures of attending opening weekends continue to hold tremendous value: "Opening weekends allow the material and sensory experience of commune. One goes to the first showings of a theatrical release precisely to be with strangers and to be part of that crowd."[32] This desire for community might also be connected to what Henry Jenkins has referred to as "pop cosmopolitanism," the sense of shared tastes and interests with others across the globe.[33] While this pop cosmopolitanism no doubt risks reinforcing the further dominance of Hollywood cinema worldwide, it also introduces the possibility of opening oneself up to other cultures. In fact, a number of prominent

English-language film blogs take it as their task to promote Korean cinema, Bollywood, and other non-U.S. cinemas.[34]

Because this desire to be in the know depends upon being able to participate in a conversation about a film soon after it is released to theaters, the publishing of film blogs is bound up with the rhythms of the film schedule itself and, to a different extent, the physical locations of individual bloggers who may not have access to films simultaneously with the rest of the country. As a result, blogs can best be characterized in terms of this desire to be a part of this larger conversation, to be in the know about a significant cultural event. This quality can feed a competitive desire to "scoop" other people, as often happens in the spoiler culture associated with web writing, but it may also feed the "impression of collectivity" described by Acland.[35]

For professional bloggers, the imperative of posting regularly is imposed, in part, because a reduced number of posts could contribute to a decline in traffic to the web site, thus lowering the site's value as a source of advertising revenue; however, as Horbal's discussion of termite critics suggests, frequent updates can also help to foster sustained attention on a given topic. At the same time, the speed of publication can inspire other temporalities as well. While Horbal implies, for example, that bloggers may be less committed to writing the "definitive review" of a given film, the reputational economy of blogs may actually feed a more general desire to be one of the first writers to comment on a subject. This desire to be in the know can have the effect of reinforcing the promotion of Hollywood films. In fact, the pioneering film web site and proto-blog Ain't It Cool News (AICN), run by the Austin-based Harry Knowles, became notorious for getting scoops on the production of Hollywood blockbusters, and studios quickly realized that courting AICN writers would be a useful way to achieve positive buzz for their films, a practice that persists more generally today.[36]

Similarly, the desire to be in the know can be used to promote or discuss independent films as well. In an interview with DVD Panache, GreenCine Daily blogger David Hudson observes, "I just enjoy the occasional opportunity to get word out early on a film, whether that word's positive or negative. Of course, it's not long before that early word is drowned out by louder, better positioned voices, but it's fun while it lasts."[37] Hudson, in fact, was part of the wider network of bloggers that helped to promote the Mumblecore films as they began to gain attention after prominent screenings at the South by Southwest Film Festival. This emphasis on timeliness potentially allows the blogger to have an additional influence on the reception of a film, especially if he or she is able to see the film at a festival. Thus, as Matt Hills observes,

new media technologies can help to shape the timing of fan responses, with enthusiastic film bloggers often posting days or even hours after they have seen a film.[38]

To describe this highly structured fan activity in which fans post responses to their favorite shows immediately after they have aired, Hills coined the phrase "just-in-time fandom." Hills intentionally echoes the post-Fordist production practices to illustrate how these accelerated responses work "ever more insistently to discipline and regulate the opportunities for temporally-licensed 'feedback,' and the very horizons of the fan experience."[39] In this context, the production of value for a given movie is caught up in the production of meaning. As bloggers discuss their viewing experiences, they are also caught up in adding to the value of those films, a process that Hills recognizes as "an intensification rather than a transcendence of commodification."[40] Blogs are crucial to this network of promotion and distribution, extending the life of a film well beyond the confines of the movie screen. By perpetuating the life of a text, blogs provide new lines of access to these films. However, the affective elements of participation in these larger conversations cannot be ignored.

While Hills is correct to emphasize these spatiotemporal relationships, the relative differences between the industries of television and film production also produce certain specific differences that complicate his "just-in-time" model when it comes to film blogs. Because film culture is structured around modes of anticipation that build audience enthusiasm many months in advance of a film's release, blog posts about a film are less likely to follow a specific schedule than those about a television series broadcast weekly on television. As Hills points out, a flurry of posts typically appears on discussion boards and blogs immediately after a show airs. In fact, many bloggers participate in live-blogging events, in which they gather at a specific blog and react to the show as it airs, creating what amounts to a virtual online water cooler, such as the live-blogging of the AMC show *Mad Men* on the Newcritics web site, where I am an occasional participant.[41] In a sense, these live online discussions formalize the desire for and expressions of a larger community based around shared tastes. Thus, Hills's emphasis on the affective ties inherent to fan and cinephile cultures are crucial to these activities.

Other bloggers participate in "memes," in which participants are invited to disclose something about their movie tastes or movie-watching habits. Sample memes might ask users to highlight films they have and haven't seen from a random list or to disclose the first DVD or VHS tape they purchased and how many DVDs they own. Most function like a list in that bloggers are invited to respond to a series of questions

that can be cut and pasted into another author's blog. These memes typically spread via blog links, with a standard component of most memes being a list of other people a blogger would like to see participate in the meme. These links can function as a way of reaching out to another member outside the community, or they can be used to reinforce already existing community ties. As a result, these memes tend to have a relatively short lifespan, circulating in a matter of days across film communities on the web. Thus, memes are often designed to provide the blogger with an excuse to disclose something personal about his or her movie tastes. Significantly, as the genre of film blogging has matured, the need to participate in memes seems to have diminished, perhaps because the social ties that blogs were meant to reinforce have become relatively hardened, creating less of a need for arbitrary excuses for posting.

One of the more compelling forms of this kind of activity is the blogathon, a pre-planned event where a blogger will "host" a discussion of a filmmaker, star, genre, era, or question and offer an open invitation to other bloggers to write on that topic on a given day.[42] Blogathons often focus on topics ranging from avant-garde cinema and Alfred Hitchcock movies to broader topics such as favorite comedy scenes to "three performances that changed my life," and the only criterion for being included is sending a link to the organizer of the blogathon. The host blogger then writes a detailed entry in which he or she links to the other blog entries, usually framing them in a larger narrative, making connections between similar entries, and, potentially, introducing bloggers with similar interests to each other. These blogathons are often mentioned on popular aggregator blogs such as GreenCine Daily, where readers are more likely to discover them. Typically the blogathon is characterized by thoughtful, engaged, detailed, and, quite often, eccentric posts, provoking discussions that Julia Lesage has described as a kind of "processual knowledge-building."[43] This reading of blogathons aligns them with the kinds of "collective intelligence" that Henry Jenkins, borrowing from Pierre Levy, has come to associate with fan cultures, and at the very least they help to foster the open-ended conversation that can be used to build community online.[44] While all these activities are connected to a larger desire for community, they also serve to structure attention in specific ways, directing conversation.

BLOG TYPES

While the attentional economy of links helps to shape conversation online, it also informs the primary types of blogs that have emerged on the web. In what follows, I focus on some of the more significant

categories of film blogs, arguing that each type offers an interesting con-
tribution to the networked film publics that provide the primary audi-
ence for Hollywood, independent, and international films. These
categories represent a range of possibilities, and it is important to note
that they are not mutually exclusive. Given that blogs are characterized
by frequent—often daily—updates, individual bloggers may engage in a
variety of practices over the history of their blogs, shifting from one
interpretive circle to another as their interests and tastes change. In fact,
my own blogging practices have shifted quite a bit as my research inter-
ests and personal tastes have changed. However, this map can function
as a thumbnail for talking about how the blogosphere constructs a num-
ber of networked communities online while also illustrating the degree
to which the media industry can take advantage of the strong affilia-
tions expressed online by film fans. Because they have received the most
attention, I start by looking at some of the prominent gossip blogs such
as TMZ, Perez Hilton, and the Defamer. While these often deploy a pop-
ulist, sometimes oppositional language, they are often the web sites
most directly related to the industry and most involved in directing
attention to a relatively narrow slice of Hollywood culture. These blogs
are complemented by others written primarily to promote movies or
TV series. A third category would include what I have called "meta-
industry" blogs, which entail a range of blogs written by industry insid-
ers and new media journalists seeking to define digital cinema and
therefore to shape the practices of film distribution and exhibition. The
most prominent example, Mark Cuban's Blog Maverick, mixes a per-
sonal and a corporate style that allows Cuban to complain about bas-
ketball referees one day (he owns the NBA's Dallas Mavericks franchise)
while discussing day-and-date releasing the next. These meta-industry
discussions can have enormous impact in naturalizing certain percep-
tions of how the entertainment industry should operate; however, they
can also provide space for other practices of self-theorizing and commu-
nity building within marginal groups such as documentary and DIY pro-
ducers. Alongside these blogs, I discuss the wider community of fan and
cinephile blogs, in which groups of mostly amateur writers discuss, ana-
lyze, and review films, often with a specific focus on one genre, era, or
style of filmmaking. I conclude by looking at the role of film blogs in
promoting the independent, documentary, and DIY cultures that have
begun to emerge with the advent of digital distribution. These categories
are not meant to include or account for all different forms of web writ-
ing about film. Instead, I hope to illustrate how film blogs function
within a larger economy of attention, shaping how we think and write
about film in a digital age.

Perhaps the best-known film blogs are the celebrity or gossip blogs, which focus primarily on documenting or spreading information and gossip about celebrities. While it is tempting to dismiss these blogs as merely feeding our guilty enjoyment of tabloid culture, they can, in some instances, offer a piecemeal attempt to address concepts of stardom and identity. In addition, gossip blogs can reinforce conservative gender representations, particularly when it comes to policing the behavior of female entertainers, often scrutinizing the nightlife activities of starlets such as Britney Spears, Tara Reid, and Paris Hilton in obsessive detail. More crucially, the high-profile gossip blogs have become an official or at least semi-official part of the media industry, in some cases owned by the same media conglomerates that produce and distribute Hollywood films. In fact, the most prominent gossip blog, TMZ, is a collaboration of America Online (AOL) and Telepictures Productions, both of which are owned by TimeWarner. These connections clearly make it difficult to read TMZ as truly existing in an oppositional, much less a critical, relationship to the film industry. While Perez Hilton, who happily describes his blog as "Hollywood's most hated website," has cultivated an image as an outsider, his enthusiastic praise of a number of media celebrities has earned him quite a bit of attention from the marketing departments of a number of media conglomerates.[45] In fact, Hilton happily attaches himself to favorite celebrities and cites actresses who reference him in interviews. In this sense, Hilton's deliberately crude style and his intentionally outrageous appearance, complete with dyed orange hair and garish outfits, can be read as part of a larger branding strategy that he has developed in order to create a media persona accessible in a number of media channels, including a syndicated radio show, appearances on a number of TV gossip shows, and a six-episode reality series on VH1, *What Perez Sez*. Thus, these blogs exist less as amateur discussions of the film industry than as a form of professional discourse that feigns its outsider status.

In this sense, gossip blogs cannot be separated from the larger economy of celebrity or tabloid culture and may be seen as supplanting or at least supplementing shows such as *Entertainment Tonight* and magazines such as *People* or *Us Weekly* when it comes to shaping celebrity identities. In fact, Anne Petersen argues that gossip blogs such as TMZ and Perez Hilton have this ability to influence perceptions of specific celebrities and celebrity culture in general. Citing the infamous example of Tom Cruise on *The Oprah Winfrey Show* leaping on a couch to declare his love for much-younger Hollywood starlet Katie Holmes, Petersen claims that "a blogger may significantly use posts to influence box office pulls and dent, inflate, and damage a star image."[46] Here,

Petersen's comments echo the popular narratives that film blogs can have an effect on Hollywood box office. While I wouldn't doubt the possibility that the cumulative effect of a number of blog posts on a given film or celebrity, it is difficult to trace any causal relationships between box office and blog reviews. In fact, the gossip about Cruise may be a response to any number of factors, and claims that his career is in decline exaggerate the relative failure of a single film, *Mission Impossible III*. The blog posts may, in fact, simply echo existing narratives hatched in more commercial media outlets, such as the opening monologues of late-night talk shows, where Cruise's stunt was also mocked. Significantly, Petersen associates the instability of Cruise's star image with the instability of the current economic model in Hollywood, noting that his escapades on Oprah's couch and his frequent promotion of Scientology had led Paramount to cut ties with the formerly bankable Hollywood star, while suggesting that blogs figure prominently in producing Cruise's star image.[47] Here, Petersen is correct to read film bloggers, especially those invested in the issues of celebrity, as occupying "a unique position in the 'industry,' functioning as both producer and consumer of the star image."[48] However, this process is part of a larger network of images, and the actions of Perez Hilton and the TMZ bloggers cannot be separated from others involved in the production of these images. Thus, while gossip blogs may appear autonomous from a larger entertainment culture, they are, in fact, involved in attracting further attention to it.

Much like gossip blogs, official and unofficial promotional blogs function primarily as an adjunct to the film industry, promoting awareness of Hollywood films. Like gossip blogs, promotional blogs tend to take a one-to-many approach, disseminating information about upcoming Hollywood releases. A number of the official promotional blogs simply extend the work performed in director and star commentary tracks and in making-of documentaries while helping to create anticipation for upcoming films, extending further the boundaries of what counts as a film text. Like the commentary tracks, many of these texts are relatively standard supplements that provide further information about the filmmaking process while promoting a specific film. For example, Bryan Singer, the director of *Superman Returns*, kept a video blog depicting the film production process.[49] The journal was designed to resemble the pages of a comic book, but when a user would click on a panel, he or she would activate a video, with Singer narrating some aspect of the film's production. In this sense, the blog provided behind-the-scenes images that might have normally appeared in the DVD but could be used instead to create anticipation for the film. Similarly, the

marketing team behind David O. Russell's *I Heart Huckabees* created a
number of fake web sites to expand the presence of the film on the web,
including one for two of the fictional companies depicted in the film
and, most prominent, an eponymous blog authored by one of the film's
characters, the environmentalist firefighter Tommy Corn (played in the
movie by Mark Wahlberg).[50] The blog featured impassioned, vaguely
political rants about the energy industry while also introducing
Tommy's depression over his unsettled relationship with his wife, a
major plot point in the film. While the blog did not offer any specific
insights into his character, it did serve the purpose of appealing to blog-
gers who might wish to be in the know about a film by a popular indie
film director like Russell. The Tommy Corn blog attracted links from a
number of others, including the widely read gossip blog The Defamer.

Similar activities include promotional videos that tie a movie to
current events. For the 2008 neo-Blaxploitation film *Black Dynamite*,
marketers sent a video, "Black Dynamite Meets Barry," to several promi-
nent bloggers in which the film's lead character gruffly lectures a young
boy named Barry not to emulate him, telling the boy he "could be
president someday," a sly reference to the then-ongoing campaign of
Barack Obama.[51] The video helps establish the nostalgia for the 1970s
blaxploitation films while also creatively referring to Obama's biogra-
phical connections to the south side of Chicago. Although the video
itself may have essentially been a harmless joke, something bloggers
would mention in passing, the video served the primary purpose of
directing traffic to the *Black Dynamite* web site and building some
manufactured grassroots buzz for the film.

"Black Dynamite Meets Barry" illustrates some of the specific chal-
lenges viral marketing raises to critical theory. Ostensibly part of the
expanded text of the film itself, the video uses the social networks of
blogs, Facebook, and MySpace in order to create brand awareness for the
movie. Further, by tying into the youthful enthusiasm over Obama's
presidential candidacy without ever naming him—the young boy is
referred to as "Barry" throughout the video—they are able to create the
illusion of enthusiasm for the movie without an explicit reference to the
candidate, an impression made even stronger due to the fact that blog-
gers were not paid for placing the links. Similarly, viral marketing in the
blogosphere can attach itself to the reputation of bloggers as outsiders
and blogs as the spontaneous expressions of the new tastemakers who
are not part of the entertainment industry. The "Black Dynamite" video,
like the humorous anti-piracy PSAs produced by Judd Apatow, seem
banal enough, but they do complicate easy analysis, in part, as Caldwell
suggests, because "viral referrals work only if the product is seen to say

more about the person referring it than to the product itself."[52] Blogging the "Young Barry" video was, perhaps, a way for Obama supporters to express enthusiasm for him becoming the Democratic presidential nominee—the video was posted on June 4, 2008, around the same time that Hillary Clinton conceded the nomination—in a way that outstripped the fact that they were voluntarily promoting *Black Dynamite*. To be sure, many bloggers are attentive to this process and choose to opt out by not linking, while others are critical of these techniques.

The most notorious attempt to market a film using "unofficial," grassroots approach can be seen in the promotion of the faux cult film *Snakes on a Plane*, which would have been little more than a standard high-concept thriller had the title not come to the attention of a few bemused bloggers, who began linking to news about the film and discussing their enthusiasm for it. In fact, during the summer of 2006, the film became the paradigmatic example of the idea that consumers had finally triumphed over the studio system. Among the more enterprising bloggers was Brian Finkelstein, a Georgetown University law student who began writing Snakes on a Blog with the hopes of attracting enough attention from New Line, the film's producers, to score an invitation to the film's premiere, for which he was successful. During the summer of 2006, the film became, for many observers, a symbol of the newly acquired power that fans were ostensibly gaining over the studios, especially after New Line reedited the film from a tepid PG-13 thriller to a slightly raunchier R-rated film, with the edits including a brief glimpse of a nude woman having sex in the airplane's bathroom and a few altered lines of dialogue. Fans also lobbied for New Line to keep the film's incredibly literal original title instead of the far less descriptive "Pacific Air Flight 121." In fact, in June 2006, a number of articles had begun touting the film's grassroots buzz, comparing it to the earlier internet phenomenon *The Blair Witch Project*. These articles often pitted "out-of-touch" Hollywood executives against eager and knowledgeable fans, including one that went as far as describing *Snakes* as the "most influential" film of 2006 because of the grassroots promotion that seemed to suggest, for once, that fans were in charge rather than studio suits.[53]

Many of the popular press articles emphasized the idea that blogs and web forums had finally returned power to increasingly active consumers who could demand the kind of content they desired, not the tired formulas normally associated with Hollywood films. In this sense, many of the articles reinforced digital cinema myths celebrating a participatory culture in which power relationships seemed to have been leveled, a sentiment echoed months later when *Time* named "You" its Person of the Year. However, while New Line may have taken fan

suggestions into consideration, the film's producers carefully cultivated the idea that they had made a cult film that would appeal to web savvy audiences. This approach inspired a strong backlash among many popular culture critics, including rock critic Chuck Klosterman, who saw through New Line's marketing gimmicks as a form of "prefab populism" in describing *Snakes on a Plane* as "the Wikipedia version of a movie."[54] As Klosterman implies, while studios have made some effort to align themselves with fans, it is less clear whether the studios have genuinely ceded control to film audiences. However, rather than defending the possibilities made available through participatory culture, Klosterman criticizes the new cinematic populism on aesthetic grounds, arguing that the wisdom of crowds actually leads to banal films designed to satisfy everyone.

Thus, while Snakes on a Blog may have appeared as the fully spontaneous behavior of a small group of enthusiastic fans that became a grassroots phenomenon, the buzz surrounding the film cannot be seen as entirely unanticipated by the studio, which ultimately fully incorporated fan activity into the film's promotion, exemplified in part by their invitation of Finkelstein to the film's premiere. Of course, the film proved to be a moderate box office success at best—it grossed only $62 million worldwide, albeit on a reported budget of $33 million, suggesting that the power of these grassroots marketing techniques may be overstated—but I am less interested in how box office success is defined than in the debates about fan activity and the accounts of fans actively shaping the film text through blogs and other discussion boards. While events such as the *Snakes* phenomenon seem to offer a more inclusive model of film spectatorship, it is important to bear in mind the ways in which this fan activity is structured by the studio in order to promote an otherwise marginal high-concept film. Klosterman's comments help to underscore the extent to which the model of the empowered consumer has become crucial to film and television promotion in the United States. This new digital interactivity seems to allow consumers to become greater participants in the production of the vast story worlds that constitute media properties, and in the case of *Snakes on a Plane*, bloggers seem to be involved in authoring the film texts themselves, suggesting lines of dialogue and visuals that can be incorporated into the film. In this sense, film blogging becomes just another link in the chain of a more entrenched distribution system, helping to facilitate what Caldwell describes as "utterly traditional business activities like direct-to-consumer marketing."[55]

In addition to extending the marketing reach of the entertainment industry, blogs can be used to promote a specific image of film culture, whether through advocacy for certain kinds of practices, such as Mark

Cuban's promotion of day-and-date releasing on Blog Maverick, or by fostering informational networks among other media producers. These meta-industry blogs range from industry insiders to a number of documentary, indie, and DIY filmmakers who can share experiences and make suggestions to others who may be making films on a low budget, such as Paul Harrill's Self-Reliant Filmmaking. These blogs quite often can provide compelling spaces for the kinds of industry self-theorizing that can be valuable by allowing groups to participate in wider public discussions of how to make the industry more equitable or transparent.

The final major category of film blogs are those that have typically been described as "cinephile blogs," which usually consist of reviews of and commentary on both recent movies and past films. Unlike the promotional and gossip blogs, these blogs are more likely to focus on neglected auteurs, genres, or cultures, and because of the networked, heavily linked nature of these blogs, they often provoke public debate about certain films and filmmakers, sometimes leading to the revaluation of films that were dismissed by professional critics. In some ways, the cinephile blogs do fit within the promotional and marketing discourses that redirect attention to Hollywood films; however, they also offer one of the more compelling sites when individuals can participate in the kinds of knowledge-building emphasized by Benkler, Jenkins, and Lesage. These blogs are generally the sites where blogathons and other community-building activities take place, and they can also be understood as a version of what Benkler refers to as "the networked public sphere," in which individuals engage in significant debates without needing the resources of a major media outlet. While this power can be siphoned off, in some instances, for the purposes of viral marketing, it can also be used in non-market ways.[56]

Perhaps the best example of this process of revaluation occurred with Terrence Malick's critically maligned 2005 film *The New World*, a revisionist account of the Pocahontas story. While the film received tepid reviews from print-based critics and quietly disappeared from theaters, a small group of enthusiastic bloggers, led by Matt Zoller Seitz of The House Next Door and Nick Pinkerton of Stop Smiling Magazine, began championing the film for what they saw as its utopian yearning for an idealized America, one that might have been all the more alluring given the dissatisfaction with American politics during the waning years of the Bush administration.[57] Seitz, in particular, explained his encounter with *The New World* in terms that evoked a spiritual, almost mystical experience, describing the film as his "new religion" and Malick as a builder of "cathedrals." By contrast, Pinkerton chose to attack the film's critics, his column reading like a checklist of the guilty.

Significantly, both Seitz and Malick linked the pleasures of seeing *The New World* to the larger communal pleasures of seeing the film on the big screen in the dark with a roomful of strangers. In fact, as J. Hoberman observed in his discussion of the blog reception of Malick's film, "there is the sense that *The New World* won't work on DVD, even though Malick is preparing a new three-hour collectors' version; its presence is dependent on the big screen."[58] Pinkerton offers a litany of cities across the country, "Cary, North Carolina, and Middletown, Ohio, and Durango, Colorado," where the film had played, suggesting an almost transcendently American experience. Meanwhile, Seitz described in detail the "demographic mosaic" that attended a screening of the film in Brooklyn. These descriptions of *The New World* audiences evoke Susan Sontag's description of moviegoing: "To see a great film only on television isn't to have really seen that film. It's not only a question of the dimensions of the image: the disparity between a larger-than-you image in the theater and the little image on the box at home. The conditions of paying attention in a domestic space are radically disrespectful of film To be kidnapped, you have to be in a movie theater, seated in the dark among anonymous strangers."[59] Much like Sontag, both Seitz and Pinkerton place emphasis on the shared, collective experience of moviegoing, and while digital cinema has often emphasized the anytime, anywhere convenience of watching movies in whatever situation one chooses, film bloggers can, and often do, privilege these collective experiences.

However, while *The New World* may be the most prominent film to receive renewed attention from the blogosphere, it is far from the only one. What seems more significant here is the fact that blogs are structurally suited for the kinds of frequent posts that allow enthusiasm for a film to develop. While the cult status of Malick and the subject matter of *The New World* may help feed its cult status, it is important to acknowledge the ability of blogging as a genre to enable the repeated, enthusiastic attention that Seitz, Pinkerton, and others gave the film.

FILM BLOGS AND INDIE FILM PROMOTION

While blogs have been widely used to promote studio films, as the examples of New Line's *Snakes on a Plane* and Fox Searchlight's *I Heart Huckabees* illustrate, their more interesting use has been in the promotion of documentary, independent, and DIY films. Through the tight social networks cultivated via blogs, individual bloggers are able to cultivate credibility, making film blogs a useful site for independent filmmakers to obtain reviews of their films. While I am attentive to the use of blogs as a promotional tool for Hollywood films, independent

filmmakers, many of whom choose to self-distribute, have been able to obtain insightful, thoughtful reviews from high-profile film bloggers who are willing to help these independent and documentary filmmakers find a wider audience. In his spring 2007 "Industry Beat" column, Anthony Kaufman explains that the film blog community allows DIY filmmakers to find a wider audience for their movies and to generate buzz through reviews published on prominent film blogs. As Kaufman observes, "When it comes to getting the word out about an interesting film, the pendulum is definitely swinging toward dotcom criticdom."[60] As distribution models continue to evolve, many independent filmmakers have seen the internet in general, and film blogs more specifically, as a useful tool for raising awareness of their films. Even a link to a film's official web site ensures that the film will be easier to find on Google, arguably creating a wider audience for the film. For example, Tara Wray, the director of the autobiographical documentary *Manhattan, Kansas,* saw bloggers as a useful means for promoting her film in order to "get a grassroots movement going," implicitly illustrating that indie filmmakers may consciously cultivate an aura of "grassroots" enthusiasm in much the same way that major studios might.[61] Kaufman's column and a similar article by Stacey Parks highlighted the value for independent filmmakers in fostering the connections provided in the blogosphere. Parks's article, which serves primarily as a kind of self-help guide to DIY filmmakers, defines blogging primarily in terms of building audience: "Think of it as investing in an audience for life for your entire film career" (ellipsis in the original).[62] In addition to the more evident goal of mining positive reviews for promotional materials, the temporality of blogs—which can reward sustained conversations over time—can also be used to build a community among bloggers, as many of the Mumblecore filmmakers have done.

One of the more interesting experiments in using blogs as a form of independent film promotion was conducted by Randy Olson, a Harvard-trained biologist who left academia to become a filmmaker after the success of his documentary short "Barnacles Tell No Lies." In July 2008, Olson sought to combine the temporal orientation and the networked structure of blogging in order to create an online event that could call attention to the premiere of his new mockumentary, *Sizzle: A Global Warming Comedy,* which sought to address the so-called "framing wars," in which scientists have debated about how to frame the issue of global warming to a wider public. Recognizing that well-funded global warming skeptics have been successful at confusing the public over the existence, severity, and cause of global warming, a number of scientists and environmentalists had been discussing ways to educate people,

a debate in which Olson's film sought to intervene. The mockumentary featured Olson playing a hapless scientist, Randy, who was trying to make a movie about global warming.[63] In order to promote the film and to provoke some dialogue, Olson sent copies of the film to approximately fifty bloggers, most of whom worked on science and environmental issues. Other bloggers, myself included, had a reputation for reviewing or writing about independent films and documentaries. In an attempt to emulate the blogathons that have served as a means of creating community and fostering debate, the bloggers were instructed to post their reviews at exactly 5 A.M. eastern daylight time on July 15, 2008. Olson would then, in turn, post links to all the reviews on the film's web site, where interested readers could click through to get a sense of how the film was reviewed or, potentially, to become further immersed in the framing wars addressed in the film. Olson hoped to capitalize on the desire to be in the know commonly found in the blogosphere while also characterizing his film as something worthy of conversation or debate. Ultimately, he was able to provide links to forty-four reviews, a significant total for an independently produced movie.[64] In this sense, the reviews illustrate that blogs could support vibrant debate about important political issues via a series of linked film reviews.

While in some cases, film blogs can perpetuate negative reviews of a film, thus potentially burying an independent film's chances at wide distribution whether in theaters or on DVD, Wray's arguments help to illustrate how the socially networked film buffs generally serve the interests of low-budget and no-budget independent filmmakers who have little access to the marketing budgets associated with major studios. In addition to the potential benefits of a positive review, the network itself can provide valuable benefits. As Wray observes, even a few extra links to the film's official web site can increase a film's profile, noting that "the more Google-able the film, the better."[65] Wray is referring to the ways in which Google defines page rank, in part, by incoming links, and the more blog buzz that a film can create, the more likely it is to find a wider audience. Thus, even as print critics worry that film blogs may lead to a decline in the public film cultures that watch, discuss, and debate films, virtually the opposite situation seems to be emerging as bloggers and fans increasingly find public and semipublic spaces where they can discuss movies together, often despite geographic and temporal barriers.

CONCLUSION

While this chapter, in places, risks romanticizing a medium in which I have been a participant for some time, I am also aware that blogs can

provide a valuable site for cultivating a more engaged critical culture, one that turns its attention not only to the films themselves but also to the production and distribution cultures that shape industry practices. My comments here are not meant to suggest that film blogging entails anything like an autonomous culture, and, in fact, film bloggers operate alongside and are often shaped by the dominant media industries, including the Hollywood studio system. As we have seen with the online hype surrounding *Snakes on a Plane* and the viral marketing of *Black Dynamite*, Hollywood studios are primed to take advantage of the energies of fans as well as to build upon perceptions that digital cinema cultures offer opportunities for greater participation and community. In this sense, blogging is inseparable from these processes of promotion and marketing, and movie studios have been quick to tap into this enthusiasm.

However, these conversations, facilitated by a variety of social networking tools and by activities such as film blogathons, have also enabled cinephiles not only to expand their knowledge of film but also to cultivate a larger community of people thinking and writing about film. The degree of engagement evident in many film blogs demonstrates that the democratization of film reviews has not led to a decline in public conversations about film but has instead only expanded and facilitated those conversations. While many film bloggers may very well be separated geographically and may watch the films they discuss on DVD or through the internet, film blogs are perhaps the most significant evidence yet of a vibrant and engaged networked film audience.

HOLLYWOOD REMIXED
Movie Trailer Mashups, Five-Second Movies, and Film Culture

W hile film blogs offered film audiences a significant way to connect with each other across geographical distances, the popularization of video sharing via YouTube, beginning in late 2005, offered a new means for film fans to connect with each other and to reflect on the practices associated with film culture. Like film blogs, video sharing allowed audiences to discuss and debate their favorite films and television series with the added benefit of being able to upload, edit, and share video with unprecedented ease. At the same time, web video also provided a means of reinforcing the cultures of anticipation associated with the promotion of Hollywood films, essentially turning fans into laborers in the production of value for popular movies. While there were a number of other video sharing sites that appeared much earlier, the narrative framing of YouTube led to its widespread adoption as the primary site where video sharing takes place and as a symbol of the cultural and industrial shifts that were taking place within film exhibition and production contexts. In fact, any understanding of YouTube must recognize the crucial role of the social sphere in determining the dissemination and use of new technologies, as Brian Winston has observed.[1]

In this sense, the sudden popularity and widespread promotion of web video as a cultural form reactivates many of the utopian claims made on behalf of digital cinema. Like film blogs, YouTube promised the enticing possibility of greater participation to users who were told to "Broadcast Yourself." The result was a vast proliferation of videos

that were posted to the site, with 65,000 videos uploaded to YouTube alone every day. Similarly, the promoters of YouTube sought to connect this access to participation with wider narratives of community and diversity, emphasizing an image of inclusiveness and diversity. This image is one that is often expressed via videos that seek to link people from across the globe through associative editing techniques, suggesting a world community of people with shared interests and values. However, while this image of community became a crucial means by which YouTube was promoted, other features of the site—namely, the anonymity that allowed other users to leave intentionally offensive comments—led to these attempts at community often being undercut. Finally, YouTube's organization also potentially had the effect of privileging certain kinds of videos at the expense of others, in particular its use of ratings to reward the videos that received the most views and highest ratings. These popularity ratings not only feed a rhetoric of discovery that might stoke relatively traditional fantasies of stardom; it also potentially shaped the kinds of content that users would submit to the site. In this sense, YouTube's populist promise to revolutionize entertainment was constrained by these conscious and unconscious attempts to shape the site's content.[2]

Many of these new possibilities came together around the unplanned release of Robert Ryang's fake trailer mashup "Shining" in October 2005. Remixing footage from Stanley Kubrick's horror film *The Shining* (1980) into what appeared to be a family comedy, the mashup quickly went viral as a number of bloggers linked to it soon after it was posted on the web. While most of these links offered little commentary, they brought millions of viewers to Ryang's video, which was eventually posted on dozens of humor sites such as College Humor, in addition to being distributed across multiple video sharing sites. Even though "Shining" was hardly the first remixed trailer, much less the first to appear on the web, the uncanny disjunction between Kubrick's horror film and Ryang's remix enabled the video to find an audience very quickly while spawning a number of imitations and video responses, as others experimented with the fake trailer format. The video crystallized, for a number of observers, a shift in the relationship between fans and filmmakers, between producers and consumers. As a result, a number of observers were led to argue that the consumers were becoming empowered, often at the expense of the movie studios. And while the entertainment industry has embraced movie and TV remixes when they are beneficial, these videos also represent a subtle means for video creators to talk back to the industry. By looking at fake trailers, I am, of course, bracketing off the vast majority of content that appears

on YouTube and other video sharing sites; however, the debates that emerged over web video were often shaped by the very problems raised by these parody videos. In addition, I examine here only a small sample of the thousands of remixes that have been posted to YouTube; the cases addressed in this chapter, however, do represent some of the common genres of remixes.

"Shining," like the many other user-generated videos that accompanied it, also offered new models for thinking about intertextuality and film reception. In part, fake trailers could be a means for video creators to demonstrate what Matt Hills calls their "semiotic solidarity" with other fans of a given film. Remixing trailers of familiar films, in other words, is a way for video creators to communicate shared tastes with a wider community.[3] This process of remixing older films can be connected to the practice of quoting lines from movies with friends, a practice that Barbara Klinger identifies as serving to build social ties, often along gender- and generation-specific lines. Klinger describes this activity as a form of "karaoke cinema," in which a participant "'steals' lines, taking them out of context, while affectionately deifying the original text with a devoted rendition."[4] This theft, Klinger adds, becomes a means of demonstrating cleverness, of illustrating one's facility with a text. While movie remixes do not always embrace the original films, the recycling of the original is certainly connected to a desire for building community while also providing the video maker a venue for illustrating his or her skill in manipulating a familiar text. At the same time, the humor of these videos encouraged fans of fake trailers or of the remixed films to embed or post links to these remixes on their web sites, particularly when the fake trailer phenomenon was relatively new. While this no doubt fed into the "viral" spread of these videos, it also positioned bloggers as participants in spreading word about these humorous texts. As a result, fake trailers appeal to that desire to be in the know, to be a part of a larger community of film fans in on a special joke.

This practice of quotation is also connected to larger textual practices within film culture. Because digital cinema seemingly makes the entire history of film available at the click of a mouse, movie remixes become a way of navigating a wider audiovisual culture. It is worth noting that remixed videos depend, in part, on the DVD culture that has made countless films available and the principle of incompleteness that allowed viewers to recognize that texts were ready to be ripped apart and reassembled in playful new ways. This is not to suggest that the practices of the remix and mashup are new. In fact, they have a much longer history within avant-garde and experimental filmmaking practices; however, the transformation of home viewers into "film geeks"

helped to give rise to this remix sensibility as fans sought to express their cinematic sensibilities. The selection of remixed films suggests, in part, that fake trailers and other web parodies can serve as a subtle means of canon formation. Moreover, the videos constitute not only complex reinterpretations of the remixed films and genres but also of trailers themselves. By exposing the conventions of movie trailers and other promotional shorts, the remixes have the effect of mocking these marketing conventions while retaining a certain amount of solidarity with the films and TV shows used in the videos.

In addition to offering new modes of vernacular textual analysis, these videos helped to contribute to public definitions of internet video. Articles in magazines such as *Wired* collaborated in depicting YouTube as fostering a populist rebellion against a status quo entertainment system, or enumerating the ways in which readers could become "internet famous," bringing us ever closer to the moment when the boundaries between television and the internet will be indistinguishable and the lines between content producers and consumers will be utterly blurred.[5] The perception that user-generated video could lead to fame—or even a professional career in the entertainment industry—has shaped the discourses of amateur film production for some time, as Patty Zimmermann has carefully documented.[6] This discourse has trickled down into articles commenting on the movie remix phenomenon, with many commentators depicting the videos as "calling cards" for careers in the industry, thus defining the videos not merely as pleasurable leisure activities but as a form of apprenticeship for an entertainment career.

This attempt to locate a utilitarian purpose for these videos should not be too surprising. After all, the primary role of a site such as YouTube has been to extend the reach of the content produced by major media conglomerates, while also providing new sites for advertising and promotion on the web. In this sense, video sharing sites are inseparable from what Dan Schiller refers to as a "consumer-marketing complex," one that allows consumers themselves to become collaborators in the marketing of Hollywood films.[7] Similarly, John T. Caldwell argues that metacritical analyses—even the potential critical commentaries made by fake trailers and other movie remixes—retain a focus on the entertainment industry, serving to "fuel the entertainment machine."[8] In this sense, even negative attention serves to reinforce the ongoing existence of the entertainment machine itself, to maintain the ever-expansive text of a TV show or movie, even when many of these productions are unofficial.

And yet, despite the site's ability to attract audiences—many of the more prominent fake trailers have been viewed several million

times—Google has struggled to translate that into advertising revenue, in part because advertisers are skittish about having their ads placed next to amateur, potentially offensive, content, but also because of the site's ongoing litigation over copyright violations, illustrating some of the challenges the media industry has faced in building business models on web video in general and around amateur content in particular.[9] However, even while Google struggled to figure out how to match page views to advertising dollars, the site does provide major media conglomerates with additional, inexpensive sources of visibility for films and television series, with many official trailers available on the web alongside these unofficial parodies. In fact, these promotional practices often lead to certain unexpected ironies, as when the Viacom-owned video sharing site iFilm promoted "Seven Minutes Sopranos," a video celebrating the HBO gangster series, essentially offering free advertising for a media rival.[10] As Caldwell points out, this logic has now become a crucial component of the entertainment-marketing complex: "the collapse of traditional distinctions between entertainment content and marketing . . . now spurs corporations to go with the flow of the audience, rather than to fight it; to tap the audience hive as a source for production not just consumption."[11]

The fake trailer genre is also appropriate to YouTube simply because most videos that appear on the site are relatively short, lasting only three or four minutes at most. Whether this is a permanent feature of user-generated video or a temporary practice remains to be seen; however, YouTube and other sites were actively promoted as offering brief distractions from the boredom of the daily routine, with *Wired* describing these short videos as a part of the "snack culture" that has come to dominate the web. In her "Minifesto for a New Age," Nancy Miller offers the magazine's typically celebratory account of this evolution in entertainment: "We now devour our pop culture the same way we enjoy candy and chips—in conveniently packaged bite-size nuggets made to be munched easily with increased frequency and maximum speed. This is snack culture—and boy is it tasty (not to mention addictive)."[12] In this regard, snack culture becomes a means of filling time, the idle moments of waiting in shopping lines or boredom in the office, until the user can satisfy the desire for feature-length films. These shorter videos should not be seen as a substitute for longer-form entertainment, whether movies or television, but instead complement, promote, and in many ways depend on the feature films and TV shows they parody. However, an unacknowledged subtext of Miller's definition is the idea that users are simply consuming videos on YouTube, passively watching instead of actively participating, a definition that

threatened to turn the site primarily into an "entertainment destina-tion," not one where the act of producing media is being done.

While YouTube and similar video sharing sites have become rede-fined largely as sources for marketing entertainment culture, fake trail-ers and similar practices do offer a valuable site for theorizing the reception of Hollywood films. This attempt to analyze the content of YouTube videos, in some ways, flies against the hegemonic depiction of the site. In the *Wired* article on "snack culture," YouTube was celebrated as a site for quick "bites" of entertainment: briefly enjoyed, quickly for-gotten.[13] By depicting these fleeting texts as mere distractions, *Wired* and other venues in essence inoculate them against more careful scrutiny. Such texts, however, offer very specific challenges not only for media scholars but also for the industry personnel who were witnessing their content being appropriated and rewritten by YouTube users. In this context, this chapter seeks to trace out the practices of intertextu-ality deployed in video remixes and delineate the ways in which these textual strategies can simultaneously be used to "talk back" critically to Hollywood marketing discourse while also embracing many of the remixed films and television shows. In addition, the trailers, even with-out the addition of original content, can become direct expressions of a semiotic solidarity with others who share similar cultural tastes and val-ues. At the same time, these seemingly unruly texts also become part of a larger marketing chain, in which audiences become involved in the very processes of production for the studios themselves.

FAKE TRAILERS, PARODY, AND INTERTEXTUALITY

Movie remixes, as I have suggested, often have a complicated relation-ship to the films that provide them with their source material. On the one hand, movie remixes can allow a fan to produce an affirmative expression of solidarity with a favorite text; however, most fake trailers strive to comment on, criticize, or reinterpret a film or genre, often through techniques associated with parody. In particular, fake trailers often expose the conventions of high-concept films, playfully mocking formulaic Hollywood scripts, implicitly commenting on the connec-tions between what Justin Wyatt describes as the "modularity" of high-concept films and their marketability using stock promotional techniques.[14] In this sense, trailer mashups are the most recent inheri-tors of a longer tradition of film parodies. In fact, the genre mixing and the parodies of film conventions in many fake trailers build upon tech-niques developed in what Wes D. Gehring refers to as the "parody genre," films and television shows that offer recognizable parodies of

prior films.[15] These films and TV shows position us, from the beginning, to view genres critically, to make ourselves aware of the ways in which texts are constructed, and as a result they are able in the best cases to challenge the authority of dominant texts. Similarly, movie remixes often seek to use parody critically, to provoke discussion and criticism of other media forms, most commonly the marketing discourse of Hollywood films.

In this sense, the critical tone of many of these movie mashups derives from what Jonathan Gray describes as "critical intertextuality." Shows such as *The Simpsons* and *The Daily Show* not only rely upon intertextual references for their humor but also use intertextuality to criticize contemporary social or political practices. It is important to note that while these shows often feature scathing commentary on such topics as the state of the news media or the commercialization of culture, they are also part of the very industries they criticize, placing them in what Gray calls a position of "economic complicity."[16] Even though fake trailers are produced voluntarily by fans who seek no financial compensation for their work, they are also involved in the production of value, whether that value comes from the advertising revenue accumulated by video sharing sites such as YouTube or from the attention directed toward the media texts featured in the parodies. However, even while these videos cannot be fully extricated from a wider promotional culture, they can model a more critical and reflective relationship to popular culture.

This production of meaning grows out of the complicated relationship between digital media and intertextuality. Anna Everett offers a useful approach for thinking about these issues of intertextuality in relationship to new media, coining the term "digitextuality" to describe the ways in which "the digital revolution has introduced new visual and aural media codes that draw extensively from the medium specificities of film, video, and radio while introducing new characteristics and imperatives that are properties of digital technologies alone."[17] In the case of fake trailer mashups, the tension between film and video as media contribute to the humor of individual trailers. Sophisticated video creators use crosscutting and other film editing techniques often seen in theatrical trailers to create unexpected juxtapositions, although the goal of the fake trailer itself is to create the illusion of a "seamless" trailer for a movie that might have been. These edits are particularly effective in fake trailers because theatrical trailers themselves are often unstable texts, filled with gaps and jarring edits designed to reveal plot information without giving away too many details about the movie. In her discussion of digitextuality, Everett goes on to argue that "what this

means is that earlier practices of bricolage, collage, and other modernist and postmodernist hybrid representational strategies and literary gestures of intertextual referentiality have been expanded for the new demands and technological wizardry of the digital age."[18] Everett's concept of digitextuality helps to illustrate the ways in which digital media work to reinterpret prior media while introducing new aesthetic and formal strategies.

At the same time, most movie mashups conform to a limited set of categories or genres, although, as with film genres themselves, there is certainly some "genre mixing" that takes place. Following Jason Mittell's argument that genres evolve and change over time, I argue that movie mashup genres evolve and change as technical and social conditions change. In *Genre and Television*, Mittell argues, "Genres are cultural products, constituted by media practices and subject to ongoing change and redefinition."[19] While genre theory might seem like an unusual fit for a discussion of mashup videos, like Mittell I am less interested in defining specific genres of movie mashups than in using genres to account for the ways in which specific types of movie mashup videos proliferate online, how certain mashups seem to inspire responses, or at worst imitations. While these genres may only exist briefly before being replaced by other genres and types, it is clear that popular mashups inspire responses and encourage imitations that use similar discursive and narrative techniques.

In this chapter, I describe several notable genres of movie mashups, the genre remix, and the related "Brokeback" trailers. In the first genre, trailers are recut, often with sound cues from outside the original film, to create the illusion that a film is of a different genre. Thus, Stanley Kubrick's *The Shining* becomes a family comedy and *The Ten Commandments* becomes a teen rivalry movie. "Brokeback" trailers are a subset of the genre remixes, in which a film is recut to create the illusion that the movie features a homosexual romance, after the trailer for Ang Lee's *Brokeback Mountain*. In addition to "Brokeback" trailers, movie remixes can also be used to comment on current events, thus turning these videos into a self-conscious form of pop-political commentary. The final primary genre is the compilation video. Compilation videos encompass a number of different approaches, including the "Five-Second Movies" series in which a high-concept film or film series is boiled down to (approximately) five seconds, thus exposing and playfully mocking the formulaic nature of many Hollywood films. Similarly, compilation videos can include related scenes from multiple films and have been used to parody film culture in some way. These genres of political mashups often borrow techniques

from each other, as well as from a larger popular culture in which satire is a common tool for political or social critique.

In most fake trailers, this critical intertextuality turns back on film trailers themselves, as video makers sought to mock the canned marketing of Hollywood films that many trailers represent. Long derided for revealing too much plot information, for creating false expectations, or for delaying the beginning of movies in theaters, trailers represent an ideal object for parody. Lisa Kernan's discussion of the film trailer offers some suggestive ways of thinking about how trailers create meaning, noting that trailers are "quintessentially persuasive cinema texts" in the efforts to convince us to see a film, to "buy" into the film experience promised by the trailer.[20] In addition, Kernan notes, with the current blockbuster era creating a highly competitive film culture, trailers must increasingly work to ensure that they are persuasive by establishing a sense of anticipation for the film while also allowing viewers to place the film within a certain genre or set of categories. In short, trailers must carefully balance novelty and familiarity in order to ensure that the advertised film will find an audience. Kernan argues that trailers changed considerably after the rise of the high-concept film in the 1970s and 1980s, pointing out that "the increased embeddedness of marketing within film production practices results in a contemporary body of trailers that is at once highly formulaic and predictable—at times almost neoclassical—and visually dynamic and arresting."[21] It is precisely this formulaic quality that makes trailers such a ripe target for parody. Because they conform to such easily recognizable categories, YouTube viewers quickly recognize and interpret the trailer conventions that are being parodied.

In addition to serving as objects of persuasion designed to sell viewers on a film, trailers also share a number of similar formal features. Unlike the films they promote, trailers are often narratively incoherent, with images chosen for their visual or aural effect or to provide potential audiences with information about the stars, the genre, and plot of the film, and yet, as Kernan points out, trailers must maintain at least some relationship with the original film narrative.[22] In fact, trailers serve as a vivid reminder of the incompleteness of the film itself, its necessary dependence on and negotiation with other texts for the creation of meaning. It is this tension between the trailer and the actual film narrative that the fake trailer exploits. Voiceovers, music, and sound overlapping are important, formal components of the trailer as genre; however, the most crucial component of trailers is the use of editing. Here, Kernan offers the useful concept of "discontinuity editing" to describe the editing techniques deployed in film trailers.[23] This use of discontinuity editing in trailers invites parodists to play with and

subvert the original narrative of the film through the fake trailer. In this sense, fake trailers, much like trailers produced for studio films, are actively engaged in the production of meaning.

COPYRIGHT AND MOVIE REMIXES

While mashups have been a fan practice for some time, they began receiving renewed attention in the fall of 2005 with the viral spread of Robert Ryang's "Shining" mashup. These discussions accelerated in early 2006 when YouTube became a fixture of discussions of Web 2.0. "Shining" first appeared on waxy.org in August 2005 before being posted on several other video sharing sites, including College Humor and YouTube, and through blogs and other links it quickly gained a much wider audience. By late September, "Shining" was the subject of a *New York Times* article by David Halbfinger, with several other high-profile articles following soon after.[24] Halbfinger's article reflected the tone for much of the news coverage of trailer mashups, focusing on their viral popularity and authorship, as well as whether the trailer mashup violated copyright law. A few months later, YouTube exploded in popularity in February 2006 with the appearance of the "Lazy Sunday" sketch from *Saturday Night Live*, which played up the value of YouTube in highlighting short videos while also establishing YouTube's centrality to debates about posting copyrighted material.[25] This battle over copyright has raged throughout the first couple of years of the site's history, with many media companies threatening to sue YouTube if it did not come up with an effective means to prevent copyrighted material from being posted, and eventually Viacom and News Corp pressed YouTube to remove clips that they perceived to be in violation of copyright protections.[26] As a result, these videos have entered into larger debates over who has control over the meaning and dissemination of images.

As these discussions of copyright indicate, trailer mashups also occupy a complicated space in the new film cultures that are rapidly forming online. Deploying a cut-and-paste aesthetic that takes existing material to create new meanings, fake trailers are subject to some of the same copyright restrictions that have been used against other forms of fan fiction. However, because media companies were more concerned about protecting their properties, unauthorized uses were often seen as a threat to their profitability. As a result, many remixes, including fake trailers, have been taken down. It is worth noting, as Henry Jenkins points out in *Convergence Culture*, that if parody falls more clearly under "fair use," it is better protected than works that more explicitly embrace the original source, such as fan videos and tribute videos. Jenkins adds

that such a division may have gendered implications because most parody videos are produced by male editor-producers, but most tribute videos are made by female fans.[27] And as Lawrence Lessig has argued, debates about what constitutes fair use have unnecessarily clouded what counts as legal, making it difficult to know if the "sampling" of a scene from a movie is considered legal, a conflict that quite often unnecessarily burdens independent producers such as mashup creators.[28] In October 2007, YouTube presented a solution that would require media companies to provide the video sharing site with master copies of their videos, which YouTube could then use to detect unique properties so that it could delete copies posted on the internet.[29] Such an approach to copyright raises a number of important questions about whether the fake trailer genre will continue to thrive online and, more broadly, about the fair use of copyrighted materials in general.

While piracy issues receive the most attention, debates about movie remixes are also connected to larger questions about control over content. As Toby Miller et al. argue in *Global Hollywood*, copyright regulations do more than simply regulate ownership. Instead, they add that "the law itself is normative; outside the statutory sphere, copyright permeates our everyday assumptions about the uses of culture. Copyright conditions our ideas of authenticity and originality and draws boundaries that divide the winners from the losers in cultural production; it systematizes the 'semiotic affluence' of reception practices through the enumeration, governance, and disciplining of audiences."[30]

Thus, debates about copyright violation may be less about the potential financial loss associated with having a clip from a movie appear on YouTube than about regulating and shaping reception practices on the internet. In this sense, copyright law makes certain kinds of textual production possible while constraining others, reminding us that the processes of making meaning are inseparable from larger questions of power. As Gray points out in his discussion of parody, accounts of intertextuality that treat it in terms of open, unlimited play do so at the risk of ignoring these power relationships.[31] While Jenkins argues that parody may be more protected than fan videos, mashups remain a contested site for negotiating what kinds of unauthorized uses entertainment companies and content creators would be willing to tolerate.

One significant example of these debates about copyright infringement is the case of That Guy with Glasses (hereafter GWG), whose "5 Second Movie" series was removed from YouTube because of copyright infringement.[32] GWG became a popular mashup producer with his short, irreverent videos in which he reduced the content of several Hollywood films into shorts lasting no more than a few seconds, in

some cases collapsing an entire series of sequels into thirty-second video bites. Not unlike the fake trailers, GWG's videos call attention to and parody genre conventions, particularly in the sequels that GWG condenses down to a short video clip. For example, a twenty- to thirty-second video depicts all the different Batman actors repeating the catch-phrase "I'm Batman," culminating in a campy shot from the Adam West TV series. Similarly, the three *Back to the Future* videos all feature Doc Brown saying, "Great Scott" and Marty McFly saying, "Whoa, this is heavy," parodying the films' use of catchphrases and the reliance on these sound bites in high-concept films in general. And yet, the five-second movies clearly retained an affection for the original films they parodied, in part by quoting familiar lines of dialogue and showing iconic scenes, and in a sense reminding us of why we like these movies in the first place. The videos thus engage with a complicated play between repetition and anticipation, with the repeat—and in this case, partial—viewings heightening our sense of anticipation as we watch to see what scenes will be included and how they will be recontextualized. At the same time, the viewer is able to feel somewhat superior to the original, to laugh at the reliance upon the repetition associated with the formulaic writing and imagery in many high-concept films. Because copyright holders have complained, all of GWG's videos have now been removed on two different occasions (as of October 2007), and GWG has been banned from posting videos from his original account. Since then, GWG has sought to get around these restrictions by reemerging on YouTube using a different alias for each video, making it virtually impossible for YouTube to remove all of them but also making it difficult for GWG to maintain a coherent presence on the web site.

However, as the fan cultures surrounding trailer mashups continue to evolve, many studios have allowed such videos to remain online, even finding ways to profit from them. Recognizing that fan creativity can be used to cultivate new audiences and create new meanings for popular texts, some copyright holders have gone so far as to actively embrace video mashups, as in the case of HBO and the online "Seven-Minute Sopranos." By directing attention to the real *Sopranos* series, "Seven Minutes Sopranos" may have actually helped HBO to attract new audiences, particularly previous viewers who had fallen hopelessly behind but who wanted to watch the show's final season. Such activity clearly feeds into what Miller et al. have referred to as "cultures of antic-ipation."[33] Indeed, only people who were fully immersed in the excite-ment for the show's upcoming season could have produced the mashup, which enthusiastically details the series' major plot points, happily lapsing into fan-speak and using repetition to parody ongoing

plot elements, including Carmela and Tony's marital conflict. In many ways, the video departed from the show's operatic style, choosing to tell the Sopranos' story in a format that a *New York Times* critic aptly described as "hyperglib, antic, and rendered at an auctioneer's pace."[34] For all of this, it would have been easy for HBO to demand that the clip be removed, but many of the show's executives saw the unexpected advertising as generating positive buzz among internet fans. The video supplements an original text or series of texts, with "Seven Minute Sopranos" offering not only a shorthand for recalling the intricate details of over seventy-five hours of episodes but also an interpretation of the show, focusing primarily though not exclusively on Tony's actions as a crime boss and reducing his domestic problems to an ongoing back story. Thus, instead of distracting from the show, the video serves in many ways to expand its reach as well as our definition of what counts as part of the world of the original text.

INTERTEXTUALITY, FAKE TRAILERS, AND GENRE SWITCHING

Instead of anticipating upcoming films, most fake trailers mock the rhetoric of anticipation using the clichés commonly associated with movie trailers and advertisements. In one version a film is converted from one genre to a significantly different genre, a process that I refer to as a genre remix. Genre remixes, more than movie mashups in general, depict the modularity of most high-concept films. Perhaps the most famous example of genre remix is Ryang's aforementioned "Shining" trailer. The humor of "Shining" depends almost entirely on the viewer's familiarity with the original Kubrick film, but it also builds upon audience expectations about film trailers as objects and popular distaste for how trailers artificially shape expectations of a film. In transforming "Shining" into a family drama-comedy, Ryang carefully edited scenes to suggest bonding moments between father and son, while Jack Nicholson's feverish dancing is recast as cheerful exuberance, in large part through careful visual and sound editing. Ryang also uses editing devices such as wipes, infrequently used in narrative films but often appearing in trailers.[35] "Shining" culminates with Peter Gabriel's "Solsbury Hill," a song movie previews often include to market films with a romantic or emotional subtext, most memorably in ads for the Topher Grace-Scarlett Johansson romantic drama *In Good Company* and the Tom Cruise-Penelope Cruz romantic thriller *Vanilla Sky*. Thus the song helps to place Ryang's mock trailer in a subtle intertextual relationship not only with Kubrick's film but with the other film trailers that use that song, often without using it in the movies themselves.

While these trailers have frequently been read as mocking the Hollywood films that provide the source material for the video, the use of the Peter Gabriel song and the voiceover seem to suggest that it is the trailer itself that is the object of parody. As Mark Caro observes, "These people are making it impossible to view most movie trailers with a straight face. And that's a good thing."[36] Thus, instead of subverting Hollywood films themselves, fake trailers aim at an easier target, the Hollywood marketing machine that relentlessly promotes the latest films and by doing so emphasize the formulaic quality of all trailers and the Hollywood marketing machine in general. However, while movie trailers and the Hollywood marketing machine may be ripe targets for satire, it is worth noting that these fake trailers, at least in part, may be expressions of a desire for more transparent media. As Jonathan Gray notes in his discussions of *Simpsons* audiences, many of the viewers developed a shared community around the show's critical impulse, and Caro's comments illustrate the extent to which viewers might be seeking alternatives to what seems like an intrusive form of promotion.[37]

While many movie remixes significantly rework the original film, most popular fake trailers seem to have at least some affection for their sources, serving as what Wes Gehring has referred to as "parodies of affirmation."[38] Most of the films that receive the fake trailer treatment are either recent theatrical releases (when the 2007 action blockbuster *300* was released to theaters, it was given the fake trailer treatment a number of times, even before the film was on DVD) or part of a relatively limited canon focusing on films made by popular male directors such as Martin Scorsese and Stanley Kubrick. As Klinger argues in her discussion of online movie parody videos, with which fake trailers have an affinity, "Parodies help the original to gain or maintain a toehold in mass cultural canons, just as they help to indicate what constitutes mass cultural legitimacy."[39] As a result, these mashups help to establish what films are most worthy of attention and commentary while ignoring others that seem less relevant or memorable. There are, of course, fake trailers that seem far less affectionate toward their original source, such as the "Scary Mary Poppins" trailer that appears to be hostile to the children's classic, turning it into an *Exorcist*-style horror flick. Similarly, *Sleepless in Seattle* is translated from a romantic comedy into a *Fatal Attraction*-style scorned-woman film, with the perpetually chipper Meg Ryan depicted as stalking Tom Hanks, whose manic energy becomes recoded as nervousness. Significantly, many of the films that are treated more negatively seem to be genres that are associated with women or girls, such as romantic comedies or children's musicals, suggesting in some ways that the trailer mashup may be a predominantly masculine genre.[40] This

gender bias also seems to be reflected in a number of video mashups meant to criticize 2008 presidential candidate Hillary Clinton. These depictions should lead to a discussion of how YouTube's populist sensibility can serve to license hegemonic masculinity online. These movie remixes, therefore, should be read as reproducing knowledge not only of film culture but also of a gendered knowledge as well.

"BROKEBACK" TRAILERS: SEX AND THE MOVIE MASHUP

When fake trailers first began to appear in 2006–07, one of the more popular and persistent subgenres was the "Brokeback" genre, which mashed together the structure and music of the original *Brokeback Mountain* trailer with the content of another film. These trailers often work to subvert the hetero-normative orientation of most Hollywood films, but they also parody *Brokeback*'s widely seen trailer with its unambiguous heartfelt pleas for tolerance that did as much as anything to cement Ang Lee's romance as the "gay cowboy" movie. These Brokeback spoofs, like much amateur content, range from insightful to insipid; however, their commentary on filmic depictions of homosocial relationships managed to attract attention from a number of mainstream observers, including *New York Times* television critic Virginia Heffernan.[41] Brokeback spoofs invariably made use of Gustavo Santaolalla's mournful score, combining that with clips from the remixed film featuring the two male leads of another movie and the title cards from the *Brokeback* trailer hinting at the film's "taboo" topic. The most famous example is "Brokeback to the Future," which pairs Marty McFly and Doc Brown while making extensive use of the double-coding often associated with time travel to hint at a homosocial romance between the two. The *Back to the Future* films are, of course, especially ripe for a queer reading given that the time travel narratives often require Marty and Doc to stumble for explanations of their behavior, even to remain in hiding regarding their identity as time travelers. Moreover, the *Back to the Future* trilogy also offers the clever play with the incest taboo, especially in the first film of the trilogy, in which Marty travels to an era in which his mother is a teenager and he must resist her sexual advances and re-create the "primal scene" in which his parents first meet and fall in love.[42] However, while "Brokeback to the Future" is informed by audiences more attuned to queer readings, the trailer's position with regard to that reading is less clear. Further, while such queer readings may have been novel when they were first introduced, they may actually point to a limitation of the web video as a form of organic film criticism.

Most people who encounter "Brokeback to the Future" will likely be familiar with the *Back to the Future* trilogy, whether they are repeat viewers or merely familiar with the star personas of Michael J. Fox (Marty) and Christopher Lloyd (Doc). Because of the ubiquitous *Brokeback Mountain* advertising campaign in 2005 and 2006, film fans would have been equally familiar with Lee's film and its promotion, whether they had seen it or not. This familiarity with both texts informs the humor of the trailer mashup and guides the "homosocial" reading of the *Back to the Future* trilogy via *Brokeback Mountain*. Like most fake trailers, "Brokeback to the Future" opens with a green ratings card, in this case warning viewers that the advertised "film" is rated R. The point here might be to suggest that a film with homosexual content would more likely receive an R rating than a similar heterosexual romance that would probably get a PG-13.[43]

Like other fake trailers, "Brokeback to the Future" includes a brief glimpse of a studio logo, in this case Universal's, as Santaolalla's romantic score wells up in the audio track. After the ratings card, "Brokeback" introduces the fake trailer's central conceit, the romance between the trilogy's two central characters and companions in time travel, Doc and Marty. A sweeping crane shot from *Back to the Future III*, in which Doc and Marty travel back to the nineteenth-century American West, sets up *Back to the Future III*'s parody of Hollywood westerns. The crane shot of Marty's hometown of Mill Valley is followed by a black title card with the phrase, "From the producers who brought you *Brokeback Mountain*." The western motif is reinforced with additional shots of Doc and Marty riding horses and sleeping by a campfire, suggesting an intimacy that might not be as easily recognizable in a "straight" reading of their relationship. Like that for *Brokeback Mountain*, the "Brokeback" trailers typically hold their shots a little longer than most previews and make extensive use of fades and dissolves to suggest a sense of romance.

Keeping the premise of Doc and Marty as a romantic couple, "Brokeback to the Future" then features a shot from *Back to the Future* in which Marty tells the mad scientist, "I'm from the future, and I came here in a time machine that you invented." The line is delivered with an intensity that in the movie suggested urgency, as Marty desperately tries to find a way to return to the 1980s, but in the fake trailer the line becomes a profession of love between the two men. This reading is reinforced by a fade to black followed by titles that read, "It was an experiment in time," an idea visually reinforced by a shot of Doc Brown wearing dark protective goggles and holding a pair of jumper cables. The screen fades to black again with another title adding, "But the one

variable they forgot was love," with the word "love" lingering on screen just a few seconds longer to playfully emphasize the romantic text.

At this point, the trailer uses plot points from the three films to suggest a clandestine affair, and especially to hint at the age gap between Marty and Doc. Again, the coded language associated with time travel stands in for the secrecy of an affair between the two men. This is first suggested in a clip from the first *Back to the Future* film in which Marty's high school principal warns him, "This so-called Doc Brown is dangerous, a real nutcase. Hang out with him and you'll end up in real trouble." The video also recasts *Back to the Future*'s comic depiction of the incest taboo. In the original film, Marty is sent back to the 1950s, where he inadvertently interrupts the first meeting between his mother and father, unintentionally substituting himself as the object of his mother's affection. The video plays off this comic tension, including a scene from the first film in which Marty introduces Doc to Lorraine (Lea Thompson), telling her, "This is my doc, I mean uncle, Doc Brown." Marty's nervousness in the film is explained by the fact that Lorraine, his mother, has become attracted to him, but in the context of the video, Marty appears to be covering for an affair. Thus, Marty's fumbling explanations for why he can't become involved with Lorraine become recoded as his attempts to hide an affair with Doc Brown. Through such techniques, "Brokeback to the Future" established the basic structure of future "Brokeback" trailers, using decontextualized scenes and disjunctive editing to create the illusion of a romance between two male leads.

The "Brokeback" subgenre proved to be one of the more commonly imitated forms of the fake trailer, with "Point Brokeback" parodying the homosocial relationship in the cops-and-robbers/surfer movie *Point Break*, as well as "Star Wars: The Empire Brokeback," which finds a homosocial romance between the series' popular robots, C3PO and R2D2.[44] But like many others, the "Brokeback" genre depended in part on timeliness. As *Brokeback Mountain* aged, it lost its cultural relevance and video makers moved on to other genres. The project of creating queer readings of films with hypermasculine subject matter persisted, however, with one creative video maker producing "It's Raining 300 Men," a sly retake on Zack Snyder's action epic *300*, to the tune of the Weather Girls' "It's Raining Men." This approach also plays off the role of intertextual materials in "queering" popular celebrities. A similar video, "Gay Top Gun," appeared on YouTube in June 2006. In their attempts to identify the ways in which *Top Gun* "looks a little less than straight," the video's editors distance themselves from the "Brokeback" trailer for the film ("not the Brokeback trailer! Something different and

way funnier"); however, to suggest that a video is unpacking the "latent homosexual subtext" in a film in which there is very little that is actually latent exaggerates the insightfulness of this particular use of web video.

What is most compelling about "Gay Top Gun" is its use of Quentin Tarantino's cameo in the 1994 film *Sleep with Me* as Duane, a film geek who offers a "queer" reading of *Top Gun* during a drunken monologue at a party. Intercut with scenes from *Top Gun* that illustrate Duane's point, the short video seems to offer a nondescript if entertaining commentary on *Top Gun*'s homosocial elements. Duane's comments are further reinforced through playful editing that lifts scenes from the film out of context. However, what seems significant here is the implicit rivalry between the movie "outsider," Tarantino, and the consummate Hollywood star Tom Cruise. In this sense, the video seems less interested in producing yet another queer reading of *Top Gun*, which would have been redundant even by 1994 when *Sleep with Me* came out, but instead puts into motion two competing versions of stardom, the film geek versus the pop fan. Thus, "Gay Top Gun" seemed to reflect a more general sensibility of web video, both in its attempt to canonize the image of a familiar, hip, Hollywood "indie" star in Tarantino while also seeking to distance itself from the Brokeback genre in general by offering something "new." While Tarantino's economic relationship to Hollywood by 2008 hardly made him an independent director, his stature as someone who makes films that defy conventional norms—the fragmented chronology, the extensive allusions to world cinema—code him as indie for many young film fans. The use of Tarantino as an "interpreter" of *Top Gun* offered the video maker a means to use the self-reflexive techniques of the mashup to challenge the authority of Hollywood films to control and shape meaning, while also seeking to reproduce a form of semiotic solidarity with other indie film fans, tying the video in with a larger film geek culture.

PRESIDENTIAL POLITICS AND TRAILER MASHUPS

In addition to parodying movie trailers themselves, video mashup producers have also used the language of fake trailers to serve other, more explicitly political purposes, usually via an explicit partisan stance on a political candidate or issue. Because these fake trailers can be assembled relatively quickly through the combination of scenes from popular movies and from television news, political movie mashups represent an opportunity for what Patricia Zimmerman has referred to in the broader context of web cinema as a "rapid response to world events."[45] As a result, political mashups take us from the terrain of parody into something

closer to satire, commenting on current events rather than remaining content to focus on genre conventions. In fact, in many cases, the genre conventions themselves are used as a form of satire. Further, because the "snack culture" of web video privileges not only brevity but also timeliness, political commentary became an easy way for video creators to gain notice quickly while also weighing in on a current political affair. In essence, these political parodies allow mashup artists to break through the noise cluttering a specific political event and to comment, often humorously, on important issues. Like fake trailers, these rapid-response videos rely on our familiarity with both the political issue and the popular culture text used to comment on it, creating what might be regarded as a just-in-time political commentary. In fact, these videos came to be understood as the ultimate example of the disposable entertainment associated with snack culture, offering a quick observation about an event that would soon be lost in the constant cycle of news and spin. What seems significant about them, however, is their staying power in reinforcing specific perceptions of major political and public figures.

Much like the movie remixes, political parody videos as used during the 2008 U.S. presidential election relied upon a semiotic solidarity, with favored candidates being identified through editing or digital compositing with preferred characters or films. As a result, cultural fandom and political affiliation could be mapped onto each other in creative ways. Given his appeal to younger voters, it was probably no surprise that Barack Obama tended to receive the benefits of these popular-political expressions of allegiance, with Obama's two major rivals, Democrat Hillary Clinton and Republican John McCain, often cast as villains or identified with undesirable semiotics. Finally, despite the Obama campaign's success in using the web to rally support from younger voters, it is important to be cautious about identifying YouTube and other video sharing sites with a purely utopian ideal of revolutionizing politics. Because the site privileges those videos that are most popular, oppositional or unexpected political messages can be ignored or marginalized. As Alex Juhasz has argued, political videos may receive less attention or disappear from view if they support controversial or radical political ideals: "The society's already accepted opinions about race, or politics, are most highly valued, receive the most hits, and thus are easiest to see."[46] Despite these potential problems, political parody videos often prove to be effective texts not only for reading political culture against the grain but also for thinking about our place within a wider film culture as well.

The use of popular culture to comment on politics itself takes on a variety of genres and styles, often using forms of shared textual tastes in

order to endorse or criticize political candidates. In "Godfather IV," an appropriation of the conventions of the fake trailer made an overt political point about a current event: the Justice Department scandal in which then Deputy Attorney General Alberto Gonzales sought to get approval from Attorney General John Ashcroft for a new terrorist surveillance program. While the video likely requires a fairly deep and specific knowledge of the situation, it also uses the cinephiles' shared distaste for the third *Godfather* movie to view the scandal as yet another bad sequel. In a slightly different approach, "Hillary's Downfall" built upon a popular subgenre, or meme, of videos that uses scenes from the Hitler biopic *Downfall* but with new English subtitles designed to place the Hitler character in contemporary predicaments. In one example, Hitler is depicted as being on the phone with the Microsoft help desk; in another, he complains about his Xbox not working properly. In this case, Hitler literally becomes a beleaguered Hillary Clinton, his recognition that the war was lost being transformed into a commentary on Clinton staying in the presidential race long after the conclusion seemed inevitable. Here the association between Hitler and Clinton is meant not only to shock but to depict her as stridently authoritarian and antidemocratic. In this sense, the video reinforced the conservative frame through which Clinton is often perceived. A third set of videos used digital compositing to overlay the faces of Barack Obama, Hillary Clinton, and other public figures onto the stars of famous movies such as *Rocky* and *The Empire Strikes Back*. In the first case, Obama is transformed into "Baracky," a strange hybrid of the underdog boxer and the superstar politician that culminated in Rocky/Baracky's triumphant run up the steps of the Philadelphia Museum of Art, creating in essence a visual fantasy of Obama winning the Democratic primary in Pennsylvania. Meanwhile, "The Empire Strikes Barack" depicted Obama as a light-saber wielding hero fighting back against a Hillary Clinton–Darth Vader hybrid. In all these cases, shared cinematic values become mapped onto shared political values, and the cultural texts become a means for video makers to comment on current events, sometimes in critical ways.

COMPILATION VIDEOS

While fake trailers are among the more dominant and widely discussed forms of movie mashup parodies, they are but one category of fan engagement with Hollywood films. Compilation videos provide yet another way for film cultures to come together over shared cinematic tastes. Like the fake trailers, compilation videos rely upon the ready availability of Hollywood film history, on the degree to which YouTube

not only materially but also metaphorically keeps all texts available for reuse and recycling into new narratives. There are dozens of examples of videos where the creators assemble video compilations of "best" and "worst" movie scenes. One of the more compelling examples of a compilation video is "100 Movies 100 Quotes 100 Numbers," produced by the "Alonzo Moseley Film Institute," a sly parody of the American Film Institute's compilation shows in which they honor the Top 100 movies, 100 sexiest stars, the 100 greatest movie quotes, and so on. As I have argued, the AFI lists have come under scrutiny from film bloggers and reviewers because of the lists' inherent biases in promoting a relatively safe film canon. Thus, like the blog lists, these compilation videos do valuable work in questioning the role of institutions such as AFI in normalizing and homogenizing taste. At the same time, the practice of sharing these videos also functions as a means of building community with other film fans, which this video does through the practices of creative citation. If film blogging represents a means for groups to develop a sense of connection, potentially across the globe, then web video extends this sense of what Acland has called "felt internationalism," allowing viewers to "geek out" over the reinscription of several of their favorite movies into entirely new contexts.

While new editing technologies make these compilation videos much easier than they might have been in the past, they do require a significant amount of (unpaid) labor, especially for some of the more elaborate compilation videos. In this sense, they should be understood in terms of the tremendous investment—in time and attention—required to make them. The "Seven-Minute Sopranos" video, for example, took a reported 90 to 100 hours to edit and record sound. That time does not include the number of hours spent watching episodes of the show, often several times, that gave the editor-producers the knowledge of the show necessary to produce a factually accurate video about a TV series that had run for approximately 77 hour-length episodes when the video was made.[47] The "100 Movies 100 Quotes 100 Numbers" video, which has been viewed well over one million times, parodies the AFI compilation videos by including scenes of actors from prominent movies delivering lines with numbers in them, arranged to count down from one hundred to one, echoing the AFI practice of counting down to the highest-ranked film on their list.[48]

Unlike the AFI list, the "100 Numbers" list favors films that might not be regarded as canonical by traditional standards, although many of the cited films—*The Breakfast Club, Dead Poets Society, The Princess Bride,* and *Midnight Run,* to name a few—betray a distinctly 1980s sensibility, turning the video into a kind of time machine for revisiting one's

personal experiences with the cited movies. In her discussion of her students' repeat viewings of 1980s films, Klinger points out the ways in which repeat viewings can be used both as a form of personal therapy associated with comfort viewing and as a form of reinforcing "generational, gender, and other bonds."[49] These social elements are reflected in the ongoing stream of comments posted to the video's page on YouTube. While the vast majority of comments simply express fawning admiration for the video's cleverness, others transcribe or list their favorite quotes ("I knew 36 would be Clerks!"), while a somewhat smaller group cites films they think were wrongfully omitted ("42 should have been Hitchhiker's Guide to the Galaxy"). In this sense, the video cannot be separated from the role of quoting favorite movies as a form of community-building as people discuss their shared memories of the movies cited in the video.

A similar compilation video, found on YouTube under the title "Women in Film," presents a much more complicated set of relations between images. Unlike the visible cuts in the "100 Numbers" video, "Women in Film" morphs between a number of Hollywood actresses, starting from Marlene Dietrich and Marilyn Monroe to Nicole Kidman and Catherine Zeta-Jones, and featuring Yo-Yo Ma's performance of the prelude to Bach's Cello Suite no. 1.[50] As a number of commentators, including *Hollywood Reporter* columnist Anne Thompson, pointed out, the effect of the video is somewhere between creepy and hypnotic, with viewers drawn into seeking out their favorite actresses while finding themselves similarly astounded by the skillful use of digital morphing technologies.[51] In his discussion of morphing, Lev Manovich associates morphing with "the aesthetics of continuity," observing that "computer-generated morphs allow for a continuous transition between two images—an effect which before would have been accomplished through a dissolve or cut."[52] By this logic, the aesthetic of continuity seems to reinforce the idea that these actresses remain the object of what Laura Mulvey famously described as the male gaze.[53] Like the classical Hollywood actresses described by Mulvey, the morphing between actresses in this video holds the viewer's gaze. The visual continuity between the actresses suggests and implicitly celebrates their similar appearances and the actresses become a site for contemplation for the viewer, prompting a couple of comments on the video site asking for a "Men in Film" video and others to note that few women of color were featured, which is more than likely the result of Hollywood's history of privileging whiteness than it is of the video maker's biases. In fact, the contemporary stars included Angela Bassett, Penelope Cruz, and a number of other black, Latina, and Asian stars.

More crucially, the use of morphing the video points to the ongoing remediation of film by video, a process evoked in the video's title, "Women in Film." And yet, the video retains a remarkable affinity for film itself as a medium, pointing to the ways in which digital media have incorporated and adapted to film not with a distinct rupture, but through continuities, embracing rather than rejecting film. Moreover, the "Women in Film" video, through its reverential use of these images of Hollywood starlets, reinforced via the classical music sound track, stands in stark contrast to the parody videos more commonly found on the web. Unlike the parody videos that define the video makers as "renegades," "Women in Film" is more explicit about its affirmative relationship to the Hollywood actresses it depicts. At the same time, the video seems to be compelled by a similar impulse for a shared community of appreciation for Hollywood films.

STUDIO APPROPRIATION OF MOVIE REMIXES

As movie remixes became more popular, movie studios increasingly recognized the potential benefits of engaging with the fan cultures that enthusiastically embrace their work. Hoping to capitalize on what amounted to a form of voluntary labor that was directing attention to major movie franchises, a number of studios began inviting fans to produce fake trailers and other mashup videos, even at the risk that fans might take that content in unanticipated directions, while most fake trailers and other remixes have been allowed to remain online.

In one of the more ambitious attempts to tap into fan activity, Twentieth Century Fox created Fox Atomic, a new genre label featuring horror films targeted at teen audiences. In the summer of 2007, they launched a blender tool that allows fans to create mashups using scenes from the label's upcoming films, including *The Hills Have Eyes 2*, *Shooter*, and *28 Weeks Later*. Of course, it's unclear whether the Fox Atomic experiment generated increased ticket sales; however, the web site presented itself as embracing participatory culture, with one executive seeking to describe Fox Atomic as "the anti-studio."[54] Fox clearly seemed to be trying to attract the enthusiasm and energy associated with fan communities, illustrating the ways in which these community-building and social activities can be appropriated by the entertainment industry. As a result, the Fox Atomic experiment illustrated the degree to which these fan activities are not inherently liberating. Significantly, Fox Atomic was relatively short-lived. Only a year after the label was established, its marketing wing was eliminated and brought back under the direction of its parent company.[55]

Twentieth Century Fox used a similar approach when a fan-produced video celebrating its *Die Hard* films appeared on YouTube a few weeks before the summer 2007 release of *Live Free or Die Hard*, the fourth installment of the Bruce Willis action series. The video was posted by the novelty rock band Guyz Nite and featured clips from the *Die Hard* films and lyrics expressing the band's enthusiasm for the trilogy. When the video appeared, Fox initially demanded that YouTube pull the clip, but with the release of the fourth installment in the *Die Hard* film series, Fox not only invited Guyz Nite to repost the video to YouTube but also provided the band with an early synopsis of *Live Free or Die Hard*, as well as footage from the film that they could incorporate into a revised version of their video.[56] Fox then began using the song to promote the movie and DVD, even in a number of television commercials. While the studio was able to recognize the benefits of collaborating with their fans, their decision to incorporate the video into their marketing campaign also raises important questions about the limits of the fan-produced videos that are allowed to remain on the web. Unlike GWG's "5 Second Videos," the Guyz Nite song offered a much more affirmative treatment of the original films, uncritically celebrating John McClane's (Bruce Willis) model of wise-cracking bravado and resourcefulness. Thus, studios are more likely to block videos and other texts that offer a more critical approach or even an approach that takes a movie completely out of its original context.

CONCLUSION

By raising questions about why these new film cultures are identified with the home, trailer mashups represent an interesting challenge to traditional models of film studies that place emphasis on theatrical screenings. Instead of being associated with what Klinger refers to as "home film cultures," fake trailers, like the film blogs that link to and often discuss them, represent an emerging networked film culture in which film buffs produce, distribute, and discuss videos that rework and comment upon Hollywood films. These practices often allow for forms of critical engagement, whether through the parody of Hollywood marketing or through the use of cultural texts to comment on current affairs, but there have also been web sites such as Fox Atomic that seek to channel fan activity directly into the promotional aims of the studio. While it would be a mistake to read user-generated fake trailers as oppositional practice, they often parody the rhetoric of promotion found in movie trailers. Similarly, compilation videos, such as "100 Movies 100 Quotes 100 Numbers," offer an irreverent glance at the

processes by which classical Hollywood films become canonized—and marketed—to film audiences, even while they celebrate other films that may be perceived as wrongfully ignored or devalued. In both cases, however, an affirmative relationship to Hollywood film culture remains unquestioned. Thus, despite the revolutionary rhetoric that has come to define many of these changes, the rise of the fake trailer and other forms of web video implies not a radical break with the cinematic past but a series of continuities and reinterpretations of it. And ultimately these fake trailers illustrate that, whatever else digital cinema is doing, it is also quite clearly a means for expanding the sites where cinema can be commodified, for bringing movies to the widest possible audiences.

However, the reactions within the entertainment industry to these forms of fan activity cannot be separated from the industrial, social, and historical conditions that shape film exhibition, distribution, production, and consumption. While a number of media companies, including Viacom, have attempted to contain these fan productions, others, such as Fox Atomic, have sought to co-opt them by providing fans with material for creating their own videos. There is little doubt that such activities served primarily to promote the Fox Atomic brand as a kind of "anti-studio," one that dispenses with the opposition between fans and the studio, between producers and consumers. The fan activities on the Fox Atomic site remained oriented toward current and upcoming theatrical releases, retaining an emphasis on first-run features appearing in theaters.

While there will always be a number of efforts on the part of the entertainment industry to control or limit these intertextual practices, movie remixes continue to occupy a complicated position from which film culture can be viewed. The celebratory accounts of these mashups help to foster the utopian ideal that anyone with a computer is a potential producer, able to remix, rewrite, and reinterpret Hollywood movies. And, in fact, trailers often comment critically on the very processes of marketing, seemingly offering an alternative to a wider media culture that is seen as manipulative. At the same time, discussions of fake trailers provide individuals with opportunities for forging connections over shared cinematic tastes. These videos also allow users to find a new language informed by popular culture with which they can comment on current events. As a result, movie remixes, through their complicated renegotiation of intertextuality, illustrate the degree to which texts work in constant dialogue not only with other texts but also with audiences themselves. These texts should serve as an important reminder to scholars to remain attentive to the expanding film archive and its role in shaping interpretation.

CONCLUSION

The current moment of digital transition is introducing significant changes to the medium of film. In fact, it seems clear that the proliferation of portable media players and distribution streams have altered our relationship to film culture in ways that remain difficult to predict. Although Ira Deutchman has referred to the current phase as a "post-studio, pre-internet" moment, that label is somewhat misleading: studios still wield enormous power and influence over what we watch, where we watch it, and even how we watch. Nevertheless, his comments illustrate the felt sense that cinema is being reinvented by digital technologies. While a number of observers have sought to characterize the digital turn in cinema as providing consumers with increased choice and control over the consumption of movies at home, it is far less clear whether digital projection will provide audiences with as many choices outside the theater, despite the innovative efforts of a number of independent producers. At the same time, the ongoing shift to digital exhibition challenges traditional economic models and exhibition protocols, altering not only the selection of movies available but also our relationship to film as a medium.

In my attempt to map out the terrain of digital cinema, I have sought to address the ways in which film is defined not merely as a technological apparatus, but also as Lisa Gitelman reminds us, in terms of the social practices associated with it.[1] Watching a movie in a theater, at home on a DVD player, or on the subway on an iPod entails far more

than the activity of looking at a screen, and in some cases the uses of new technologies, especially portable media players, upset normative definitions of public and private space, requiring people to develop new codes of etiquette to match the new technologies. Thus, my use of the term digital cinema here is meant to incorporate not only film culture as it is practiced in theaters but also as it is reimagined by the new devices that place emphasis on instantaneous one-click access to what appears to be an unlimited amount of content. This ability to access movies anytime or anywhere seemingly places viewers in much greater control over their cinematic experience while also establishing the conditions by which the web is transformed into what Dan Schiller has described as "a self-service vending machine of cultural commodities."[2] As Schiller's comment illustrates, commercial interests still dominate the production and distribution of movies, and while the celestial jukebox may have virtually unlimited choices, viewers are still guided toward certain choices at the expense of others, in part through the manufactured hype that accompanies the release of any Hollywood blockbuster. In addition, this anytime, anywhere distribution model also has the effect of reshaping theatrical distribution model based on scarcity, in which there are only a limited number of screens available at any given time.

In addition to offering new devices and contexts for viewing films, digital cinema is also associated with a vast expansion of content, a situation I have sought to address in part through Nicholas Rombes' concept of incompleteness. Rombes observed that with the inclusion of extras on the DVD, audiences were given the perception that movies are infinitely malleable or expandable.[3] More recently, of course, film texts are expanded even further through additional scenes posted to the web, allowing viewers to broaden their experience of a film well beyond the initial textual boundaries, while also ensuring a seamless mix of entertainment, marketing, and branding. Of course, these supplemental do more than promote specific films; they also promote a specific relationship with the film industry itself, addressing us on DVDs in particular, as connoisseurs, as experts on film culture. As John T. Caldwell has documented, these textual materials present an important site for the ongoing definition and "self-theorization" of the production cultures associated with film and television.[4]

At the same time, we are also witnessing a vast expansion of DIY and ultra-low-budget film production, due in part to inexpensive production and distribution equipment, leading to a significant transformation of the practices associated with film exhibition. Thus, even though Hollywood blockbusters are breaking box office records, indies face the recognition that many films that had historically played in

theaters would now be unlikely to receive theatrical exhibition, except perhaps at a few festival screenings. This has forced many major independents to shut down or seriously curtail production while others must create new models that avoid the theatrical "bottleneck." In the summer of 2008, these shifting distribution models contributed to a profound sense of crisis within the independent film industry, with a number of filmmakers and entertainment journalists asserting that a "glut" of DIY films was gumming up the works, making it more difficult for the "good" independent films to emerge from the clutter of what *Salon* writer Andrew O'Hehir described as "a deluge of abysmal crap."[5] Although I am less interested in identifying specific causes of the indie crisis, the debate over the new status of independent films does say quite a bit about the perceptions of cinema's social role and how digital distribution might alter it.

The argument that too many films are being produced ultimately carries quite a bit of weight, with *Variety* columnist Anne Thompson pointing out that the number of submissions to the Sundance Film Festival increased from 750 to over 3,600 in the course of just six years.[6] Others, such as Carrie Rickey, speculated that the number of indie films might also pressure theaters to replace films more quickly, preventing smaller movies from developing the necessary word-of-mouth buzz to compete in a competitive marketplace.[7] Few people articulated this sense of crisis more powerfully than The Film Department CEO Mark Gill, who looked at the highly unstable indie market and declared, "The digital revolution is here. And boy does it suck."[8] Gill's comments came as several major indies, including Picturehouse and Warner Independent, were shutting down completely while others, such as New Line and Sidney Kimmel, were forced to downsize significantly. As Gill implored his audience to "make fewer better," his remarks conveyed a sense that the business models of Indiewood were coming into question, thanks in no small part to digital cinema.

The implied snobbery of O'Hehir and Gill's comments toward DIY filmmakers notwithstanding, their characterization of a "glut" of indie movies raises two important questions about digital film culture. First, the new distribution models transform the means by which we use filters in order to find movies. In many cases, these filters can be social, based on blog reviews, for example. In fact, Rickey's emphasis on the idea that indie films need more time to generate buzz illustrates what essentially amounts to a breakdown in the filtering system. However, many of these filtering systems have become increasingly automated. As the Netflix contest to create a better recommendation algorithm illustrates, the ability to chart a person's taste can be quite powerful.

However, while the Netflix model may be incredibly adept at identifying genres and films that an individual film consumer might enjoy, these filters may also have the effect of fragmenting audiences even further, contributing to the loss of a common culture. I am always struck, for example, when I look on Netflix at the "local favorites" for Fayetteville, North Carolina, where I live and teach, how few of the top movies look interesting, or in some cases, familiar. To be sure, Hollywood studios continue to produce massive blockbusters seen by millions of people, but the sheer volume of movies may have the effect of fragmenting audiences even while providing individuals with precisely the films they would most enjoy.

At the same time, the discussion of the indie crisis was remarkable because of the degree to which the movie theater remained at the center of how film culture is defined. Rickey, for example, was attentive to the ways in which the changing distribution models contribute to "churn" in theaters, ignoring the role that DVD and other forms of distribution can have in sustaining and even expanding the life of a film. Similarly, Gill's account also defines independent film almost entirely in terms of theatrical screenings, both in his emphasis on the slim chances of a even a Sundance-endorsed film getting theatrical distribution and making money and in his depiction of an adult theatrical audience seeking out a communal experience. While Gill later acknowledges that audiences will eventually consume indie movies via "whatever that large pipe that goes to all of our houses will be called," cinema remains defined primarily in terms of theatrical distribution.[9] Significantly, many of the indie filmmakers and film critics who responded to Gill's comments emphasized his depiction of moviegoing, arguing in some sense that the cultural role of the movie theater had changed. Specifically, David Poland asserted that independent film consumers were "EXACTLY the audience that is abandoning theaters. Teens aren't. Lower income people aren't. It is people over 30 with busy lives who can afford bigger TVs, a wide array of pay cable channels, and DVD rental and purchase."[10] Kent Nichols, one of the producers of the popular web series *Ask a Ninja*, echoed Poland's claims, emphatically stating that "adults don't go to theaters anymore."[11] While both Nichols and Poland underestimate the fact that many theaters only rarely offer content targeted toward older adults, their more general point—that theaters have been redefined in large part as sites of youth activity—seems crucial here. Theaters have always been destination points for teenagers on dates or social outings, yet Poland and Nichols depict the abandonment of theaters as a deliberate choice by consumers based on their distaste for going out among the crowds of kids, not as an effect of a lack of choices at the theater itself.[12] In this

sense, Poland and Nichols are essentially defining the theater almost exclusively in terms of its role in showing Hollywood blockbusters and in catering to younger audiences. Movie consumption for indie film fans, from this perspective, becomes less about the communal experience of moviegoing and more about navigating a menu watching a specific film.

Ultimately, many critics were left with the perception that one version of indie film appeared to be endangered, with the result that theatrical distribution could become even more undemocratic and placing even more power in the hands of a few media conglomerates. As a result, a number of indie film producers and distributors, including IndiePix, SnagFilms, IFC, and IndieFlix, have sought to create new distribution models on the web or via video-on-demand. In fact, while studio filmmakers and theater owners continued to criticize day-and-date releasing, characterizing it in some cases as a threat to the very definition of film, a number of indie filmmakers have recognized it as a viable option for getting their films seen. These models have been successful in helping some low-budget filmmakers find a wider audience, but it remains unclear how these models will be used. Viewing at home may prevent audiences from feeling as if they are participating in the communal act of moviegoing and the larger connection between cinema and "civic life."[13]

However, while one version of this communal activity seems to be in danger of being lost, many of these indie distribution sites also deploy many of the techniques of social networking in order to build the shared sense of collectivity associated with public moviegoing. In fact, virtual web communities, including film bloggers and mashup artists, can congregate virtually online, with many bloggers even structuring events, such as blogathons and live blogging, to create a sense of simultaneity. Although major media conglomerates can also reincorporate these practices back into the promotion of commercial films, blogs in particular at least maintain the imagined experience of the communal experience of watching with a crowd.

Many of these desires are encapsulated in From Here to Awesome (FHTA), the new distribution and discovery model designed by successful DIY filmmakers Arin Crumley, Lance Weiler, and M. Dot Strange. FHTA was billed as a cross-platform, multi-venue festival that would provide a central hub where filmmakers could tap into the power of social networking sites in order to promote their films. Participants would submit a short teaser video to the FHTA web site promoting their film. Significantly, these teasers were not traditional trailers but more like video statements from the films' directors explaining why they made the film and at the same time building a sense of connection with the

viewers. In addition, the directors mention the various social networking sites, such as blogs, Facebook, MySpace, and Twitter, where more information about the film can be found. And if the viewers decided they were interested in seeing the movie, they would then be instructed to click a button on the FHTA page indicating that the film "looks awesome," allowing them to become virtual festival programmers. The use of direct address in these videos can be quite effective, and the cultivation of a longer-term connection between filmmakers and viewers not only ensures a more sympathetic audience, but also serves as an attempt to revive some of the social aspects of movie consumption.

After the voting, winning films went through a further vetting process before the festival itself in July 2008, which included ten features and ten short films, with FHTA releasing the films simultaneously on Amazon Unbox, Vudu, Hulu, and several other digital platforms streaming to both TV sets and computers. In addition, they were able to organize screenings of all the winning films in cities ranging from Los Angeles and San Francisco to London and Melbourne, as well as at least two dozen drive-in screenings. And even if viewers did not live in a city where the screenings could take place, they could still participate virtually in the festival. Thus, audiences across the globe could share in the experience of participating. In this sense, FHTA has tapped into the sense of "felt internationalism" that Acland associates with the moviegoing crowd.[14] While FHTA's attempts to produce an international moviegoing audience may only be partial, this fantasy of a global, social movie audience should not be quickly dismissed. Their attempts to create a more sustainable and inclusive distribution model illustrates the potential for digital cinema in creative new alternatives, not only for filmmakers but also for the audiences who watch, think about, and discuss their films. It also reminds us of the fact that cinema continues to play a vital cultural role, no matter when, where, or how we watch.

Notes

INTRODUCTION

1. Steve Bryant, "Sicko Leak Benefits Moore," *NewTeeVee*, June 19, 2007, <http://newteevee.com/2007/06/19/sicko-leak-benefits-moore/>.
2. Quoted in ibid.
3. David Poland provided the most thorough analysis of the leak of *Sicko* to YouTube. See Poland, "Sicko Piracy Updated," *Hot Blog*, June 18, 2007, <http://www.mcnblogs.com/thehotblog/archives/2007/06/sicko_piracy_up.html>. See also Gregg Goldstein, "Michael Moore's 'Sicko' Pirated, on YouTube," *New Zealand Herald*, June 19, 2007, <http://www.nzherald.co.nz/section/story.cfm?c_id=5&objectid=10446630>.
4. Anne Thompson, "Frustrated Indies Seek Web Distib'n," *Variety*, February 15, 2008, <http://www.variety.com/article/VR1117980978.html?categoryid=1019&cs=1>.
5. Wheeler Winston Dixon, "Vanishing Point: The Last Days of Film," *Senses of Cinema* 43 (2007), <http://www.sensesofcinema.com/contents/07/43/last-days-film.html>.
6. Barbara Klinger, *Beyond the Multiplex: Cinema, New Technologies, and the Home* (Berkeley: University of California Press, 2006), 195.
7. Charles R. Acland, *Screen Traffic: Movies, Multiplexes, and Global Culture* (Durham, N.C.: Duke University Press, 2003), 57.
8. See, for example, D. N. Rodowick, *The Virtual Life of Film* (Cambridge, Mass.: Harvard University Press, 2007).
9. Catherine Russell, "New Media and Film History: Walter Benjamin and the Awakening of Cinema," *Cinema Journal* 43.3 (Spring 2004), 83.
10. See, for example, William Boddy, "A Century of Electronic Cinema," *Screen* 49.2 (Summer 2008), 144.
11. Lisa Gitelman, *Always Already New: Media, History, and the Data of Culture* (Cambridge, Mass.: MIT Press, 2006), 7.
12. Amanda D. Lotz, *The Television Will Be Revolutionized* (New York: New York University Press, 2007), 29.
13. See, for example, John Belton, "Digital Cinema: A False Revolution," *October* no. 100 (Spring 2002), 99–114.
14. Acland, *Screen Traffic*, 221.

15. Christopher Hawthorne, "The Landmark Theatre Has Your Living Room in Its Sites," *Los Angeles Times*, June 1, 2007, <http://articles.latimes.com/2007/jun/01/entertainment/et-landmark1>.

16. Henry Jenkins, *Convergence Culture: Where Old and New Media Collide* (New York: New York University Press, 2006), 14–15.

17. One example of this is David Denby, who notoriously worried that "platform agnostic" teenagers accustomed to watching movies on video iPods and laptops would no longer value the big-screen theatrical experience. See David Denby, "Big Pictures: Hollywood Looks for a Future," *New Yorker*, January 8, 2007, <http://www.newyorker.com/critics/atlarge/articles/070108crat_atlarge>.

18. Chris Anderson, *The Long Tail: Why the Future of Business Is Selling Less of More* (New York: Hyperion, 2006), 226.

19. Dan Schiller, *How to Think about Information* (Urbana: University of Illinois Press, 2007), 141.

20. Yochai Benkler, *The Wealth of Networks: How Social Production Transforms Markets and Freedom* (New Haven: Yale University Press, 2006), 34.

21. Ibid.

22. Klinger, *Beyond the Multiplex*, 13.

23. Boddy, "A Century of Electronic Cinema," 145.

24. Ibid., 148–50.

25. Godfrey Cheshire, "The Death of Film/The Decay of Cinema," *New York Press*, August 26, 1999, <http://www.nypress.com/print.cfm?content_id=243>.

26. Brian Winston, *Media, Technology and Society, A History: From the Telegraph to the Internet* (London: Routledge, 1998), 2.

27. Winston, *Media Technology, and Society*, 11–12.

28. Lotz, *The Television Will Be Revolutionized*, 20.

29. Michele Pierson, *Special Effects: Still in Search of Wonder* (New York: Columbia University Press, 2002), 53.

30. Claudia Springer, "Psycho-Cybernetics in Films of the 1990s," in *Alien Zone II*, ed. Annette Kuhn (London: verso, 1999), 203–220.

31. Anderson, *The Long Tail*, 3.

CHAPTER 1: THE RISE OF THE MOVIE GEEK

1. See, for example, Caetlin Benson-Allott, "Before You Die, You See *The Ring*," *Jump Cut* 49 (Spring 2007). See also Chuck Tryon, "Video from the Void: Video Spectatorship, Domestic Movie Cultures, and Contemporary Horror Film," *Journal of Film and Video*, forthcoming.

2. Barbara Klinger, *Beyond the Multiplex: Cinema, New Technologies, and the Home* (Berkeley: University of California Press, 2006).

3. Elvis Mitchell, "Everyone's a Film Geek Now," *New York Times*, August 17, 2003, <http://query.nytimes.com/gst/fullpage.html?res=9F06E3DC1E31F934A2575BC0A9659C8B63>.

4. Michele Pierson, *Special Effects: Still in Search of Wonder* (New York: Columbia University Press, 2002), 53.

5. Toby Miller, *Cultural Citizenship: Cosmopolitanism, Consumerism, and Television in a Neoliberal Age* (Philadelphia: Temple University Press, 2007), 7.

6. Toby Miller, Nitin Govil, John McMurria, and Richard Maxwell, *Global Hollywood* (London: British Film Institute, 2001), 61.

7. John Thornton Caldwell, *Production Culture: Industrial Reflexivity and Critical Practice in Film and Television* (Durham, N.C.: Duke University Press, 2008), 300.

8. Edward Jay Epstein, *The Big Picture* (New York: Random, 2006), 209.

9. Motion Picture Association of America, "Entertainment Industry Market Statistics," 2008, <http://www.mpaa.org/USEntertainmentIndustryMarketStats.pdf>.

10. In fact, according to some estimates, Wal-Mart accounts for 60 percent of sales for a best-selling DVD. See David D. Kirkpatrick, "Shaping Cultural Tastes at Big Retail Chains," *New York Times*, May 18, 2003, <http://nytimes.com>.

11. Patrick von Sychowski, "Digital Cinema Is Not a Technology," Digimart Global Distribution Summit, September 22, 2005, <http://digimart.org/en/index.php#>.

12. Michelle Abraham, cited in Robert Alan Brookey and Robert Westerfelhaus, "Hiding Homoeroticism in Plain View: The *Fight Club* DVD as Digital Closet," *Critical Studies in Media Communication* 19.1 (March 2002), 21.

13. For the details of the industry's process in arriving at a single digital format, see Epstein, *The Big Picture*, 213.

14. Laserdiscs produced by Criterion, for example, cost as much as $150, pushing them well out of the price range of anyone other than the most avid collector. See Bradley Schauer and Susan Arosteguy, "The Criterion Collection in the New Home Video Market: An Interview with Susan Arosteguy," *Velvet Light Trap* 56 (Fall 2005), 35.

15. Klinger, *Beyond the Multiplex*, 60–68.

16. J. D. Lasica, *Darknet: Hollywood's War against the Digital Generation* (Hoboken, N.J.: Wiley, 2005), 61.

17. Thomas Elsaesser, "Cinephilia or the Uses of Disenchantment," *Cinephilia: Movies, Love, and Memory* (Amsterdam: Amsterdam University Press, 2005), 41.

18. See, for example, Hoda Kotb, "Video Clerk to Box Office Icon," MSNBC.com, April 25, 2004, <http://www.msnbc.msn.com/id/4817308/>.

19. Steve Erickson, "Permanent Ghosts: Cinephilia in the Age of the Internet and Video, Essay 1," *Senses of Cinema* 4 (March 2000), <http://www.sensesofcinema.com/contents/00/4/cine1.html>.

20. Theo Panayides, "Permanent Ghosts: Cinephilia in the Age of the Internet and Video, Essay 2," *Senses of Cinema* 4 (March 2000), <http://www.sensesofcinema.com/contents/00/4/cine2.html>.

21. D. N. Rodowick, *The Virtual Life of Film* (Cambridge, Mass.: Harvard University Press, 2007), 26. Emphasis in the original.

22. For a discussion of the role of VHS and DVD in reshaping distribution culture, especially as it pertains to network television, see Amanda D. Lotz, *The Television Will Be Revolutionized* (New York: New York University Press, 2007), 119–151.

23. Bryan Reesman, "Raiders of the Lost Art," *Moviemaker* 15.73 (Winter 2008), 68.

24. Dan Schiller, *How to Think about Information* (Urbana: University of Illinois Press, 2007), 116.

25. Derek Kompare, "Publishing Flow: DVD Box Sets and the Reconception of Television," *Television & New Media* 7.4 (November 2006), 337.

26. Caldwell, *Production Culture*, 283, 299. For a discussion of the role of Disney's use of television in negotiating technology, see J. P. Telotte, *The Mouse Machine: Disney and Technology* (Urbana: University of Illinois Press, 2008).

27. In fact, there is some evidence that DreamWorks, the studio that produced *The Ring*, held back the U.S. distribution of *Ringu* in order to ensure that the remake would be as profitable as possible. However, the practices of pirating the original may have had the opposite effect of generating interest in the American remake. See, for example, Vera H-C Chan, "Asian Pop: Korean Movies, Hold the Koreans," *San Francisco Chronicle*, July 1, 2004, <http://sfgate.com/cgi-bin/article.cgi?f=/g/a/2004/07/01/korcine.DTL>.

28. Charles Shiro Tashiro, "Videophilia: What Happens When You Wait for It on Video," *Film Quarterly* 45.1 (1991), 7–17.

29. The concept of time-shifting originates with Akio Morita, the longtime Sony chairman. See Akio Morita, *Made in Japan: Akio Morita and Sony* (New York: E.P. Dutton, 1986), 208–209. The most thorough analysis of time-shifting in relationship to the VCR is Anne Friedberg, *Window Shopping: Cinema and the Postmodern* (Berkeley: University of California Press, 1993).

30. Morita, *Made in Japan*, 208–209.

31. Jason Mittell, "Exchanges of Value," *Flow* 3.4 (October 2005), <http://flowtv.org/?p=264>; Lotz, *The Television Will Be Revolutionized*, 61–62.

32. Nicholas Rombes, "Incompleteness," Digital Poetics, March 30, 2006, <http://professordvd.typepad.com/my_weblog/2006/03/incompleteness.html>.

33. Michael O'sullivan, "Take Two: A 'Keane' Remix by Soderbergh," *Washington Post*, March 24, 2006, <http://www.washingtonpost.com/wp-dyn/content/article/2006/03/23/AR2006032300541.html>.

34. Thomas Elsaesser, "The Blockbuster: Everything Connects, but Not Everything Goes," in *The End of Cinema as We Know It: American Film in the Nineties*, ed. Jon Lewis (New York: New York University Press, 2001), 11, 15.

35. Kimberly Owczarski, "The Internet and Contemporary Entertainment: Rethinking the Role of the Film Text," *Journal of Film and Video* 59.3 (Fall 2007), 4.

36. ClearPlay, accessed June 26, 2007, <http://www.clearplay.com>.

37. William Boddy, "A Century of Electronic Cinema," *Screen* 49.2 (Summer 2008), 153.

38. For a discussion of the controversy over Jarecki's repositioning the documentary as a kind of juridical thriller, see Paul Arthur, "True Confessions, Sort Of: *Capturing the Friedmans* and the Dilemma of Theatrical Documentary," *Cineaste* (Fall 2003), 3–7.

39. Caldwell, *Production Culture*, 232–33.

40. Henry Jenkins, *Convergence Culture: Where Old and New Media Collide* (New York: New York University Press, 2006), 94–97.

41. Felicia Lee, "Paramount Vantage Takes a Trim," *New York Times*, June 5, 2008, <http://www.nytimes.com/2008/06/05/arts/05arts-PARAMOUNTVAN_BRF.html?ref=arts>; T. L. Stanley, "Hollywood Relying More on Franchises," *Hollywood Reporter*, June 16, 2008, <http://www.hollywoodreporter.com/>.

42. See for example, Sweded Cinema, a blog focused on compiling these videos from around the web, <http://swededcinema.com/>, and "Be Kind Rewind: How to Swede," in which director Michel Gondry and star Jack Black offer instructions on how to make a good sweded video: <http://www.youtube.com/watch?v=i5Rd8x4OJoY>.

43. Klinger, *Beyond the Multiplex*, 191–237.

44. Quoted in Stanley, "Hollywood Relying More on Franchises."

45. John Thornton Caldwell, "Second-Shift Media Aesthetics: Programming, Interactivity, and User Flows," in *New Media: Theories and Practices of Digitextuality*, ed. Anna Everett and John T. Caldwell (New York: Routledge, 2003), 131.

46. Caldwell, *Production Culture* 192.

47. Brookey and Westerfelhaus, "Hiding Homoeroticism," 22.

48. Lisa Kernan, *Coming Attractions: Reading American Movie Trailers* (Austin: University of Texas Press, 2004), 38. Freud's most famous account of deferred action appears in his "Wolf-Man" case study, "From the History of an Infantile Neurosis." See Sigmund Freud, *Three Case Studies*, ed. Philip Reiff (New York: Collier, 1963), 161–280.

49. Devin Orgeron, "La Camera-Crayola: Authorship Comes of Age in the Cinema of Wes Anderson," *Cinema Journal* 46.2 (Winter 2007), 40–65. See also Adrian Martin, "Posseessory Credit," *Framework* 45.1 (Spring 2004), 95–99.

50. Orgeron, "La Camera-Crayola," 41.

51. Brookey and Westerfelhaus, "Hiding Homoeroticism," 34–35.

52. Eric Kohn, "Champion of the Format Wars." *Moviemaker* 15.75 (2008), 25.

53. Don Reisinger, "LionsGate: Piracy a Major Deciding Factor for Blu-Ray Support," CNET News, January 10, 2008, <http://news.cnet.com/8301-13506_3-9847914-17.html?hhTest=1>.

CHAPTER 2: THE SCREEN IS ALIVE

1. Susan Buck-Morss, *The Dialectics of Seeing: Walter Benjamin and the Arcades Project* (Cambridge, Mass.: MIT Press, 1989), 293.

2. Vincent Mosco, *The Digital Sublime: Myth, Power, and Cyberspace* (Cambridge, Mass.: MIT Press, 2004), 76.

3. Anne Friedberg, *Window Shopping: Cinema and the Postmodern* (Berkeley: University of California Press, 1993), xi. For a slightly different take on the relationship between television, the mall, and the highway, see Margaret Morse, *Virtualities: Television, Media Art, and Cyberculture* (Bloomington: Indiana University Press, 1993), 99–124. Friedberg's analogy between the department store display window and the movie screen is echoed by Mary Ann Doane in *The Desire to Desire: The Woman's Film of the 1940s* (Bloomington: Indiana University Press, 1987), 24.

4. Edward Jay Epstein, *The Big Picture* (New York: Random House, 2006), 347.

5. Mosco, *The Digital Sublime*.

6. Daniel Langlois, "Introduction by Daniel Langlois," Digimart Global Digital Distribution Summit, September 2005, <http://www.digimart.org/?lang=en>.

7. Lev Manovich, *The Language of New Media* (Cambridge, Mass.: MIT Press, 2001), 309.

8. Ibid., 309.

9. Cited in Lisa Kennedy, "Spielberg in the Twilight Zone," *Wired* (June 2002), 113.
10. William J. Mitchell, *The Reconfigured Eye: Visual Truth in the Post-Photographic Era* (Cambridge, Mass.: MIT Press, 1995), 19.
11. Manovich, *The Language of New Media*, 174.
12. Jerry Cobb, "Product Placement Goes Digital, Gets Lucrative," MSNBC.com, March 8, 2006, <http://www.msnbc.msn.com/id/11728512/>.
13. J. Robert Craig, "Establishing New Boundaries for Special Effects: Robert Zemeckis's *Contact* and Computer-Generated Imagery," *Journal of Popular Film and Television* 28 (Winter 2001), 158–165. For an interesting reading of the special effects sequences in *Forrest Gump*, see Jennifer Hyland Wang, "'A Struggle of Contending Stories': Race, Gender and Political Memory in *Forrest Gump*," *Cinema Journal* 39.3 (Spring 2000), 92–115.
14. Craig, "Establishing New Boundaries for Special Effects," 161.
15. Susan Sontag, *On Photography* (New York: Farrar, 1977), 5.
16. Craig, "Establishing New Boundaries for Special Effects," 162.
17. Mosco, *The Digital Sublime*, 76; Ray Kurzweil, *The Age of Spiritual Machines* (New York: Viking, 1999), 2.
18. Mike Davis, *City of Quartz: Excavating the Future in Los Angeles* (New York: Vintage, 1992), 18.
19. Robin Wood, "Ideology, Genre, Auteur," in *Film Genre Reader*, ed. Barry Keith Grant (Austin: University of Texas Press, 1986), 61.
20. Henry Jenkins, *Convergence Culture: Where Old and New Media Collide* (New York: New York University Press, 2006), 93–130.
21. Ibid., 104.
22. Mosco, *The Digital Sublime*, 15.
23. For a discussion of the relationship between the rise of cyberspace and the supposed end of politics, see ibid., 98–115.
24. Tom Gunning, "An Aesthetic of Astonishment: Early Film and the (In)Credulous Spectator," in *Viewing Positions: Ways of Seeing Film*, ed. Linda Williams (New Brunswick, N.J.: Rutgers University Press, 1995), 114–133.
25. Ibid., 115.
26. Ibid., 118.
27. Dayton Taylor, "Virtual Camera Movement: The Way of the Future," *American Cinematographer* 77.9 (September 1996), 93–100.
28. Patricia Mellencamp, "The Zen of Masculinity—Rituals of Heroism in *The Matrix*," in *The End of Cinema as We Know It: American Film in the Nineties*, ed. Jon Lewis (New York: New York University Press, 2001), 85.
29. Claudia Springer, "Psycho-Cybernetics in Films of the 1990s," in *Alien Zone II: The Spaces of Science-Fiction Cinema*, ed. Annette Kuhn (London: Verso, 1999), 206.
30. It is also worth noting that the film uses people of color to indicate the distinction between the "real" world and the artificial reality of the matrix. See Lisa Nakamura, *Cybertypes: Race, Ethnicity, and Identity on the Internet* (New York: Routledge, 2002), 75.
31. "The Metropolis Comparison," *Dark City*, DVD, New Line, 1998.
32. John Thornton Caldwell, *Production Culture: Industrial Reflexivity and Critical Practice in Film and Television* (Durham, N.C.: Duke University Press, 2008), 362.
33. Manovich, *The Language of New Media*, 322.
34. Garrett Stewart, *Between Film and Screen: Modernism's Photo Synthesis* (Chicago: University of Chicago Press, 1999), 363.
35. Ibid.
36. Wheeler Winston Dixon, "Twenty-Five Reasons Why It's All Over," in Lewis, *The End of Cinema as We Know It*, 366.
37. Armond White, "Greed Racer," *New York Press*, May 6, 2008, <http://www.nypress.com/21/19/film/ArmondWhite.cfm>.
38. Thomas Elsaesser, "The Blockbuster: Everything Connects, but Not Everything Goes," in Lewis, *The End of Cinema as We Know It*, 19.
39. Wheeler Winston Dixon, "Vanishing Point: The Last Days of Film," *Senses of Cinema* 43 (2007), <http://www.sensesofcinema.com/contents/07/43/last-days-film.html>.
40. McKenzie Wark, "Cyberhype," *World Art*, inaugural U.S. edition (November 1994), 66. Cited in Pierson, *Special Effects*, 83.

CHAPTER 3: WALL-TO-WALL COLOR

1. John Thornton Caldwell, *Production Culture: Industrial Reflexivity and Critical Practice in Film and Television* (Durham, N.C.: Duke University Press, 2008), 274.
2. Godfrey Cheshire, "Grindhouse Aims to Resurrect Movies, Not Bury Them," *The Independent Weekly*, April 11, 2007, <http://www.indyweek.com/>.
3. John Patterson, "I Was a Teenage Grindhouse Freak," *Guardian*, March 3, 2007, <http://film.guardian.co.uk/features/featurepages/0,,2024479,00.html>.
4. Wheeler Winston Dixon, "Vanishing Point: The Last Days of Film," *Senses of Cinema* 43 (2007), <http://www.sensesofcinema.com/contents/07/43/last-days-film.html>.
5. Kevin J. Corbett, "The Big Picture: Theatrical Moviegoing, Digital Television, and Beyond the Substitution Effect," *Cinema Journal* 40.2 (Winter 2001), 18.
6. Ibid., 19.
7. Charles R. Acland, *Screen Traffic: Movies, Multiplexes and Global Culture* (Durham, N.C.: Duke University Press, 2003), 224.
8. "The Final Frontier: How Digital Technology Is Changing the Way Cinemas Work," *Economist*, July 12, 2007, <http://www.economist.com/>.
9. Acland, *Screen Traffic*, 213.
10. Edward Jay Epstein, *The Big Picture* (New York: Random House, 2006), 348.
11. Mark Cuban, "Keynote Address," Digimart Global Digital Distribution Summit," September 22, 2005, <http://digimart.org/en/index.php#>.
12. Randall Stross, "Is Mark Cuban Missing the Big Picture?" *New York Times*, December 18, 2005, <http://nytimes.com>.
13. John Fithian, "Letter to Digital Cinema Initiatives," *National Association of Theater Owners*, December 19, 2006, <http://www.natoonline.org/Digital.htm>.
14. Epstein, *The Big Picture*, 348.
15. David Halbfinger places the cost at approximately $75,000 per auditorium, while Michael Price estimates a cost of $100,000 per screen, about three times the cost of a standard film projector. Kristin Thompson places the cost at about $150,000 per auditorium. Michael H. Price, "Rave Theaters Complete Digital Movie Conversion," *Fort Worth Business Press*, July 8, 2008, <http://www.fwbusinesspress.com/display.php?id=6481>. David Halbfinger, "Studios Announce a Deal to Help Cinemas Go 3-D," *New York Times*, March 12, 2008, <http://www.nytimes.com/>. Kristin Thompson, "A Turning Point in Digital Projection?" *Observations on film art and Film Art*, October 21, 2007, <http://www.davidbordwell.net/blog/?p=1419>.
16. Halbfinger, "Studios Announce a Deal." See also, Pamela McClintock, "Studios, Theaters Near Digital Pact," *Variety*, March 10, 2008, <http://www.variety.com/article/VR1117982175.html?categoryid=2502&cs=1>.
17. Carly Harrington, "Regal CEO Says Digital Upgrade May be Delayed," *Knoxville News-Sentinel*, October 24, 2008, <http://www.knoxnews.com/news/2008/oct/24/regal-ceo-says-digital-upgrade-may-be-delayed/>.
18. Michael Goldman, "Digitally Independent Cinema," *Filmmaker* 16.2 (Winter 2008), 92–95.
19. "How DLP Technology Works." *DLP Technology: The Ultimate Viewing Experience*, Texas Instruments Incorporated 2007, <http://www.dlp.com/tech/what.aspx>.
20. Acland, *Screen Traffic*, 216–218.
21. "Looking More Convincing," *Economist*, July 12, 2007, <http://www.economist.com/business/displaystory.cfm?story_id=9482930>.
22. Robert Sklar, *Movie-Made America: A Cultural History of American Movies* (New York: Vintage, 1994), 283–285.
23. Andre Bazin, *What Is Cinema?* Trans. Hugh Gray (Berkeley: University of California Press, 1967).
24. Charles R. Acland, "IMAX Technology and the Tourist Gaze," *Cultural Studies* 12.3 (1998), 433.
25. Ibid., 431.
26. "U2 3D Production Notes," *National Geographic.com*, 2008, <http://ftp.nationalgeographic.com/pressroom/film_u23d>.
27. Acland, "IMAX Technology," 431.
28. Jay David Bolter and Richard Grusin, *Remediation: Understanding New Media* (Cambridge, Mass.: MIT Press, 1999).

29. Ibid., 31–44.

30. Frank Rose, "A Second Chance for 3-D," *Wired* 15.11 (November 2007), 162.

31. "Kids Duped into Seeing 'Hannah Montana' Film?" MSNBC.com, February 6, 2008, <http://www.msnbc.msn.com/id/23036640/>.

32. "DreamWorks Animation Goes 3D," *DreamWorks Animation SKG*, March 13, 2007, <http://www.dreamworksanimation.com/dwa/opencms/movies/articles/index.html>.

33. D. N. Rodowick, *The Virtual Life of Film* (Cambridge, Mass.: Harvard University Press, 2007), 20.

34. J. Hoberman, "Back to Nature: The Art of Destruction," *Village Voice*, March 19–25, 2003. Peter Delpeut's 1991 film *Lyrical Nitrate* offers a similar compilation of images taken from the decomposing film stock of silent films made between 1905 and 1915.

35. Robert C. Allen, "'Please Rewind the Tape, Daddy': Writing the Last Chapter of the History of Hollywood Cinema," unpublished lecture, cited in Rodowick, *Virtual Life*, 27; Jon Lewis, ed., *The End of Cinema as We Know It: American Film in the Nineties* (New York: New York University Press, 2001).

36. Philip Rosen, *Change Mummified: Cinema, Historicity, Theory* (Minneapolis: University of Minnesota Press, 2001), 336.

37. "Independent Exhibitors Step into the Digital Future," *National Association of Theater Owners*, April 1, 2008, <http://www.natoonline.org/>. Michael Karagosian, "Demystifying Digital Cinema Part 2: Less Can Be More," *In Focus* 2.11 (November 2002), <http://natoonline.org/infocus/02November/digital.htm>.

38. William Boddy, "A Century of Electronic Cinema," *Screen* 49.2 (Summer 2008), 155. See also Wheeler Winston Dixon and Gwendolyn Audrey Foster, *A Short History of Film* (New Brunswick: Rutgers University Press, 2008), 382.

39. "Patron Behavior," *National Association of Theater Owners*, <http://www.natoonline.org/pdfs/Talking%20Points/TP-Patron%20Behavior.pdf>.

40. See Barbara Klinger, *Beyond the Multiplex: Cinema, New Technologies, and the Home* (Berkeley: University of California Press, 2006), 4. See also Roy Rosenzweig, "From Rum Shop to Rialto: Workers and Movies," in *Moviegoing in America*, ed. Gregory A. Waller (Oxford: Blackwell Publishers, 2002); and Janet Staiger, "Writing the History of American Film Reception," in *Hollywood Spectatorship: Changing Perceptions of Cinema Audiences*, ed. Melvyn Stokes and Richard Maltby (London: British Film Institute Publishing, 2001).

41. "ShoWest 2008 Talking Points and Fact Sheet," *National Association of Theater Owners*, March 2008, <http://natoonline.org>.

42. David Denby, "Big Pictures: Hollywood Looks for a Future," *New Yorker*, January 8, 2007, <http://www.newyorker.com/critics/atlarge/articles/070108crat_atlarge>.

Neal Gabler, "The Movie Magic Is Gone," *Los Angeles Times*, February 25, 2007, <http://www.latimes.com/news/opinion/commentary/la-op-gabler25feb25, 0,4482096.story?coll=la-home-commentary>.

Joe Morgenstern, "'Pod People," *Wall Street Journal*, February 23, 2008, <http://online. wsj. com/public/article_print/SB120372124413686875.html>.

43. Chris Anderson, *The Long Tail: Why the Future of Business Is Selling Less of More* (New York: Hyperion, 2006), 2.

44. Gabler, "The Movie Magic Is Gone."

45. Ian Mohr, "Box Office, Admissions Rise in 2006," *Variety*, March 6, 2007, <http://www.variety.com/article/VR1117960597.html?categoryid=13&cs=1>. Kristin Thompson, "Movies Still Matter." Observations on film art and *Film Art*, March 14, 2007, <http://www.davidbordwell.net/blog/?p=475>.

46. For a useful overview of recent box office trends, see the web site Media by Numbers, <http://mediabynumbers.com/>. Media by Numbers shows little change in the number of admissions since 1998, with the exception of small drops in attendance in 2000 and 2005.

47. "Movie Attendance Study 2007," *Motion Picture Association of America*, <http://www.mpaa.org/MovieAttendanceStudy.pdf>. The MPAA numbers actually measure attendance from mid-July of 2006 through mid-July of 2007, suggesting that actually box office attendance in 2007 may have been higher.

48. Caldwell, *Production Culture*, 9.

49. Godfrey Cheshire, "The Death of Film/The Decay of Cinema," *New York Press*, August 26, 1999, <http://www.nypress.com/print.cfm?content_id=243>.

50. For an interesting discussion of how this bias even affects media studies scholarship, see Michelle Hilmes, "The Bad Object: Television in the American Academy," *Cinema Journal* 45.1 (Fall 2005), 111–116.

51. Lynn Spigel, *Make Room for TV: Television and the Family Ideal in Postwar America* (Chicago: University of Chicago Press, 1992), and Anna McCarthy, *Ambient Television: Visual Culture and Public Space* (Durham, N.C.: Duke University Press, 2001).

52. "Patron Behavior."

53. Rosen, *Change Mummified*, 333.

54. *Mystery at Mansfield Manor*, <http://www.mysteryatmansfieldmanor.com/>.

55. Lev Manovich, *The Language of New Media* (Cambridge, Mass.: MIT Press, 2001), 207.

56. Mutable Cinema: Interactive New Media Movie Experience, <http://www.mutablecinema.com/>.

57. John Hopewell and Marcelo Cajueiro, "Digital Logs Demand," *Variety*, February 11, 2008, <http://www.variety.com>.

58. Boddy, "A Century of Electronic Cinema," 151.

59. Chuck Tryon, "Video Mobility," *BraintrustDV*, November 30, 2005, <http://www.braintrustdv.com/roundtables/ipod.html#Tryon>.

60. Judy Wajcman, *TechnoFeminism* (Cambridge: Polity, 2004), 47.

61. Nicholas Rombes, "Roundtable on the Video iPod," *BraintrustDV*, November 30, 2005, <http://www.braintrustdv.com/roundtables/ipod.html##Rombes>.

62. Raymond Williams, *Television: Technology and Cultural Form* (New York: Schocken, 1974), 26.

63. Dan Schiller, *How to Think about Information* (Urbana: University of Illinois Press, 2007), 169.

64. David Denby, "Big Pictures."

65. Ryan Stewart, "Editorial: The 'Transformers' Story That Never Happened and Why That's Too Bad," *Cinematical*, July 9, 2007, <http://www.cinematical.com/2007/07/09/editorial-the-transformers-story-that-never-happened/>.

66. Morley Winograd and Michael D. Hais, *Millennial Makeover: MySpace, YouTube, and the Future of American Politics* (New Brunswick, N.J.: Rutgers University Press, 2008), 1–2.

67. Andrew O'Hehir, "Beyond the Multiplex," *Salon.com*, July 12, 2007, <http://www.salon.com/ent/movies/review/2007/07/12/btm/index.html>. O'Hehir's article echoes the common consensus that cinema itself is in a state of transition, one that may lead to new models of film publics. See also Karina Longworth, "Distribution Wars: How Irrational Fear of the Cellphone Might Kill The Movie Theater," *Spout.com*, July 13, 2007, <http://blog.spout.com/#1792>.

68. Longworth, "Distribution Wars."

69. O'Hehir, "Beyond the Multiplex."

70. Amanda D. Lotz, *The Television Will Be Revolutionized* (New York: New York University Press, 2007), 17.

71. Henry Jenkins, *Convergence Culture: Where Old and New Media Collide* (New York: New York University Press, 2006), 16.

72. Eddie Guy, "Snack Attack," *Wired* 15.3 (March 2007), 124–135.

73. Quoted in "D-Day February 2009," *National Association of Television Programming Executives*, <http://www.natpe.org/>.

74. Laura Holson, "Hollywood Loves the Tiny Screen. Advertisers Don't," *New York Times*, May 7, 2007, <http://www.nytimes.com/2007/05/07/business/media/07cell.html?ex=1190001600&en=4ee3c1aaa9c25658&ei=5070>.

75. "ShoWest 2008 Talking Points & Fact Sheet."

76. Paul Tenny, "Hollywood Writers Score Victory in Battle Over Webisodes," *Associated Content*, August 10, 2007, <http://www.associatedcontent.com/article/342364/hollywood_writers_score_victory_in.html>.

77. Caldwell, *Production Culture*, 325.

78. *United Hollywood*, March 2008, <http://unitedhollywood.blogspot.com>.

79. Caldwell, *Production Culture* 326.

80. Schiller, *How to Think about Information*, 170.

81. Ibid.

82. "Patron Behavior." While the "Patron Behavior" memo did not explicitly call for cell phone jamming, which is prohibited by the Federal Communications Commission, they did favorably mention a 2004 French law that allowed cell phone jammers in movie theaters and concert halls.

83. Barbara De Lollis, "Laptop Etiquette Takes to the Skies," *USA Today*, August 21, 2007, <http://www.usatoday.com/travel/flights/2007-08-20-laptop-etiquette_N.htm#uslPageReturn>.

84. In fact, as Anna McCarthy has noted, patrons frequently resist the incursion of televisions into locations where they are forced to watch, although this resistance is often temporary. For example, she mentions that gym members briefly boycotted sponsors of Health Club TV because of its intrusive presence in gyms. Of course, now television sets are a commonplace feature of most gyms. Anna McCarthy, *Ambient Television*, 94.

85. George Will, "IPod's Missed Manners," *Washington Post*, November 20, 2005, B7, <http://www.washingtonpost.com/wp-dyn/content/article/2005/11/18/AR2005111802400.html>.

86. Morgenstern, "Pod People."

87. J. G. Ballard, "The Mobile Phone," in *Speed: Visions of an Accelerated Age*, ed. Jeremy Millar and Michiel Schwarz (London: Photographers Gallery, 1998), quoted in David Morley, *Home Territories: Media, Mobility, and Identity* (London: Routledge, 2000), 97–98.

88. Lotz, *The Revolution Will Be Televised*, 78.

89. Anna McCarthy, *Ambient Television*, 4.

90. Gabler, "The Movie Magic Is Gone."

CHAPTER 4: DESKTOP PRODUCTIONS

1. According to James Berardinelli's review of the film, *The Last Broadcast* was completed for approximately $900. "The Last Broadcast," *Reel Views*, 2000, <http://movie-reviews.colossus.net/movies/l/last_broadcast.html>.

2. Joe Neulight, "Off the Grid," *Variety*, September 10, 2006, <http://www.variety.com/>.

3. Mark Pesce, "When the Going Gets Weird," Digimart Global Digital Distribution Summit, September 22, 2005, <http://www.digimart.org/en/#>.

4. Chris Anderson, *The Long Tail: Why the Future of Business Is Selling Less of More* (New York: Hyperion, 2006), 7.

5. A. O. Scott, "The Shape of Cinema, Transformed at the Click of a Mouse," *New York Times*, March 18, 2007, <http://www.nytimes.com/2007/03/18/movies/18scot.html?ex=1190001600&en=43207b1f09fd5e27&ei=5070>.

6. Bob Fisher, "Facing the Digital Dilemma," *MovieMaker* 15.75 (Summer 2008), 22.

7. Anderson, *The Long Tail*, 5.

8. Henry Jenkins, *Fans, Bloggers, and Gamers: Exploring Participatory Culture* (New York: New York University Press, 2006), 152–153.

9. Mark Gill, "LAFF: Mark Gill on Indie Film Crisis," *Thompson on Hollywood*, June 21, 2008, <http://weblogs.variety.com/thompsononhollywood/2008/06/laff-mark-gill.html>.

10. Jamie Stuart, "Theatrical Thoughts," *Stream*, July 12, 2008, <http://www.wonderlandstream.com/stream_blog.aspx?blog_id=711>.

11. Anderson, *The Long Tail*, 90.

12. Janet Wasko, *Hollywood in the Information Age: Beyond the Silver Screen* (Austin: University of Texas Press, 1994), 246.

13. Anderson, *The Long Tail*, 128.

14. Yocahi Benkler, *The Wealth of Networks: How Social Production Transforms Markets and Freedom* (New Haven: Yale University Press, 2006), 10.

15. Ibid., 9.

16. Robert Putnam, *Bowling Alone: The Collapse and Revival of American Community* (New York: Simon and Schuster, 2000), 45.

17. Myles Weissleder, "Reflections on Meetup's 3rd Anniversary. Are Americans 'Bowling Alone' Less?" *Meetup Watch*, June 14, 2005, <http://press.meetup.com/watch/archives/001115.html>.

18. Judy Wajcman, *TechnoFeminism* (Cambridge: Polity, 2004), 59.

19. Ibid., 61.

20. Joshua Tanzer, "Disc-covering America," *OffOffOff*, December 2, 2003, <http://www.offoffoff.com/film/2003/uncovered.php>.

21. Michelle Goldberg, "Now Playing in 2,600 Home Theaters: Bush's Lies about Iraq," *Salon.com*, December 9, 2003, <http://archive.salon.com/news/feature/2003/12/09/uncovered/index.html>.

22. Ibid.

23. Mark Pesce, "When the Going Gets Weird."

24. Robert Greenwald, "Robert Greenwald, Producer/Director of 'Uncovered: The Whole Truth About the Iraq War,' A New Documentary That Reveals How the Bush Administration Lied the Nation Into War," *Buzzflash*, November 3, 2003, <http://www .buzzflash.com/interviews/03/11/int03031.html>.

25. A significant exception to the news media's complicity in promoting the war was the work of Knight-Ridder reporters Warren Strobel and Jonathan Landay, who in September 2002 wrote a widely read article challenging the Bush administration's claims about weapons of mass destruction in Iraq. See Steve Ritea, "Going It Alone," *American Journalism Review*, August/September 2004, <http://www.ajr.org/article_printable.asp?id=3725>.

26. Robert S. Boynton, "How to Make a Guerilla Documentary," *New York Times*, July 11, 2004, <http://query.nytimes.com/gst/fullpage.html?res=9904E3D6143BF932A257 54C0A9629C8B63>.

27. Steve Gorman, "Anti-Bush Iraq Documentary Makes the Party Circuit," *Boston.com*, December 19, 2003, <http://boston.com>.

28. Jim Gilliam, "Outfoxed Interviews Available for Remixing," *Jim Gilliam's Blog*, September 14, 2004, <http://www.jimgilliam.com/2004/09/outfoxed_interviews_available_for _remixing.php>.

29. John Fithian, "Comments by John Fithian," ShoWest Opening Ceremonies, March 11, 2008, <http://www.natoonline.org>.

30. Mark Sullivan, "Hollywood Goofs on Campus Piracy Numbers," *PC World*, January 23, 2008, <http://blogs.pcworld.com/staffblog/archives/006350.html>. Fithian, "Comments by John Fithian."

31. Sullivan, "Hollywood Goofs."

32. Katey Rich, "Fighting Back: MPAA & NYC Unveil Campaign to Stem Piracy," *Film Journal International*, June 25, 2007, <http://www.filmjournal.com>.

33. Hugh Hart, "Mark Cuban to Show New Movies on TV Before Theatrical Release," *Wired*, July 9, 2008, <http://blog.wired.com/underwire/2008/07/cuban-to-show-n.html>.

34. Wasko, *Hollywood in the Information Age*, 95.

35. Dave Nuttycombe, "A Silverdocs Report," *Nutco Enterprises*, June 24, 2008, <http://nuttycombe.com/blog/2008/06/24/a-silverdocs-report/>.

36. Frederick Wasser, *Veni, Vidi, Video: The Hollywood Empire and the VCR* (Austin: University of Texas Press, 2001), 116–117. Unlike Wasser, Wasko speculates that Twentieth Century released *9 to 5* so quickly out of anger over the resolution of a Justice Department case against the company's planned pay cable channel, Premiere (79).

37. Edward Jay Epstein, "Hollywood's Death Spiral," *Slate.com*, July 25, 2005, <http://www.slate.com/id/2123286/>.

38. Patrick Corcoran, "Average Video Announcement and Video Release Windows (as of 3/3/2008)," *National Association of Theater Owners*, March 3, 2008, <http://www .natoonline.org/>.

39. Quoted in J. D. Lasica, *Darknet: Hollywood's War against the Digital Generation* (Hoboken, N.J.: Wiley, 2005), 62.

40. William Boddy, "A Century of Electronic Cinema," *Screen* 49.2 (Summer 2008), 153.

41. "On the Record: Studio Executives and Directors Overwhelmingly Support Preservation of the Theatrical Window," *National Association of Theater Owners*, December 2006, <http://www.natoonline.org>.

42. Cited in ibid.

43. Quoted in Gary Gentile, "Bubble Breaks New Ground with Simultaneous Release Strategy," *North County Times*, January 25, 2006, <http://www.nctimes.com/articles/2006/ 01/27/entertainment/movies/12506112651.txt>.

44. Sharon Waxman, "Missed It in the Theater? See It on DVD Tonight," *New York Times*, January 23, 2006, <http://www.nytimes.com/2006/01/23/business/media/ 23independent.html?ex=1295672400&en=3e601031dd524273&ei=5088>.

45. Eugene Hernandez, "At IFC Films, 'Penelope' Shift Points to a Change in Focus; Company Emphasizing First Take Slate," *IndieWIRE*, August 14, 2007, <http://www.indiewire.com/ biz/2007/08/at_ifc_films_pe.html>.

46. See, for example, Anne Thompson, "Indie Sector on Shaky Ground," *Variety*, June 26, 2008, <http://www.variety.com/article/VR1117988181.html?categoryid=2508&cs=1>; and Carrie Rickey, "Art Houses are Empty—but It Is Summer," *Philadelphia Inquirer*, June 22, 2008, <http://www.philly.com/>.

47. Thompson, "Indie Sector."
48. Chuck Tryon, "Watch Now: Netflix, Streaming Movies, and Networked Film Publics," *Flow* 6.5 (August 2007), <http://flowtv.org/?p=706>.
49. As of November 2008, the Watch Now player still only worked in Internet Explorer, although an Internet Explorer tab could be added to Firefox to allow the player to work, while Netflix had developed a player that allowed instant viewing for Mac users.
50. Mike Musgrove, "Coming Soon to an Xbox Near You," *Washington Post*, July 15, 2008, <http://www.washingtonpost.com/wp-dyn/content/article/2008/07/14/AR2008071401999.html>.
51. Barry Keith Grant, "Diversity or Dilution? Thoughts on Film Studies and the SCMS," *Cinema Journal* 43.3 (Spring 2004), 89.
52. Musgrove, "Coming Soon to an Xbox."
53. Thomas Heath, "Lenosis's 'Filmanthropy' Plants a Seed with Buddies," *Washington Post*, January 25, 2007, D1.
54. SnagFilms, <http://www.snagfilms.com>.
55. Anderson, *The Long Tail*, 110.
56. Ibid., 17–18. For a discussion of this "classic urban/rural split," see Douglas Gomery, *Shared Pleasures: A History of Movie Presentation in the United States* (Madison: University of Wisconsin Press, 1992), 277.
57. Joan Hawkins, "Dish Towns USA (or Rural Screens) Part One," *Flow* 6.3 (June 29, 2007), <http://flowtv.org/?p=525>.
58. Tama Leaver, "*Battlestar Galactica* Webisodes and the Tyranny of Digital Distance," *Blogcritics*, September 12, 2006, <http://blogcritics.org/archives/2006/09/12/063843.php>.
59. Reed Hastings, quoted in Anderson, *The Long Tail*, 109.
60. Barry Schwartz, *The Paradox of Choice: Why More Is Less* (New York: Harper, 2004).
61. For a discussion of the Radio Boys, see Susan J. Douglas, *Listening In: Radio and the American Imagination* (Minneapolis: University of Minnesota Press, 1999), 67–70.
62. Jordan Ellenberg, "The Netflix Challenge," *Wired* 16.3 (March 2008), 114–122.
63. Kelly Bit, "Video Stores React to Netflix by Focusing on Human Touch," *New York Sun*, July 31, 2006, <http://www.nysun.com/article/37009>.
64. Mark Glaser, "What We Lose (and Gain) Without Video Stores," *Media Shift*, April 13, 2007, <http://www.pbs.org/mediashift/2007/04/netflix_returnwhat_we_lose_and.html>.
65. For a discussion of the effects of big-box retailers on local economies, see Stacy Mitchell, *Big-Box Swindle: The True Cost of Mega-Retailers and the Fight for America's Independent Businesses* (Boston: Beacon, 2007).
66. Dennis Lim, "A Generation Finds Its Mumble," *New York Times*, August 19, 2007, <http://www.nytimes.com/2007/08/19/movies/19lim.html>.
67. See for example, Anthony Kaufman, "The SXSW All-Stars: A New Ultra-Indie Movement," *indieWIRE*, March 13, 2007, <http://blogs.indiewire.com/anthony/archives/012986.html>, and Eugene Hernandez, "Mumblecore Movie? Swanberg, Bujalski, Duplass, and Others Unveil 'Hannah Takes the Stairs,'" indieWIRE, March 14, 2007, <http://www.indiewire.com/ots/2007/03/sxsw_07_daily_d_3.html>.
68. Matt Dentler, "First Person: Matt Dentler on Indie Film for the MySpace/YouTube/iPod Generation," *indieWIRE*, August 19, 2007, <http://www.indiewire.com/people/2007/08/first_person_ma.html>.
69. J. Hoberman, "It's Mumblecore!" *Village Voice*, August 8, 2007, <http://www.villagevoice.com/2007-08-14/film/it-s-mumblecore/>; Amy Taubin, "All Talk?" *Film Comment* (November/December 2007), <http://www.filmlinc.com/fcm/nd07/mumblecore.htm>.
70. "Oxford Word of the Year: Locavore," *OUPBlog*, November 12, 2007, <http://blog.oup.com/2007/11/locavore/>.
71. Lim, "A Generation."
72. Dentler, "iPod Generation."
73. Joe Swanberg and Kris Williams, "Young American Bodies," <http://www.youngamericanbodies.com/>.
74. In order to differentiate between the filmmakers and their representation in the film, I refer to the characters in the movie as Susan and Arin and the filmmakers as Buice and Crumley.

75. Susan Buice and Arin Crumley, "Four Eyed Monsters: Video Podcast Episodes," <http://foureyedmonsters.com/index.php/video_podcast/episodes/>.
76. See, for example, Charles Lyons, "Join a Revolution. Make a Movie. Go Broke," *New York Times*, November 20, 2005, <http://www.nytimes.com/>.
77. Lance Weiler, "Navigating the Digital Divide," *Filmmaker* 16.2 (Winter 2008), 102.
78. Erik Davis, "Interview: 'Four Eyed Monsters' Co-Director Arin Crumley—Part One," *Cinematical*, July 25, 2007, <http://www.cinematical.com/2007/07/25/interview -four-eyed-monsters-co-director-arin-crumley-part/>.
79. Erik Davis, "Interview: 'Four Eyed Monsters' Co-Director Arin Crumley—Part Two," *Cinematical*, July 29, 2007, <http://www.cinematical.com/2007/07/29/interview -four-eyed-monsters-co-director-arin-crumley-part-t/>.
80. Gill, "Indie Film Crisis."
81. Schiller, *How to Think about Information*, 141.

CHAPTER 5: TOPPLING THE GATES

1. A. O. Scott, "Avast, Me Critics! Ye Kill the Fun: Critics and the Masses Disagree About Film Choices," *New York Times*, July 18, 2006, <http://www.nytimes.com/2006/07/ 18/movies/18crit.html>.
2. See, for example, Craig D. Lindsey, "Best Critics Keep All of Us Honest," *Raleigh News-Observer*, July 13, 2008, <http://www.newsobserver.com/105/story/1140023 .html>; Phillip Lopate, "Critics in Crisis," *Film in Focus*, July 25, 2008, <http://www .filminfocus.com/essays/critics-in-crisis.php>; and Jay Rayner, "Is It Curtains for Critics?" *Guardian*, July 13, 2008, <http://arts.guardian.co.uk/art/visualart/story/ 0,,2290623,00.html>.
3. Scott Kirsner, "Everyone's Always Been a Critic—but the Net Makes Their Voices Count," *Boston Globe*, April 30, 2006, <http://www.boston.com>.
4. Clay Shirky, *Here Comes Everybody: The Power of Organizing without Organizations* (New York: Penguin, 2008), 55; Dan Gillmor, *We the Media: Grassroots Journalism by the People, for the People* (North Sebastopol, Canada: O'Reilly, 2004); Chris Anderson, *The Long Tail: Why the Future of Business Is Selling Less of More* (New York: Hyperion, 2006), 99.
5. Lev Grossman, "Time Person of the Year: You," *Time*, December 25, 2006, 38–41.
6. Henry Jenkins, *Fans, Bloggers, and Gamers: Exploring Participatory Culture* (New York: New York University Press, 2006), 151.
7. Yochai Benkler, *The Wealth of Networks: How Social Production Transforms Markets and Freedom* (New Haven: Yale University Press, 2006), 10.
8. For a discussion of the connection between blogging and media consolidation, see Henry Jenkins, "Blog This," *Technology Review*, March 2002, <http://www.technologyreview .com/Energy/12768/>.
9. Clay Shirky, "RIP The Consumer 1900–1999," *Clay Shirky's Writings about the Internet*, <http://www.shirky.com/writings/consumer.html>.
10. John Thornton Caldwell, *Production Culture: Industrial Reflexivity and Critical Practice in Film and Television* (Durham, N.C.: Duke University Press, 2008), 325.
11. Ibid., 336.
12. Toby Miller, Nitin Govil, John McMurria, and Richard Maxwell, *Global Hollywood* (London: British Film Institute, 2001), 116.
13. Benkler, *The Wealth of Networks*, 15.
14. Jonathan Rosenbaum, "Film Writing on the Web: Some Personal Reflections," *Film Quarterly* 60.3 (2007), 78.
15. Jonathan Rauch, "How to Save Newspapers and Why," *National Journal*, June 14, 2008, <http://www.nationaljournal.com/njmagazine/st_20080614_5036.php>.
16. David Carr, "Now on the Endangered Species List: Movie Critics in Print," *New York Times*, April 1, 2008, <http://www.nytimes.com/2008/04/01/movies/01crit.html>.
17. Sharon Waxman, "A Blunt Instrument at the *Washington Post*," *WaxWord*, May 16, 2008, <http://sharonwaxman.typepad.com/waxword/2008/05/a-blunt-instrum .html>.
18. Rauch, "How to Save Newspapers."
19. Benkler, *The Wealth of Networks*, 10–11, 241.

20. Rebecca Blood, "Introduction," *We've Got Blog: How Weblogs are Changing Our Culture* (Cambridge, Mass.: Perseus, 2002), ix.
21. Anderson, *The Long Tail*, 74.
22. Benkler, *The Wealth of Networks*, 12.
23. Charles R. Acland, *Screen Traffic: Movies, Multiplexes, and Global Culture* (Durham, N.C.: Duke University Press, 2003), 243.
24. David Hudson, "Behind the Blog: David Hudson of GreenCine Daily," *Film in Focus*, <http://www.filminfocus.com/essays/behind-the-blog-david-hudson-g.php>.
25. Judy Wajcman, *TechnoFeminism* (Cambridge: Polity, 2004), 42–43.
26. Clay Shirky, "Power Laws, Weblogs, and Inequality," *Clay Shirky's Writings on the Internet*, February 8, 2003, <http://www.shirky.com/writings/powerlaw_weblog.html>.
27. Jenkins, *Fans, Bloggers, and Gamers*, 2.
28. *United Hollywood*, <http://unitedhollywood.blogspot.com/>.
29. "Surprise!" *Totally Unauthorized*, July 11, 2008, <http://filmhacks.wordpress.com/2008/07/11/surprise/>.
30. Andy Horbal, "Film Criticism in 'The Blog Era,'" *Mirror/Stage*, July 6, 2007, <http://true spies.org/mirror-stage/2007/07/06/film-criticism-in-the-blog-era/>. Although Horbal uses the metaphor of the termite, his concept of the termite critic seems unrelated to Manny Farber's concept of "termite art." See Manny Farber, *Negative Space* (New York: Da Capo, 1998), 134–144.
31. Jenkins, *Fans, Bloggers and Gamers*, 134–151; and Pierre Lévy, *Collective Intelligence: Mankind's Emerging World in Cyberspace*, trans. Robert Bononno (Cambridge, Mass.: Perseus Books, 1997).
32. Acland, *Screen Traffic*, 242.
33. Jenkins, *Fans, Bloggers, and Gamers*, 152–172.
34. See, for example, Kimberly Limbergs, *Cinebeats*, <http://www.cinebeats.com/>, a blog focusing on 1960s and 1970s cinema with a special focus on non-U.S. film.
35. Acland, *Screen Traffic*, 243.
36. Lessley Anderson, "Hot Gossip: Ain't-it-Cool-News.com Harry Knowles—Online Publisher," *Wired* 5.11 (November 1997), <http://www.wired.com>.
37. David Hudson and Adam Ross, "Friday Screen Test: David Hudson," *DVD Panache*, June 6, 2008, <http://dvdpanache.blogspot.com/2008/06/friday-screen-test-david-hudson .html>.
38. Matt Hills, *Fan Cultures* (New York: Routledge, 2002), 178.
39. Ibid., 179.
40. Ibid.
41. See, for example, M. A. Peel, "Live Blogging Mad Men: 'And You, Sir, Are No John Galt,'" *New Critics*, October 12, 2007, <http://newcritics.com/blog1/2007/10/12/live -blogging-mad-men-and-you-sir-are-no-john-galt/>.
42. Julia Lesage discusses film blogathons in "The Internet Today, or How I Got Involved in Social Book Marking," *Jump Cut* 49 (2007), <http://www.ejumpcut.org/>. "Blogathons" are more commonly described as "carnivals," such as the teaching carnivals organized by academic bloggers, <http://teachingcarnival.blogspot.com/>. Surprisingly, despite her emphasis on blogathons that address past filmmakers, Lesage seems to dismiss film blogs and blogathons, implying that they privilege "contemporaneity."
43. Lesage, "The Internet Today."
44. Jenkins, *Fans, Bloggers, and Gamers*, 136–140. Lévy, *Collective Intelligence.*
45. Mireya Navarro, "Love Him or (He Prefers) Hate Him," *New York Times*, July 29, 2007, <http://www.nytimes.com/2007/07/29/fashion/29perez.html>.
46. Anne Petersen, "Celebrity Juice, Not from Concentrate: Perez Hilton, Gossip Blogs, and the New Star Production," *Jump Cut* 49 (Spring 2007), <http://www.ejumpcut.org/>.
47. Petersen's argument builds upon the long history of scholarship focusing on the role of paratextual materials such as fan magazines and publicity photos in shaping a star's image. See, for example, Richard Dyer, *Stars* (London: British Film Institute, 1998); Dyer, *Heavenly Bodies* (London: Routledge, 2002); and Paul McDonald, *The Star System* (London: Wallflower, 2000).
48. Petersen, "Celebrity Juice, Not from Concentrate."
49. "*Superman Returns*: Bryan's Journals—Video Blogs from the Set," <http://www2 .warnerbros.com/supermanreturns/videoblog/>.
50. Tommy Corn, *Tommy Corn*, <http://tommycorn.blogspot.com/>.

51. "Black Dynamite Meets Barry," YouTube, June 4, 2008, <http://www.youtube.com/watch?v=2pGTOquif7E>.
52. Caldwell, *Production Culture*, 313.
53. Neva Chonin, "'Snakes on a Plane' Blog Buzz Forces Hollywood into Overdue Attitude Adjustment," *San Francisco Chronicle*, June 12, 2006, <http://www.sfgate.com/cgi-bin/article.cgi?f=/c/a/2006/06/12/DDGJSJBSU21.DTL>.
54. Chuck Klosterman, "The Tragedy of the Best Titled Movie in the History of Film," *Esquire*, July 1, 2006, <http://www.esquire.com/features/ESQ0806KLOSTERMAN_60>.
55. Caldwell, *Production Culture* 325.
56. Benkler, *The Wealth of Networks*, 10–11.
57. See, for example, Matt Zoller Seitz, "There Is Only This . . . All Else Is Unreal," House Next Door, January 2, 2006, "Just Beautiful," House Next Door, January 26, 2006, and "One 'World,'" House Next Door, January 29, 2006, <http://mattzollerseitz.blogspot.com/>. See also Nick Pinkerton, "Art in the Age of Myopia: Terrence Malick's The New World," Stop Smiling, February 3, 2006, <http://www.stopsmilingonline.com/story_detail.php?id=502>.
58. J. Hoberman, "Paradise Now," *Village Voice*, March 7, 2006, <http://www.villagevoice.com/film/0610,hoberman,72427,20.html>. See also Umberto Eco, *Travels in Hyperreality* (New York: Harvest, 1990), 197–212.
59. Susan Sontag, "The Decay of Cinema," *New York Times*, February 25, 1996, <http://query.nytimes.com/gst/fullpage.html?res=9802EFDF1139F936A15751C0A960958260>.
60. Anthony Kaufman, "Industry Beat," *Filmmaker* 15.3 (Spring 2007), 26, 97.
61. Ibid., 97. I was one of the bloggers that Wray invited to review her documentary.
62. Stacey Parks, "Blogging Your Way to Stardom," *MovieMaker* 15.75 (2008), 37.
63. In order to differentiate between the filmmaker and his representation in the film, I refer to the character in the movie as Randy and the filmmaker as Olson.
64. The reviews were compiled at "Sizzle Tuesday," ScienceBlogs, July 15, 2008, <http://scienceblogs.com/sizzle.php>. While I reviewed the film, my review was not linked from the *Sizzle* web site.
65. Kaufman, "Industry Beat," 97.

CHAPTER 6: HOLLYWOOD REMIXED

1. Brian Winston, *Media, Technology, and Society: A History: From the Telegraph to the Internet* (London: Routledge, 1998).
2. Annalee Newitz, "User-Generated Censorship," *AlterNet*, April 30, 2008, <http://www.alternet.org/mediaculture/84060/>.
3. Quoted in Henry Jenkins, *Fans, Bloggers, Gamers: Exploring Participatory Culture* (New York: New York University Press, 2006), 156.
4. Barbara Klinger, *Beyond the Multiplex: Cinema, New Technologies, and the Home* (Berkeley: University of California Press, 2006), 185.
5. Jason Tanz, "Almost Famous," *Wired* 16.8 (August 2008), 106–113.
6. Patricia R. Zimmermann, *Reel Families: A Social History of Amateur Film* (Bloomington: Indiana University Press, 1995).
7. Dan Schiller, *How to Think about Information* (Urbana: University of Illinois Press, 2007), 115.
8. John Caldwell, "Convergence Television: Aggregating Form and Repurposing Content in the Culture of Conglomeration," *Television after TV: Essays on a Medium in Transition*, ed. Lynn Spigel and Jan Olsson (Durham: Duke University Press, 2004), 53.
9. Kevin J. Delaney, "Google Push to Sell Ads on YouTube Hits Snags," *Wall Street Journal*, July 9, 2008, A1.
10. Virginia Heffernan, "Gotta Minute? So, There's This Guy Tony . . . ," *New York Times*, April 6, 2007, <http://www.nytimes.com>.
11. John Thornton Caldwell, *Production Culture: Industrial Reflexivity and Critical Practice in Film and Television* (Durham, N.C.: Duke University Press, 2008), 333–334.
12. Nancy Miller, "Minifesto for a New Age," *Wired* 15.3 (March 2007), 16–28.
13. Eddie Guy, "Snack Attack," *Wired* 15.3 (March 2007), 124–135. In keeping with the celebration of brevity, the article itself consisted of a "collage" of examples of the transition

into short-form entertainment, including the death of the record album, the rise of web videos, and other web sites celebrating brevity.

14. Justin Wyatt, *High Concept: Movies and Marketing in Hollywood* (Austin: University of Texas Press, 1994), 20.

15. Wes D. Gehring, *Parody as Film Genre* (Westport, Conn.: Greenwood Press, 1999).

16. Jonathan Gray, *Watching with The Simpsons: Television, Parody, and Intertextuality* (New York: Routledge, 2006), 9.

17. Anna Everett, "Digitextuality and Click Theory: Theses on Convergence Media in the Digital Age," in *New Media: Theories and Practices of Digitextuality*, ed. Anna Everett and John T. Caldwell (New York: Routledge, 2003), 5.

18. Everett, "Digitextuality and Click Theory," 7.

19. Jason Mittell, *Genre and Television: From Cop Shows to Cartoons in American Culture* (London: Routledge, 2004), 1.

20. Lisa Kernan, *Coming Attractions: Reading American Movie Trailers* (Austin: University of Texas Press, 2004), 5.

21. Ibid., 32.

22. Ibid., 7.

23. Ibid., 10.

24. David Halbfinger, "His 'Secret' Movie Trailer Is No Secret Anymore," *New York Times*, September 30, 2005, <http://www.nytimes.com/2005/09/30/movies/30shin.html>.

25. For a discussion of the role of "Lazy Sunday" in jump-starting the popularity of YouTube and the copyright debates that framed its early history, see Tim Anderson, "'TV Time' Is Now the New 'Playtime,'" *Flow* 4.1 (March 2006), <http://flowtv.org/?p=148>.

26. Geraldine Fabrikant and Saul Hansell, "Viacom Tells YouTube: Hands Off," *New York Times*, February 3, 2007, <http://www.nytimes.com/2007/02/03/technology/03tube.html>.

27. Henry Jenkins, *Convergence Culture: Where Old and New Media Collide* (New York: New York University Press, 2006), 190.

28. Lawrence Lessig, *Free Culture: How Big Media Uses Technology and the Law to Lock Down Culture and Control Creativity* (New York: Penguin, 2004), 100–108.

29. Michelle Quinn, "YouTube Unveils Copyright Protection Plan," *Los Angeles Times*, October 16, 2007, <http://www.latimes.com/business/la-fi-youtube16oct16,0,3144564.story?coll=la-home-business>.

30. Toby Miller, Nitin Govil, John McMurria, and Richard Maxwell, *Global Hollywood* (London: British Film Institute, 2001), 115.

31. Gray, *Watching with The Simpsons*, 36.

32. Anna Pickard, "The Five-Second Movies and Why You Should Watch Them," *Guardian*, November 19, 2007, <http://blogs.guardian.co.uk/film/>.

33. Miller et al., *Global Hollywood*, 116.

34. Heffernan, "Gotta Minute?"

35. Kernan (13) argues that wipes serve "to endow the trailer with a graphical surface that prohibits our ordinary cinematic relationship to the screen."

36. Mark Caro, "Love Those Trailer Mashups," *Chicago Tribune* (Pop Machine Blog), April 24, 2006, <http://featuresblogs.chicagotribune.com/entertainment_popmachine/2006/04/love_those_trai.html>.

37. Gray, *Watching with The Simpsons*, 131–133.

38. Gehring, *Parody as Film Genre*, 7. See also Klinger, *Beyond the Multiplex*, 223, on "the principle of affectionate appropriation."

39. Klinger, *Beyond the Multiplex*, 233.

40. See, for example, Karina Longworth, who argues that *Mary Poppins* seems to have been "reworked with the masculine (and maybe even misogynist) gaze in mind." See Karina Longworth, "Karina's Capsule: Women & Online Comedy," *NewTeeVee*, April 25, 2007, <newteevee.com/2007/04/25/karinas-capsule-women-online-comedy/>.

41. See, for example, Virginia Heffernan, "Brokeback Spoofs: Tough Guys Unmasked," *New York Times*, March 2, 2006, <http://www.nytimes.com/2006/03/02/movies/02heff.html>.

42. For a discussion of *Back to the Future's* playful treatment of time travel and the primal scene, see Constance Penley, *The Future of an Illusion: Film, Feminism, and Psychoanalysis* (Minneapolis: University of Minnesota Press, 1989), 126–128.

43. For a discussion of the perceived double standard regarding the ratings system and the depiction of homosexuality, see Kevin S. Sandler, *The Naked Truth: Why Hollywood Doesn't Make X-Rated Movies* (New Brunswick, N.J.: Rutgers University Press, 2007), 159–162.

44. While posting histories on YouTube are notoriously unreliable, it seems significant that "Brokeback to the Future" appeared on YouTube on February 1, 2006, while several other "Brokeback" parodies appeared within the next two weeks. If the YouTube posting dates are reliable, then that would seem to suggest that "Brokeback to the Future" significantly influenced subsequent production.

45. Patricia R. Zimmerman, "Digital Deployment(s)," in *Contemporary American Independent Film: From the Margins to the Mainstream*, ed. Chris Holmlund and Justin Wyatt (New York: Routledge, 2005), 247.

46. Alex Juhasz and Henry Jenkins, "Leaning from YouTube: An Interview with Alex Juhasz," *Confessions of an Aca/Fan*, February 20, 2008, <http://www.henryjenkins.org/2008/02/learning_from_youtube_an_inter.html>.

47. For information on the making of "Seven-Minute Sopranos," see Brendan M. Leonard, "Interview: Paul Gulyas & Joe Sabia (Seven-Minute Sopranos)," *Cinematic Happenings Under Development*, April 7, 2007, <http://www.chud.com/index.php?type=thud&id=9645>; and Heffernan, "Gotta Minute?"

48. "100 Movies 100 Quotes 100 Numbers" is available on YouTube, <http://www.youtube.com/watch?v=FExqG6LdWHU>. A complete list of the films used in the "100 Numbers" video is also available online. See "For those who just HAVE to know," *Acrentropy*, May 17, 2007, <http://acrentropy.blogspot.com/2007/05/for-those-who-just-have-to-know.html>. Alonso Moseley is the name of the FBI detective chasing Robert DeNiro and Charles Grodin's characters in *Midnight Run*.

49. Klinger, *Beyond the Multiplex*, 181.

50. Eggman913, "Women in Film" YouTube, <http://www.youtube.com/watch?v=vEc4YWICeXk>.

51. Anne Thompson, "Viral Video: Women in Film," *Thompson on Hollywood*, August 4, 2007, <http://weblogs.variety.com/thompsononhollywood/2007/08/viral-video-wom.html>.

52. Lev Manovich, *The Language of New Media* (Cambridge, Mass.: MIT Press, 2001), 143.

53. Laura Mulvey, *Visual and Other Pleasures* (Bloomington: Indiana University Press, 1989).

54. Steven Zeitchik, "Fox Atomic Brings New Twists," *Variety*, February 18, 2007, <http://www.variety.com/article/VR1117959777.html?categoryid=1350&cs=1>.

55. Nikki Finke, "Fox Atomic's Marketing Operations Folds," *Nikki Finke's Deadline Hollywood Daily*, January 11, 2008, <http://www.deadlinehollywooddaily.com/fox-atomics-marketing-operations-fold/>.

56. Craig Rubens, "Video Free and Die Hard," *NewTeeVee*, June 2, 2007, <http://newteevee.com/2007/06/02/video-free-and-die-hard/>.

CONCLUSION

1. Lisa Gitelman, *Always Already New: Media, History, and the Data of Culture* (Cambridge, Mass.: MIT Press, 2006), 7.

2. Dan Schiller, *How to Think about Information* (Urbana: University of Illinois Press, 2007), 141.

3. Nicholas Rombes, "Incompleteness," *Digital Poetics*, March 30, 2006, <http://professordvd.typepad.com/my_weblog/2006/03/incompleteness.html>.

4. John Thornton Caldwell, *Production Cultures: Industrial Reflexivity and Critical Practice in Film and Television* (Durham, N.C.: Duke University Press, 2008).

5. Andrew O'Hehir, "Indie Film Is Dying—Unless It Isn't," *Salon*, June 24, 2008, <http://www.salon.com/ent/movies/btm/feature/2008/06/24/indie_death/index.html>.

6. Anne Thompson, "Indie Sector on Shaky Ground," *Variety*, June 26, 2008, <http://www.variety.com/article/VR1117988181.html?categoryid=2508&cs=1>.

7. Carrie Rickey, "Art Houses Are Empty—But It Is Summer," *Philadelphia Inquirer*, June 22, 2008, <http://www.philly.com>.

8. Mark Gill, "LAFF: Mark Gill on Indie Film Crisis," *Thompson on Hollywood*, June 21, 2008, <http://weblogs.variety.com/thompsononhollywood/2008/06/laff-mark-gill.html>.

9. Ibid.

10. David Poland, "The Indie Thing," *Hot Button*, June 23, 2008, <http://www .mcnblogs.com/thehotbutton/2008/06/the_indie_thing.html>.
11. Kent Nichols, "Stop Worrying about Indie Film," *Kent's Official Blog*, June 26, 2008, <http://kentnichols.com/2008/06/26/stop-worrying-about-indie-film/>.
12. In "Indie Sector on Shaky Ground," Thompson speculates that one of the reasons that boomers and other older audiences have abandoned theaters is that Hollywood no longer makes films with them in mind.
13. Charles R. Acland, *Screen Traffic: Movies, Multiplexes, and Global Culture* (Durham, N.C.: Duke University Press, 2003), 245.
14. Ibid., 243.

Bibliography

Acland, Charles. "IMAX Technology and the Tourist Gaze." *Cultural Studies* 12.3 (1998), 429–445.

———. *Screen Traffic: Movies, Multiplexes, and Global Culture.* Durham, N.C.: Duke University Press, 2003.

Anderson, Chris. *The Long Tail: Why the Future of Business Is Selling Less of More.* New York: Hyperion, 2006.

Anderson, Lessley. "Hot Gossip: Ain't-it-Cool-News.com Harry Knowles—Online Publisher." *Wired* 5.11 (November 1997), <http://www.wired.com>.

Anderson, Tim. "'TV Time' Is Now the New 'Playtime.'" *Flow* 4.1 (March 2006), <http://flowtv.org/?p=148>.

Arthur, Paul. "True Confessions, Sort Of: *Capturing the Friedmans* and the Dilemma of Theatrical Documentary." *Cineaste* (Fall 2003), 3–7.

Askwith, Ivan. "A Matrix in Every Medium." *Salon*, May 12, 2003, <http://dir.salon.com/story/tech/feature/2003/05/12/matrix_universe/index.html>.

Bazin, Andre. *What Is Cinema?* Trans. Hugh Gray. Berkeley: University of California Press, 1967.

Behlil, Melis. "Ravenous Cinephiles." *Cinephilia: Movies, Love, and Memory.* Ed. Marijke de Valck and Malte Hagener. Amsterdam: Amsterdam University Press, 2005. 111–124.

Belton, John. "Digital Cinema: A False Revolution." *October* no. 100 (Spring 2002), 99–114.

Benkler, Yochai. *The Wealth of Networks: How Social Production Transforms Markets and Freedom.* New Haven: Yale University Press, 2006.

Benson-Allott, Caetlin. "Before You Die, You See The Ring." *Jump Cut* 49 (Spring 2007), <http://ejumpcut.org/archive/jc49.2007/bensonAllott/text.html>.

Berardinelli, James. "The Last Broadcast." *Reel Views* 2000, <http://movie-reviews.colossus.net/movies/l/last_broadcast.html>.

Bit, Kelly. "Video Stores React to Netflix by Focusing on Human Touch." *New York Sun*, July 31, 2006, <http://www.nysun.com/article/37009>.

Blood, Rebecca. "Introduction." *We've Got Blog: How Weblogs Are Changing Our Culture.* Cambridge, Mass.: Perseus Books, 2002.

Boddy, William. "A Century of Electronic Cinema." *Screen* 48.2 (Summer 2008), 142–156.

———. *New Media and Popular Imagination: Launching Radio, Television, and Digital Media in the United States.* Oxford: Oxford University Press, 2004.

Bolter, Jay David, and Richard Grusin. *Remediation: Understanding New Media*. Cambridge, Mass.: MIT Press, 1999.

Boynton, Robert S. "How to Make a Guerilla Documentary." *New York Times*, July 11, 2004, <http://query.nytimes.com/>.

Brookey, Robert Alan, and Robert Westerfelhaus. "Hiding Homoeroticism in Plain View: The *Fight Club* DVD as Digital Closet." *Critical Studies in Media Communication* 19.1 (March 2002), 21–43.

Bryant, Steven. "Sicko Leak Benefits Moore." *NewTeeVee*, June 19, 2007, <http://newteevee.com/2007/06/19/sicko-leak-benefits-moore/>.

Buck-Morss, Susan. *The Dialectics of Seeing: Walter Benjamin and the Arcades Project*. Cambridge, Mass.: MIT Press, 1989.

Caldwell, John Thornton. "Convergence Television: Aggregating Form and Repurposing Content in the Culture of Conglomeration." *Television after TV: Essays on a Medium in Transition*. Ed. Lynn Spigel and Jan Olsson. Durham, N.C.: Duke University Press, 2004.

———. *Production Culture: Industrial Reflexivity and Critical Practice in Film and Television*. Durham, N.C.: Duke University Press, 2008.

———. "Second-Shift Media Aesthetics: Programming, Interactivity, and User Flows." New Media: Theories and Practices of Digitextuality. Ed. Anna Everett and John T. Caldwell. New York: Routledge, 2003. 127–144.

Caro, Mark. "Love Those Trailer Mashups." *Chicago Tribune* (Pop Machine Blog), April 24, 2006, <http://featuresblogs.chicagotribune.com/>.

Carr, David. "Now on the Endangered Species List: Movie Critics in Print." *New York Times*, April 1, 2008, <http://www.nytimes.com/2008/04/01/movies/01crit.html>.

Center for Social Media. "Code of Best Practices in Fair Use for Online Video." American University School of Communication, July 2008, <http://www.centerforsocialmedia.org/resources/publications/fair_use_in_online_video/>.

Chan, Vera H-C. "Asian Pop: Korean Movies, Hold the Koreans." *San Francisco Chronicle*, July 1, 2004, <http://sfgate.com/>.

Cheshire, Godfrey. "The Death of Film/The Decay of Cinema." *New York Press*, August 26, 1999, <http://www.nypress.com/print.cfm?content_id=243>.

———. "Grindhouse Aims to Resurrect Movies, Not Bury Them." *Independent Weekly*, April 11, 2007, <http://www.indyweek.com/>.

Chonin, Neva. "Snakes on a Plane' Blog Buzz Forces Hollywood into Overdue Attitude Adjustment." *San Francisco Chronicle*, June 12, 2006, <http://www.sfgate.com/>.

Cobb, Jerry. "Product Placement Goes Digital, Gets Lucrative." MSNBC.com, March 8, 2006, <http://www.msnbc.msn.com/id/11728512/>.

Corbett, Kevin J. "The Big Picture: Theatrical Moviegoing, Digital Television, and Beyond the Substitution Effect." *Cinema Journal* 40.2 (Winter 2001), 17–34.

Corcoran, Patrick. "Average Video Announcement and Video Release Windows (as of 3/3/2008)." *National Association of Theater Owners*, March 3, 2008, <http://www.natoonline.org/>.

Craig, J. Robert. "Establishing New Boundaries for Special Effects: Robert Zemeckis's *Contact* and Computer-Generated Imagery." *Journal of Popular Film and Television* 28 (Winter 2001), 158–165.

Cuban, Mark. "Keynote Address." Digimart Global Digital Distribution Summit, September 22, 2005, < http://digimart.org/en/index.php#>.

Davis, Erik. "Interview: 'Four Eyed Monsters' Co-Director Arin Crumley—Part One." *Cinematical*, July 25, 2007, <http://www.cinematical.com/2007/07/25/interview-four-eyed-monsters-co-director-arin-crumley-part/>.

———. "Interview: 'Four Eyed Monsters' Co-Director Arin Crumley—Part Two." *Cinematical*, July 29, 2007, <http://www.cinematical.com/2007/07/29/interview-four-eyed-monsters- co-director-arin-crumley-part-t/>.

Davis, Mike. *City of Quartz: Excavating the Future in Los Angeles*. New York: Vintage, 1992.

"D-Day February 2009." *National Association of Television Programming Executives*, <http://www.natpe.org/>.

Delaney, Kevin J. "Google Push to Sell Ads on YouTube Hits Snags." *Wall Street Journal*, July 9, 2008, A1.

De Lollis, Barbara. "Laptop Etiquette Takes to the Skies." *USA Today*, August 21, 2007, <http://www.usatoday.com/>.

Denby, David. "Big Pictures: Hollywood Looks for a Future." *New Yorker*, January 8, 2007, <http://www.newyorker.com/critics/atlarge/articles/070108crat_atlarge>.

Dentler, Matt. "First Person: Matt Dentler on Indie Film for the MySpace/YouTube/iPod Generation." *indieWIRE*, August 19, 2007, <http://www.indiewire.com/people/2007/08/first_person_ma.html>.

Dixon, Wheeler Winston. "Twenty-Five Reasons Why It's All Over." *The End of Cinema as We Know It: American Film in the Nineties*. Ed. Jon Lewis. New York: New York University Press, 2001. 356–366.

———. "Vanishing Point: The Last Days of Film." *Senses of Cinema* 43 (2007), <http://www.sensesofcinema.com/contents/07/43/last-days-film.html>.

Dixon, Wheeler Winston, and Gwendolyn Audrey Foster. *A Short History of Film*. New Brunswick: Rutgers University Press, 2008.

Doane, Mary Ann. *The Desire to Desire: The Woman's Film of the 1940s*. Bloomington: Indiana University Press, 1987.

Douglas, Susan J. *Listening In: Radio and the American Imagination*. Minneapolis: University of Minnesota Press, 1999.

"DreamWorks Animation Goes 3D." *DreamWorks Animation SKG*, March 13, 2007, <http://www.dreamworksanimation.com/>.

Dyer, Richard. *Heavenly Bodies*. London: Routledge, 2002.

———. *Stars*. London: British Film Institute, 1998.

Eco, Umberto. *Travels in Hyperreality*. New York: Harvest, 1990.

"Economic Downturns and the Box Office." *National Association of Theater Owners*, <http://www.natoonline.org/pdfs/Talking%20Points/TP-Economic%20Downturns%20and%20the%20Box%20Office.pdf>.

Ellenberg, Jordan. "The Netflix Challenge." *Wired* 16.3 (March 2008), 114–122.

Elsaesser, Thomas. "The Blockbuster: Everything Connects, but Not Everything Goes." *The End of Cinema as We Know It: American Film in the Nineties*. Ed. Jon Lewis. New York: New York University Press, 2001. 11–22.

———. "Cinephilia or the Uses of Disenchantment." *Cinephilia: Movies, Love, and Memory*. Amsterdam: Amsterdam University Press, 2005. 27–44.

———. "Digital Cinema: Delivery, Event, Time." *Cinema Futures: Cain, Abel or Cable?: The Screen Arts in the Digital Age*. Ed. Thomas Elsaesser and Kay Hoffmann. Amsterdam: Amsterdam University Press, 1998. 201–222.

"Entertainment Industry Market Statistics." Motion Picture Association of America 2008, <http://www.mpaa.org/USEntertainmentIndustryMarketStats.pdf>.

Epstein, Edward Jay. *The Big Picture: Money and Power in Hollywood*. New York: Random House, 2006.

———. "Hollywood's Death Spiral." *Slate.com*, July 25, 2005, <http://www.slate.com/id/2123286/>.

Erickson, Steve. "Permanent Ghosts: Cinephilia in the Age of the Internet and Video, Essay 1." *Senses of Cinema* 4 (March 2000), <http://www.sensesofcinema.com/contents/00/4/cine1.html>.

Evangelista, Benny. "DVD Player to Edit Movies." *San Francisco Chronicle*, April 7, 2004, <http://www.sfgate.com/>.

Everett, Anna. "Digitextuality and Click Theory: Theses on Convergence Media in the Digital Age." *New Media: Theories and Practices of Digitextuality*. Ed. Anna Everett and John T. Caldwell. New York: Routledge, 2003. 3–28.

Fabrikant, Geraldine and Saul Hansell. "Viacom Tells YouTube: Hands Off." *New York Times*, February 3, 2007, <http://www.nytimes.com/2007/02/03/technology/03tube.html>.

Farber, Manny. *Negative Space*. New York: Da Capo, 1998.

"The Final Frontier: How Digital Technology Is Changing the Way Cinemas Work." *Economist*, July 12, 2007, <http://www.economist.com/>.

Finke, Nikki. "Fox Atomic's Marketing Operations Folds." *Nikki Finke's Deadline Hollywood Daily*, January 11, 2008, <http://www.deadlinehollywooddaily.com/fox-atomics-marketing-operations-fold/>.

Fisher, Bob. "Facing the Digital Dilemma." *MovieMaker* 15.75 (Summer 2008), 20–22.

Fithian, John. "Comments by John Fithian." *National Association of Theater Owners*, ShoWest Opening Ceremonies, March 11, 2008, <http://www.natoonline.org>.

———. "Letter to Digital Cinema Initiatives." *National Association of Theater Owners Online*, December 19, 2006, <http://www.natoonline.org/Digital.htm>.

Friedberg, Anne. *Window Shopping: Cinema and the Postmodern.* Berkeley: University of California Press, 1993.

Freud, Sigmund. *Three Case Studies.* Ed. Philip Reiff. New York: Collier, 1963. 161–280.

Gabler, Neal. "The Movie Magic Is Gone." *Los Angeles Times*, February 25, 2007, <http://www.latimes.com/>.

Gehring, Wes D. *Parody as Film Genre.* Westport, Conn.: Greenwood Press, 1999.

Gentile, Gary. "Bubble Breaks New Ground with Simultaneous Release Strategy." *North County Times*, January 25, 2006, <http://www.nctimes.com/>.

Gill, Mark. "LAFF: Mark Gill on Indie Film Crisis." Thompson on Hollywood, June 21, 2008, <http://weblogs.variety.com/thompsononhollywood/2008/06/laff-mark-gill.html>.

Gilliam, Jim. "Outfoxed Interviews Available for Remixing." Jim Gilliam's Blog, September 14, 2004, <http://www.jimgilliam.com/2004/09/outfoxed_interviews_available_for_remixing. php>.

Gillmor, Dan. *We the Media: Grassroots Journalism by the People, for the People.* North Sebastopol, Canada: O'Reilly, 2004.

Gitelman, Lisa. *Always Already New: Media, History, and the Data of Culture.* Cambridge, Mass.: MIT Press, 2006.

Glaser, Mark. "What We Lose (and Gain) Without Video Stores." *Media Shift*, April 13, 2007, <http://www.pbs.org/>.

Goldberg, Michelle. "Now Playing in 2,600 Home Theaters: Bush's Lies about Iraq." *Salon*, December 9, 2003, <http://archive.salon.com/news/feature/2003/12/09/uncovered/index.html>.

Goldman, Michael. "Digitally Independent Cinema." *Filmmaker* 16.2 (Winter 2008), 92–95.

Goldstein, Gregg. "Michael Moore's 'Sicko' Pirated, on YouTube." *New Zealand Herald*, June 19, 2007, <http://www.nzherald.co.nz/>.

Gomery, Douglas. *Shared Pleasures: A History of Movie Presentation in the United States.* Madison: University of Wisconsin Press, 1992.

Grant, Barry Keith. "Diversity or Dilution? Thoughts on Film Studies and the SCMS." *Cinema Journal* 43.3 (Spring 2004), 87–89.

Gray, Jonathan. *Watching with The Simpsons: Television, Parody, and Intertextuality.* New York: Routledge, 2006.

Greenwald, Robert. "Robert Greenwald, Producer/Director of 'Uncovered: The Whole Truth About the Iraq War,' A New Documentary That Reveals How the Bush Administration Lied the Nation Into War." *Buzzflash*, November 3, 2003, <http://www.buzzflash.com/interviews/03/11/int03031.html>.

Grossman, Lev. "Time Person of the Year: You." *Time, December* 25, 2006: 38–41.

Gunning, Tom. "An Aesthetic of Astonishment: Early Film and the (In)Credulous Spectator." *Viewing Positions: Ways of Seeing Film.* Ed. Linda Williams. New Brunswick, N.J.: Rutgers University Press, 1995. 114–133.

Guy, Eddie. "Snack Attack." *Wired* 15.3 (March 2007), 124–135.

Hafner, Katie. "The Camera Never Lies, But the Software Can." *New York Times*, March 11, 2004, <http://www.nytimes.com>.

Halbfinger, David. "His 'Secret' Movie Trailer Is No Secret Anymore." *New York Times*, September 30, 2005, <http://www.nytimes.com/2005/09/30/movies/30shin.html>.

———. "Studios Announce a Deal to Help Cinemas Go 3-D." *New York Times*, March 12, 2008, <http://www.nytimes.com/>.

Harrington, Carly. "Regal CEO Says Digital Upgrade May be Delayed." *Knoxville News-Sentinel*, October 24, 2008, <http://www.knoxnews.com/news/2008/oct/24/regal-ceo-says-digital-upgrade-may-be-delayed/>.

Hart, Hugh. "Mark Cuban to Show New Movies on TV Before Theatrical Release." *Wired*, July 9, 2008, <http://blog.wired.com/underwire/2008/07/cuban-to-show-n.html>.

Hawkins, Joan. "Dish Towns USA (or Rural Screens) Part One." *Flow* 6.3 (June 29, 2007), <http://flowtv.org/?p=525>.

Hawthorne, Christopher. "The Landmark Theatre Has Your Living Room in Its Sites." *Los Angeles Times*, June 1, 2007, <http://articles.latimes.com/2007/jun/01/entertainment/et-landmark1>.

Heath, Thomas. "Lenosis's 'Filmanthropy' Plants a Seed with Buddies." *Washington Post*, January 25, 2007, D1.

Heffernan, Virginia. "Brokeback Spoofs: Tough Guys Unmasked." *New York Times*, March 2, 2006, <http://www.nytimes.com/2006/03/02/movies/02heff.html>.

———. "Gotta Minute? So, There's This Guy Tony. . . ." *New York Times*, April 6, 2007, <http://www.nytimes.com>.

Hernandez, Eugene. "At IFC Films, 'Penelope' Shift Points to a Change in Focus; Company Emphasizing First Take Slate." *IndieWIRE*, August 14, 2007, <http://www.indiewire.com/biz/2007/08/at_ifc_films_pe.html>.

———. "Mumblecore Movie? Swanberg, Bujalski, Duplass, and Others Unveil 'Hannah Takes the Stairs.'" *indieWIRE*, March 14, 2007, <http://www.indiewire.com/ots/2007/03/sxsw_07_daily_d_3.html>.

Hills, Matt. *Fan Cultures*. New York: Routledge, 2002.

Hilmes, Michelle. "The Bad Object: Television in the American Academy." *Cinema Journal* 45.1 (Fall 2005), 111–116.

Hoberman, J. "Back to Nature: The Art of Destruction." *Village Voice*, March 19–25, 2003.

———. "It's Mumblecore!" *Village Voice*, August 8, 2007, <http://www.villagevoice.com/2007-08-14/film/it-s-mumblecore/>.

———. "Paradise Now." *Village Voice*, March 7, 2006, <http://www.villagevoice.com/film/0610,hoberman,72427,20.html>.

Holson, Laura. "Hollywood Loves the Tiny Screen. Advertisers Don't." *New York Times*, May 7, 2007, <http://www.nytimes.com/>.

Hopewell, John, and Marcelo Cajueiro, "Digital Logs Demand." *Variety*, February 11, 2008, <http://www.variety.com>.

Horbal, Andy. "Film Criticism in 'The Blog Era.'" Mirror/Stage, July 6, 2007, <http://truespies.org/mirror-stage/2007/07/06/film-criticism-in-the-blog-era/>.

"How DLP Technology Works." *DLP Technology: The Ultimate Viewing Experience*. Texas Instruments Incorporated 2007, <http://www.dlp.com/tech/what.aspx>.

Hudson, David. "Behind the Blog: David Hudson of GreenCine Daily." *Film in Focus*, <http://www.filminfocus.com/essays/behind-the-blog-david-hudson-g.php>.

"Independent Exhibitors Step into the Digital Future." *National Association of Theater Owners*, April 1, 2008, <http://www.natoonline.org/>.

Jenkins, Henry. "Blog This." *Technology Review* (March 2002), <http://www.technologyreview.com/Energy/12768/>.

———. *Convergence Culture: Where Old and New Media Collide*. New York: New York University Press, 2006.

———. *Fans, Bloggers, and Gamers: Exploring Participatory Culture*. New York: New York University Press, 2006.

Juhasz, Alex, and Henry Jenkins. "Leaning from YouTube: An Interview with Alex Juhasz." *Confessions of an Aca/Fan*, February 20, 2008, <http://www.henryjenkins.org/2008/02/learning_from_youtube_an_inter.html>.

Karagosian, Michael. "Demystifying Digital Cinema Part 2: Less Can Be More." *In Focus* 2.11 (November 2002), <http://natoonline.org/infocus/02November/digital.htm>.

Kaufman, Anthony. "Industry Beat." *Filmmaker* 15.3 (Spring 2007), 26, 97.

———. "The SXSW All-Stars: A New Ultra-Indie Movement." *indieWIRE*, March 13, 2007, <http://blogs.indiewire.com/anthony/archives/012986.html>.

Kennedy, Lisa. "Spielberg in the Twilight Zone." *Wired* 10.6 (June 2002), 108–115.

Kernan, Lisa. *Coming Attractions: Reading American Movie Trailers*. Austin: University of Texas Press, 2004.

"Kids Duped into Seeing 'Hannah Montana' Film?" MSNBC.com, February 6, 2008, <http://www.msnbc.msn.com/id/23036640/>.

King, Danny. "Group Aims for 3D Home Video Format." *Video Business*, July 17, 2008, <http://www.videobusiness.com/article/CA6580247.html?rssid=207>.

Kirkpatrick, David D. "Shaping Cultural Tastes at Big Retail Chains." *New York Times*, May 18, 2003, <http://nytimes.com>.

Kirsner, Scott. "Everyone's Always Been a Critic—but the Net Makes their Voices Count." *Boston Globe*, April 30, 2006, <http://www.boston.com>.

Klinger, Barbara. *Beyond the Multiplex: Cinema, New Technologies, and the Home*. Berkeley: University of California Press, 2006.

Klosterman, Chuck. "The Tragedy of the Best Titled Movie in the History of Film." *Esquire*, July 1, 2006, <http://www.esquire.com/features/ESQ0806KLOSTERMAN_60>.

Kohn, Eric. "Champion of the Format Wars." *Moviemaker* 15.75 (2008), 24–25.

Kompare, Derek. "Publishing Flow: DVD Box Sets and the Reconception of Television." *Television & New Media* 7.4 (November 2006), 335–360.

Kotb, Hoda. "Video Clerk to Box Office Icon." MSNBC.com, April 25, 2004, <http://www. msnbc.msn.com/id/4817308/>.

Kurzweil, Ray. *The Age of Spiritual Machines*. New York: Viking, 1999.

Langlois, Daniel. "Introduction by Daniel Langlois." Digimart Global Digital Distribution Summit, September 2005, <http://www.digimart.org/?lang=en>.

Lasica, J. D. *Darknet: Hollywood's War against the Digital Generation*. Hoboken, N.J.: Wiley, 2005.

Leaver, Tama. "*Battlestar Galactica* Webisodes and the Tyranny of Digital Distance." *Blogcritics*, September 12, 2006, <http://blogcritics.org/archives/2006/09/12/063843 .php>.

Lee, Felicia. "Paramount Vantage Takes a Trim." *New York Times*, June 5, 2008, <http:// www.nytimes.com/2008/06/05/arts/05arts-PARAMOUNTVAN_BRF.html? ref=arts>.

Leonard, Brendan M. "Interview: Paul Gulyas & Joe Sabia (Seven-Minute Sopranos)." *Cinematic Happenings Under Development*, April 7, 2007, <http://www.chud.com/ index.php? type=thud&id=9645>.

Lesage, Julia. "The Internet Today, or How I Got Involved in Social Book Marking." *Jump Cut* 49 (2007), <http://www.ejumpcut.org/>.

Lessig, Lawrence. *Free Culture: How Big Media Uses Technology and the Law to Lock Down Culture and Control Creativity*. New York: Penguin, 2004.

Lévy, Pierre. *Collective Intelligence: Mankind's Emerging World in Cyberspace*. Trans. Robert Bononno. Cambridge, Mass.: Perseus Books, 1997.

Lewis, Jon. ed. *The End of Cinema as We Know It: American Film in the Nineties*. New York: New York University Press, 2001.

Lim, Dennis. "A Generation Finds Its Mumble." *New York Times*, August 19, 2007, <http://www.nytimes.com/2007/08/19/movies/19lim.html>.

Lindsey, Craig D. "Best Critics Keep All of Us Honest." *Raleigh News-Observer*, July 13, 2008, <http://www.newsobserver.com/105/story/1140023.html>.

"Looking More Convincing." *Economist*, July 12, 2007, <http://www.economist.com/ business/displaystory.cfm?story_id=9482930>.

Longworth, Karina. "Distribution Wars: How Irrational Fear of the Cellphone Might Kill the Movie Theater." *Spout.com*, July 13, 2007, <http://blog.spout.com/#1792>.

———. "Karina's Capsule: Women & Online Comedy." *NewTeeVee*, April 25, 2007, <newteevee.com/2007/04/25/karinas-capsule-women-online-comedy/>.

Lopate, Phillip. "Critics in Crisis." *Film in Focus*, July 25, 2008, <http://www.filminfocus .com/essays/critics-in-crisis.php>.

Lotz, Amanda D. *The Television Will Be Revolutionized*. New York: New York University Press, 2007.

Lyons, Charles. "Join a Revolution. Make a Movie. Go Broke." *New York Times*, November 20, 2005, <http://www.nytimes.com/>.

Malone, Michael S. "Silicon Insider: Will Hulu Replace YouTube." ABC News.com, March 14, 2008, <http://www.abcnews.go.com/Business/story?id=4446876&page=1>.

Manovich, Lev. *The Language of New Media*. Cambridge, Mass.: MIT Press, 2001.

Martin, Adrian. "Posseessory Credit." *Framework* 45.1 (Spring 2004), 95–99.

McCarthy, Anna. *Ambient Television: Visual Culture and Public Space*. Durham, N.C.: Duke University Press, 2001.

McClintock, Pamela. "Studios, Theaters Near Digital Pact." *Variety*, March 10, 2008, <http://www.variety.com/article/VR1117982175.html?categoryid=2502&cs=1>.

McDonald, Paul. *The Star System*. London: Wallflower, 2000.

Mellencamp, Patricia. "The Zen of Masculinity—Rituals of Heroism in *The Matrix*." *The End of Cinema as We Know It: American Film in the Nineties*. Ed. Jon Lewis. New York: New York University Press, 2001. 83–94.

"The Metropolis Comparison." *Dark City* (DVD). New Line, 1998.

Miller, Nancy. "Minifesto for a New Age." *Wired* 15.3 (March 2007), 16–28.

Miller, Toby. *Cultural Citizenship: Cosmopolitanism, Consumerism, and Television in a Neoliberal Age*. Philadelphia: Temple University Press, 2007.

Miller, Toby, Nitin Govil, John McMurria, and Richard Maxwell. *Global Hollywood*. London: British Film Institute, 2001.

Mitchell, Elvis. "Everyone's a Film Geek Now." *New York Times*, August 17, 2003, <http://query.nytimes.com/gst/fullpage.html?res=9F06E3DC1E31F934A2575BC0A 9659C8B63>.

Mitchell, Stacy. *Big-Box Swindle: The True Cost of Mega-Retailers and the Fight for America's Independent Businesses*. Boston: Beacon, 2007.

Mitchell, William J. *The Reconfigured Eye: Visual Truth in the Post-Photographic Era*. Cambridge, Mass.: MIT Press, 1995.

Mittell, Jason. "Exchanges of Value." *Flow* 3.4 (October 2005), <http://flowtv.org/ ?p=264>.

———. *Genre and Television: From Cop Shows to Cartoons in American Culture*. London: Routledge, 2004.

Mohr, Ian. "Box Office, Admissions Rise in 2006." *Variety*, March 6, 2007, <http://www .variety.com/article/VR1117960597.html?categoryid=13&cs=1>.

Morgenstern, Joe. "'Pod People." *Wall Street Journal*, February 23, 2008, <http://online .wsj.com/public/article_print/SB120372124413686875.html>.

Morita, Akio. *Made in Japan: Akio Morita and Sony*. New York: E. P. Dutton, 1986.

Morley, David. *Home Territories: Media, Mobility, and Identity*. London: Routledge, 2000.

Morse, Margaret. *Virtualities: Television, Media Art, and Cyberculture*. Bloomington: Indiana University Press, 1993.

Mosco, Vincent. *The Digital Sublime: Myth, Power, and Cyberspace*. Cambridge, Mass.: MIT Press, 2004.

"Movie Attendance Study 2007." *Motion Picture Association of America*, <http://www.mpaa .org/MovieAttendanceStudy.pdf>.

Mulvey, Laura. *Visual and Other Pleasures*. Bloomington: Indiana University Press, 1989.

Musgrove, Mike. "Coming Soon to an Xbox Near You." *Washington Post*, July 15, 2008, <http://www.washingtonpost.com/>.

Nakamura, Lisa. *Cybertypes: Race, Ethnicity, and Identity on the Internet*. New York: Routledge, 2002.

Navarro, Mireya. "Love Him or (He Prefers) Hate Him." *New York Times*, July 29, 2007, <http://www.nytimes.com/2007/07/29/fashion/29perez.html>.

Neulight, Joe. "Off the Grid." *Variety*, September 10, 2006, <http://www.variety.com/>.

Newitz, Annalee. "User-Generated Censorship." *AlterNet*, April 30, 2008, <http://www .alternet.org/mediaculture/84060/>.

Nichols, Kent. "Stop Worrying about Indie Film." Kent's Official Blog, June 26, 2008, <http://kentnichols.com/2008/06/26/stop-worrying-about-indie-film/>.

Nuttycombe, Dave. "A Silverdocs Report." Nutco Enterprises, June 24, 2008, <http:// nuttycombe.com/blog/2008/06/24/a-silverdocs-report/>.

O'Hehir, Andrew. "Beyond the Multiplex." *Salon*, July 12, 2007, <http://www.salon.com/ ent/movies/review/2007/07/12/btm/index.html>.

———. "Indie Film Is Dying—Unless It Isn't." *Salon*, June 24, 2008, <http://www.salon .com/ent/movies/btm/feature/2008/06/24/indie_death/index.html>.

"On the Record: Studio Executives and Directors Overwhelmingly Support Preservation of the Theatrical Window." *National Association of Theater Owners*, December 2006, <http://www.natoonline.org>.

Orgeron, Devin. "La Camera-Crayola: Authorship Comes of Age in the Cinema of Wes Anderson." *Cinema Journal* 46.2 (Winter 2007), 40–65.

O'Sullivan, Michael. "Take Two: A 'Keane' Remix by Soderbergh." *Washington Post*, March 24, 2006, <http://www.washingtonpost.com/wp-dyn/content/article/2006/03/23/ AR2006032300541.html>.

Owczarski, Kimberly. "The Internet and Contemporary Entertainment: Rethinking the Role of the Film Text." *Journal of Film and Video* 59.3 (Fall 2007), 3–14.

"Oxford Word of the Year: Locavore." OUPBlog, November 12, 2007, <http://blog.oup .com/2007/11/locavore/>.

Panayides, Theo. "Permanent Ghosts: Cinephilia in the Age of the Internet and Video, Essay 2." *Senses of Cinema* 4 (March 2000), <http://www.sensesofcinema.com/ contents/00/4/cine2.html>.

Parks, Stacey. "Blogging Your Way to Stardom." *MovieMaker* 15.75 (2008), 38–40.

"Patron Behavior." *National Association of Theater Owners*, <http://www.natoonline.org/ pdfs/Talking%20Points/TP-Patron%20Behavior.pdf>.

Patterson, John. "I Was a Teenage Grindhouse Freak." *Guardian*, March 3, 2007, <http://film.guardian.co.uk/features/featurepages/0,,2024479,00.html>.

Peel, M. A. "Live Blogging Mad Men: 'And You, Sir, Are No John Galt.'" New Critics, October 12, 2007, <http://newcritics.com/blog1/2007/10/12/live-blogging-mad-men-and-you-sir-are-no-john-galt/>.

Penley, Constance. *The Future of an Illusion: Film, Feminism, and Psychoanalysis.* Minneapolis: University of Minnesota Press, 1989.

Pesce, Mark. "When the Going Gets Weird." Digimart Global Digital Distribution Summit, September 22, 2005, <http://www.digimart.org/en/#>.

Petersen, Anne. "Celebrity Juice, Not from Concentrate: Perez Hilton, Gossip Blogs, and the New Star Production." *Jump Cut* 49 (Spring 2007), <http://www.ejumpcut.org/>.

Pickard, Anna. "The Five-Second Movies and Why You Should Watch Them." *Guardian*, November 19, 2007, < http://blogs.guardian.co.uk/film/>.

Pierson, Michele. *Special Effects: Still in Search of Wonder.* New York: Columbia University Press, 2002.

Pinkerton, Nick. "Art in the Age of Myopia: Terrence Malick's The New World." Stop Smiling, February 3, 2006, <http://www.stopsmilingonline.com/story_detail.php?id=502>.

Poland, David. "The Indie Thing." Hot Button, June 23, 2008, <http://www.mcnblogs.com/thehotbutton/2008/06/the_indie_thing.html>.

———. "Sicko Piracy Updated." Hot Blog, June 18, 2007, <http://www.mcnblogs.com/thehotblog/archives/2007/06/sicko_piracy_up.html>.

Price, Michael H. "Rave Theaters Complete Digital Movie Conversion." *Fort Worth Business Press*, July 8, 2008, <http://www.fwbusinesspress.com/>.

Putnam, Robert. *Bowling Alone: The Collapse and Revival of American Community* New York: Simon and Schuster, 2000.

Quinn, Michelle. "YouTube Unveils Copyright Protection Plan." *Los Angeles Times*, October 16, 2007, <http://www.latimes.com/business/la-fi-youtube16oct16,0,3144564.story?coll=la-home-business>.

Rauch, Jonathan. "How to Save Newspapers and Why." *National Journal*, June 14, 2008, <http://www.nationaljournal.com/njmagazine/st_20080614_5036.php>.

Rayner, Jay. "Is It Curtains for Critics?" *Guardian*, July 13, 2008, <http://arts.guardian.co.uk/art/visualart/story/0,,2290623,00.html>.

Reesman, Bryan. "Raiders of the Lost Art." *Moviemaker* 15.73 (Winter 2008), 66–70.

Reisinger, Don. "LionsGate: Piracy a Major Deciding Factor for Blu-Ray Support." *CNET News*, January 10, 2008, <http://news.cnet.com/8301-13506_3-9847914-17.html?hhTest=1>.

Rich, Katey. "Fighting Back: MPAA & NYC Unveil Campaign to Stem Piracy." *Film Journal International*, June 25, 2007, <http://www.filmjournal.com>.

Rich, Motoko. "Are Book Reviewers out of Print?" *New York Times*, May 2, 2007, <http://www.nytimes.com/2007/05/02/books/02revi.html>.

Rickey, Carrie. "Art Houses Are Empty—But It Is Summer." *Philadelphia Inquirer*, June 22, 2008, <http://www.philly.com>.

Ritea, Steve. "Going It Alone." *American Journalism Review*, August/September 2004, <http://www.ajr.org/article_printable.asp?id=3725>.

Rodowick, D. N. *The Virtual Life of Film.* Cambridge, Mass.: Harvard University Press, 2007.

Rombes, Nicholas. "Incompleteness." Digital Poetics, March 30, 2006, <http://professordvd.typepad.com/my_weblog/2006/03/incompleteness.html>.

———. "Roundtable on the Video iPod." *BraintrustDV*, November 30, 2005, <http://www.braintrustdv.com/roundtables/ipod.html##Rombes>.

Rose, Frank. "A Second Chance for 3-D." *Wired* 15.11 (November 2007), 160–166.

Rosen, Philip. *Change Mummified: Cinema, Historicity, Theory.* Minneapolis: University of Minnesota Press, 2001.

Rosenbaum, Jonathan. "Film Writing on the Web: Some Personal Reflections." *Film Quarterly* 60.3 (2007), 76–80.

Rosenzweig, Roy. "From Rum Shop to Rialto: Workers and Movies." *Moviegoing in America*. Ed. Gregory A. Waller. Oxford: Blackwell Publishers, 2002.

Rubens, Craig. "Video Free and Die Hard." *NewTeeVee*, June 2, 2007, <http://newteevee .com/2007/06/02/video-free-and-die-hard/>.

Russell, Catherine. "New Media and Film History: Walter Benjamin and the Awakening of Cinema." *Cinema Journal* 43.3 (Spring 2004), 81–84.

Sandler, Kevin S. *The Naked Truth: Why Hollywood Doesn't Make X-Rated Movies.* New Brunswick, N.J.: Rutgers University Press, 2007.

Schauer, Bradley, and Susan Arosteguy. "The Criterion Collection in the New Home Video Market: An Interview with Susan Arosteguy." *Velvet Light Trap* 56 (Fall 2005), 32–35.

Schiller, Dan. *How to Think about Information.* Urbana: University of Illinois Press, 2007.

Schwartz, Barry. *The Paradox of Choice: Why More Is Less.* New York: Harper, 2004.

Scott, A. O. "Avast, Me Critics! Ye Kill the Fun: Critics and the Masses Disagree about Film Choices." *New York Times*, July 18, 2006, <http://www.nytimes.com/2006/07/18/ movies/18crit.html>.

———. "The Shape of Cinema, Transformed at the Click of a Mouse." *New York Times*, March 18, 2007, <http://www.nytimes.com/>.

Seitz, Matt Zoller. "Just Beautiful." House Next Door, January 26, 2006. <http:// mattzollerseitz.blogspot.com/>.

———. "One 'World.'" House Next Door, January 29, 2006, <http://mattzollerseitz .blogspot.com/>.

———. "There Is Only This . . . All Else Is Unreal." House Next Door, January 2, 2006. <http://mattzollerseitz.blogspot.com/>.

Shirky, Clay. *Here Comes Everybody: The Power of Organizing without Organizations.* New York: Penguin, 2008.

———. "Power Laws, Weblogs, and Inequality." *Clay Shirky's Writings about the Internet*, February 8, 2003, <http://www.shirky.com/writings/powerlaw_weblog .html>.

———. "RIP The Consumer 1900–1999." *Clay Shirky's Writings about the Internet*, <http:// www.shirky.com/writings/consumer.html>.

"ShoWest 2008 Talking Points and Fact Sheet." *National Association of Theater Owners*, March 2008, <http://natoonline.org>.

Sklar, Robert. *Movie-Made America: A Cultural History of American Movies.* New York: Vintage, 1994.

Sontag, Susan. "The Decay of Cinema." *New York Times*, February 25, 1996, <http:/www .nytimes.com/>.

———. *On Photography.* New York: Farrar, 1977.

Spigel, Lynn. *Make Room for TV: Television and the Family Ideal in Postwar America.* Chicago: University of Chicago Press, 1992.

Springer, Claudia. "Psycho-Cybernetics in Films of the 1990s." *Alien Zone II: The Spaces of Science-Fiction Cinema.* Ed. Annette Kuhn. London: Verso, 1999. 203–220.

Staiger, Janet. "Writing the History of American Film Reception." *Hollywood Spectatorship: Changing Perceptions of Cinema Audiences.* Ed. Melvyn Stokes and Richard Maltby. London: British Film Institute Publishing, 2001. 19–32.

Stanley, T. L. "Hollywood Relying More on Franchises." *Hollywood Reporter*, June 16, 2008, <http://www.hollywoodreporter.com/>.

Stewart, Garrett. *Between Film and Screen: Modernism's Photo Synthesis.* Chicago: University of Chicago Press, 1999.

Stewart, Ryan. "Editorial: The 'Transformers' Story That Never Happened and Why that's Too Bad." *Cinematical*, July 9, 2007, <http://www.cinematical.com/>.

Stross, Randall. "Is Mark Cuban Missing the Big Picture?" *New York Times*, December 18, 2005, <http://nytimes.com>.

Stuart, Jamie. "Theatrical Thoughts." *Stream*, July 12, 2008, <http://www.wonderland stream.com/stream_blog.aspx?blog_id=711>.

Sullivan, Mark. "Hollywood Goofs on Campus Piracy Numbers." *PC World*, January 23, 2008, <http://blogs.pcworld.com/staffblog/archives/006350.html>.

"Surprise!" *Totally Unauthorized*, July 11, 2008, <http://filmhacks.wordpress.com/2008/ 07/11/surprise/>.

Tanz, Jason. "Almost Famous." *Wired* 16.8 (August 2008), 106–113.

Tanzer, Joshua. "Disc-covering America." *OffOffOff*, December 2, 2003, <http://www .offoffoff.com/film/2003/uncovered.php>.

Tashiro, Charles Shiro. "Videophilia: What Happens When You Wait for It on Video." *Film Quarterly* 45.1 (1991), 7–17.

Taubin, Amy. "All Talk?" *Film Comment* (November/December 2007), <http://www.film linc.com/fcm/nd07/mumblecore.htm>.

Taylor, Dayton. "Virtual Camera Movement: The Way of the Future." *American Cinematographer* 77.9 (September 1996), 93–100.

Telotte, J. P. *The Mouse Machine: Disney and Technology.* Urbana: University of Illinois Press, 2008.

Tenny, Paul. "Hollywood Writers Score Victory in Battle Over Webisodes." *Associated Content*, August 10, 2007, <http://www.associatedcontent.com/>.

Thompson, Anne. "Frustrated Indies Seek Web Distib'n." *Variety*, February 15, 2008, <http://www.variety.com/article/VR1117980978.html?categoryid=1019&cs=1>.

———. "Indie Sector on Shaky Ground." *Variety*, June 26, 2008, <http://www.variety .com/article/VR1117988181.html?categoryid=2508&cs=1>.

———. "Summer Boxoffice: Perfect Storm." *Thompson on Hollywood*, June 18, 2008, <http://weblogs.variety.com/thompsononhollywood/2008/06/summer-boxoffic .html>.

———. "Viral Video: Women in Film." *Thompson on Hollywood*, August 4, 2007, <http://weblogs.variety.com/thompsononhollywood/2007/08/viral-video-wom .html>.

Thompson, Kristin. "Movies Still Matter." *Observations on film art and Film Art*, March 14, 2007, <http://www.davidbordwell.net/blog/?p=475>.

———. "A Turning Point in Digital Projection?" *Observations on film art and Film Art.*, October 21, 2007, <http://www.davidbordwell.net/blog/?p=1419>.

Tryon, Chuck. "Video from the Void: Video Spectatorship, Domestic Movie Cultures, and Contemporary Horror Film." *Journal of Film and Video*, forthcoming.

———. "Video Mobility." *BraintrustDV*, November 30, 2005, <http://www.braintrustdv .com/roundtables/ipod.html#Tryon>.

———. "Watch Now: Netflix, Streaming Movies and Networked Film Publics." *Flow* 6.5 (August 2007), <http://flowtv.org/?p=706>.

"U2 3D Production Notes." *National Geographic.com* 2008, <http://ftp.nationalgeographic .com/pressroom/film_u23d>.

von Sychowski, Patrick. "Digital Cinema Is Not a Technology." Digimart Global Distribution Summit, September 22, 2005, <http://digimart.org/en/index.php#>.

Wajcman, Judy. *TechnoFeminism.* Cambridge: Polity, 2004.

Wang, Jennifer Hyland. "'A Struggle of Contending Stories': Race, Gender and Political Memory in *Forrest Gump*." *Cinema Journal* 39.3 (Spring 2000), 92–115.

Wark, McKenzie. "Cyberhype." *World Art* (November 1994), 66.

Wasko, Janet. *Hollywood in the Information Age: Beyond the Silver Screen.* Austin: University of Texas Press, 1994.

Wasser, Frederick. *Veni, Vidi, Video: The Hollywood Empire and the VCR.* Austin: University of Texas Press, 2001.

Waxman, Sharon. "A Blunt Instrument at the *Washington Post*." WaxWord, May 16, 2008, <http://sharonwaxman.typepad.com/waxword/2008/05/a-blunt-instrum.html>.

———. "Missed in the Theater? See It on DVD Tonight." *New York Times*, January 23, 2006, <http://www.nytimes.com>.

Weiler, Lance. "Navigating the Digital Divide." *Filmmaker* 16.2 (Winter 2008), 100–102.

Weissleder, Myles. "Reflections on Meetup's 3rd Anniversary. Are Americans 'Bowling Alone' Less?" *Meetup Watch*, June 14, 2005, <http://press.meetup.com/watch/ archives/001115.html>.

White, Armond. "Greed Racer." *New York Press*, May 6, 2008, <http://www.nypress.com/ 21/19/film/ArmondWhite.cfm>.

Will, George. "IPod's Missed Manners." *Washington Post*, November 20, 2005, B7, <http://www.washingtonpost.com/>.

Williams, Raymond. *Television: Technology and Cultural Form.* New York: Schocken, 1974.

Winograd, Morley, and Michael D. Hais. *Millennial Makeover: MySpace, YouTube, and the Future of American Politics.* New Brunswick, N.J.: Rutgers University Press, 2008.

Winston, Brian. *Media, Technology, and Society: A History: From the Telegraph to the Internet.* London: Routledge, 1998.

Wood, Robin. "Ideology, Genre, Auteur." *Film Genre Reader.* Ed. Barry Keith Grant Austin: University of Texas Press, 1986. 61.

Wyatt, Justin. *High Concept: Movies and Marketing in Hollywood.* Austin: University of Texas Press, 1994.

Zeitchik, Steven. "Fox Atomic Brings New Twists." *Variety*, February 18, 2007, <http://www.variety.com/article/VR1117959777.html?categoryid=1350&cs=51>.

Zimmermann, Patricia R. "Digital Deployment(s)." *Contemporary American Independent Film: From the Margins to the Mainstream.* Ed. Chris Holmlund and Justin Wyatt. New York: Routledge, 2005.

———. *Reel Families: A Social History of Amateur Film.* Bloomington: Indiana University Press, 1995.

Index

About the Author

Chuck Tryon is an assistant professor at Fayetteville State University, where he teaches film and media studies. He has published essays in *Film Criticism, Rhizomes, Pedagogy,* and *Post-Identity* and in the anthologies *The Essential Science Fiction Television Reader* and *Violating Time: History, Memory and Nostalgia in Cinema.*